Cover:
St. John the Baptist Preaching.
Cat. no. 7, detail.

RODIN'S SCULPTURE

RODIN'S SCULPTURE

A Critical Study of the Spreckels Collection

California Palace of the Legion of Honor

JACQUES de CASO and PATRICIA B. SANDERS

THE FINE ARTS MUSEUMS OF SAN FRANCISCO

CHARLES E. TUTTLE CO., INC. (1977)
Rutland, Vermont and Tokyo, Japan

To Marie-Rose de Caso, Lee Sanders and
Elizabeth and Elmo Brenden

This project is supported by grants from the National Endowment
for the Arts in Washington, D.C., a Federal agency, from
The Ford Foundation, and from The Museum Society.

Published by The Fine Arts Museums of San Francisco and
Charles E. Tuttle Co., Inc., Rutland, Vermont and Tokyo, Japan.

ISBN 0-88401-022-8 (softcover)
ISBN 0-88401-023-6 (hardcover)
Library of Congress Catalogue Card No. 76-45944

Designed and produced by Adrian Wilson.

Printed by Phelps/Schaefer Litho-Graphics Co.

Contents

Preface

This rich and careful study of the Alma de Bretteville Spreckels collection of sculptures by Auguste Rodin at the California Palace of the Legion of Honor has been evolving for a decade. Had such an undertaking been solely the responsibility of the diligent scholars to whom we are indebted for the research for and preparation of this catalogue, the task would have been completed in less time. But during the past ten years, a period of considerable growth for the museum, a number of events have occurred which lend special significance to the Rodin collection in San Francisco.

Mrs. Spreckels' death in 1968 marked the end of an era in the history of the California Palace of the Legion of Honor. Not only did the museum lose its first great patron in that year, but also the long and devoted career of Thomas Carr Howe—who served the museum for eight years as Assistant Director and twenty-nine years as Director—came to a close. But the patron and the museum director had brought to reality their shared dream of creating a cultural institution of international consequence. Mrs. Spreckels bequeathed to the Legion of Honor as permanent gifts all of the works on loan to the museum at the time of her death. The proper moment had come to consider a first thorough study of the Rodin collection.

Professor Jacques de Caso at the University of California, Berkeley, a specialist in the field of eighteenth- and nineteenth-century sculpture, and Patricia B. Sanders, then a graduate student at Berkeley and now a professor of art history at the University of the Pacific, Stockton, California, agreed to undertake the work. The Patrons of Art and Music, a membership group supporting the exhibitions, publications and other programs of the museum, agreed to fund the project. The group was unstinting in its generosity as the developing research required additional funding. Final production phases of the publication were funded through grants from The Ford Foundation and the National Endowment for the Arts, with the support of The Museum Society.

The merger of the California Palace of the Legion of Honor with the M. H. de Young Memorial Museum in 1972 and the subsequent redistribution of their collections elevated the Legion of Honor to the unique status of an American museum devoted almost entirely to the arts of France. Non-French works of art were transferred to the de Young Museum; French art works from the extensive de Young Museum collections were transferred to the Legion of Honor. In 1973, with the opening of the Medieval Galleries given by Hélène Irwin Fagan, a spectacular panorama of French art from the late fourteenth century to the twentieth century

became available to the public in a coherent context. No longer was Mrs. Spreckels' magnificent survey of Rodin's achievements viewed as a relatively isolated statement; rather, it was seen to reflect a major turning point in the history of Western art.

The moment had arrived to recognize the pivotal importance of this collection of Rodin's works and to give it deserved and visible recognition. The presence of Rodin's *The Burghers of Calais*, *Balzac* and *The Walking Man* at the Legion of Honor on a four-year loan from the Norton Simon Foundation and the arrival at Stanford University Museum of a significant segment of the B. Gerald Cantor collection of Rodin sculpture were added stimuli to create a focus on the Spreckels collection. The fiftieth anniversary of the Legion of Honor on November 11, 1974, provided the occasion. A half century had passed since the museum, a major cultural resource, had been presented by the Spreckels to San Francisco. What was a more fitting way to commemorate the generosity of the museum's donors than to designate the great central hall of the museum as a permanent gallery for the Rodin works?

Adolph Spreckels Rosekrans, architect for the museum, restored its two flanking garden courts with lovely Monte Verde and white Vermont marble floors. I designed new Verde Antique marble bases for the sculptures as well as gallery seating and dynamic (rather than static) lighting. We found space to create vitrines to hold the smaller bronzes and plasters. F. Lanier Graham, chief curator at the time, devised an installation of Rodin's early works and works by Rodin's contemporaries—Barye, Carpeaux and Carrier-Belleuse—in the south garden court; the monumental Rodins were set in the newly dedicated Rodin Gallery; and the north garden court held works by Rodin, Bourdelle and Dalou, with Maillol brilliantly represented by a recent acquisition, *L'Ile de France*. Consultation with Professor Albert Elsen at Stanford University assured that the Spreckels collection was installed so as to complement the new installation of the Cantor collection at the Stanford University Museum. Jacques de Caso, working with the Spreckels collection, and Elsen, working with the Cantor collection, gave the San Francisco Bay Area unique importance as a center in the western United States for the study of Rodin's work.

As this catalogue is published, significant changes are taking place which will increase the availability of the Rodin archival materials. We must hail Emmanuel de Margerie, President of the Museums of France, for recognizing the pleas of Rodin scholars everywhere and taking steps to make the Rodin Archives in France available for study. In this effort, the cooperation of Mme Monique Laurent, Director of the Musée Rodin, Paris, has been essential. Locally, we must note with regret the death of Jean Scott Frickelton, Mrs. Spreckels' confidante of many years, whose loss means the closing of an invaluable avenue of research. She held many of Mrs. Spreckels' papers and much of her correspondence, and the future disposition of these materials is not yet known.

Jacques de Caso and Patricia Sanders have worked in the face of considerable odds to obtain information for their work. We must thank them for their perseverance and patience; they have devoted time to the supervision of and writing for this project even while meeting the demands of teaching. They are currently continuing their research on Rodin in a common effort with the Musée Rodin to publish Rodin's writings and correspondence.

We hope that readers will find, as I did, that the eloquent clarity of the authors' style heightens one's appetite to a deeper understanding of the subject, and that the articulate photography of Joe Schopplein enriches the presentation of the master's sculptures.

IAN McKIBBIN WHITE
Director of Museums

Acknowledgments

Several individuals have supported this project from its inception: Ian McKibbin White, Director of Museums, The Fine Arts Museums of San Francisco; our colleague at the University of California, Berkeley, Professor Walter Horn; and F. Lanier Graham, from 1970 to 1976 Chief Curator of The Fine Arts Museums of San Francisco.

The cooperation of William Elsner, Curator in the Department of Paintings and Sculpture and long familiar with the collection, has proved invaluable. Our thanks also go to Ned Engle, Publications Manager for The Fine Arts Museums of San Francisco. The photographs by Joe Schopplein deserve special mention. They have given us new insights into and appreciation of these sculptures. Adrian Wilson's skill and sensitivity have enhanced the design of this catalogue immeasurably. This project would not have been possible without generous assistance from the Patrons of Art and Music of the California Palace of the Legion of Honor, which supported it from the beginning; The Museum Society, which has carried it through to its conclusion; and the National Endowment for the Arts and the Ford Foundation which have contributed so generously to it.

In writing the history of the collection, we have depended upon the reminiscences of several people who knew Mrs. Spreckels. In particular, we are indebted to the late Jean Scott Frickelton, Mrs. Spreckels' long-time friend, who generously provided rare personal insights into Mrs. Spreckels and the history of the collection.

We would like to thank Miss Mary Connolly for making available to us the records of the San Francisco Recreation and Parks Department.

We cannot possibly list all the museum officials in the United States and abroad who have assisted us. Some have been tireless in their efforts and deserve special credit: Mr. C. R. Dolph, former Director, the Maryhill Museum of Fine Arts, Maryhill, Washington; Mr. Ronald Alley, Keeper of the Modern Collection, the Tate Gallery, London; Mr. Samuel F. Oliver, Director, Museo Nacional de Bellas Artes, Buenos Aires, Argentina; I. Kuznetsova, Curator of European Art, the Pushkin Fine Arts Museum, Moscow; Dagmar Hnikova, Kunsthaus, Zurich; Mej. Drs. P. I. Dehann, the Singer Museum, Laren, the Netherlands; Mme T. Préauld, Archivist, Manufacture Nationale de Sèvres; and Mme Monique Laurent, recently appointed Conservateur, Musée Rodin, Paris.

We have also received extensive help from individuals in the United States and abroad, and would particularly like to thank: Mr. John Tancock, Mrs. Vera Green, Mr. Jay Cantor, and Mrs. Jefferson Dickson, Beverly Hills, California; and Prof. Dr. Med. W. A. Stoll, Rheinau, Switzerland.

We have made extensive use of library collections and are especially indebted to Mr. Earle E. Coleman, Assistant University Librarian for Rare Books and Special Collections of the Princeton University Library.

Modern scholarship on Rodin owes much to the writings of Professor Albert Elsen of Stanford University and to his enthusiasm for the artist. Professor Elsen has generously shared information, time and stimulating conversation. We have acknowledged his contributions throughout the catalogue. Mrs. Athena Tacha Spear, Allen Memorial Art Museum, Oberlin, Ohio, and Professor Kirk Varnedoe of Columbia University have shared their knowledge of Rodin's works.

The Department of the History of Art, University of California, Berkeley, has also assisted us greatly. We have been greatly supported by our many conversations with members of the faculty and the graduate students.

Finally, we are in debt to friends whose skills and patience helped us to improve the manuscript. Among them are Lois Miller Simpson and James Norwood Pratt. We are extremely pleased to have had the editorial guidance of Lorna Price and Gail Larrick.

J. de C.
P. B. S.

Introduction

The Rodin collection left by Mrs. Alma de Bretteville Spreckels to the California Palace of the Legion of Honor is the most salient and nearly the earliest example of America's admirable passion for an artist whose personality and works dominated the decades of 1880 to 1910. In an essay which follows this Introduction, Patricia B. Sanders has chronicled the history of Mrs. Spreckels' collecting enterprise. Mrs. Spreckels—decisive, wealthy and of independent mind—followed, seemingly first and foremost, her own tastes and fantasy over the course of nearly thirty-five years, during which she acquired the impressive selection of Auguste Rodin's works—more than seventy—in her collection. One can almost imagine that Mrs. Spreckels delighted in the prospect of outwitting historians-to-come. Little aided—counselled certainly, but only on occasion—keeping no records, or almost none, of any purchase, she simply followed her own bent in buying sculpture.

Her choice was remarkable. Before Rodin's death in 1917 and over the following years until the 1940s, she acquired, first from Rodin and later from those nearest him, bronzes, plasters and marbles—among them not only many of the most important Rodins but also many of the very best. This accomplishment places Mrs. Spreckels with Thomas Ryan at the head of the list of American collectors that includes Mrs. John Simpson and Jules Mastbaum, whose collections must be considered among the earliest and most important in America. Thanks to her, the San Francisco Bay Area, including as it does not only the Spreckels collection but the Cantor collection now at the Stanford University Museum of Art, is second only to the Musée Rodin in Paris as a center of Rodin art and studies.

As with any collection, public or private, the works Mrs. Spreckels assembled vary in historical importance and artistic quality, but the ensemble is impressive for the number of pieces of greatest interest and quality which it includes. Many of those, in fact, remain relatively little known, having only occasionally appeared in exhibitions outside California. Given the unique character of this collection, it is only fitting that a serious study of the works should appear. Such an undertaking is all the more important in that today we witness the beginning, on a worldwide basis, of a comparative study of the great Rodin collections and a general reassessment of his art.

The object of a catalogue is to provide visitors to an exhibition or a permanent collection with all the information they might wish concerning a work, permitting them to better place and judge it in the twin contexts of the artist's total production and of the art of the artist's time. In Rodin's case such an undertaking poses any number of problems. On the one hand, it is difficult to ascertain the comparative excellence of the different castings or copies made in series of the same work. The dispersion of exemplars executed at different dates and under differing conditions remains the major handicap to the study of modern sculpture. Moreover, historians of Rodin are still embarrassed by a major restriction: the archives of the artist, left by him along with his works to the museum he established in Paris before his death, have not been open to researchers. This restriction, which has recently begun to be relaxed somewhat, has hampered the first serious scholars of Rodin's art for more than ten years. Among other matters, important questions relating to conditions of commissions and to the number and the dates of exemplars within a single series cannot for the moment be dealt with at all or, in the case of many works, can be treated only provisionally. Handicaps and limitations notwithstanding, the importance of the Spreckels collection and its place within the framework of what is now known about Rodin's work encouraged us to complete our project.

Every visitor to any collection of modern sculpture quickly finds himself confronted with a striking, almost disconcerting fact: a great variety (that is, an absence of continuity) exists among the works. The diversity of nineteenth-century subjects and styles appears to surpass that of painters, allowing sculptors the most disparate subjects and styles as they move from one work to the next. Side by side we find portraits; diverse subjects whose titles call up history, mythology or religion; allegories; animals; projects for monuments commemorating the most various purposes. The stylistic unity of any sculptor's entire production must, for better or worse, harmonize the diverse demands of a multitude of particular pieces and problems. The totality of Rodin's work perfectly manifests this versatility and prompts us to search through this rich variety of different pieces for certain constants of inspiration and of style. This versatility is not particular to the work of Rodin but is common to all modern sculpture.

This apparent lack of continuity illustrates the pressure of social conditions which weigh upon the creation of a sculpture, its invention and its execution alike. One can hardly imagine a statue in bronze or in marble—a work invariably expensive to realize—left in the sculptor's studio without a buyer. Sculpture is therefore dependent upon demands, even submitting to the requirements of commissions. Sculptors thus find their art channelled into various types of works—the genres which their particular tastes and talents allow. Some find themselves most at ease with the portrait, others with monumental sculpture. Rodin did not escape these contingencies; the range and nature of his art is perfectly illustrated in the Spreckels collection.

This multiplicity of genres provides what seems to be the best basis for organizing our study of the collection and for grasping, beyond the rarity of works, those major lines of unity throughout all the art of Rodin. Thus in each category, while relating each work to its commissioning, we do not separate the desires and artistic prejudices of the client from the intentions of the artist. In this way, we may reach a better understanding of those intentions and, so far as possible, suggest the work's significance and gauge its artistic quality.

Another objective, and one no less important for a catalogue of modern sculpture, is to determine the place of a particular piece in the series of casts or copies to which it belongs. Modern sculptures are analogous to prints in that rarely does any question arise as to whether

an example is one of a kind or "the original." Setting a piece in the context of the series it exemplifies is central to the study of Rodin's art, and this aspect is daily assuming a growing importance with Rodin scholars. For example, too few people realize that more than seventy statues of *The Thinker* exist, and reportedly more than 300 of *The Kiss*! One should understand that the artistic quality of the pieces in such a series varies enormously. This variation of quality is true not only of Rodin's work but applies equally to all the sculpture of the last four centuries.

Since the Renaissance, a work of sculpture—whether Canova's or Rodin's—rarely comes into existence as an isolated or unique piece: the artistic identity of a sculpture is the sum of the diverse formats, materials and moods of a series. Consequently, to establish the history of a given work is often difficult, and to determine the extent of the artist's personal involvement in the execution of any given piece is even more difficult. This consideration is not peculiar to Rodin, but, in Rodin's case, it assumes extreme proportions.

Unlike many nineteenth-century sculptors, Rodin will never be accused of "industrial sculpture." Nonetheless, we are unable to document or in any way measure the full extent of his production and the multiplication of his works. Certainly after 1890, as an established and acclaimed artist and avid collector remembering no doubt with terror the difficult years of his youth, Rodin not only had expensive tastes and enormous needs but also was inattentive to the production of his workshop's casters, molders, practitioners and founders. From this point on, one comes to recognize the hands of these helpers and their own styles of execution. Even if we consider only those pieces whose release we know Rodin authorized, certain among them show such glaring inadequacy of execution as can only be attributed to carelessness on the part of Rodin. To go further, many fraudulantly executed works—bronzes and marbles done during the artist's lifetime or after his death—have been included in both private and public collections. Finally we must add the confusing problem of posthumous casts which are still in production today. Since molds necessarily deteriorate, each newly executed piece falls further and further short of the artist's aims. Such considerations should make us much more aware of the exceptional value of the Spreckels collection, in which the majority of pieces can be traced directly back to the sculptor himself or to his closest associates. Insofar as possible, we have endeavored to document the provenance of these works. When documentation was not possible, the usually very high quality of the casts speaks in place of the missing documents.

To direct viewers through the Spreckels collection from one end to the other is to guide them through the whole range of Rodin's work and all the different categories of sculpture to which we have alluded.

Rodin announced himself to the public of the 1870s with two works which linked him straightaway to the tastes of that generation. *The Age of Bronze* (cat. no. 1) and *St. John the Baptist Preaching* (cat. no. 7)—exhibition pieces both, and two of Rodin's first works—are represented in the Spreckels collection by two splendid casts executed before his death. These two works introduced the public and the more alert critics to Rodin.

Statuary of this sort was one of the most popular genres of nineteenth-century sculpture. The historical personage was not portrayed so much as used as subject matter or for storytelling; the nearly life-size and isolated figure was intended for a rich and spacious setting, as an accessory to the elegant life. Works of this type were meant to be viewed close at hand. Such statuary thus demands impeccable execution; artists' reputations were often made with this sort of work.

Thus *The Age of Bronze* and the *St. John the Baptist* relate directly to the requirements of "academic" or "official" sculpture favored by the Salons over the course of the nineteenth century. These works illustrate a conception of sculpture derived from classical art and reinforced from Renaissance days onward: a tradition placing the human figure, preferably completely nude, at the very center of the artist's preoccupations in sculpture. Attitudes, gestures, physiognomy—all translate dramatic or poetic situations or the feelings of the character with whom the sculptor attempts to make the viewer identify. The nude is simultaneously an art in itself and a means, a purely plastic and aesthetic creation, yet it also evokes a story by referring to an historical or literary personage. By depicting Venus or Diana, the artist presents bodily beauty; in Spartacus, courage is portrayed. Rodin's art often leans upon this traditional conception of sculpture, expressing some message while at the same time leaving the viewer the greatest freedom of interpretation.

St. John the Baptist is explicitly didactic; *The Age of Bronze*, on the other hand, minimizes the precise implications of the subject and represents radical innovation on the part of Rodin. The statue escapes mere illustration of an incident to invite each viewer's own associations; as its various titles amply indicate, the subject matter remains imprecise, the "message" is veiled. *The Age of Bronze* seems to express the dawning on primitive man of an uncomfortable new stage in his developing dominion over creation. Seen under the aspect lent by its other title, *The Vanquished*, the work portrays the young French soldier in a state of exhaustion immediately after the debacle of 1870. The subject is not announced, so to speak. This ambiguity carries through Rodin's entire life's work: the "subject" serves mainly to trigger and activate a series of different, often personal and sometimes secret associations which link the work with the viewer's experience. An approach like Rodin's necessarily relies on formal effects rather than on a code of attributes to express the character of the work. The arrangements he creates with the lines and volumes, the expressiveness of his compositions and the emotions they embody raise his art above that of other sculptors of his day.

In the following pages we have catalogued, so far as possible, the various titles Rodin, or sometimes his friends, gave his works over the course of years. A common poetic intuition is often the source of the various and sometimes unexpected titles a work may bear. Rodin's most astute critics have generally emphasized this habitual name-changing, which his detractors found so irritating or even scandalous at times. Such insightful interpreters of the *fin de siècle* sensibility as Aleister Crowley, for example, were nonetheless able to judge perfectly how these multiple titles, which sometimes seem independent of the works themselves, served to enrich Rodin's art.

The title-changing further demonstrates Rodin's adherence to a discursive, almost literary conception of his art. Although never for an instant losing sight of his works' plastic qualities, he intends for them to tell us *something*. Some such conception may be traced throughout all the art of the nineteenth century, but the tendency was exalted and magnified by the Symbolist movement. At its extreme, Symbolist art defines itself beyond any object or title whatsoever or else by means of several objects and titles offered simultaneously. Such an art reveals itself only secretly, only on occasion and always in a discontinuous, nonlogical fashion that depends upon those relationships the viewer intuitively perceives between the work of art, the world and his own existence.

Another body of works and another genre—the group—had requirements of its own: the subject matter comprises a number of figures in a pose or dramatic arrangement intended to represent a narrative expressing a didactic message. Most of Rodin's groups have their source

16

in a major program—*The Gates of Hell*—on which he was engaged for more than twenty years. He received this commission in 1880; from that time on, he seems to have devoted much of his energy to its creation. *The Gates* became an inexhaustible reservoir of forms from which Rodin drew many of the statues, groups and "ideas" on which his reputation would rest. Mrs. Spreckels could not acquire an example of *The Gates of Hell*, which was cast for the first time only in 1926, after Rodin's death. She did, however, acquire nearly fifteen works which are derived from this monumental program, among them some of the most famous: *The Thinker* (cat. no. 19), *The Three Shades* (cat. no. 20), *Eve* (Cat. no. 21), *The Kiss* (cat. no. 22) and *The Prodigal Son* (cat. no. 24).

In a number of respects, the commission for *The Gates* placed Rodin in a predicament most unusual for a sculptor of the nineteenth century. If indeed allowed to choose the subject of Dante's *Inferno*, he still had to think in terms of a monumental composition on a scale that nineteenth-century sculpture had forgotten how to employ. Rodin found himself obliged by the very amplitude of his conception to realign his art on the scope of a "philosophic art," as Baudelaire might say. Such a genre was popular throughout the nineteenth century, but in painting rather than sculpture. *The Gates* was to be exhaled, so to speak, a long sigh of a work showing episodes, obviously—a narrative and anecdotes in an elaborate compositional scheme fashioned to translate the magnitude and the moving, tormented character of the poem.

Much has been written about Rodin's passion for the poetry of Dante, but this passion was reinforced by the poetry and art of authors such as Blake, Hugo or Doré who had made the most of Dante over the course of the nineteenth century. Rodin was familiar with those interpretations. Thus *The Gates of Hell* celebrated those episodes which the nineteenth century had especially singled out—the image of Paolo and Francesca, that touching picture of passion from which Rodin drew his idea for *The Kiss*, or the depiction of the agony of Count Ugolino, he and his offspring victims of ambition and intolerance. From the first, however, Rodin took Dante as a point of departure for a personal commentary on the tragic, pessimistic character of human nature and existence—a commentary never before seen in sculpture.

The Gates of Hell became the training ground where Rodin worked out the greater number of his stylistic innovations. Rodin and his art were so inextricably bound up with *The Gates of Hell* that the work rapidly came to symbolize both and to be considered Rodin's quintessential achievement: the very picture of passionate creation—demanding, unbought and unbuyable; the damnation of an artist struggling in defiance of limitation to reach out beyond himself. Rodin confronts the viewer with an image in which all traditional narrative techniques are shattered. The episodes are not presented to be read in neat panels, images or unities following some logical order unfolded according to the viewer's expectations. Rather, the viewer is expected to recognize, select and forge the bond between the episodes from *The Inferno* and the images before him, where figures relate each to each in an ambiguous sculptural space undiscovered before Rodin. Thanks to a variable light which ceaselessly alters and affects the depth of the relief and thereby the experience of its space, those traditionally respected frontiers disappear which, in the modern age, assign to sculpture and to painting separate domains and different means of affecting the viewer's sensibilities. The essence of Rodin's style, the particular form and type of expression which was associated with Rodin from 1880 on and became the mark of his art, appears in *The Gates of Hell*.

The essential Rodin is clearly apparent in that concept of the human body which he placed at the very center of his art. In his expression of the body we find the revolutionary attitude

17

which brought forth plastic and expressive effects no one else had ever suspected could be achieved. The damned souls depicted on *The Gates* again and again lead back to Rodin's artistic preoccupations with the total and unprejudiced celebration of the human body. We can barely appreciate today the audacity and novelty of Rodin's views in his own time. While shocking contemporaries and inspiring attacks, his views led the way to one of the most fundamental conquests of the art of today. Rodin's fascination with the human body and its expressive possibilities burst upon an era when moral hypocrisy obliged artists to disguise eroticism beneath a facade of what was deemed pretty. The art of Rodin, for perhaps the first time in the history of art, postulates the existence of man and woman as inseparable from the biological life of their bodies. Playful and erotic activity is for Rodin what it was for Michelet and for Baudelaire: a manner of living more abundantly; a way of reuniting body and spirit in a single expression whose vocabulary, because personal, is also limitless.

Certain reliable witnesses have repeated in anecdotes the extent of Rodin's curiosity—almost an obsession—concerning men and women. This curiosity breaks out at every stage of his sculpted work and in his drawings. Moreover, Rodin was no longer concerned with representing that known, recognizable and finite number of virtues or feelings or states of the soul which had interested the sculptors before him: the states of attentiveness, joy, will or fear, for instance. Rodin's groups, where nudes predominate, express little-defined psychological states, the nature of which cannot be reduced to known physiognomic formulae explained by fixed psychological categories. The body's customary postures, likenesses and precise or expected gestures give way before outrageous, acrobatic, fluid, sometimes anatomically impossible attitudes, gestures and placements which are in no case classifiable. For the most part, eroticism dictates the expressive gymnastics in Rodin's most important works.

This interest is not at all limited to amorous situations or positions. Eroticism is a lasting experience, a dimension of life, a source of knowledge and poetry. Without a doubt, Rodin had after 1880 a number of remarkable intuitions which often made his art parallel the pioneer researches into unconscious behavior by physiologists of his day. The Spreckels collection includes one striking work, *The Sculptor and His Muse* (cat. no. 2), which triumphantly affirms the equation between the creative act and the erotic. In other works, he demonstrates how masculine and feminine are not separate and divisible categories. From then on, the peculiar anatomy of his figures, their contorted limbs, their poses possible only in dreams and their apparently indecipherable gestures—all express states of consciousness beyond any ever before classified by artists. We see from the way the actors in a group sculpture relate to each other in space that the body itself expresses the spirit's cravings and fulfillments; the liberty in posing and distorting the body shows us how spirit manifests itself through flesh.

The collection includes a statuette (cat. no. 28) whose significance is particularly relevant. A woman is seated but holds her heel with her hand, the leg extended. Rodin named her *Despair*, evoking the extreme of suffering at the moment when it probably becomes unbearable and is displaced from the mind, only to be distributed throughout the body by this excessive gesture which serves to fix the emotion as if in mime. Clearly such insights render almost laughable those traditional categories of feelings to which artists had formerly adhered. In this piece, Rodin invests and puts to work what came fifty years later from the *Surréalistes*—an anatomy of the body acting unconsciously which conveys experience.

The artist imposed on most of his groups those bodily gymnastics which interpret erotic or any other form of activity without regard to the anecdotes or stories they tell or from which

they are taken. Such a preoccupation with bodies entirely freed from gestures and precisely identifiable goals is perhaps even better seen in Rodin's drawings, where the nudes, singly or in groups, float in a space which only rarely has anything in common with the viewer's. In this shapeless and gravity-free space, the figures find gestures, attitudes and expressions dictated solely by their physiological existence—their desires and kinesthetic awareness. One would be mistaken to take those drawings as studies of movement—mere instantaneous, unexpected acrobatics.

Such an interest in the thing in motion, the object transfiguring its masses and appearance, does however go far toward explaining a new sculptural genre which Rodin created. We mean the fragments, the incomplete or unfinished works, reduced to the essential and often formed by the combination of heterogeneous parts in which chance and the free working of the hand were not hampered by any constraint. Torsos, studies of hands and, above all, of feet were amassed in the hundreds by Rodin, who regarded them not as studies, works in embryo or projects to develop later on but as finished works, complete and self-sufficient. Rodin gave these pieces the same standing as accomplished works of art and exhibited them along with his other works, suggesting by diverse titles their dramatic and poetic associations. Thus Rodin invented another artistic category, the liberating implications of which are basic for twentieth-century art. The numerous unfinished works—torsos, hands, feet or other parts—which we find in the Spreckels collection are of the greatest interest in deciphering Rodin's techniques of creation and, through these, his conception of sculpture as well.

Rodin did not create as most previous sculptors had, gradually realizing a work by bringing some thought or form to perfection. Such a deliberate approach was only a minimal part of his definition of artistic creation. As a result of his own approach, he was able to introduce into sculpture the accidental, the chance and a wide range of new and unexpected aspects which only a feverish and almost unconscious handling of materials and techniques could contribute. Such interest in the accidental and unexpected explains much in Rodin's style—for instance, his very particular type of surface modelling where not only are the volumes exaggerated for the sake of overexpression but where, more surprising still, the hole and the filling of it, the removal and the addition of material, occur without apparent reason. Such a technique denies likeness both of forms and of anatomy, establishing an original plastic dimension, an ideal one.

From this perspective, one may better see why in his last, most finished and thought-through works Rodin was led to revolutionary innovations whose boldness is still astonishing. The statue of Balzac, for example, was presented to the public in 1898 exactly as it had come out of a machine, the machine that all nineteenth-century sculptors used to mechanically change the scale of their models before finishing them. Rodin preserved the surfaces of the piece he had modelled just as it came out of the machine. Since the expression of this work demanded it, Rodin utterly disregarded practices integral to the accepted idea of sculpture in his day. He considered traditional finishing and exact realistic execution of surfaces finite qualities, to be seen as separable somehow from the work itself. Rodin showed that the traditional notion of skill and bravura of execution which everybody praised was only an accessory, and a negligible one at that—something any mediocre artist could easily master. Thus it was secondary in the work of a true artist, for it could only mask the profoundest and truly artistic effects which are achieved through brute creation and which should remain unspoiled by imitative and narrow execution.

Certainly Rodin did not put such radical ideas into practice in every case. The statue of

Balzac was turned down by the very people who had commissioned it. His techniques of working revealed new dimensions to a work of art, the *automatisme* of mind and hand and the anti-artistic character of the ready-made which so clearly anticipate the art of our most recent sculptors. Such practices are grounded in an intense curiosity concerning the never-before-seen and the symbolic dimension which the accidental, chance and natural metamorphosis of material may open up. These elements are to be found throughout all Rodin's art, sculpture and drawing alike. The *Man with the Broken Nose* (cat. no. 50), dating from the years of his youth, is an accidental sculpture which was broken and simply left so. The "assemblages" Rodin made by joining heterogeneous fragments and his groups consisting of figures deliberately detached from unrelated groups and made to work in situations for which they were not intended reveal his intention of capturing, along with the work, a series of conditions and relationships which link the work to a specific set of circumstances and somehow augment it. This intention also emerges from Rodin's drawings, particularly those of the 1880s where he first introduces stains, scratches and foreign elements, anticipating the collage techniques utilized in the decade of the 1920s.

Our study will go into detail concerning portraiture, another genre of sculpture, of which Mrs. Spreckels assembled a dozen examples of first-rate quality. They span almost fifty years of the artist's work and demonstrate his versatility in this category. Insofar as is possible, we have traced the history of these commissions; these details account for much of the style and the variations in style of particular pieces. Certainly the dependence upon the model that portraiture imposed on the artist forbade spectacular innovation. Rodin's portraits partake of the tradition of incisive and instantaneous representations of features such as Carpeaux had brought into favor in France during the 1860s. In this genre, Rodin stresses precise, nervous execution (*Henri Rochefort*, cat. no. 58). Occasionally, he conceives the portrait as an abbreviated representation with subdued expression; then Rodin seems simply to draw the sitter's features on a block of freshly-hewn material (*Séverine*, cat. no. 61). Working in this style he displayed at a remarkably early date features which prefigure sculpture's calm classicism in the first decades of the twentieth century. In any case, his manner of translating the model's emotional life, the way he suggests unconscious life surfacing from underneath the features and the psychological nuances with which he endowed the expression of the face put his portraits greatly in advance of any attempts at portraiture by his contemporaries.

The genre of monuments to famous individuals was early enlarged by artists to celebrate not only the people but their ideas as well. It grew in favor steadily throughout the nineteenth century. Along with funerary monuments, the nineteenth century considered such commemorative sculpture the noblest and most elevated. That genre displayed to best advantage the talents of all major sculptors: Canova, Schadow, David, Rude, Barye, Préault, Stevens, Carpeaux and Dalou. Nor was monumental statuary confined to the public square; it penetrated all levels of social life. Reductions and commercial replicas enabled such works to penetrate both the museum and the private home, thereby allowing the cult of the exceptional man to become something personal and private. The close of the nineteenth century witnessed, in fact, such a multiplication of public monuments that cities were compelled to limit further monumentalizing.

Although Rodin was solicited for these commissions, we have good reason to think that he never felt particularly at ease with them. He seriously questioned the accepted prejudices of his day concerning the allegorical aesthetics of the public monument, although he occasionally paid lip service to traditional formulae. Moreover, he seems to have hesitated over his

76-45944

Rodin's Sculpture: a critical study of the Spreckels
Collection.
ISBN: 0-8840-1023-6

NB553 R7 D36

Fine Arts Museums of San Francisco/San Francisco 1977

Rosenfeld/DK/BNH art history Mugar 20.00

AH889 Fza78

own decisions, and we know for certain that the birth of those monuments was a long and painful one. In Rodin's best-known monuments, those to Claude Lorrain and Victor Hugo, one recognizes a talent in the composition, a cleverness in handling the expression and an overall persuasiveness for which one could seek in vain in monuments by other sculptors of Rodin's generation (Dalou excepted). Rodin's conception of the monument, however, was drawn directly from traditional and not very innovative formulae: the personage appears in historical costume or else in the nude, alone or surrounded with allegorical figures which rather bombastically explain the meaning of the work, as in *The Call to Arms* (cat. no. 36).

Nevertheless, two commissions for monuments engaged Rodin more fully than any others and enabled him to innovate boldly in conceiving both the type of monument and the style of execution: the monument to the burghers of Calais and the one to Balzac. Both are represented in the Spreckels collection by studies. *The Burghers of Calais* (cat. nos. 39-44) was meant to celebrate the moving story of the townsmen-hostages, intended for a fate consented to and inevitable. By showing them on their way to meet that fate, and at the same time illustrating their resignation and the simplicity of their attitudes, Rodin attains in this work such reserved expression and such conviction of feeling that it stands in striking contrast to the declamatory conventions and emphatic gestures common to other monuments of the day.

All discursive and allegorical language is abandoned in *The Burghers of Calais*. Rodin re-aligned his means of expression on the Gothic entombment groups he so admired. Following their examples, he breaks with the prevailing sculptural conventions in which an elaborate and ornate pedestal added to the ''artistic'' character of the work even though it served to isolate the viewer. After long hesitation, Rodin finally intended to have *The Burghers of Calais* displayed within arm's reach of the viewer and at eye level in the middle of a public square. Thus the work appears a petrification of the event itself or a brutal simulation of the drama. In either case, it is an ancestral conception of sculpture which reaffirms its realistic and magical character.

We may hope that the Spreckels collection will enrich itself someday by acquiring, if possible, a study of Rodin's final *Balzac*. Mrs. Spreckels purchased only two studies for the head of this monument, which was considered Rodin's most revolutionary achievement and remains a landmark of modern sculpture. The statue of Balzac was not only made the occasion for impassioned public arguments but also assumed considerable personal significance for Rodin himself. From the standpoint of the type of monument, Rodin had placed his work in a traditional perspective. The problem was to represent Balzac, whom Rodin could not have known, by means of a likeness which would show the nature of Balzac's genius. Rodin's concern with striking a true likeness of Balzac is obvious even from his choice of the legendary garb the writer wore to conceal his corpulent body. This concern is also apparent in the wide range of Rodin's iconographical research on Balzac. Paradoxically, such concern for exactitude was understood by the more perceptive critics in terms opposed to realism. They saw in it, correctly, an almost fantasized, unreal evocation of the model. Rodin discarded the requirements of his time, the corpus of acceptable ideas concerning the monument—ideas which demanded that the statue-portrait be a recognizable effigy and not a probing interpretation. Thus he rejected declamatory gestures, exaggerated attitudes, all allegorical accessories and the small-minded, narrow execution which merely followed forms. Simplifying his forms to the extreme, conceiving them as the moving projection of profiles, Rodin revealed with the *Balzac* an idealistic evocative aesthetic which makes him a kinsman of the late nineteenth-century Symbolists.

The art of Rodin has every appearance of versatility and at times even flirts with historical styles. But his manner of using Michelangelo's precedents or the styles of the eighteenth century comprise the least interesting aspect of his art. Rodin's art is most firmly attached to the aesthetics defined by the Symbolist movement, and the Symbolist sensibility sheds the most light on his works. In our context, the term "symbolist" is used elastically—not to say loosely—and not as usually defined by movements and personalities. Rodin's devotion to the study of nature and his precise knowledge of natural forms is by no means incompatible with the metaphorical message which dwells within his art. Whatever its style may be, each work is evocative. Each opens upon a multitude of senses which cross and complement one another. The various names of his works are merely exterior signs. No one title is exclusive; all act simply as means of access to the work itself.

By the turn of the twentieth century, as the Spreckels collection so successfully demonstrates, Rodin's work had attained a spirit of amplitude and of questing which remains astonishing even today. Regrettably, we cannot in this catalogue bring to light all the major and unexpected aspects of his art or of his thought. His styles and the expressive means he invents converge and exploit the most diverse subjects, materials and techniques. We find side by side the incisive realism of his youth (*Man with the Broken Nose*), the tumultuous modelling of the works which related to *The Gates of Hell* and the anatomic and erotic gymnastics of his groups. At the same time we find massive simplifications, as evoked in the Balzac statue. The progressive critics at the end of the last century called this aspect of Rodin's work an "*art nouveau*." The *Balzac* was both an exact likeness and evocation; it became the model for a new style of monumental sculpture. One understood it, rightly, as a new and more inclusive work of art: "telling" because it went to the essence of the model; "decorative" because it was simplified in form and potentially available to all and, therefore, had social significance. The *Balzac*, then, brings together the essential ingredients of Symbolist aesthetics.

One does not usually discuss Rodin's social concerns. Nevertheless, he was passionately involved with architecture, especially medieval architecture, in which he, like Ruskin and Morris, saw the expression of a living ethos. One of the more curious works in the Spreckels collection is the crown of the *Tower of Labor* (*The Benedictions*, cat. no. 45), a project which has not received the attention it deserves but one in which Rodin was intensely interested. The project shows an empty construction whose shaft contains a spiral staircase like some Tower of Babel or Tatlin's *Monument for the Third International*. Climbing upward, the viewer was meant to discover a series of reliefs, the details of which celebrated human toil in all its aspects from manual to intellectual labor. This project is only one episode from Rodin's activities around 1900.

At this point Rodin's image was that of a respected artist who seemed difficult, even secret. He enjoyed playing the thinker, the philosopher; he received or corresponded with everyone who counted in his day. He surrounded himself with remarkable minds, people who were eager to become interpreters of his thought. His ideas obtained currency through his aphorisms and his writings to his European and American admirers. He discerned and dissected the best his era had to offer. He constantly contemplated art, the arts and artistic creativity. Taken as a whole, his writings cannot always be relied on to provide any precise definition of his thought. Rodin's thinking is difficult to grasp. He contradicts himself, he delights in employing the hermetic language so popular with Symbolist artists.

In time, somebody will attempt to discriminate between what in Rodin's writings and sayings belongs to him and what to his interpreters—Morice, Gsell and the others. Rodin's

aphorisms had nevertheless a profound and lasting effect on his own times and on ours. Putting aside the trivialities and commonplaces of certain declarations, one may be sure that the striking intuitions, the brilliant formulations and the uniquely perspicacious judgments with which these writings abound may be traced directly back to Rodin, whatever the form in which they are expressed.

The peculiarity and uniqueness of Rodin's views—his equating of art with the active, lucid intelligence, with having a vision of the world—are clearly visible throughout the Spreckels collection. While the collection remains necessarily only a selection, it allows us an encompassing look at a lifework of such richness as to transcend any definition which could capture it within the aesthetics of the various artistic and literary movements of the late nineteenth century: Naturalism, Impressionism, Symbolism or Art Nouveau.

The Spreckels collection perfectly illustrates what is fundamental in Rodin's art—the manner in which he enriched sculpture and the art of his time with a human dimension which is normally lacking in most nineteenth-century sculpture. In short, more than any other artist of his time, Rodin introduced in sculpture the full range of human conceptions, feelings and concerns in the modern world. If his forms are at times overblown, startling and varying in artistic quality, nonetheless Rodin always confronts the viewer with a potent intuition of poetic truth and a power of expression which never ceases to amaze.

<div align="right">J. de C.</div>

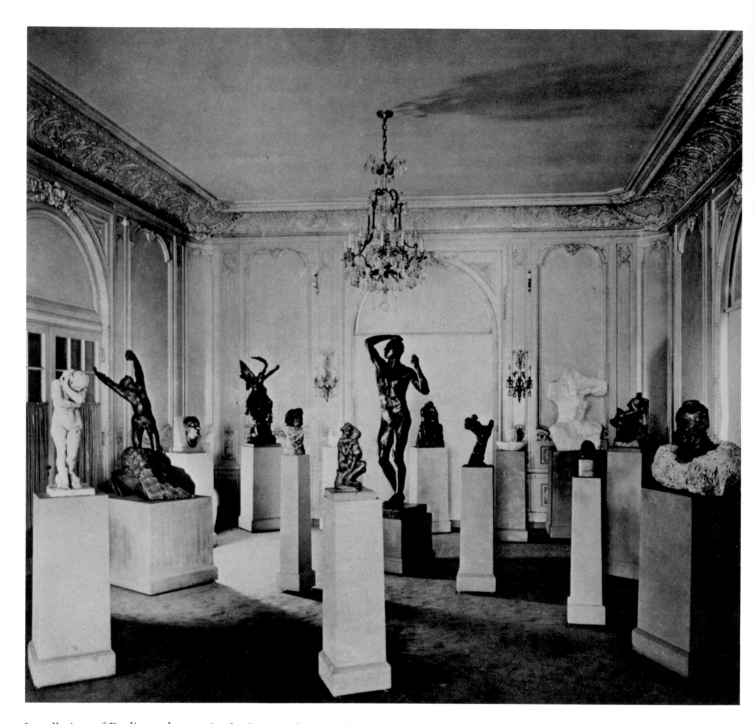

Installation of Rodin sculptures in the home of Mrs. Alma de Bretteville Spreckels.

The Spreckels Rodin Collection

Its History

The Rodin collection in the California Palace of the Legion of Honor owes its existence largely to the enthusiasm, artistic sensitivity and creative collecting of Mrs. Alma de Bretteville Spreckels (1881-1968), supported in her efforts by her husband Adolph. Not only does this outstanding collection of Rodin sculpture testify to her taste and foresight as a collector, but it was the beginning of her lifelong dedication to the arts. San Franciscans are also indebted to the Spreckels for the museum itself, and for works which number into the hundreds by artists other than Rodin.

The significance of the Spreckels Rodin collection daily becomes more broadly recognized, and deservedly so. In the United States its scope is second only to that of the Rodin Museum in Philadelphia. The quality of the collection is exceptional for the many sculptures acquired during Rodin's lifetime. Moreover, Mrs. Spreckels herself said that all of the bronzes in the collection were cast during Rodin's lifetime; these stand apart from the posthumous casts we find so often in modern collections.[1] The collection as a whole offers a fine introduction to the work of Rodin, covering all periods of his career as well as all major media employed by the sculptor. Also setting the Spreckels Rodin collection apart from most museum collections is its unusually large number of plaster casts. Besides the many famous works, the collection offers some surprises since Mrs. Spreckels had the discernment to purchase several sculptures that are unique or seldom represented even in other important collections.

The efforts to reconstruct Mrs. Spreckels' collecting activity, which spanned more than thirty years, has been limited by the minimal amount of information available to us today. Mrs. Spreckels was more interested in art than in record-keeping, so today in most cases we do not have a systematic set of documents telling us the exact date of purchase and entry into the museum. The historical record is further complicated by the fact that many sculptures were loaned rather than donated; for many years, until their final accession, their locations alternated between the museum and Mrs. Spreckels' home. Transferrals of the individual pieces were seldom documented. The history of the Spreckels collection has been uncovered in part through the archives of the California Palace of the Legion of Honor, although the

material available was limited. Perhaps a future inventory of Mrs. Spreckels' personal archives will uncover further information on her activities as a collector. The most useful materials for establishing dates of purchase have been contracts of sale, accession lists and early catalogues. While the museum archives contain some bills of lading, telling us when quantities of sculpture were shipped from France, the shipping records do not specify which pieces were contained in the freighted material. Moreover, local customs records do not exist to date the entry of specific pieces into this country. Because of these limited sources of information, it has often been difficult to establish exactly when many of the sculptures were acquired by Mrs. Spreckels.

Very often the most interesting sources of information have been outside of any Spreckels archives. Newspaper articles have provided a certain amount of information, although inadequate indexing has limited the usefulness of this resource. Photographs of Mrs. Spreckels' home showing many Rodin sculptures in place have been extremely helpful in establishing the early purchase date of many of the Rodin sculptures. The photos, formerly in the Jean Scott Frickelton collection, were likely taken before the California Palace of the Legion of Honor opened in 1924. The records of the San Francisco Park Commission have revealed information about the donation of certain pieces and about the donation and construction of the museum. Some of the potentially most fruitful sources of information about Mrs. Spreckels' Rodin collection were not available to us. I was unable to check for correspondence to Mrs. Spreckels in the Musée Rodin in Paris. The personal records of bronze founder Eugène Rudier, from whom Mrs. Spreckels bought so many works, would also have been enlightening had they been available. Some information has been forthcoming from the archives of Loïe Fuller, from whom Mrs. Spreckels seems to have bought a large part of her collection—at least eighteen pieces—rather than through art galleries. Particularly helpful is correspondence between Mrs. Spreckels and Loïe, and between Loïe and other correspondents, now in the Lincoln Center Library.[2] In one of her letters the famous veil dancer tells us that she did not act as Mrs. Spreckels' agent, but bought works of art for herself which Mrs. Spreckels later purchased. Loïe's claim is denied by certain documents as it was by Mrs. Spreckels' long-time friend, Miss Jean Scott Frickelton. When Mrs. Spreckels was not in Paris herself, her cousin, the Marquis Pierre de Bretteville, usually authorized her purchases, and not Loïe. Sometimes these acquisitions were arranged by Loïe and others prominent in the art world, such as the sculptor of the Statue of Liberty, Bartholdi.

From Mrs. Spreckels' own account, we know that her interest in Rodin went back many years to the summer of 1914 when she fortuitously encountered Loïe Fuller. Loïe had known Rodin for many years and had helped to promote his art with American patrons by holding the first substantial exhibition of his work in this country in 1903.[3] Mrs. Spreckels tells how she was taken by Loïe to Rodin's country home at Meudon, a suburb of Paris, where she met the short man with flowing white beard and black velvet beret to whose work she was to devote herself in years to come. Loïe Fuller was to be an important intermediary for the Rodin collections for other museums in this country as well, notably the Cleveland Museum of Art and the Maryhill Museum of Fine Arts in Maryhill, Washington.

When Mrs. Spreckels returned to San Francisco just as World War I broke out in Europe, she had still not made her first purchase of Rodin sculpture. The following year, the Panama Pacific International Exposition, a grand-scale fair commemorating the completion of the Panama Canal, opened in San Francisco. Rodin exhibited twelve sculptures in the French pavilion, then located just south of Maybeck's Palace of Fine Arts, the only structure which

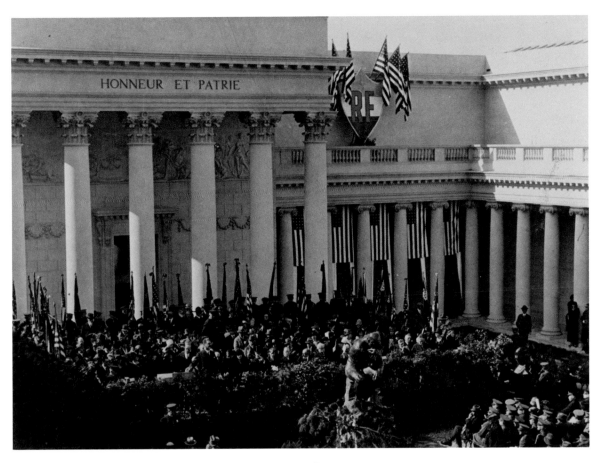

Dedication of the California Palace of the Legion of Honor, 1924.

remains from the exposition that once covered blocks of San Francisco's northern waterfront. The ubiquitous Loïe Fuller arrived with her dance troupe; her enthusiasm inspired Mrs. Spreckels to buy her first Rodin sculptures (five from the exposition, plus one other, possibly from Loïe's own collection): *The Thinker, The Age of Bronze, The Prodigal Son, The Siren of the Sea, Henri Rochefort* and *Youth and Old Age*.[4] Possibly in memory of this momentous first purchase, Rodin sent Mrs. Spreckels a photograph of himself, inscribed with a dedication to her.[5]

After her initiation to collecting Rodin sculpture, her purchasing began to gain momentum. Over the next thirty years or so, she would add such important pieces as *Christ and the Magdalene, Eve, Fugit Amor, The Call to Arms,* the *Heads of Balzac, Man with the Broken Nose, Mignon* and two casts of *The Mighty Hand*.

During the 1915 Exposition, Mrs. Spreckels and her husband, Adolph, were much impressed by the French pavilion, a replica of the Palais de la Légion d'Honneur in Paris. They decided to have a permanent version of a portion of the French building constructed in Lincoln Park as a museum to eventually house her growing collection, now including important paintings, sculptures and *objets d'art*. Her emphasis on collecting the art of France made this museum the only one in this country to emphasize French art. The construction of the California Palace of the Legion of Honor was delayed by World War I; in the meantime,

Mrs. Spreckels turned her own San Francisco home into a museum and cultural center. Important photographs of Mrs. Spreckels' home in the ex-Frickelton collection show several Rodin sculptures in a room dedicated to the master. Her ever growing collection was to become the nucleus of the California Palace of the Legion of Honor and was also to greatly enrich the collection in the Maryhill Museum of Fine Arts, established by her friend Samuel Hill.[6]

The California Palace of the Legion of Honor was finally completed in 1924; at that time Mrs. Spreckels presented thirty-one Rodin sculptures, nearly half of her total donation of works by that artist. Recognizing Mrs. Spreckels' important contribution to the dissemination of French culture in this country through her gifts of the museum and the important works of French art it housed, the French government awarded her the medal of the Legion of Honor.

Mrs. Spreckels continued to make frequent trips to Paris, where she added to her Rodin collection over the years. She became friends with Eugène Rudier, Rodin's preferred founder for at least the last fifteen years of his life. She bought a number of Rodin sculptures from Rudier's personal collection, no doubt developed as a result of the common practice by bronze founders of making one cast of each important piece for themselves. In 1929 she acquired from him the set of five reduced bronze *Burghers of Calais*. Rudier sold her in 1933 an important collection of nineteen rare plaster casts of Rodin sculpture.[7] From the founder, Mrs. Spreckels also made her last purchases of seven Rodin bronzes in 1949.

Mrs. Spreckels' interest and skill at collecting art developed with amazing rapidity; in a few short years she was able to make a significant contribution to the museum that she herself had founded. From the first she was concerned that her beloved Rodin be shared with those who lived in and visited San Francisco. Such generosity and unselfishness are exemplary and deserving of our token of homage, which in part this catalogue represents.

P. B. S.

NOTES

1. Letter from Mrs. Spreckels to Miss Jean Scott Frickelton, February 5, 1934. Much of the information used in this essay regarding Mrs. Spreckels and her Rodin collection was generously provided by Miss Frickelton, her friend of many years, who spent hours tracking valuable material from the papers of Mrs. Spreckels. I am also grateful for the personal recollections Miss Frickelton shared with me before her death in January, 1977.

2. Undated letter from Loïe Fuller to Gabrielle Bloch. This information on the Lincoln Center archives has been kindly shared with me by Margaret H. Harris, a guest curator at The Fine Arts Museums of San Francisco, who is currently doing research on Loïe Fuller.

3. This exhibition was held at the National Arts Club in New York; "The Art of Rodin. Sculptures by the Famous French Impressionist at the Arts Club," *New York Times*, May 9, 1903, p. 5. We do not know when Rodin and Loïe met, but he mentions her in a letter of November 26, 1897, to Roger Marx; this letter from the former Ernst Durig collection is now in the Musée Rodin, Paris.

4. Copies of the receipts of these transactions were in the collection of Miss Jean Scott Frickelton, Palo Alto, California.

5. This photograph is today in the Maryhill Museum of Fine Arts, a museum founded by Mrs. Spreckels' friend Samuel Hill.

6. According to the director of the Maryhill Museum, Mrs. Spreckels did not donate any Rodin sculptures to that museum; however, the provenance of many of the Rodin works in that collection is not documented.

7. Insufficient documentation prevents us from determining exactly which plasters were part of this 1933 purchase. Mrs. Spreckels' donation at the same time of several casts purchased earlier further complicates the problem of identification.

Notes on Rodin's Technique

Even general knowledge of the production techniques for Rodin's sculpture greatly enhances the appreciation and understanding of his art and, additionally, serves to inform both viewer and historian about problems connected with it.

Tracing the production of Rodin's sculptures presents a variety of problems. The foremost question is to discover what work was done by Rodin himself and what was left to assistants. This determination is complicated by scanty and often-conflicting information provided by Rodin's biographers and by the scarcity of available documents.[1] Although Rodin's studio practices undoubtedly varied over the years, he seems from the first to have relied on specialists to execute his clay models in bronze or marble. If Rodin's workshop grew with his reputation, by the turn of the century his studios must have teemed with assistants.

As a successful sculptor, Rodin himself would do the actual work of modelling in clay, but assistants prepared his armatures with moveable parts covered with clay, after the rough form of a small sketch that Rodin would first provide.[2] Rodin modelled rapidly but accurately, studying his sitters from several angles and using homemade tools and deft fingers to create works of remarkable vitality and complexity.[3] As a sculpture developed, Rodin would call in his plaster caster, a highly specialized technician, to record impressions of the work at various stages.[4]

When, after perhaps months of working and reworking, the sculpture was finally completed, it was usually sent to the bronze founder. Before the turn of the century, Rodin seems generally to have preferred to cast by the lost-wax method, a highly esteemed method being revived by a few founders at the time.[5] Regarding the casting of *The Gates of Hell*, Rodin wrote in 1881:

> The work of casting by *cire perdue*, the only method which can render my sculpture, will be very long. It will be done in five pieces—two pilasters, two doors, and the entablature. Each piece will come to me from the founder in prepared wax and I will retouch it.[6]

This technique produces a very fine surface and faithful reproduction of detail. It is accomplished by making several transitional molds of the sculpture to be cast, resulting in a wax "positive" the thickness of the final bronze piece. This outer wax shell is filled with a core of

Detail showing an Alexis Rudier founder's mark.

investment plaster and is then surrounded by a massive supporting mold. The entire mold is then heated until the wax either vaporizes or drains out through vents provided for that purpose. The void formerly occupied by the wax is then filled with molten bronze and left to cool, after which the investment and outer mold are broken away from the bronze sculpture. Never does the bronze cast come directly from the mold in perfect condition. Shafts attached to the piece, which have been formed by molten metal flowing into the vents for pouring and for escaping gases, must be removed. Flanges left by seeping bronze must be filed down. Most sculptors in Rodin's day demanded that such flaws be removed to the point that the bronze surface was perfectly smooth, but Rodin preferred to leave evidences of the casting process, such as traces of piece mold, realizing the greater liveliness of surface that this effected. After the bronze cast was chased by the *ciseleur*, who specialized in this delicate work, it went to the patinator who was skilled in applying a variety of finishes to the natural bronze. Rodin was often demanding in the matter of patination; his *Bellone* had to be redone three times before he was satisfied with it.[7] One craftsman who met his standards and continued to finish Rodin bronzes many years after his death was Jean Limet.[8]

So exacting a method of reproduction naturally made the fabrication of bronze casts very slow and tedious, since only one cast could be obtained from a mold. As demand for Rodin's sculpture increased in the 1890s, the artist turned to other techniques to increase his output of bronze casts. He began to have both reductions and enlargements of a single work made by his reducer, Henri Lebossé.[9] At the same time, Rodin contracted with certain big art bronze founders to produce large editions of his more popular sculptures, among them *The Kiss*, *Eternal Spring*, *Youth and Old Age* and *St. John the Baptist Preaching*.[10] To give an example of how large these commercial editions could be, the Barbedienne art foundry is reported to have produced 319 bronzes, in varying sizes, of *The Kiss* alone.[11]

In contrast to these large editions, Rodin occasionally made unique casts. In 1891 he described the bronze sculpture *The Idyll*, which he had sold to the collector Antony Roux, as a unique cast: "This model is unique and will never be reproduced in any material. I have broken the plaster model which served for the casting in bronze, no other existing."[12]

As Rodin's fame grew, it was not always certain that the founder would comply with a request for a unique cast. Loïe Fuller pointed out to Mrs. Spreckels the difficulty of finding a founder who could be trusted to make only one cast.[13] Sometimes instead of sending a definitive plaster cast to a founder, Rodin sold it to a collector with all rights of reproduction.

Georges Rudier founder's mark on *Nude Study for Eustache de Saint-Pierre*. Cat. no. 37.

Such an arrangement was made more than once between Rodin and Antony Roux in the 1880s.[14]

Of greater concern, however, than the unique cast was the ever-increasing demand for Rodin's sculptures that led him to seek methods of casting that produced pieces of higher quality than those produced in large editions yet were more efficient than the slow lost-wax method. His solution was to turn to the sand-casting technique, long practiced and much favored by French founders. From the turn of the century, Rodin employed this method almost exclusively. Although the technique of sand casting differed from foundry to foundry, current methods used by Georges Rudier, founder for the Musée Rodin[15] and nephew of Rodin's founder, Eugène Rudier, allow us to reconstruct the probable technique used to cast Rodin's bronzes. This foundry, which Rodin preferred from the turn of the century until his death, was established by Alexis Rudier, who was succeeded at his death in 1897 by his son, Eugène.[16] This foundry continued to produce sand-cast Rodin bronzes until 1952; in 1954 Eugène was succeeded by Georges Rudier. During his lifetime Rodin apparently had made what the French called *moules à bon creux*—master forms in plaster of sculptures from which several impressions could be taken. These forms were used to make negative impressions in another mold medium—in this case, the fine claylike sand which, after hardening, would receive the molten bronze. The *moules à bon creux* could be used a number of times to make new impressions in successive sand molds. Rodin left his *moules à bon creux* as part of his large donation to France, so that the Musée Rodin continues today to cast Rodin's sculpture. Cécile Goldscheider, former director of the Musée Rodin, has explained the procedure the museum follows when a collector orders a cast:

> For each cast commissioned, we find the *moule à bon creux* in plaster in our reserves at the Meudon studio [Rodin's former residence in a suburb of Paris, now part of the Musée Rodin] and we send it to the founder Georges Rudier. From this *moule à bon creux*, Georges Rudier makes a *moule en matière sableuse* [sand mold] which reproduces the hollow relief in which later will be cast the bronze.[17]

Eventually the *moules à bon creux* become so worn down from use that good-quality impressions can no longer be obtained from them. For this reason, Rodin allegedly demanded that the number of posthumous casts to be made from each master mold be limited to twelve.[18] Despite Rodin's supposed authorization of such casts after his death (1917), some

The Musée Rodin copyright on *Nude Study for Eustache de Saint-Pierre*. Cat. no. 37.

people question the authenticity and value of the posthumous casts. Some sculptors feel that only a cast that has been personally reworked by the artist can be considered authentic.[19] For this reason it is important to distinguish between casts made before Rodin's death and those made after, a task that is often seemingly impossible. In recent years, posthumous casts are identifiable by the Musée Rodin copyright and the date of casting inscribed in bronze; the number of the cast is usually not inscribed but indicated only in a certificate from the museum.[20] Some sculptures—for example, *The Thinker* and *The Age of Bronze*—have reached their full edition of twelve, so that no more can legitimately be cast. The question of posthumous casts becomes extremely complicated with casts bearing the stamp of the Alexis Rudier foundry. This foundry continued to use this stamp until 1954 without, so far as we know, adding any distinguishing mark to separate the casts made before and those made after Rodin's death. The *cachet*, a "signature" stamp usually pressed into the core of the mold so that the marking "A. Rodin" appears in relief on the inside of the bronze cast, cannot, as is sometimes claimed, be taken as evidence of a posthumous cast. Exactly when this marking was first used we cannot say, but it occurs frequently on casts made during Rodin's lifetime, such as *The Prodigal Son* (cat. no. 24) in this collection, and continues to be applied to Musée Rodin casts. Signatures are of little help in sorting out posthumous from lifetime casts since it was common practice in Rodin's time and still is today for the founder to add the signature. While we may note striking changes in the signature style from his earliest (see p. 261) to his later casts, the exact sequence has not been determined.

To add to the uncertainties of the collector, a number of counterfeit and unauthorized sculptures were made both during and after Rodin's lifetime (see cat. no. 75). The problem of illicit casts deserves much fuller attention than can be given here.

While bronze casts constitute the greatest part of Rodin's work, a considerable number of marbles were also produced during his lifetime. These marbles were greatly admired by his contemporaries, although they are less highly regarded today. This aspect of Rodin's *oeuvre*, like his bronzes, is burdened with perplexities. Since the turn of the century, debate has continued concerning the nature of Rodin's part in their production.

Certain eyewitnesses have insisted that Rodin did participate in the carving of his marbles. Mrs. Kate Simpson, whose portrait bust Rodin executed in 1903, assured the art dealer René Gimpel that Rodin finished all his marbles, although some were extensively worked by the sculptor Bourdelle,[21] who was one of many marble carvers who transferred the model cast in

Detail showing Rodin's relief cachet stamp.

plaster to the stone, usually with the assistance of a pointing machine.[22] The practice of employing a technician to do the majority of the carving and leaving the finishing touches to the artist himself was common. Photographs made during Rodin's lifetime of marbles still in progress as well as certain unfinished marbles in the Musée Rodin bear signs that Rodin supervised the carving in its various stages; these have pencil markings that were apparently his means of giving instructions to his carvers.[23] The sculptress Malvina Hoffman, who worked for several years with Rodin, witnessed the aged sculptor finishing his own marbles:

> I have watched Rodin carving his own marbles at his studio in the rue de l'Université, and have marvelled at the way he could suggest soft feathers of a great broken wing, carving them directly in the block without referring to the small plaster model . . . He had a perfectly definite technique which is easily recognized, and he told me he had spent many hours identifying the strokes of certain tools, and just what effects they were capable of giving, in the collection of Michelangelo's sculptures in Florence.[24]

When the marbles were completed, Rodin usually made a record copy in plaster.[25] He also followed the curious practice of having bronzes cast after the marble, sometimes even making various reductions of these.[26] *The Kiss* is an example of a work whose bronze casts are made primarily from the large marble.

Besides the traditional sculptural media—bronze, marble, plaster and terracotta—Rodin occasionally employed a variety of less common ones such as wax, silver, ceramic and glass. None of these media make up a substantial portion of Rodin's work, but they do indicate his willingness to experiment with less conventional materials, whether costly or cheap, an attitude he shared with many other artists around the turn of the century. His essays in ceramic with colorful glazes are particularly interesting; these works were made around the turn of the century in collaboration with ceramicist Paul Jeanneney. In this medium Rodin made casts of the life size *Jean d'Aire*, a bust of *Jean d'Aire* and a monumental head of *Balzac*.[27] In 1911 he had Jean Cros, whose father had rediscovered the glass-paste method of casting, reproduce a series of portrait heads by this rare technique.[28]

Numerous other aspects of the production of Rodin's sculpture must be left for a more specialized study.[29] A more detailed history of each piece, in its variations of forms, media and sizes, is included with individual catalogue entries.

P. B. S.

33

NOTES

1. In the nineteenth century, the keeping of account books was common practice among founders. We know that Rodin's founders kept such records, although unfortunately these books had not been made available to Rodin scholars by the Musée Rodin in Paris where they are located. A detailed study of Rodin and his founders, essential to an understanding of Rodin's attitude towards the casting of his own sculpture in bronze, can only be done after a thorough examination of those documents.

2. Frisch/Shipley, pp. 29, 30 and 113.

3. Malvina Hoffman, *Sculpture Inside and Out*, New York, 1939, p. 106.

4. Malvina Hoffman, *Heads and Tales*, New York, 1939, p. 43; Frisch/Shipley, p. 189; Cladel, 1950, p. 275; Mathias Morhardt, "La Bataille du 'Balzac,'" *Mercure de France*, t. CCLVII: 879 (December 15, 1934), p. 467. Only a few of Rodin's plaster casters are known by name. Frisch recalled that the Montagutelli brothers (misspelled by him "Montacutelli") were "Rodin's favorite plaster casters" (Frisch/Shipley, pp. 178, 220). Later, at least one of the brothers was implicated in counterfeit suits (see Appendix, cat. no. 75). Apparently Guioché (also spelled Guilloché in some texts) who cast the plaster *Fragment of the Gates of Hell* (cat. no. 29) now in this collection, was also a plaster caster for Rodin. Judith Cladel says that he cast for Rodin for twenty-eight years (*Rodin*, New York, 1937, p. x).

5. The effort to revive the *cire perdue* method was described by Victor Champier, "L'Ecole des Fabricants de Bronze," *La Revue des arts décoratifs*, 10(1889-90), p. 214. By the turn of the century, that method was preferred to the long-used sand-casting process (Louis Vauxcelles, "La Fonte à Cire perdue," *Art et Décoration*, 18 [1905], p. 189; Edouard Lanteri, *Modelling: A Guide for Teachers and Students*, v. 2, London, 1904, p. 145). Founders employed by Rodin at the end of the last century who used the lost-wax method include Eugène Gonon, P. Bingen, employed by Rodin in 1884-1889; Thiébaut Frères; A. Hébrard, employed 1903-1905; (Jianou/Goldscheider, p. 82). According to a release at the time of the Rodin "fakes" trial, "the genuine *Cires perdues* are all known and catalogued," so presumably such a list exists in the Musée Rodin in Paris (*London Times*, January 16, 1919, p. 7). Access to this list would greatly increase our knowledge of Rodin's use of lost-wax casting.

6. Letter of December 11, 1881, to the Beaux-Arts Commission, quoted in translation by Elsen, *Gates*, 70; cf. Bartlett, pp. 199, 225 and 250.

7. Lami, p. 163.

8. Cladel, *op. cit.*, 1937, p. x; Lami, p. 168.

9. Lami, pp. 162-63.

10. Rodin contracted with the Leblanc-Barbedienne firm in 1898 to reproduce *The Kiss* and *Eternal Spring*, reserving the right to have sand-cast copies made in different sizes (Jianou/Goldscheider, p. 82). He made a similar contract in the same year with Fumière et Cie for *St. John the Baptist* and *Youth and Old Age* (ibid.) Copies of the contract with the Fumière firm were formerly in the Ernst Durig collection and are now in the Musée Rodin, Paris.

11. *Ibid.*, p. 100.

12. "Ce modèle est unique et ne pourra jamais être reproduit en aucune matière. Je m'engage à briser le modèle en plâtre qui a servi à la fonte en bronze, aucun autre n'existant" (quoted in *Collection Antony Roux*, Galerie Georges Petit, Paris, May 19 and 20, 1914, no. 133).

13. Undated letter, addressed from Hôtel Plaza Athénée, in the Lincoln Center Library.

14. A receipt for the plaster *Iris* is reproduced in the 1914 Antony Roux sale catalogue: "Reçu de M. Antony Roux la somme de . . . pour un groupe 'Iris,' dont il a la propriété entière . . . (21 septembre 1885)." The cataloguer adds that the plaster was transmitted with the exclusive right of reproduction (*Collection Antony Roux, op. cit.*, no. 137).

15. In recent years the Musée Rodin has also employed the Susse and Godard foundries. For more on sand casting, see Jack Rich, *The Materials and Methods of Sculpture*, New York, 1947, 141-46.

16. For more on Eugène Rudier and the Alexis Rudier foundry, see Paul Moreau-Vauthier, "Le Maître Fondeur Eugène Rudier," *L'Art et les Artistes*, ser. 2, 32 (March, 1936), pp. 203-209. *Time* magazine published the following anecdote about the begining of the Rodin-Eugène Rudier association: " 'Rodin,' recalls the *maître*, 'was not particularly friendly. He asked me a few questions and then handed me a bust—by another sculptor.' Rudier worked long hours forming the mold of sand, tapping, carving and measuring it to exact proportions, finally cast the sculpture in a single piece of bronze. 'When I returned with the finished product, Rodin looked at it for a long time and caressed it with his fingers. All he said was 'excellent' " (*Time*, 59, May 5, 1953, p. 82). The date 1902 is usually cited as the beginning of Rodin's relationship with the Alexis Rudier foundry; however, the bust of Dalou in the Detroit Art Institute, which still bears the label of the 1900 Paris Exposition Centennale, is stamped "Rudier"; E. H. Payne, "Jules Dalou, friend of Rodin," *Detroit Art Institute Bulletin*, 41:3 (Spring, 1962), p. 47.

17. "Pour chaque épreuve commandée, nous allons chercher le 'moule à bon creux' en plâtre dans nos réserves de l'atelier de Meudon et nous le transmettons au fondeur Georges Rudier . . . A partir de ce 'moule à bon creux,' Georges Rudier fait un 'moule en matière sableuse' qui prend le relief en creux dans lequel par la suite il coule le bronze" (Sabine Marchand, "Rénovation du Musée Rodin," interview with C. Goldscheider in *Le Figaro*, March 7, 1968).

18. *Ibid.*

19. Frisch/Shipley, p. 393.

20. "Nous remettons . . . toujours à l'Acheteur un certificat d'origine, contrôlé par la Cour des Comptes, en même temps qu'un numéro d'épreuve et qu'un numéro d'inventaire" (Marchand, *op. cit.*).

21. R. Gimpel, *Journal d'un collectionneur marchand de tableaux*, Paris, 1963, p. 183.

22. M. Hoffman, *Heads and Tales, op. cit.*, p. 96, and *Yesterday Is Tomorrow*, New York, 1965, p. 129.

23. See Gustave Kahn, *Auguste Rodin*, London/ Leipzig, 1909, plate opposite p. 35 (*Pygmalion and Galatea*), and *World's Work*, 1904, 6827 (*Christ and the Magdalene*).

24. M. Hoffman, *Heads and Tales, op. cit.*, p. 97.

25. René Chéruy, one of Rodin's secretaries, has pointed out that Rodin had a cast made of each of the first marble copies of his sculptures (letter of September 6, 1957, Tate Gallery archives). Many of these plaster replicas can still be traced; see Athena Tacha Spear, "A Note on Rodin's *Prodigal Son* and on the Relationship of Rodin's Marbles and Bronzes," *Allen Memorial Art Museum Bulletin* (Oberlin College), XXVII:1 (Fall, 1969), p. 27.

26. On Rodin's practice of making bronze casts from marbles, see Spear, *op. cit.*, pp. 26-27, and Spear, "*The Prodigal Son*: Some New Aspects of Rodin's Sculpture," *Allen Memorial Art Museum Bulletin* (Oberlin College), XXII:1 (Fall, 1964), pp. 30 and 33. For more on nineteenth-century reproductive practices, see Jacques de Caso, "Serial Sculpture in Nineteenth-Century France," pp. 1-27, and Arthur Beale, "A Technical View of Nineteenth-Century Sculpture," pp. 29-55, *Metamorphoses in Nineteenth-Century Sculpture*, Cambridge, Mass.: Fogg Art Museum, Harvard University Press, 1975.

27. The ceramic cast of the life-size *Jean d'Aire* in the Musée Rodin at Meudon is inscribed "Jeanneney 1900" (Athena Tacha Spear, *Rodin Sculpture at the Cleveland Museum of Art*, Cleveland, 1967, p. 95). The ceramic monumental heads of *Balzac* seem to lack Jeanneney's signature; however, the presentation of a ceramic replica of this head to the Petit Palais by Jeanneney suggests his participation in these casts. The ceramic *Balzac* head in the B. Gerald Cantor collection (on loan to the Portland Art Museum) is inscribed "1903."

28. Grappe, 1944, nos. 420-24.

29. For a further discussion of Rodin's techniques, see Patricia Sanders, "Auguste Rodin: The Man with the Broken Nose, The Little Man with the Broken Nose, The Kiss," *Metamorphoses in Nineteenth-Century Sculpture*, pp. 145-77.

Remarks

In most cases sculpture titles traditionally used at the California Palace of the Legion of Honor are retained, although a few have been changed for greater accuracy. Since, in Rodin literature, the titles of sculptures are often given in French, the French equivalents, or the most common French title when it exists, follow English titles.

Measurements were taken by the museum staff in inches; we have converted these to centimeters. Dimensions of sculptures in the Legion of Honor are recorded in both inches and centimeters; measurements of comparative works are usually given in centimeters only. In recording the dimensions, height is followed by width and depth. Any single measurement given without designation is for height. Unless otherwise specified, dimensions do not include the base.

The accession number given with each entry includes the date of gift. Most of these sculptures were donated to the Legion of Honor by Mrs. Alma de Bretteville Spreckels, although she gave some in her son's name. A few were given by other donors. *The Thinker* and *The Three Shades* were given to the City and County of San Francisco but have always been closely associated with the Legion of Honor.

Each entry includes as much information as possible on the history, provenance and significance and indicates whether a piece is a cast or carved version. Much of the information that has allowed us to give a summary discussion of versions and variants associated with each piece has been provided by other museums and collectors. We have collected extensive information on these casts and replicas, and in emulation of current scholarly studies of Rodin sculpture, our initial conception of this catalogue included versions and variants in other collections; in the final manuscript, however, they were deleted.

We have given quoted material wherever possible in both our English translation and original text. Occasionally this material was available only in typewritten transcripts or in translation; in certain cases, we have quoted only in English because an English source was the most accessible in this country.

Each entry in the catalogue introduces a work of sculpture in The Fine Arts Museums of San Francisco; an entry is referred to in the text by the designation "cat. no."

The major portion of the research and writing for this catalogue was completed in 1974, at a time when the Musée Rodin in Paris was still pursuing a policy of restricting access to valuable source material on Rodin. That policy is changing now, however, and we look forward to seeing what can only be a rich addition to the body of knowledge on Auguste Rodin and his art.

For abbreviations of standard texts cited frequently in the notes, see the Selected Bibliography.

STATUES AND GROUPS

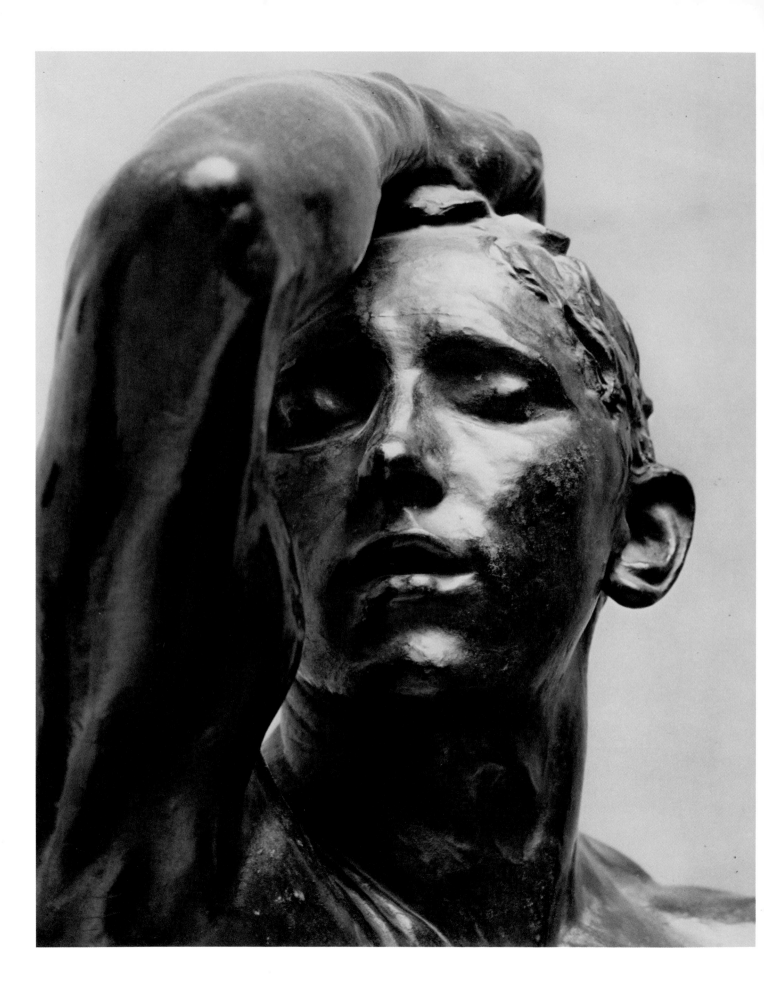

1

The Age of Bronze
(*L'Age d'Airain*)

Bronze, dark brown patina
71 1/2 x 21 1/4 x 25 1/2″ (180.4 x 54 x 64.8 cm)
Signed: Rodin (base, top right)
Stamped: ALEXIS. RUDIER./FONDEUR. PARIS. (base, left side)
1940.141

The Age of Bronze, one of Rodin's most famous works, was the first full-size figure exhibited by the sculptor. Conceived as a masterpiece, the work was intended to win him long overdue public recognition. Rodin told his Belgian collaborators apropos of this work that "it is not necessary to hurry It is sufficient for an artist to make a single statue in order to establish his reputation."[1] To accomplish this goal, Rodin painstakingly represented the model with great fidelity, carefully studying his profiles from various angles. Rodin associated this method of modelling with that used by ancient sculptors,[2] comparing their naturalism with his own:

> I am rather a realist, like the Ancients; instead of trying to correct, I apply myself to rendering
> the admirable architecture of the human body. That first gave me my *Man of the Age of Bronze*
> of a very exact and very rigorous naturalism.[3]

Several of Rodin's contemporaries noted this parallel between *The Age of Bronze* and Greek sculpture.[4] Still Rodin's figure is not an attempt to paraphrase the antique, much less Michelangelo, as is sometimes claimed.[5] Rodin attempted to portray a specific man, not a type—a daring step in light of the expectations of many of his contemporaries. Despite his specificity, Rodin avoids the trivial through the universalizing nudity of the figure and the elimination of any attributes. Hence, the dilemma for Rodin's public over *The Age of Bronze*: they found the statue at once overly precise in modelling yet imprecise in meaning.

Rodin did not expect the work's exacting naturalism to stir up rumors that it was cast from the model. A suggestion was made when *The Age of Bronze* was first shown in Belgium that it had been produced by taking an impression from the model, a practice not uncommon at the time.[6] The rumor followed *The Age of Bronze* to Paris, nearly preventing its second exhibition at the Salon. Though the piece was admitted eventually, it was poorly placed.[7] Rodin continued to protest accusations of *surmoulage*; after many delays and an investigation, he was finally exonerated.[8] The positive result of this controversy was considerable public attention for Rodin; soon writers began to rally around him.

Left: *The Age of Bronze*. Cat. no. 1, detail.

Like many of Rodin's contemporary viewers, we are puzzled, yet intrigued, by the enigmatic gestures of the figure's raised arms—one hand rests on the head, the other is clenched and held in mid-air as if grasping a staff—and the languid, somnambulistic movement. His closed eyes suggest some unrevealed suffering. Even the step is halting and uncertain; though the figure seems stable when seen from the front, the side view shows an almost stumbling walk.

The ambiguities of *The Age of Bronze* left it open to a variety of interpretations by Rodin himself and by his contemporaries, evidenced in its many titles and in the bewilderment of Rodin's critics.[9] Since *The Age of Bronze* has so long been noted for its variety of meanings, an early biographer surprisingly explains Rodin's intentions as primarily formal ones:

> The sole idea in the sculptor's mind was to make a study of the nude, a good figure, correct in design, concise in style, and firm in modeling—to make a good piece of sculpture In this instance the question of subject is not included. The position, movement, attitude of the model, as found by the artist, is satisfactory to him, and he makes the statue. After it is completed it suggests various names and subjects to those who see it, though it is really nothing more nor less than a piece of sculpture—an expression of the sculptor's sense of understanding of the character of his model, and of his capacity to reproduce it in clay.[10]

Despite this de-emphasis of subject, the purposeful pose and gestures of *The Age of Bronze* undeniably imply something beyond a mere representation of the model. As with many of Rodin's works, both form and meaning are deeply involved in his conceptions; to separate them would be pointless.[11]

We can better understand Rodin's intentions by examining the successive titles of the work. That examination reveals *The Age of Bronze* as the first of the sculptor's works typically open to reinterpretation. To single out a specific meaning for the sculpture would be futile. Rodin himself commented on the changes the piece underwent in the process of its creation: "I was in the deepest despair with that figure . . . and I worked so intensely on it, trying to get what I wanted, that there are at least four figures in it."[12]

When in 1877 Rodin first exhibited this figure at the Cercle Artistique in Brussels, he called it *The Vanquished (Le Vaincu)*.[13] His first thought, then, was to represent an injured warrior—the work is also called *The Wounded Soldier*—and Rodin even selected an enlisted man as his model.[14] Whether the figure originally held a lance, as an early drawing shows, is uncertain.[15] The implications of the titles, however, are still clear from the pained facial expression, the hand placed on the head (a gesture of despair), the stumbling gait and the trim physique. These qualities make the statue an appropriate emblem for the tragedies of war, specifically the recent Franco-Prussian war of 1870-1871.

Such a subject had great appeal for the French people, who had not yet recovered from their defeat; yet Rodin changed the title to *The Age of Bronze (L'Age d'Airain)* when the sculpture was exhibited for the second time that same year in Paris. Perhaps the substitution of a less specific title was an attempt to avoid further criticism because of the lack of attributes; a Belgian reviewer had already complained that Rodin had forgotten to "explain his subject."[16] The new title clearly evokes the nineteenth-century interest in primitive man—an association immediately made by Parisian critics.[17] This interpretation, by far the most common, was reinvoked by subsequent titles: *Man of the Age of Bronze*, *Man of the First Ages*, *Man Who Awakens*, *Man Awakening to Nature*, *Primitive Man*, *Awakening of Humanity*.[18] The work has also been associated with each of the three archaeological ages: *The Age of Iron*, *The*

Right: *The Age of Bronze*, drawing. (Léon Maillard. *Auguste Rodin, Statuaire*. Paris: H. Floury, 1899.)

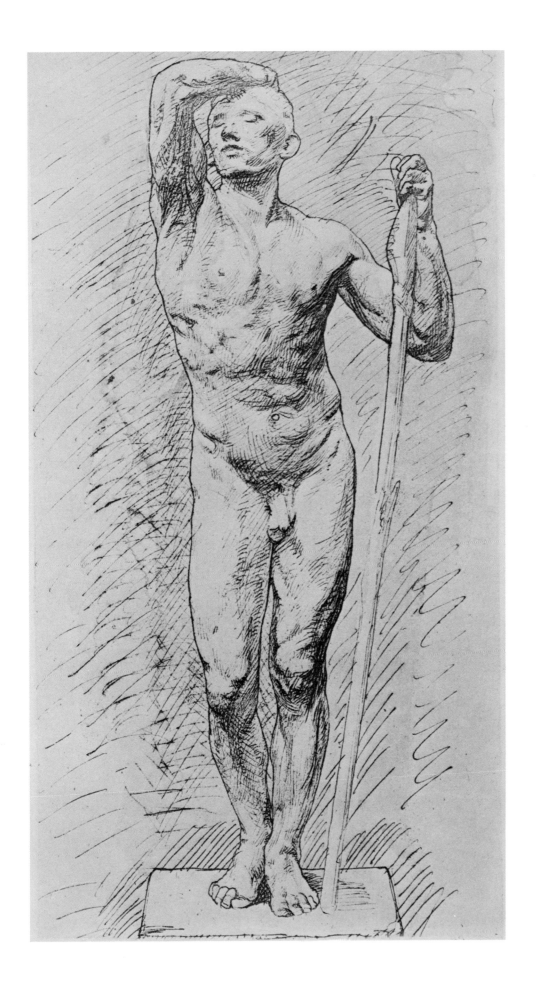

Age of Stone and *The Age of Bronze* (*L'Age de Bronze*). In their general references to early man, these names have a variety of implications. The most common epithet, *The Age of Bronze*, which has been used consistently over the years side-by-side with newer titles, is an inevitable reminder of Hesiod's cycle of man.[19] The third of the four ages of man (the others are the Golden, Silver and Iron ages), the Bronze Age is marked by sorrow, violence and destruction, qualities similar to those evoked by the earlier appellation for Rodin's figure. Listed as *The Man Who Awakens* in the catalogue of Rodin's 1900 exhibition (no. 62), the sculpture is explained in terms of another ancient myth: the Ovidian tale of how Deucalion and his wife, Pyrrha, being the only survivors of a worldwide flood, created mankind anew from stones.[20]

One biographer saw the source of Rodin's inspiration not in classical myths, but rather in Jean-Jacques Rousseau's vision of primal, untarnished man. Rodin's conception came to him while walking in the Belgian countryside, just as Rousseau discovered his vision of primitive times when wandering through the forest. According to this biographer's explanation, Rousseau's vision provided the basis for Rodin's representation of "one of the first inhabitants of our world, physically perfect, but in the infancy of comprehension, and beginning to awake to the world's meaning."[21] This dawning of comprehension, suggested by the apparent transition from a sleeping to a wakeful state, was stressed even more by Paul Gsell, who saw *The Age of Bronze* as "the first palpitation of conscience in a humanity still young, the first victory of reason over the brutishness of the prehistoric ages." He supported this analysis by pointing out the ascending movement of the figure itself:

> The legs of the youth, who is not yet fully awake, are still lax and almost vacillating, but as your eye mounts you see the pose become firmer—the ribs rise beneath the skin, the chest expands, the face is lifted towards the sky, and the two arms stretch in an endeavor to throw off their torpor.
>
> The subject of this sculpture is exactly that—the passage from somnolence to the vigor of being ready for action.[22]

In a letter of 1906, Rodin himself emphasizes this transitional, waking quality: "It is the awakening, the slow return home from a deep dream, expressed by the dreaming attitude and appearance."[23] From this view it is but a step to associate the piece with creative awakening, and so some have related the work to Rodin himself.[24] Since artists traditionally associated dreaming with melancholy, it is not surprising that one early biographer called the sculpture *The Age of Sorrow*.[25]

Rodin seems to have begun the statue before his trip to Italy in 1875, well over a year before the first exhibition of the plaster version in January, 1877.[26] The first bronze cast, commissioned by the French State, was the one exhibited in the Salon of 1880.[27] Since that official endorsement, *The Age of Bronze* has become one of Rodin's more popular pieces, and a great number of casts in varying sizes exist.[28] At some point Rodin had reductions in two sizes made, though we do not know when these reductions were done.

The Spreckels life-size bronze was acquired from Rodin through Loïe Fuller early in 1915; Mrs. Spreckels took possession of it at the end of the 1915 Panama Pacific Exposition where it was displayed. The work was on loan to the California Palace of the Legion of Honor from 1924 onward.

Right: *The Age of Bronze*. Cat. no. 1.

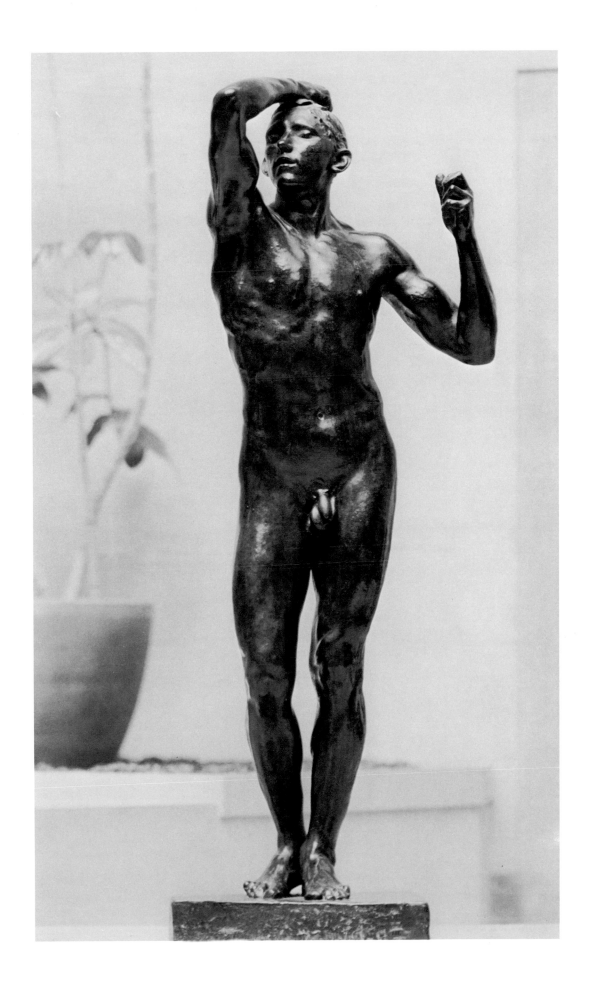

NOTES

1. "Il ne faut pas se hâter Il suffit qu'un artiste fasse une seule statue pour établir sa réputation" (quoted in Cladel, 1950, p. 114. Cf. Lawton, p. 44).

2. After comparing *The Age of Bronze* and an ancient *Apollo*, Rodin wrote: "Then I saw that though on the surface everything seems to be done at a stroke, in reality all the muscles are built up and one sees the details come to light one by one. That is because the ancients studied everything in its successive profiles, because in a figure and every part of a figure no profile is like another; when each has been studied separately the whole appears simple and alive" (article in *Musée*, January - February, 1904, quoted by Mauclair, p. 75). Cladel explained Rodin's method of working on *The Age of Bronze*: "Il modèle celle-là sous tous ses profils, monte sur une échelle afin de déterminer les plans exacts du dessus de la tête, des épaules, des hanches, des pieds . . ." (1950, p. 114). Cf. Dujardin-Beaumetz, pp. 11-12.

3. "Je suis plutôt un réaliste, comme les Anciens; au lieu d'essayer de corriger, je me suis appliqué à rendre l'admirable architecture du corps de l'homme. Cela m'a d'abord donné mon *Homme de l'âge d'airain* d'une reproduction très exacte tout-à-fait rigoureuse" (Cladel, 1903, pp. 38-9). Cf. Lawton, p. 46. Rodin noticed the similarity between his *Age of Bronze* and an antique sculpture he saw while in Italy in 1875: "While engaged on my *Age d'Airain*, I paid a visit to Italy, and I saw there an Apollo, with a leg in exactly the same pose as that of my figure on which I had spent months of labour . . ." (Rodin, quoted by Lawton, p. 193. Cf. Mauclair, p. 75). From Rodin's comment to Coquiot, we learn that this antique statue was in the Naples museum (*Rodin à l'Hôtel de Biron*, p. 100). Interestingly, the gestures of *The Age of Bronze* are variations on similar ones found in certain representations of Apollo.

4. Cladel wrote that in *The Age of Bronze* Rodin "adopted the balanced rhythm of Greek sculpture" (1917, p. 260). To Paul Mantz, writing in 1880, ". . . the style is curiously archaic and almost Grecian . . ." (quoted in Bartlett, p. 101). Others associated it with Greek naturalism (Lawton, p. 17; review in *l'Echo du Parlement*, quoted in Bartlett, p. 65). Donatello was also mentioned in connection with *The Age of Bronze*; Bartlett, p. 113; Gustave Geffroy, "Rodin," *Art et Décoration*, 8 October, 1900), p. 106.

5. Some modern writers have overemphasized the relationship between *The Age of Bronze* and Michelangelo's work, but the style of Rodin's figure does not support this comparison. In fact, its emphatic upward movement contrasts with the descending force of Michelangelo's sculptures. The sinuous quality of *The Age of Bronze* is unique to Rodin. Furthermore, this figure differs greatly from works where Michelangelo's influence is most pronounced—*The Thinker*, *Adam* and *The Three Shades*, for instance. *The Age of Bronze* is much closer to Rodin's later analysis of Greek sculpture than to his explanation of Michelangelo's (*On Art and Artists*, ch. X).

6. This suggestion was made in the *Etoile Belge* of January 29, 1877: "Quelle part la sourmoulure [sic] a dans ce plâtre, nous n'avons pas à l'examiner ici" (quoted in Cladel, 1950, p. 115). The nineteenth-century practice of making a mold from the model (called *moulage* or *surmoulage*) is illustrated in a painting by Dantan showing a sculptor in his studio making a cast of his model (*Un moulage sur nature*); ill. *La Revue illustrée*, 1(1887), p. 317. The extent of the practice of *surmoulage* around the time Rodin showed his *Age of Bronze* is indicated by Jules Adeline who wrote: "le commerce des plâtres moulés est infesté de surmoulages" (*Lexique des Termes d'Art*, Paris, 1887, p. 382).

7. Cladel, 1950, p. 116; Bartlett, p. 27; Will Low, *A Chronicle of Friendship*, New York, 1908, pp. 205-06.

8. Cladel, 1950, pp. 117-18; Lawton, p. 49. This incident as reported by Rodin's biographers has never been fully substantiated. An unpublished letter (courtesy of Princeton University Library) allows us to verify it:

Paris, July 15, 1880

Monsieur Tardieu,

For a long time, I have wanted to thank you for what three years ago you kindly wrote in my favor in the battle where I was completely overwhelmed.

I am happy to announce to you that you have brought luck and [that you have] discovered Gemito and me. The newspapers and the Jury have been favorable to this artist.

As for me, I am still in a period when the public responds with difficulty to my art, and although a part of the Jury appreciates me it only gave me a third [class] medal. Here are some passages from a letter signed Dubois, Chapu, Falguière, Delaplanche, Thomas, Carrier-Belleuse, Moreau M., Chaplain engraver.

After a visit to his studio, and a thorough study of his works, we are glad, in the interest of this artist and also in the interest of [art], to call your attention to the noble tendencies of his talent; thus the figures, grouped or alone, the fragments of sketched or finished studies such as the *St. John*, the creation of man, the bust of the Republic, and above all *The Age of Bronze*, are testimonies of an energy and of the very rare power of modeling and even more of a very great character.

Our praises, unanimous and sincere, have for their goal the denial of the accusations of casts from life that are absolutely erroneous.

We would be happy, Mr. Under-Secretary of State, if, taking our wishes into consideration, you would like to encourage this artist whom we expect to hold a great place among the sculptors of our time.

I bring this to your attention, Mr. Tardieu, because your judgment is confirmed after three years and it is only at the library of the Sèvres manufactory, where I read two months ago, the end of the salon of 1877 sculpture [sic].

Right: *The Age of Bronze*. Cat. no. 1.

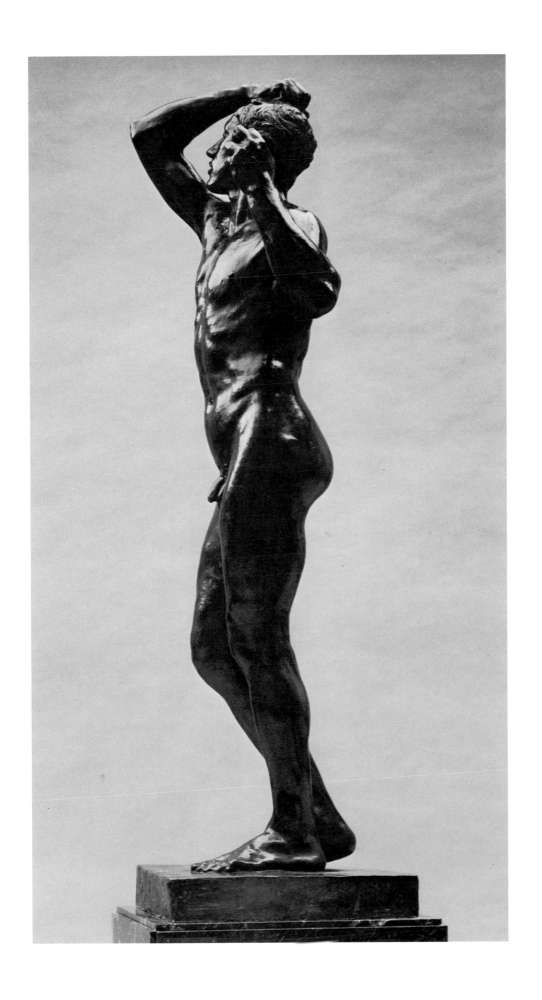

I assure you of my gratitude and more particularly now; three writers have been very helpful to me, you, M. Tardieu, M. Rousseau and M. Camille Lemonier [sic] who spoke of my exhibitions recently in the journal *l'Europe*. During my stay in Belgium I was treated with the solicitude that you would show one of your good Belg[ian] artists.

I thank you then for the strength that you have given me which will help me end the delays that make me grow old without producing what I have learned.

Accept, M. Tardieu, the expression of my strongest gratitude.

A. Rodin

Rodin 268 rue Saint-Jacques

Paris, 15 juillet 1880

Monsieur Tardieu,

Depuis longtemps j'ai le désir de vous remercier de ce qu'il y a trois ans vous avez bien voulu écrire en ma faveur dans la lutte où j'étais complètement abimé.

Je suis heureux de vous annoncer que vous avez porté chance et deviné Gemito et moi. Les journaux et le Jury ont été pour cet artiste favorables.

Quant à moi je suis encore dans un temps de difficile appréciation pour le public et une partie du Jury quoique m'appréciante m'a donne [sic] qu'une 3 ème médaille. Voilà quelques passages d'une lettre signée Dubois, Chapu, Falguière, Delaplanche, Thomas, Carrier-Belleuse, Moreau M., Chaplain graveur.

Après une visite à son atelier et une étude approfondie de ses travaux, nous sommes heureux dans l'intérêt de cet artiste et aussi dans l'intérêt de [l']art de vous signaler les tendances élevées de son talent; Ainsi les figures groupées ou seules, des fragments d'études ébauchées ou finies tel [sic] que le S. Jean, la création de l'homme, le buste de la République et surtout l'âge d'airain, sont des témoignages d'une énergie et d'une puissance de modelé très rare et de plus d'un très grand caractère.

Nos appréciations unanimes et sincères ont pour but de mettre à néant les accusations de surmoulage qui sont absolument erronnées.

Nous serions heureux M. le S.S. d'Etat si prenant nos voeux en considération vous voulussiez bien encourager cet artiste qui nous paraît appelé à tenir une grande place parmi les sculpteurs de notre temps.

Je vous marque ceci Monsieur Tardieu parce que votre appréciation se trouve confirmée au bout de 3 ans et ce n'est qu'à la bibliothèque de la Manufacture de Sèvres où j'ai lu il y a 2 mois la fin du Salon de 1877 sculpture [sic].

Je vous témoigne ma gratitude et plus particulièrement maintenant; trois écrivains m'ont été très secourables vous Monsieur Tardieu, M. Rousseau et M. Camille Lemonier [sic] qui a parlé de mon exposition ces jours-ci dans le journal l'Europe. Le séjour que j'ai fait en Belgique m'a valu d'être traité avec la sollicitude que vous auriez pour un des vos bon artistes Belg[es].

Je vous remercie donc de la force que vous m'avez donnée et qui m'aidera à en finir avec les retards qui me vieillissent sans produire ce que j'ai appris.

Agréez Monsieur Tardieu l'expression de la plus vive reconnaissance.

A. Rodin

Rodin 268 rue Saint-Jacques

In this letter, Rodin refers to Charles Tardieu's brief and not uncritical mention of *The Age of Bronze,* where he nevertheless defends the sculptor of charges of making casts from life ("Le Salon de Paris 1877: La Sculpture," *L'Art*, 10, 1877, 108).

9. See note 1. Bartlett quotes one puzzled critic: "Incomprehensible, this *Age of Brass* (Rodin). Why does this little man grasp his head? Why do his eyes appear to be blinded? Why, anyway, does he not stand straight on his legs?" (p. 101). Writing of the same piece, Paul Lefort was equally bewildered in 1883: *The Age of Bronze* is "d'un caractère plus particulièrement tragique et d'une expression singulièrement troublante." He wondered if he was "le fils du chaos organisé, le symbolique premier-né de la création? Que cherche-t-il au fond de sa pensée, sans doute encore vaguement obscure et inconsciente, et pourquoi son visage est-il bouleversé par on ne sait quelle farouche angoisse? Vient-il de s'éveiller seulement à la vie, ou sort-il de s'arracher à quelque cauchemar douloureux? Nous ne saurions le dire. Mais toujours est-il que cette étrange figure, inquiétante comme une énigme, surprend et retient longtemps le regard" ("L'Exposition Nationale de 1883," *Gazette des Beaux-Arts*, ser. 2, 28 [December, 1883], pp. 462-63).

10. Bartlett, p. 263.

11. Rodin's contemporary critics frequently separated form and content in their appraisal of his works. Many maintained that the subject was suggested by the form (Cladel, 1917, p. 301; Frisch/Shipley, p. 201). Others emphasized his dependence upon literary associations; Rodin seems to have been sensitive to this criticism, as evidenced in a brief comment of 1887: "*Je suis peut-être trop littéraire . . .*" (J. Dolent, *Amoureux d'Art*, Paris, 1888, p. 235).

12. Bartlett, p. 65.

13. Cladel, 1950, p. 107; Bartlett, p. 100.

14. Coquiot quotes Rodin: "Je voulais d'abord en faire un soldat blessé, s'appuyant sur une lance; et cela, d'après le soldat belge qui me servait de modèle" (*Rodin à l'Hôtel de Biron*, p. 100). This model, Auguste Neyt, was chosen from among eight or ten young soldiers (Bartlett, p. 45; Cladel, 1950, p. 114). Louis Vauxcelles says that *The Age of Bronze* was first called "*le soldat blessé*" (*Histoire Générale de l'Art français de la Révolution à nos jours*, v. 2, Paris, 1922, p. 248).

15. A drawing after the completed *Age of Bronze* shows a broken lance in the left hand (ill. Maillard, opposite p. 6). Whether the spear actually accompanied the sculpture and, if so, when, has long been a subject of conjecture. However, it certainly was not present when *The Age of Bronze* was first exhibited in Brussels, since a reviewer for the *Echo du Parlement* points out that "the raised hand ought to hold two spears" (quoted in Bartlett, p. 65). Lawton (p. 46) has explained that Rodin removed the lance because it interfered with "the play of light on the side."

16. Bartlett, p. 65.

46

17. For example, Paul Mantz called *The Age of Bronze* *"un homme des temps primitifs"* ("Le Salon," *Le Temps*, June 6, 1880, p. 1).

18. The date when each of these titles was first used is not known, though we have some clues. Rodin called the work *l'Homme de l'âge d'airain* in 1903 (Cladel, 1903, pp. 38-9). Maillard referred to the work as *l'Homme des premiers âges* (p.153). It was listed as *l'Homme qui s'éveille* in the catalogue of the 1900 Rodin exhibition (no. 62). In her 1903 biography (p. 78), Cladel said the "true title" of the work is *l'Homme qui s'éveille à la Nature*. This title was later approved by Rodin, according to his secretary, Marcelle Tirel (*The Last Years of Rodin*, New York, 1925, p. 23). *The Primitive Man* is the name used in Mauclair's 1905 monograph (p. 124). When Léon Bourgeois's colleagues at the Hague peace conferences offered him a reduced bronze cast of *The Age of Bronze*, it was renamed for this occasion, *The Awakening of Humanity* (*l'Eveil de l'Humanité*) (Cladel, 1950, pp. 260-61). Cladel does not specify whether this award was made at the 1899 or 1907 conference. Grappe (1944, no. 36) lists the titles *l'Age de Fer*, *l'Age de pierre* and *l'Age de Bronze* (an alternative form of *l'Age d'Airain*).

19. Leconte de Lisle (trans.), *Hésiode, Hymnes Orphiques, Théocrite, Bion, Moskhos, Tyrtée, Odes anacréontiques*, Paris (1869), "Les Travaux et les Jours," Livre I, p. 62. Significantly, Rodin, like Leconte de Lisle, preferred the poetic term *airain* to the more mundane *bronze* for the second title of his work. We know that Rodin was familiar with Hesiod, though it is uncertain when he first read the works of the Greek writer. Hesiod was certainly much in Rodin's mind in 1913 when he twice paraphrased him: *On Art and Artists*, pp. 224-25; "Promenades dans la Forêt de Meudon," *Montjoie*, I:1 (February 10, 1913), p. 1. Somewhat earlier Rodin had created a marble (dated 1906) called *Hésiode et les Pléiades* (Cladel, 1908, p. 160). This work has not been identified.

20. Ovid, *Metamorphoses*, I. Lawton (p. 46) repeats this explanation: "The sculptor's intention, however, supplies the best interpretation: the man of the First Ages, strongly built and muscled, an emblem of creation, one of the stones which Deucalion cast behind him, and which rose painfully into human form."

21. Lawton, pp. 44-5.

22. *On Art and Artists*, pp. 87-8.

23. Letter of January 29, 1906, quoted in German translation in Emil Waldmann, *Auguste Rodin*, Vienna, 1945, p. 73.

24. Bartlett suggested that *The Age of Bronze* represents "the sculptor himself concealed in the figure of a young warrior waking from the half-sleep of unknown strength" (p. 250). Cladel feels that it describes the interior drama of the artist himself (1950, p. 107). In a medallion of 1880, Rodin's friend Ringel uses *The Age of Bronze* as an emblem of the sculptor; ill. *Magazine of Art*, 8 (1885), 385.

25. Bartlett, p. 99.

26. See note 3. Rodin's comparison of *The Age of Bronze* with the *Apollo* seen in Naples is strong evidence that the figure was begun before his Italian journey, which Cladel tells us occurred at the end of the winter of 1875 (1950, p. 109). Bartlett (p. 45) indicates that Rodin began to work on *The Age of Bronze* after he completed the Loos Monument in Antwerp and after he dissolved his partnership with Van Rasbourg. The date of the dissolution of the partnership has recently been dated to the winter of 1874-1875; Albert Alhadeff, "Michelangelo and the Early Rodin," *Art Bulletin*, 45 (December, 1963), p. 364. Two biographers tell us that Rodin worked on *The Age of Bronze* for eighteen months (Bartlett, p. 65; Cladel, 1950, p. 114). Since it was completed at least by January, 1877, or by December, 1876, as Cladel suggests, it was probably begun in the summer of 1875. This first version is listed as a plaster in the catalogue for the 1877 Paris Salon, no. 4107.

27. Bartlett, pp. 99 and 101; Cladel, 1950, p. 120. This bronze is now in the Musée Rodin. *The Age of Bronze* was exhibited many times after 1880, including the Exposition nationale des Beaux-Arts (Paris) of 1883, an exhibition at Burlington House (London) in 1886, the Exposition Universelle (Paris) of 1889, the Exposition centennale de l'art français (Paris) of 1900, the 1900 Rodin exhibition (Paris) and the Rodin exhibition in Prague in 1902.

28. According to Emil Waldmann, by 1945, 150 bronzes had been cast by Rudier alone (*op. cit.*, p. 72-3).

2

The Sculptor and His Muse
(*Le Sculpteur et sa Muse*)

Bronze, dark brown patina with traces of red and green
25 15/16 x 18 13/16 x 19 15/16″ (65.9 x 47.8 x 50.6 cm)
Inscribed: A. Rodin (base, front right)
Stamped: A. Rodin (inside, front), and:
 ALEXIS.RUDIER./FONDEUR.PARIS. (rear, lower right)
1941.34.2

In this pair of figures—an old but still athletic man and a young woman—Rodin reinterprets traditional attitudes toward artistic inspiration. Surging rhythms set the figures in motion as both sway to the left; viewed in profile, base and figures sweep upward with the surge of a wave about to crash. Male and female move almost as one, the convoluted form of the woman weighing heavily on the man. The figures are pressed so closely together that they nearly merge, and the spilling hair of the woman covers both heads. This transformation and ambiguity of a single element as well as the interlocking forms and the contortion of the woman's body to maximize the curvilinear motif—note particularly the flamelike fingers of the right hand—link this group with Art Nouveau tendencies. Though the sinuous female body is related to the art of the 1890s, the man derives from earlier sculptures by Rodin: his pose and muscular build recall *The Thinker* (cat. no. 19), while the face resembles the *Little Man with the Broken Nose* (cat. no. 51).

The man partially covers his wrinkled and tormented face with his right hand as if to suppress a cry of anguish. The cause of his torment is not immediately apparent. Is it what the woman whispers in his ear? Does he react to the peculiar erotic caress of the woman's right hand? Again we are faced with the ambiguous meaning typical of Rodin's sculpture. The name, *The Sculptor and His Muse*, which Rodin used in the 1900 exhibition catalogue (no. 93), identifies the figures, but does not completely elucidate his intentions.[1] The title indicates that Rodin's group is an allegorical representation of inspiration, a theme expressed in several groups succeeding the Victor Hugo monument.[2] While not in itself a new idea, Rodin's conception of inspired and inspirer, however, is extremely personal. With the athletic representation of the sculptor, Rodin realigns himself with the Renaissance view of the artist as an active, strong man. As in *The Thinker* and in the *Balzac*, physical power becomes a symbol of artistic potency.

The muse is an essential element of the composition. Though traditional categories include no muse for sculpture, Rodin gives us one, presented not as the remote, spiritual being found in earlier representations but as a real woman. Such personalization of the muse had gradually evolved since the mid-nineteenth century in art and literature alike. An early

example is Ingres's painting, *Cherubini and the Muse of Lyric Poetry* (1842), where the muse, seen at close range, is modelled on the features of an identifiable person. Ultimately this trend led to such intensely personalized conceptions as the ethereal, tender hermaphrodites of Gustave Moreau, the modern, gartered muse of Félicien Rops, the contemporary ladies in Maurice Denis's *The Muses* (1893) and the impish personage portrayed by Rodin. Rops and Rodin introduced an erotic element into the personalized muse, though in his "Nuits" poems, Alfred de Musset, whom Rodin greatly admired, had already suggested an amorous relationship between poet and muse.[3]

It remained for Rodin to make this erotic relationship between muse and artist explicit. Rodin, like many before him, associated the women in his own life with inspiring muses. He wrote of this to his friend, Helene von Nostitz:

> A gentle woman is the mighty intermediary between God and us artists. Through her we express a thousand-fold that which is in us Is there not great joy in imagination and is it not an advantage of man that he created the muse, the powerful awakener, like the Beatrice of Dante? Everyone has in his life a force which watches over him.[4]

Perhaps the overwhelming strength of the muse in Rodin's sculpture represents this power, which for him was primarily sexual. He saw sexual love as a way to artistic achievement:

> I have heard the bellowing of my spirit in battle for woman. I have spied on myself in my moments of passions, of the intoxication of love, and I have studied them for my art[5]

Rodin found this relationship between sex and genius aptly expressed by Baudelaire: "Baudelaire caught the truth [about *volupté*] when he said that a man's sexual sensitivity measures his genius."[6] In *The Sculptor and His Muse*, this association is clearly expressed; the muse, who stimulates the sculptor sexually while she whispers in his ear, has both erotic and intellectual powers.[7] Her overbearing posture, which bends the muscular sculptor to the side, demonstrates the intensity of her force. The tension expressed on the sculptor's face suggests that she tortures the artist even while inspiring and arousing him. She is not a consoling, but a tormenting, muse.

Rodin commented on this dualistic aspect of woman, who had the ability to both suppress and inspire the artist:

> Feminine charm which crushes our destiny, mysterious feminine power that retards the thinker, the worker, and the artist, while at the same time it inspires them—a compensation for those who play with fire![8]

Perhaps the woman's flowing hair spilling over the sculptor's head symbolizes the ensnaring power of woman, as it did for Baudelaire.[9] The overbearing insistence of the muse suggests that inspiration is no longer a beneficial gift, but a curse. The intense struggle to create produces exhaustion, despair and eventually the inability to create. Is this the significance of the gesture of the sculptor's right hand that covers his mouth as if to suppress a scream? Rodin once commented on this inhibiting effect of inspiration:

> Those who have a preconceived idea—an "inspiration," as they call it—are seldom able to render their ideal, as, in art, the brain cannot express a form too nicely calculated, too concise.[10]

The Sculptor and His Muse.
Cat. no. 2, two views.

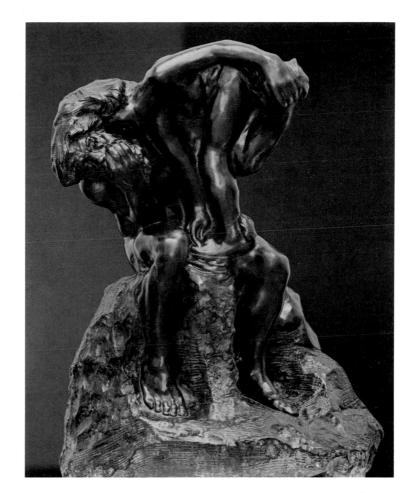

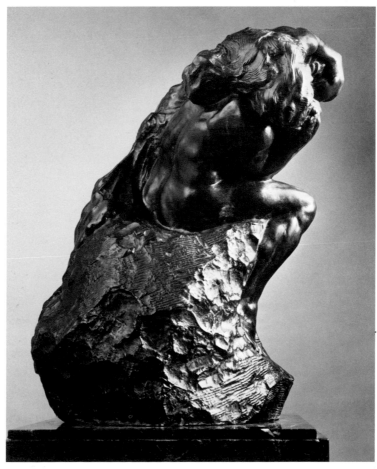

Inspiration seen as a destructive force with creativity occurring despite, not because of the inspiration, then, seems to explain Rodin's distrust of inspired moments and his preference for hard work and the faithful representation of nature.[11] The struggle that accompanies artistic creativity is also implied by the agonized face and writhing pose of the sculptor in this group.

> The men at the top should say to the beginners, "At each corner there is suffering and fresh struggles. We who have conquered passed by that weary road, you can go no other way.[12]

Clearly, *The Sculptor and His Muse* has not only personal but great artistic significance as well. It holds no single message but a mixture of meanings, which sometimes appear to be contradictory. The multiple themes in a work such as this led some of Rodin's contemporaries to complain that since no single meaning was evident, the work must have no meaning at all.[13] On the contrary, the overlapping significances enrich the work and continue to challenge its viewer.

Exactly when Rodin conceived *The Sculptor and His Muse* is uncertain, but it was completed by the 1890s. The group appeared in a painting by René Avigdor, *Rodin in His Studio* (Salon of 1898).[14] Similarities between *The Sculptor and His Muse* and the studies for the Victor Hugo monument suggest a date around 1890. The voluptuous, sinuous woman is like Rodin's studies of muses whose pliant limbs are pushed into unconventional poses. The juxtaposition of muse and seated, cogitative man is another link to the Victor Hugo studies. Even the convex shape of *The Sculptor and His Muse* is comparable to studies for the second Victor Hugo monument, where the poet is shown standing with a winged figure above. This jutting compositional arrangement, however, is a frequent feature of Rodin's sculpture.

The bronze *Sculptor and His Muse* in the California Palace of the Legion of Honor was purchased by Mrs. Spreckels through Loïe Fuller.[15] It entered the Museum in 1924 as a loan.[16] This bronze is one of the ca. 66-cm-high versions, but a ca. 39.5-cm version also exists. We have located relatively few casts of either size. In addition to the bronze casts, a stone, and possibly a marble, version also exist.[17] The stone replica, exhibited in the 1900 Rodin show, is, not surprisingly, less precise in detail than the bronzes; it also has a broader base. A variant appears in a photograph of Rodin's studio reproduced in 1905 by Mauclair.[18] This image shows the figure of the sculptor holding a lyre with his left arm; his legs are slightly altered to accommodate an additional figure, an armless version of the allegory of Day from the *Tower of Labor*.

1. Whether other titles for this group had Rodin's sanction is uncertain, but they are close in meaning to the name used in the 1900 catalogue. In the Kunsthalle Bremen the group is called *Inspiration of the Sculptor* and in the National-Galerie, Berlin, *Man and His Genius*.

2. Among the artist and muse groups are *L'Homme et sa Pensée* (1889; Grappe, 1944, no. 225), *Le Poète et la Muse* (before 1905; Grappe, 1944, no. 341) and the *Study for a Monument (to Eugène Carrière?)* (see cat. nos. 48-49).

3. Cladel, 1950, 79; L. Bénédite, *Rodin*, New York, 1927, p. 14. One of Rodin's later works, *Le Poète et la Muse*, dated before 1905 by Grappe (1944, no. 341), is inscribed with a line from "La Nuit de Mai": "Poète, prends ton luth et me donne un baiser." A fragment of this same line, *"prends ton luth,"* appears also on a drawing of two fighting men in the Goupil album, *Les Dessins de Auguste Rodin* (1897).

4. Helene von Nostitz, *Dialogues with Rodin*, New York, 1931, pp. 75-6. Rodin seems to have used the term "muse," a common expression of endearment in the nineteenth century, to refer to the Duchess of Choiseul, his companion from 1904 to 1912 (M. Tirel, *The Last Years of Rodin*, New York, 1925, passim).

5. Frisch/Shipley, pp. 356-57.

6. *Ibid.*, p. 356.

7. The relationship between the sexual potency and artistic inspiration is also indicated in one of the nude studies for Rodin's *Balzac*, where the athletic figure grasps his erect penis with his right hand (Athena Tacha Spear, *Rodin Sculptures in the Cleveland Museum of Art*, Cleveland, 1967, pl. 38). The inspiring power of sex was realized by the late nineteenth-century neurologist, Krafft-Ebing: "Sexual influence is just as potent in the awakening of aesthetic sentiments. What other foundation is there for sculpture or poetry? From (sensual) love arises that warmth of fancy which alone can inspire the creative mind, and the fire of sensual feeling kindles and preserves the glow and fervour of art" (*Psychopathia Sexualis*, New York, 1965, p. 6).

8. Cladel, 1917, p. 176. Cf. Frisch/Shipley, pp. 6 and 357.

9. See, for example, Baudelaire's "Une nuit que j'étais près d'une affreuse Juive," in *Les Fleurs du Mal*.

10. Quoted in B. von Vorst, "Rodin and Bernard Shaw," *Putnam's*, 3 (February, 1908), p. 535.

11. "Have patience! Do not count on inspiration. It does not exist." ("De la patience! Ne comptez pas sur l'inspiration. Elle n'existe pas.") Auguste Rodin, "Aux Jeunes Artistes," *Les Arts Français*, 11 (January, 1918), p. 44. On numerous other occasions, Rodin expressed his distrust of "moments of inspiration," preferring instead continuous hard work.

12. Anne Leslie, *Rodin, Immortal Peasant*, New York, 1937, p. 271.

13. This type of criticism is satirized by Aleister Crowley, who in 1907 published a collection of poems called *Rodin in Rime* based on Rodin's sculpture: "Rodin's works, it is said, *mean* nothing. He makes a study: people see it in his studio: A. goes up and says to the Master: 'Ah, how beautiful,' etc., *ad nauseam*—'I suppose it is "Earth and the Spring."' B. follows, and suggests 'Hercules and Cacus'; E. varies it with 'Moses breaking the Tables of the Law'; F. cocks his eye warily, and asks if it is not meant for 'Mary Magdalene'" Crowley then continues in a more serious vein: "I am given to understand that something of the sort described above does sometimes take place in the naming of a statue (of the allegorical description especially). But that is a question of felicity, of epigram; never of subject" (*The Works of Aleister Crowley*, III, 1907, p. 109f).

14. Now in the Musée Rodin, Paris. III. W. H. Hale, *The World of Rodin*, New York, 1969, p. 166.

15. Note signed "A. S." [Alma Spreckels] at the bottom of a letter addressed to Mrs. Spreckels from Isabel Scott dated January 10, 1928. The exact date of the purchase is not known.

16. The 1924-1925 California Palace of the Legion of Honor (CPLH) catalogue, no. 165.

17. Cladel lists and dates 1902 a marble version (1908, p. 159). Since no marble version has been located, perhaps Cladel confuses this with the stone version exhibited in 1900.

18. Mauclair, p. 108. This group may be the one now in the Musée Rodin, Meudon.

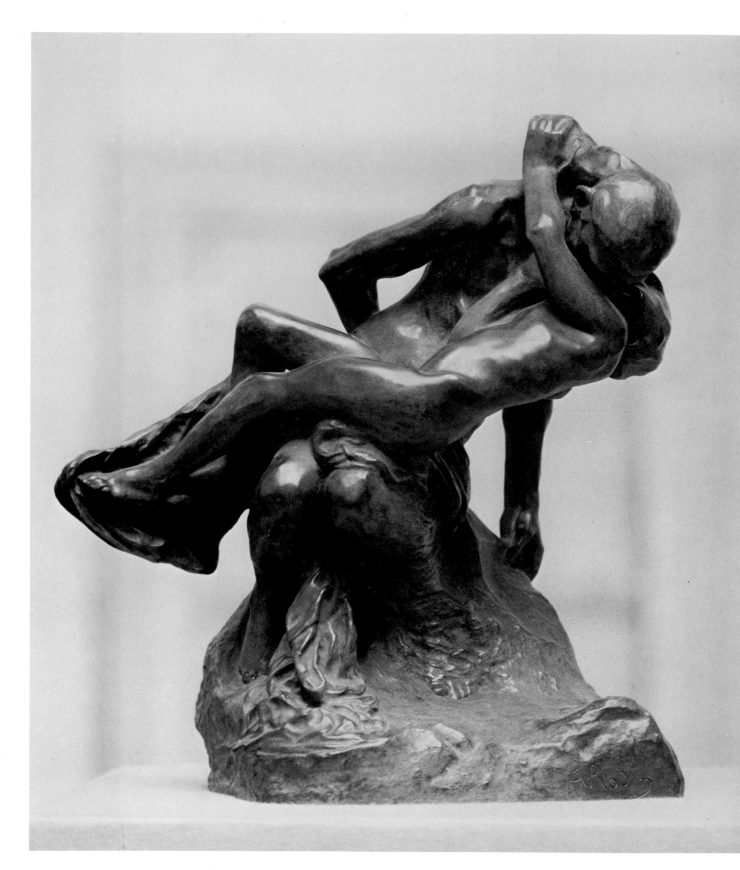

3

Youth and Old Age

(La Jeunesse Triomphante)

Bronze, green to black patina
20 1/2 x 18 x 13 3/8″ (52.1 x 45.8 x 34 cm)
Inscribed: A. Rodin (front of base, right)
1941.34.3

In *Youth and Old Age*,[1] a decrepit old woman and a young girl form a strange union. In this enigmatic work, the girl perches precariously on the crone's knees, offering her an embrace which is not returned; her weary partner lets one arm drop to her side, while the other lies behind her back. The old woman's slumping pose contrasts with the adolescent's youthful energy; both seem about to topple over. The rich and daring modelling of the elderly woman is an outstanding proof of Rodin's adages that nothing in nature is ugly and that what most would consider ugly in nature can be made beautiful by the artist.[2] The cadaverous body of the old woman and the firm flesh of her young companion contrast sharply, betokening the effect of time on the body.

Bodily changes that accompany the passing of years have always held a compelling fascination. At the end of the century many artists, such as Puvis de Chavannes, Gauguin and Munch, expressed the cyclic nature of life by juxtaposing in their work figures representing various stages of human existence. Interest in the life cycle helped foster an emerging focus on the adolescent, important in art, literature, and scientific studies around 1890. Viewed as a period of awakening, particularly of sexual awareness, adolescence gradually took on erotic overtones, which culminated in Colette's perverse Claudine novels popular at the turn of the century.[3]

These interests are reflected in Rodin's *Youth and Old Age*, but other aspects of this work cannot be so easily explained. The adolescent and aged bodies can be seen as the earliest and latest stages in a woman's life: the time when she first becomes fully aware of her sexual identity and the age when she sees her sexuality as ended. Rodin suggests budding eroticism in the languorous pose of the slender girl and her insistent embrace. The title used for this work in the 1896 salon, *Old Age and Adolescence (Vieillesse et Adolescence)*, makes this intention quite clear. The old woman, a slightly altered version of *The Old Courtesan* (also called *Celle qui fut la belle heaulmière*), can be interpreted as a modern memento mori, reminding man of the inevitability of death. The old woman alone has long been associated with François Villon's poem, "Les Regrets de la Belle Heaulmière" ("The Lament of the Beautiful Helmetmaker"), and perhaps in the group, the young girl represents the aged beauty's memory of her past.[4] Villon's theme of the inevitability of death, the unremitting passage of time, is strongly evoked in an early title for Rodin's group, *Young Girl and Fate (La jeune fille et la Parque)*.

A similar title, *Fate and the Convalescent*,[5] suggests a slightly different meaning. The old woman is identified as Fate by the scissors, visible on the back of the base, that she has let fall from her right hand. She has taken pity on the young girl and decided that it is not yet time to cut short the life of one still so young.

The continuous victory of youth over death is expressed in yet another common name for the group, *Triumphant Youth*. The aggressive embrace of the girl may express the continual replacement of the aged by the young, yet the erotic implications are surprising, even shocking. We would expect the aged woman to embrace the girl, symbolizing the invigorating qualities youth has for the old. Such a situation could be accounted for in psychological terms as well; the phenomena of senile dementia, a reawakening of the sexual instinct in old age, which is often directed towards children, had been described by Krafft-Ebing.[6] In Rodin's group the reverse of this situation takes place: the young girl is attracted by the decaying form of the old woman. This combining of decay and eroticism recalls an essential aspect of Baudelaire's aesthetics. In *Youth and Old Age*, realism and symbolism exist side by side, a duality that is at the heart of Rodin's sculpture. The ambiguities of the particular and the universal and the wide range of implied meanings for this work make it forever enigmatic and, therefore, forever fascinating. Not Rodin's greatest work, it remains a significant statement on essential concerns of his time.

The old woman in this group is based on *The Old Courtesan*; the girl also appears to have been developed independently at an earlier date.[7] This explains the rather awkward joining of the two figures. The pose of the old woman does not seem to take the girl into account; the adolescent's feet protrude at an abrupt angle. Rodin has softened these disparities by adding an otherwise inexplicable drapery, which sweeps around the adolescent's legs and flows down onto the base.

After exhibiting a marble version at the Salon of 1896,[8] Rodin decided to edit the group on a commercial basis; in 1898 he transferred reproduction rights to Fumière et Cie. That foundry cast many replicas of the 50.1-cm model.[9] Casts have been made by other founders, but the group exists in only one size.

The Legion of Honor cast of this work was among the first six sculptures purchased by Mrs. Spreckels from Loïe Fuller in 1915. It remained in Mrs. Spreckels' home until it entered the museum in 1924.[10]

The Old Courtesan
(*Celle qui fut la belle heaulmière*),
bronze, 19½" high.
Philadelphia Museum of Art.

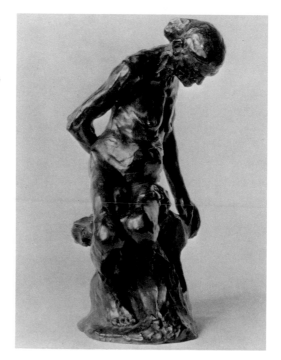

56

Youth and Old Age. Cat. no. 3, detail.

1. *Youth and Old Age* is the title traditionally used in the CPLH. Usually the piece is called *Triumphant Youth (Jeunesse Triomphante)*.

2. ". . . Everything in nature has its charm and beauty, and what we call ugliness has that strength of beauty which is called 'character' " (". . . tout, dans la Nature, a son charme et sa beauté, et ce que l'on appelle 'laideur' a cette force de beauté qu'on appelle 'le caractère' "), *On Art and Artists*, p. 68. "What is commonly called *ugliness* in nature can in art become full of great beauty" (*Ibid*., p. 59).

3. For further information on erotic interest in the adolescent around the turn of the century, see Patrick Waldberg, *Eros in la Belle Epoque*, New York, 1969, pp. 107-118.

4. The earlier sculpture of the old woman by herself differs in regard to the position of her feet, the shape of the base, the amount of drapery used and the more exciting modelling. Grappe tells us that *The Old Courtesan* was shown at Angers in 1889, and he dates it before 1885 (1944, no. 122). It may actually date from 1880, when Rodin designed a similar figure for the vase called *Les Limbes* (Roger Marx, *Rodin céramiste*, Paris, 1907, p. 43). The same figure is used in the lower left corner of the left pilaster of *The Gates of Hell* (cat. no. 29); despite the differing poses, the same model was probably used for both this figure and *The Old Courtesan*. At least ten casts of the 50.8-cm *Old Courtesan* exist. From this work Rodin made a variant, juxtaposing two casts of the same figure and called *Les Sources Taries*. This variant was exhibited in the Monet-Rodin show in 1889; the plaster cast is today in the Musée Rodin at Meudon (59.7 x 55.2 x 40 cm). In addition to this variant, Rodin also executed a charcoal drawing after *The Old Courtesan* to illustrate a book by Maurice Guillemot (54 x 38.7 cm); Sotheby sale, April 24, 1968, no. 60).

5. "La Parque et la Convalescente" is the caption used for a photograph of the group in the Rodin number of *La Plume* (1900), p. 67. Still another purely descriptive title for the group is *Le Baiser de l'aïeule* (Grappe, 1944, no. 270).

6. *Psychopathia Sexualis*, New York, 1965, p. 38.

7. Spear has pointed out that this figure was also used in the group called *The Earth and the Moon* (*Rodin Sculptures in the Cleveland Museum of Art*, p. 77). According to Grappe, who dates that group before 1898, both figures were probably first developed for *The Gates of Hell* (1944, no. 294). Replicas of *The Earth and the Moon* are found in the Museo Nacional de Bellas Artes, Buenos Aires, and the Musée Rodin, Paris.

8. The present location of the marble version is unknown, but it was mentioned in Cladel, 1908, p. 158, and is illustrated in the *Gazette des Beaux-Arts*, s. 3, 15 (1896), p. 453.

9. Copies of the contracts made with these firms for *Youth and Old Age* are in the Musée Rodin, Paris (ex-Coll. Durig). According to Goldscheider, nineteen bronzes were cast by the Fumière foundry (Jianou-Goldscheider, p. 82). However, the cast in the Cleveland Museum of Art is No. 24 and the one in the Durban Museum and Art Gallery is No. 39, certifying that substantially more casts were made by the foundry which became Thiébaut-Fumière. Although Goldscheider also indicates that *Youth and Old Age* was edited in four sizes, only one size is known.

10. Copies of the contracts between Mrs. Spreckels and Loïe Fuller were in the collection of Miss Jean Scott Frickelton, Palo Alto. The donation was made official in 1941.

4

The Fallen Angel

(*L'Ange déchu*)

Bronze, black to natural bronze patina
20 13/16 x 21 1/2 x 32" (52.9 x 54.6 x 81.3 cm)
Signed: A. Rodin (top of base, right)
Stamped: A. RUDIER FONDEUR PARIS (rear)
1940.139

Limbs interlace, bodies fold and unfold, surfaces pulsate and melt to generate in this group an energy potential like that in a bud about to burst into flower. One woman draws herself into a ball, embracing a woman who stretches languorously over a rocky protrusion, her wings dipping into the water below. Different as these two women are, the one full blown, voluptuous, the other lean and almost sexless, both are types repeated by Rodin. One allowed him to explore the smooth, sensuous contours of the female body; the other lent itself to a virtuoso demonstration in sculpture of the play of bone against flesh. The more mature figure approaches the sleek quasi-pornographic nudes of late nineteenth-century academic art, whereas the more adolescent one reflects a type popular around the turn of the century.

Many elements in this group link it with Art Nouveau aesthetics. The slender woman was a favorite with artists of the avant-garde style of the 1890s. Art Nouveau also emphasized complex curves as found throughout Rodin's composition. The watery base, which denies the supportive function of this element, is used by Rodin and by contemporary artists like Gallé. The Art Nouveau delight in smooth sensuous forms is also a major factor in Rodin's *Fallen Angel*.

To pinpoint the meaning Rodin intended to give to this group is difficult. Is it erotic or spiritual? The joining of two females—one in a frankly sensuous pose as the other embraces her—hints at the oft-repeated theme of lesbianism, less explicit in this piece than in other of Rodin's works (see, for instance, cat. no. 15). The wings on the fallen figure, however, are an unmistakable indication of spirituality. This aspect was probably the most significant for Rodin, since the supine posture and early titles suggest the theme of lost illusions, frequent in nineteenth-century art and literature. The original cumbersome title, *Illusion falls, her wing broken, the Earth receiving her*, evinces this.[1] Other titles indicate that Rodin associated his group with specific manifestations of this theme. One, the *Fall of Icarus*, shows the importance of this common nineteenth-century image for Rodin. In other sculptures and drawings, Rodin alludes to Ovid's tale of Icarus, which in the last century was often used as a metaphor for the artist's attempt to rise above mundane existence, though with foreknowledge of his inevitable fall, or disillusionment.[2] Similar meanings are implied by other titles for this group, like *The Fallen Angel (l'Ange déchu)* and *The Fall of an Angel (La Chute d'un Ange)*. Such titles

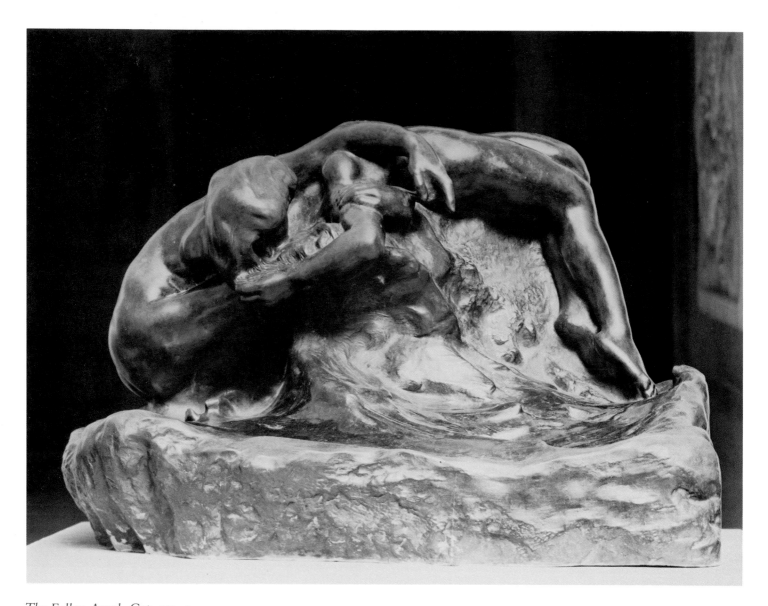

The Fallen Angel. Cat. no. 4.

Right: *The Fallen Angel.* Cat. no. 4, detail.

indicate a fall from grace or virtue and are probably taken from Lamartine's epic poem, *La Chute d'un Ange*, though Rodin's group reflects the poem in only the most general way.[3] As in certain poems—for example, Vigny's *Eloa* and Hugo's *La Fin de Satan*—Rodin depicts the angel as a woman rather than the customary beautiful young man. Divergent erotic and spiritual elements are reconciled in Rodin's group to suggest a love that fuses soul and body. Indeed, the merging of antithetic moods is one of the most extraordinary innovations in this work.

Equally successful is the nearly unnoticeable joining of two figures created earlier. If the viewer were not familiar with the *Torso of Adele*, from which several figures are derived, and with the *Fallen Caryatid* (see cat. no. 23), he would be unaware that these figures are restated.[4] Though both can be dated in the 1880s it is uncertain when they were united to become *The Fallen Angel*.[5]

Rodin created two versions of *The Fallen Angel*; which one came first is unknown. Replicas in marble of both versions are found in the Musée Rodin. The bronze in the Spreckels collection, on loan to the Legion of Honor from 1924, is cast after the marble version that shows the crouching woman's left arm draped across the other figure and was exhibited in 1900.[6] The original material can be detected in the Spreckels' bronze by the traces of chisel marks on the base and by the imprecise modelling of the crouching woman. In the second marble version, the crouching figure places her left arm behind her partner.[7] The right wing is diminished and partly replaced by an abundant flow of hair. A small number of bronze and plaster replicas have been cast after both marbles, but most seem to be cast after the same marble as the Spreckels' bronze.

NOTES

1. *L'illusion tombe, l'aile brisée, la Terre la recueille* (Grappe, 1944, no. 277).

2. The importance of this theme in nineteenth-century literature has been stressed by Maurice Z. Shroder, *Icarus, the Image of the Artist in French Romanticism*, Cambridge, Mass., 1961. Its role in Rodin's work is suggested by the many references to Icarus in titles for various works. The sculpture usually called *Le Rêve* has also been known as *L'Illusion, fille d'Icare*, *La Chute d'Icare* and *Icaresse* (Grappe, 1944, no. 237). A late variant of *La Martyre* is titled *L'Illusion, fille d'Icare* and *La Chute d'Icare* (Athena Tacha Spear, *Rodin Sculpture in the Cleveland Museum of Art*, Cleveland, 1967, p. 56). The group usually called *La Chute des Anges* was exhibited as *La Chute d'Icare* in New York (Grappe, 1944, no. 411). Several drawings are related to the Icarus theme. In the 1897 album, we find an early drawing inscribed "*icar/Phaeton*," suggesting the close relationship between Ovid's two myths of ascendency and fall (*Les Dessins de Auguste Rodin*, Paris: Goupil, pl. 86). Another early drawing, a study for Rodin's first conception of Ugolino, is inscribed "*Icare le génie*" (beneath a phrase from Dante), stressing the common association of Icarus with the man of genius (Elsen, *Gates*, pl. 30). A third drawing shows Icarus plunging to the sea (*op. cit.*, pl. 94). See also Elsen's discussion on the importance of the Icarus theme in *The Gates of Hell* (*op. cit.*, pp. 134-36). This

longing for spiritual flight, represented by the Icarus theme, persisted well into the Symbolist period. Examples of such themes can be found in the poetry of Mallarmé and Leconte de Lisle as well as many others.

3. Lamartine's poem is about the trials of the angel Cédar, who became human because of his love for the beautiful Daidha. The theme of the fall of angelic or human beings was a recurrent one in the nineteenth century.

4. According to Cladel, the *Torso of Adele* was a study for two caryatids to be placed on the Villa Neptune, a program Rodin allegedly worked on under the sculptor Charles Cordier in 1878 (1936, p. 135). However, little is known of this commission.

5. Grappe dates *The Fallen Angel* 1895, but without documentation (1944, no. 277). *The Fallen Angel* was exhibited in the 1900 Rodin exhibition (cat. no. 73). No medium is given in the catalogue; however, the photograph shows that it was not marble, but rather clay or plaster. Even though the figures reused were created in the 1880s, this date does not preclude the possibility that Rodin joined them only in the 1890s, as Grappe suggests.

6. Grappe lists only a plaster cast of this version (1944, no. 277). The marble is illustrated by Bernard Champigneulle (*Rodin*, New York, 1967, pl. 100).

7. This version is illustrated by Descharnes/Chabrun (p. 135).

5
Study for The Eternal Idol
(*L'Eternelle Idole*)

White, untinted plaster with traces of piece mold
7 1/16 x 5 5/8 x 3 3/8″ (18 x 14.3 x 8.6 cm)
No inscription
1933.12.8

In this plaster study for one of his most successful groups, Rodin explores the relationship of man and woman. The nude man kneels reverently before the adored woman, kissing her tenderly beneath the left breast. Curbing his passions, he clasps his arms behind his back; yet, in the ardor of his veneration, he leans against his half-standing, half-kneeling goddess, who draws back, nonchalantly grasping her right foot. Her inclined head and modest carriage reflect innocent aloofness, as she majestically acknowledges the man's adoration with her extended left hand.

Like many of Rodin's works of the late 1880s and early 1890s, *The Eternal Idol* is remarkable for its captivating simplicity, a quality seen in the sketch not only in the geometrical grouping of the figure, but also in the abbreviated treatment of the figures themselves. Rodin emphasizes the disposition of the bodies, reducing faces and other details to a minimum. Seen from either end, the rhythmical swaying of the figures suggests a dreamlike movement achieved by the deviations from the triangular arrangement of the figures. This illusion of motion precludes an overly rigid composition and adds subtlety to Rodin's simplicity, making this group one of his most engaging.

Despite the uncomplicated disposition of the figures, the meaning of the group remains elusive. Many questions arise as we study it: if the woman is really an idol, why does she look human, and why does the man kiss her as if she were a woman? If she is merely a woman, why does she behave with the aloofness of an idol? Does the woman stand for a real woman or a real idol or for an abstract idea? Rilke, Rodin's most perceptive contemporary analyst, clearly explained the problematic nature of this group when he wrote:

> One does not dare (as so often with Rodin) to give it one meaning. It has thousands. Thoughts glide over it like shadows, new meanings arise like riddles and unfold into clear significance.[1]

On one level we can see the man's kiss as an erotic gesture—and a photograph of this group appears in a book on eroticism.[2] It could represent the ritualistic inception of young love or a young man's appreciation of his sexual partner.[3] Still the casual response of the woman in contrast to the ardent man is a relationship typical in erotic art and one met frequently in

63

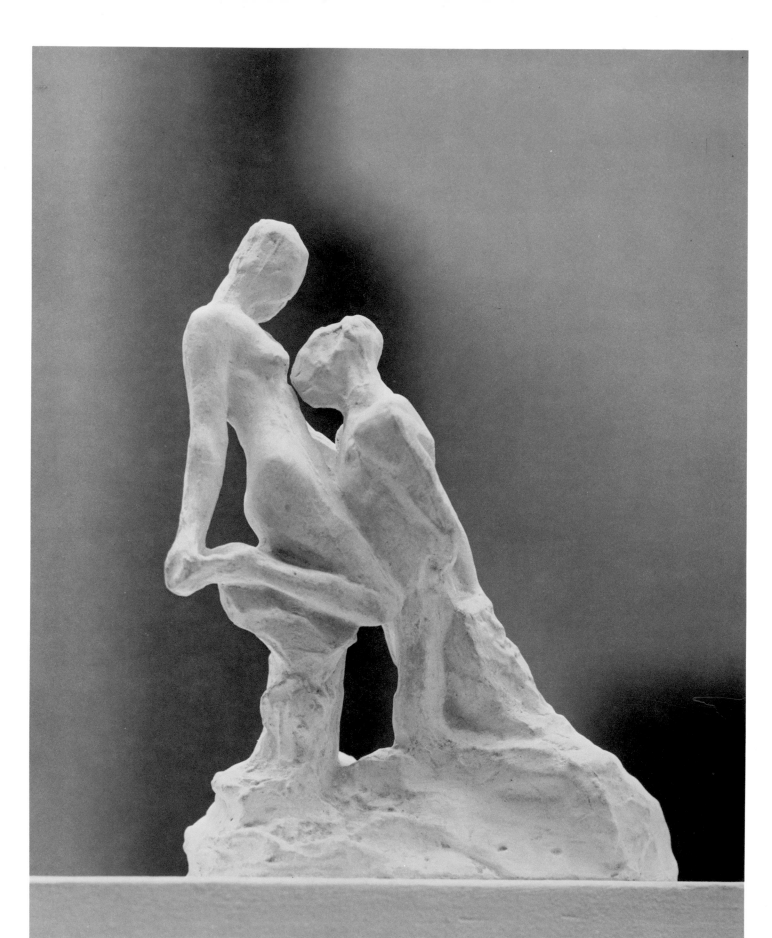

Rodin's male-female groups.[4] Moreover the title, *The Eternal Idol*, reflects an attitude towards woman expressed in nineteenth-century poetry, where women are frequently described as idols.[5] The aloofness and restraint of the venerated woman are expected of an idol. However, these characteristics were also associated with the powerful woman, who was ultimately victorious over man; some of Rodin's contemporaries saw this work in this way.[6] Rodin explained that this sculpture was inspired in part by certain lines in Alfred de Vigny's poem, "La Colère de Samson," where the cold and treacherous Delilah remains indifferent to the passionate love of the biblical hero.[7] Despite Rodin's comparison, the woman herself bears few signs of malice. Unexpected ideas are conjured by the original title, *The Host*.[8] Though this name evokes something of the veneration and deification associated with the word "idol," in such a context it smells of sacrilege. Rodin liked to play with this confusion of carnal and spiritual; we have another example in his *Christ and the Magdalene* (see cat. no. 11). In *The Eternal Idol*, the replacement of the symbolic body of Christ with the body of a beautiful woman is reminiscent of the backward masses of the satanists.

An even more complex title for this work is *Ideal Love*, a name which further expands the meaning of the work and is open to various interpretations. It may describe an exemplary love relationship, whether physical or spiritual or both, or one never to be achieved. Works like this one have many titles, and these suggest many possible interpretations. But the names attached by Rodin are not without significance. Indeed, they often open doors to unexpected allusions and enrich our enjoyment of the sculpture. The allusiveness of Rodin's titles, with their variety of possible meanings, reveals Rodin's close relationship to Symbolist poetry. Mallarmé explained the inappropriateness of naming an entity too directly.

The Eternal Idol,
marble, 28¾ x ca. 23″ high.
Courtesy of the Fogg Art Museum,
Harvard University.

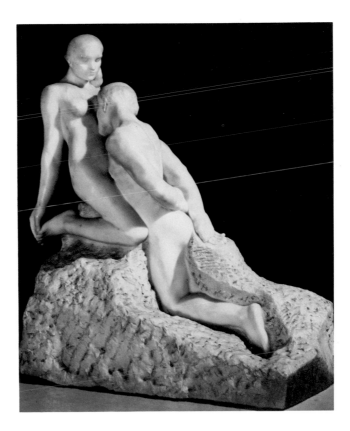

Left: *Study for The Eternal Idol.* Cat. no. 5.

> *To name* an object is to suppress three-quarters of the enjoymnent of the poem which brings happiness by unfolding itself little by little; *to suggest*, that is the dream. It is the perfect use of this mystery that constitutes the symbol; to evoke little by little an object in order to show a state of the soul, or, inversely, to choose an object and to extricate from it a state of the soul, by a series of decipherings.[9]

These ideas, which had wide currency in the late nineteenth century, have a striking parallel with Rodin's attitude towards titles. As in Mallarmé, only by the gradual revelation through a series of titles did Rodin's sculptures unveil ever-growing significances.

The exact dating of *The Eternal Idol* has not been firmly established, though on stylistic grounds we can place it in the 1880s, along with other sculptures celebrating the kiss. The group was certainly completed by 1891, when visitors to Rodin's studio reported seeing it.[10]

Surprisingly few replicas of the definitive group exist, though cheap commercial reproductions are still popular. The Spreckels' plaster sketch is closest to the bronze versions (ca. 18 cm and ca. 30 cm high), which show the figures more detached from the base and less refined in details than in the marble replicas and in plasters taken from the marbles. In the latter version, the figures sink into the massive base, which gives greater stability and weight to the group. Like so many of Rodin's sculptures, *The Eternal Idol* became a starting-point for other compositions. A plaster cast of the sketch of the woman combined with a seated woman with a real branch at its side has been associated with the monument to Puvis de Chavannes.[11] The sketch of the woman reappears in *The Gates of Hell* in the lower right corner of the right door. Both figures are reused, with a third figure, in the group called *God Protecting His Creatures*.[12] *The Eternal Idol* as a group inspired Rodin to create a dark and mysterious lithograph of the sculpture seen from behind.[13]

NOTES

1. "Man wagt (wie so oft bei Rodin) nicht, ihr eine Bedeutung zu geben. Sie hat tausende. Wie Schatten gehen die Gedanke uber sie, und hinter jedem steigt sie neue und ratselhaft auf in ihrer Klarheit und Namenlosigkeit" (*Auguste Roḋin*, Leipzig, 1920, 35-36).

2. François des Aulnoyes, *Histoire et Philosphie de l'érotisme*, n. p., 1958, frontispiece.

3. A more personal interpretation of this gesture is also likely. It may be Rodin's way of celebrating woman as the source of beauty, of inspiration for the sculptor (cf. cat. no. 2). Desbois told Frisch of how he once saw Rodin at the end of the day bending over a nude model lying on a couch and tenderly kissing her on the stomach, "as a sign that work was over, but even more as a reverent gesture of thanks to the sacred source of beauty" (Frisch/Shipley, p. 354). A similar association is made by Roger-Milès, who sees the woman as a muse: "C'est l'homme agenouillé devant la muse inspiratrice et buvant sa sève vivifiante, sous son sein gauche, tout près du coeur, qui bat, serein et régulier, sans que les mains, obstinément ramenées derrière le dos, tentent d'effleurer le corps sacré, d'un toucher qui pourrait être charnel et deviendrait une souillure" (cited in Antony Roux sale catalogue, Galerie Georges Petit, May 19 and 20, 1914, no. 127). Rodin may have encouraged this interpretation, since the companion piece to *The Eternal Idol* in an exhibition of 1896 (see note 8) is alternately called *The Poet and the Muse* and *Man and His Thought* (Cladel, 1917, opposite p. 270; Grappe, 1944, no. 225).

4. One example among many is an engraving of Ch. Eisen's painting, *L'Amour Européen* (c. 1775), showing the woman reclining on a couch reading, while the man kneels on the floor kissing her hand. This engraving is inscribed: "Cette fière Beauté, de l'Amour qu'elle brave/Sent en secret toute l'ardeur;/ Mais de ses Sens Maîtresse et jouant la froideur,/Ainsy de son amant elle fait son Esclave" (Illustrated, Eduard Fuchs, *Geschichte der erotischen Kunst*, Munich, 1922, III, following p. 312).

5. Such epithets are common in Baudelaire's poems; an example is found in his "Chanson d'après-midi" in the *Fleurs du Mal* (LVIII): "Je t'adore, ô ma frivole,/Ma terrible passion!/Avec la dévotion/Du prêtre pour son idole."

6. For example, Arsène Alexandre wrote of this piece in the catalogue to the 1900 Rodin exhibition

(no. 95): "A première vue, on croirait qu'ici il y a communion plus étroite entre l'idole et son adorateur. Mais observez qu'elle se laisse adorer, et que, dans ce groupe, l'homme se donne tout entier, avec une sorte de ferveur, tandis que la femme le domine, avec un joli geste de bête, cette main qui tient le pied délicat et impatient; elle hésite tout au moins; elle permêt, elle n'éprouve point." Similarly Jules Renard described the group he saw in 1891: ". . . un homme, les bras derrière le dos, vaincu, embrasse une femme au-dessous des seins, lui colle ses lèvres sur la peau, et la femme a l'air tout triste" (*Le Journal de Jules Renard*, entry for March 8, 1891, 1. 87, Paris, 1927).

7. These lines are quoted by Arthur Symons: "Une lutte éternelle en tout temps, en tout lieu,/Se livre sur le terre, en présence de Dieu,/Entre la bonté d'Homme et la ruse de Femme,/Car la femme est un être impur dc corps et d'âme;" "Notes on Auguste Rodin," *Apollo*, 14:80 (1931), p. 96.

8. Grappe says that this sculpture was exhibited in 1889 as *L'Hostie* (1944, no. 241). This title stayed with the piece through the 1890s, though *L'Eternelle Idole* also came into use at this time. In his account of his visit to Rodin's studio, Jules Renard calls it by the latter name (*op. cit.*, p. 87). When exhibited in 1896 with *Man and His Thought*, the two pieces were known collectively as *Les deux Hosties* (Grappe, 1944, no. 241). In his lecture of 1899, Charles Morice still refers to the piece as "L'Hostie" (*Rodin*, Paris, 1900, p. 6). In the 1900 Rodin exhibition catalogue (no. 95), the group is listed as *L'Eternelle Idole*. This title was apparently suggested in casual remark by the legislator, M. Rivet, while visiting Rodin's studio, and the sculptor found it a more suitable name (Lawton, p. 287).

9. "*Nommer* un objet, c'est supprimer les trois-quarts de la jouissance du poème qui est faite du bonheur de deviner peu à peu; le *suggérer*, voilà le rêve.

C'est le parfait usage de ce mystère qui constitue le symbole; évoquer petit à petit un objet pour montrer un état d'âme, ou, inversement, choisir un objet et en dégager un état d'âme, par une série de déchiffrements"; cited by Jules Huret, *Enquête sur l'évolution littéraire*, Paris, 1894, p. 60. The exact nature of the Rodin-Mallarmé relationship has never been firmly established. The two seem to have been intimately acquainted in the 1890s, though their friendship may stem from the 1880s, since both were part of the Léon Cladel circle (Carl Paul Barbier, ed., *Correspondance Mallarmé-Whistler*, Paris, 1964, pp. 203, 259, 284, 292; Cladel, 1950, p. 32).

10. Renard, *op cit.*, p. 87. Grappe reports that M. Byvanck also saw it in Rodin's studio in that year (1944, no. 241). He reports its exhibition as *L'Hostie* in 1889. No work by this title is found in the 1889 Monet-Rodin exhibition catalogue.

11. "*Petit groupe à deux personnages*" (C. Goldscheider, *Rodin inconnu*, Paris, 1962, no. 126). The final conception for the Puvis de Chavannes monument, which was never finished, showed a bust on an altar with the *Genius of Eternal Repose* on the left and a tree in the rear (Mauclair, 1905, pp. 89-90; Lawton, p. 270; A. Symons, *From Toulouse-Lautrec to Rodin*, London, 1929, pp. 241-42. Cf. Grappe, 1944, nos. 292 bis and 293).

12. In the Boston Museum of Fine Arts, this piece is titled *Study for the Victor Hugo Monument*, but this identification seems doubtful.

13. Loys Delteil, "Rude, Barye, Carpeaux, Rodin," *Le Peintre Graveur Illustré. XIXe et XXe siècle*, VI:12 (Paris, 1910). Dating of this lithograph varies. Grappe dates it 1890 (1944, no. 251). However, Delteil, without giving specific information, claims that it is "très postérieure aux autres estampes de Rodin," suggestive of a later date ("Rodin," *op. cit.*, n. p.).

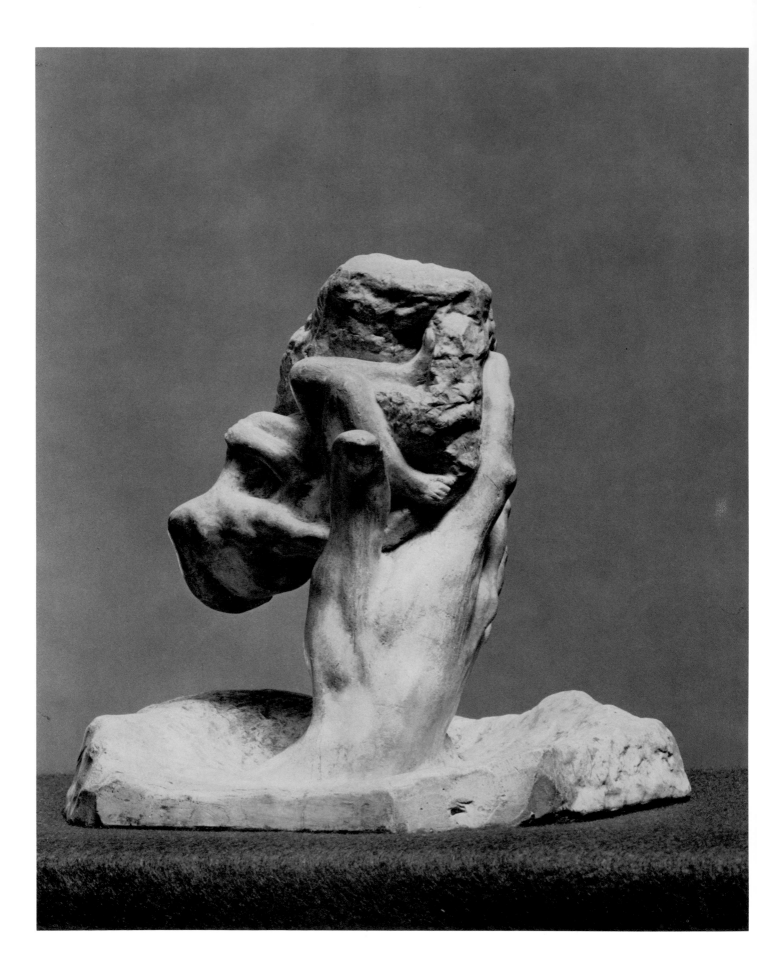

6
The Hand of God
(*La Main de Dieu*)

Plaster, tinted light brown; some traces of piece mold
6 1/16 x 6 7/8 x 5 1/2" (15.4 x 17.5 x 14 cm)
No inscription
1933.12.19

In this striking symbol of creativity, Rodin equates the life-giving hand of God with the formative hand of the sculptor. The hand, spread fanlike as if in the very act of shaping, rises from an amorphous mass and holds a lump of material from which, incompletely modelled, emerge the first lovers. Not yet free from the earthy matrix, Adam and Eve already respond to God's first command to "be fruitful and multiply."[1]

Executed sometime before 1898, *The Hand of God* is another expression of Rodin's long fascination with the creative impulse.[2] Does not *The Thinker* struggle to give birth to an idea? Were not the first man and woman originally appendages to *The Gates of Hell*? Involved with the monuments to Hugo and Balzac, Rodin contemplated the source of artistic genius anew, producing numerous metaphors for creativity.[3] But Rodin was by no means the first among nineteenth-century artists and writers to be fascinated by the creative urge. For example, painters frequently revealed this concern in depictions of the artist's studio. Throughout the century, interest in the artist's hand increased as part of this cult of genius. To make casts of the hands of artists and writers was common practice.[4] One of Rodin's critics pointed out at an early date the affinity between his sculptures of isolated hands and Verlaine's poetic portrayal of hands as independent personalities,[5] but this celebration of the hand as the primary and independent instrument of creation is unique in sculpture.

The significance of Rodin's sculpture as a symbol of creative force is clear from both image and titles.[6] The reference to the Hand of God recalls the disembodied *Dextera Dei*, a metaphor of God's power, found in medieval art. In later representations of God, the hands are given special significance as creative instruments—look at the powerful hands of the creating God in Michelangelo's Sistine Chapel ceiling. Rodin delighted in expounding on the analogy of God to the sculptor, an analogy certainly not new by this time.[7] In *The Hand of God*, Rodin makes this association between the creative powers of God and artist indubitable. The work is a concise and personal statement of his idea of the nature of creation, complex in its overlapping metaphors, innovative in its celebration of the hand as a creative instrument, but surprisingly direct in the images selected.

The Spreckels' cast of *The Hand of God* is one of many replicas in a variety of sizes ranging from ca. 15 cm to ca. 100 cm high. Most are like the small Spreckels' cast, though the base

Left: *The Hand of God*. Cat. no. 6.

varies, particularly among the marbles.[8] Usually both cast and carved replicas show the hand emerging from a scooped-out base, but one version (an example is the plaster dedicated to Loïe Fuller in the Maryhill Museum of Fine Arts) has a flatter base which exposes more of the hand and wrist. Details are somewhat clearer in this version, and the mass from which the figures emerge is smaller and more claylike than the rocky matrix of other replicas. Probably this less common version is based on the original clay model. In the typical version we find a strange mixture of passages resembling both unfinished marble and clay, which may indicate a cast from a marble version with some reworking. Could this be the version which Louis Vauxcelles tells us was revised in 1902?[9] The considerable number of replicas attests the popularity of *The Hand of God*.

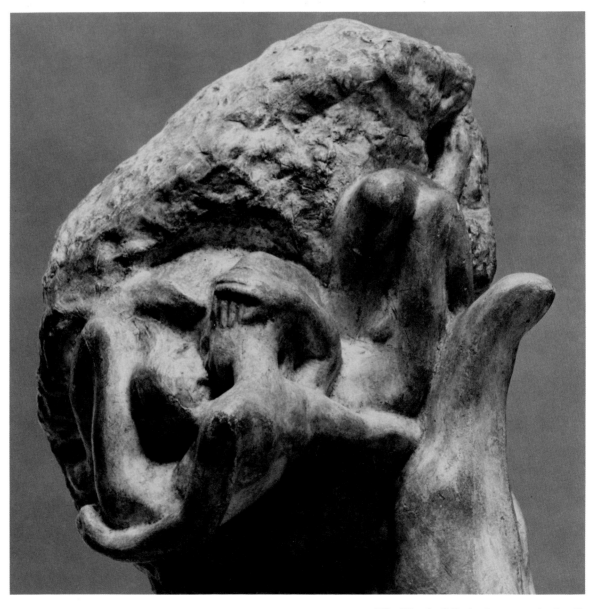

The Hand of God. Cat. no. 6, detail.

NOTES

1. George Wyndham reported Rodin's statement on *The Hand of God* to his sister in a letter of 1904: "This is the Hand of God. Emerging from rock, chaos, clouds. It's really got a sculptor's thumb. It's holding the soil and from it Adam and Eve are created. Woman is man's crown. Life, energy—are all those ours? . . ." (letter of May 24, 1904, quoted in Anne Leslie, *Rodin, Immortal Peasant*, New York, 1937, p. 216).

2. *The Hand of God* was described in an article by Edouard Rod, who calls it *La Création* and "la grande main de Dieu" ("L'Atelier de M. Rodin," *Gazette des Beaux-Arts*, ser. 3, 19 [May, 1898], p. 427). Possibly this work was executed several years earlier, however, since Rod lists *The Hand of God* among works detached from *The Gates of Hell*, and since the hand has been associated with the right hands of the burghers, Pierre and Jacques de Wiessant (Athena Tacha Spear, "A Note on Rodin's Prodigal Son . . .," 1969, p. 79). Furthermore, the two entwined lovers bear a close stylistic resemblance to the piece known as *L'Idylle Antony Roux*, which was shown at the 1889 Monet-Rodin exhibition according to Grappe (1944, no. 208). Perhaps the germinal idea for *The Hand of God* is found in the marble, *Two Hands Upright*, in the Fogg Art Museum at Cambridge. In this piece, the two hands enclose a lump of unformed matter (36.2 x 38.1 cm); inscribed: "A mon grand ami/Maurice Haquette/A. Rodin", 81'' (former coll. Arnold Arnold; Grenville L. Winthrop bequest, 1943).

3. Among these we can list *The Sculptor and His Muse* (cat. no. 2); *The Poet and Contemplative Life* (Grappe, 1944, no. 198); *Pygmalion and Galatea* (Grappe, 1944, no. 233); *The Poet and the Muse* (Grappe, 1944, no. 341; *The Creation of Woman* (Grappe, 1944, no. 344).

4. A striking example of the artist's facination with the hand is Géricault's repeated studies of his own left hand made on his deathbed. Assistants commonly made casts of the face and hands of their masters, and Géricault inscribed a plaster cast of his hand, "A tous ceux que j'aime. Adieu!" (Lorenz Eitner, *Géricault*, Los Angeles, 1971, no. 125). Casts also exist of the nineteenth-century artists Auguste Préault (Ernest Chesneau, *Peintres et Statuaires Romantiques*, Paris, 1880, p. 139) and of Alexandre Cabanel (*Catalogue des Peintures et Sculptures*, Montpellier, 1904, no. 1113). This practice was still current during Rodin's time: three weeks before Rodin's death, Amédée Bertault executed a cast of the sculptor's hand holding a torso (Grappe, 1944, no. 438). Casts of hands of others who relied on the hand as a tool of creation were also made during the nineteenth century—for example, Balzac and Hugo. Gallé created a glass hand in 1904, which probably follows Rodinesque prototypes.

5. Gustave Kahn, "Les Mains chez Rodin," *Rodin et son Oeuvre (La Plume)*, 1900, p. 28. Kahn probably had in mind poems like "Mains" in Verlaine's *Parallèlement* (first published July, 1889), where he writes *"les mains ont leur caractère"* and *"La main droite est bien à ma droite, l'autre à ma gauche, je suis seul"* (*Oeuvres complètes de Paul Verlaine*, Paris, 1920, II, pp. 186-88).

6. In the 1900 Rodin exhibition catalogue, the piece was called by its best-known title, *Main de Dieu* (no. 67), but Rodin suggested numerous titles to a lady who asked its name: "What mental indolence! Name the piece what you will, according to the impression it makes on you. Look: it might be *Creation*, or *The Beginning*, or perhaps *Religion*, or again *The Creator's Hand*. Naturally the title depends upon what strikes you first, or most strongly. Always the forms give rise to the ideas" (Frisch/Shipley, p. 202). Though Rodin suggests a variety of titles, all refer back in some way to the idea of creativity.

7. For example, Rodin described, like Victor Hugo before him, the importance of modelling in God's creation of the world: ". . . la première chose à laquelle Dieu a pensé en créant le Monde, si nous pouvons nous imaginer la pensée de Dieu—c'est au modèle. C'est drôle, n'est-ce pas, de faire de Dieu, avant tout un sculpteur? . . ." (Cladel, 1903, p. 77. Cf. Mauclair, 1905, pp. 65-66).

8. Apparently Rodin continued to produce marble replicas of this piece until he died. Loïe Fuller tells us that at the moment of Rodin's death, the Russian sculptor "Soudbinne" [Seraphin Soubdinine, a marble cutter for Rodin and the sculptor of a bust of Rodin in the CPLH] was executing a marble version of this piece (typescript in CPLH archives, p. 4).

9. *Histoire Générale de l'Art français de la Révolution à nos jours*, Paris, 1922, II, p. 257. Several of Rodin's biographers date *The Hand of God* 1902, despite its mention in Rod's article of 1898 and its exhibition in 1900. The later dating may be based on a reworked version, as Vauxcelles suggests, or on a significant exhibition. We have not discovered an exhibition of *The Hand of God* in 1902 (unless it was exhibited under a different title in the 1902 Prague Rodin show), though Joseph Breck claims that both marble and bronze versions were shown that year ("The Collection of Sculptures by Auguste Rodin in the Metropolitan Museum," *Metropolitan Museum of Art Bulletin*, supp., May, 1912, 20). On the other hand, Valentine de Saint-Point says that this piece was "très remarquée au premier Salon d'Automne [1903]" ("La Double Personnalité d'Auguste Rodin," *La Nouvelle Revue*, n. s., XLIII [Nov. 15, 1906], p. 199).

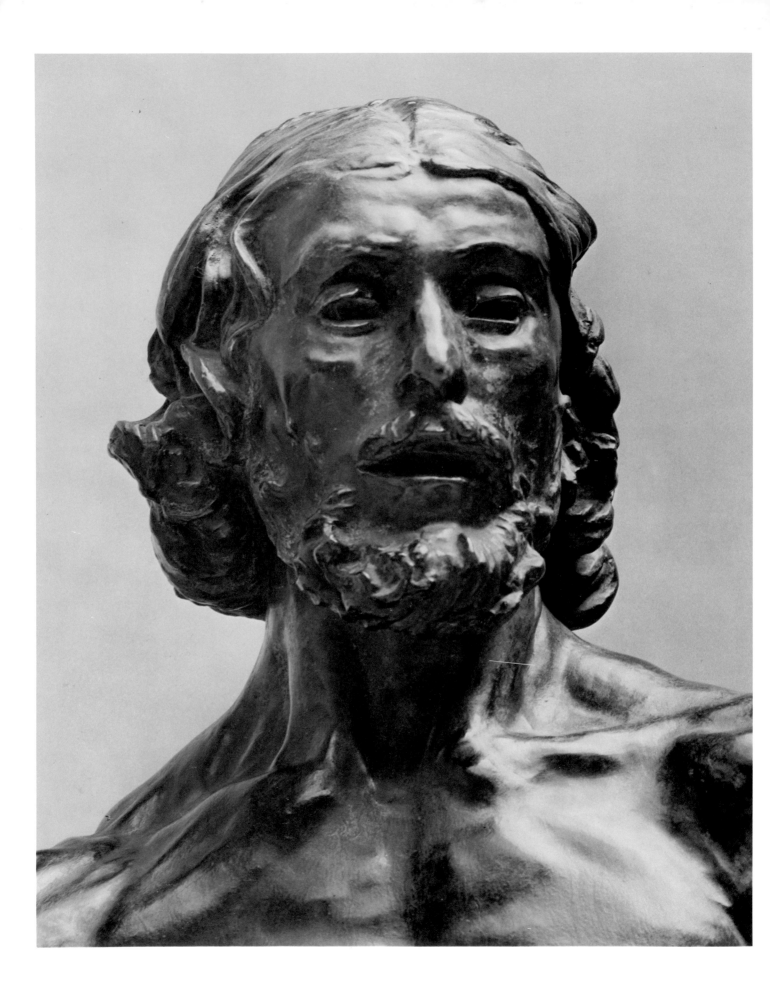

7

St. John the Baptist Preaching
(*Saint Jean-Baptiste prêchant*)

Bronze, black to natural bronze patina with some areas of green
79 1/2 x 51 5/8 x 38 5/8″ (202 x 54.7 x 98.1 cm)
Signed: Rodin (base, top right)
Stamped: A. RUDIER. FONDEUR. PARIS. (base, side at back)
1940.140

With *St. John the Baptist Preaching*[1] Rodin creates an unprecedented image of both physical and spiritual vigor. As a work making a clear break with conventional sculpture, the *St. John* caused a great stir among Rodin's contemporaries.

Rodin began working on the *St. John* around 1878, partly with the intention of clearing himself of the charges which had been made against his *Age of Bronze* (cat. no. 1), namely that he had cast it from the living model.[2] He decided to make this figure larger than life-size, beginning as he often did with a sketch half the projected dimensions of the definitive statue. According to some biographers, Rodin's conception arose from a pose arbitrarily assumed by a 42-year-old Italian peasant named Pignatelli, who had never before modelled.[3] Though the completed figure was not exhibited until 1880, a plaster bust painted bronze was shown in the Salon of 1879 (no. 5322).[4] The plaster statue was purchased by the French government and subsequently cast in bronze. In its new material, the *St. John* was exhibited in 1881 and 1883.[5]

One of the most fundamental innovations of the *St. John* is its simulation of movement. Rodin represents the saint striding forward with dignity and confidence as he actively delivers a sermon. However, the firmly planted feet seem to argue with the definite impression of walking. Rodin explained this apparent contradiction as an attempt to synthesize the various movements involved in walking:

> . . . Now, for example, while my Saint John is represented with both feet on the ground, it is probable that an instantaneous photograph from a model making the same movement would show the back foot already raised and carried toward the other. Or else, on the contrary, the front foot would not yet be on the ground if the back leg occupied in the photograph the same position as my statue.
>
> Now it is exactly for that reason that this model photographed would present the odd appearance of a man suddenly stricken with paralysis and petrified in his pose . . .
>
> And this confirms what I have just explained to you on the subject of movement in art. If, in fact, in instantaneous photographs, the figures, though taken while moving, seem suddenly fixed in mid-air, it is because, all parts of the body being reproduced exactly at the same twentieth or fortieth of a second, there is not progressive development of movement as there is in art.[6]

The modelling of the *St. John* reflects Rodin's intention that the viewer's gaze be focused on those views of the sculpture that best emphasize the striding movement. Compared with the modelling of the front and sides of the figure, the back of the torso appears less finished. Rodin has selected a frontal view as the most expressive in one of his few drawings after his finished sculptures.[7]

Though Rodin attached extreme importance to the movement of the figure, he also introduced it as a new physical type. The exaggeration of certain anatomical parts, like the bulging muscles of back and arms and the ribs pushing through the chest, anticipate sculptures like *The Thinker*. However, a difference in proportions is apparent, for the *St. John* is slight and bony. The contrast between muscularity and wiry build suggests the ascetic habits of the desert dweller and the strength of his convictions. With his unusual figure type and with the unique method for representing movement, Rodin was able to create a sculpture with a forceful presence unlike anything his contemporaries had ever seen.

No wonder the *St. John* unleashed the greatest barrage of criticism which had yet greeted Rodin's sculpture. While some were brave enough to admire this daring work, most attacked it for the usual reasons: an obvious disregard for conventions, a lack of decorum and the absent attributes. Some criticized the pose which rejected the academic preference for *contrapposto*—having the weight of the body borne by one leg—and which showed the feet too far apart. They found the ambivalence of a figure which seemed to be both walking and standing difficult to accept. Some attacked the impropriety of a nude preacher, while others found the figure ugly and trivial, a criticism reminiscent of the barbs hurled against Courbet and the realists more than twenty years earlier. Some denounced the *St. John* as too realistic, but others found it not realistic enough. Still, some were able to appreciate the innovative qualities of the statue, to admire its powerful modelling and uncompromising naturalism.[8]

Even without the traditional attributes necessary to make Rodin's figure a "true" St. John—the camel's hair tunic, the leather belt, the cross and the scroll—the identification with the saint is clear.[9] Some of Rodin's biographers imply that the title for the work followed the execution of the figure, but this order seems doubtful, contemporary critics not withstanding, since Rodin's *St. John* has so much in common with traditional representations.[10] The ascetic appearance, haggard face and flowing hair and beard are related to certain fifteenth-century depictions.[11] The very appearance of the model brought the subject to Rodin's mind: "I thought immediately of a St. John the Baptist; that is, a man of nature, a visionary, a believer, a forerunner come to announce one greater than himself."[12] With this idea in mind Rodin reiterated the open mouth and the pointing hand that are typically found in representations of St. John the Baptist.

If Rodin's *St. John* has formal relationships with earlier images of the saint, it is less spiritualized and more robust, more down to earth, than its predecessors. This explains the criticism that Rodin had selected "a low physical and mental type" to represent the Baptist.[13] Such viewers expected the beautiful type of St. John, which Lecomte, Houdon and Rude had depicted, and not the cruder type preferred by Renaissance artists and by Rodin. The unpolished qualities of the model from the "wilds" of the Abruzzi attracted Rodin and suggested to him both St. John and the elemental man: "Seeing him, I was struck with admiration: that rough, unkempt man, expressing in his bearing, in his features, in his physical strength all the violence, but also all the mystical, character of his race."[14] Rodin saw Pignatelli as a savage with glittering eyes and mussed hair, as a beast, a wolf.[15] In his statue, the sculptor conveys this quality, along with a definite dignity, through the vehement

gestures, the energetic movement and the ferocious head, with its tousled locks. His deeply gouged eyes and wrinkled brow suggest simultaneously conviction and nobility. In fact, this portraitlike depiction of a preaching St. John accords with mid-nineteenth-century conceptions of saints and biblical personages as ordinary human beings. Rodin's statue vividly recaptures the mood of Renan's description of St. John's violent and severe sermons.[16] Similarly, Flaubert saw this saint as animalistic and violent: "His eyes blazed; his voice roared; he raised his arms, as if to bring down the thunder!"[17] Despite its kinship with certain literary and artistic depictions of the saint, Rodin's *St. John* represented such a break with his immediate predecessors in sculpture that it could not but shock the public of the early 1880s.

St. John the Baptist, drawing, 12¾ x 8¾". Courtesy of the Fogg Art Museum, Harvard University

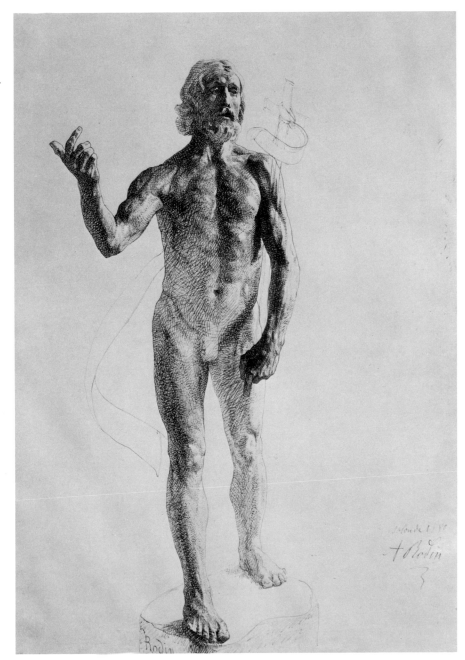

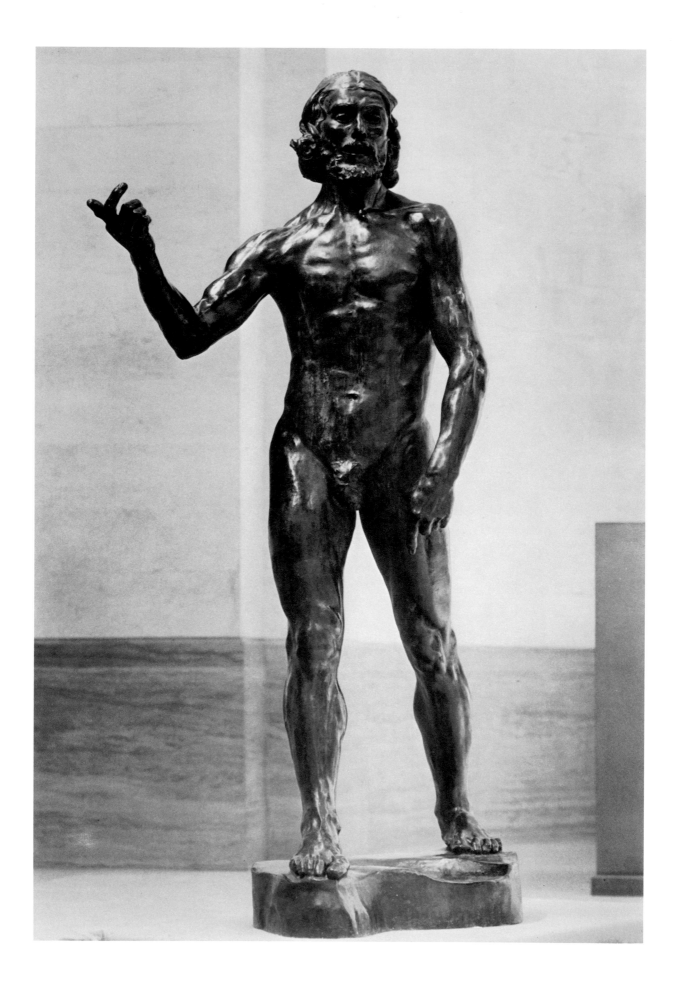

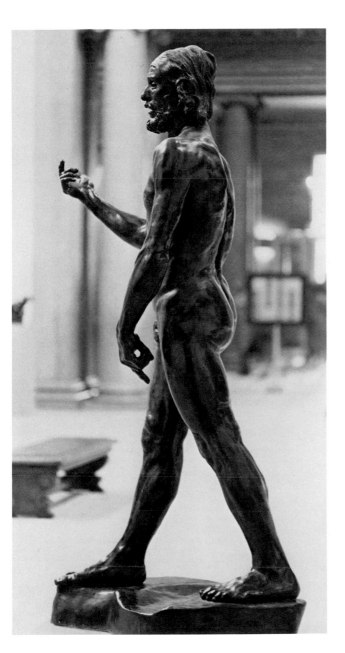

St. John the Baptist Preaching. Cat. no. 7.

The Walking Man, bronze, 7½″ high.
Smith College Museum of Art.

Left: *St. John the Baptist Preaching*. Cat. no. 7.

In time, however, through frequent exposure, the *St. John* lost its revolutionary character and became so admired that casts were in great demand. In 1898 Rodin authorized Fumière et Cie to reproduce casts in three sizes: 80 cm, 50 cm and 20 cm.[18] This foundry alone cast twenty-one bronzes. Admiration for the *St. John* was also intense outside France; in 1902 a large cast was purchased by public subscription for the Victoria and Albert Museum.[19] The Spreckels' casts of the largest and the smallest versions of the figure were among the first acquired in this country. One cast, most likely the life-size bronze, was purchased by Mrs. Spreckels from Loïe Fuller in 1915; it had been on display in the French Pavilion at the Panama Pacific Exposition in San Francisco that year. The date of purchase for the small bronze is unknown. Both casts were loaned to the Legion of Honor in 1924. Besides these casts of the full figure—nearly fifty are in existence—Rodin had casts made of the ca. 55-cm bust of *St. John*.[20]

Another work which has recently received a great deal of attention and which is intimately related to the *St. John* is *The Walking Man*. Although lacking both head and arms, the proportions and pose of *The Walking Man* are similar to the *St. John*. This fragmental sculpture is an assemblage of parts worked separately: a sketchy torso has been planted on more smoothly modelled legs.[21] The treatment of these legs is close to the *St. John*, but the left leg of *The Walking Man* is lengthened to accommodate the somewhat more extreme stride.[22] The nature of *The Walking Man* and the lack of historical data concerning it make it difficult to determine whether it is a study, an alternative or a later reinterpretation of the *St. John*.[23] A statement by Rodin to Dujardin-Beaumetz implies that the germinal idea for *The Walking Man* was inspired by the model for the *St. John*:

> The peasant undressed, mounted the revolving table as if he had never posed . . . The movement was so right, so expressive, and so true that I burst out: "Why it is a walking man!" I resolved immediately to make what I had seen.[24]

Rodin went on to indicate the order of the creation of the two works: "That is how I made successively *The Walking Man* and the *Saint John the Baptist*. I only copied the model that chance had sent me."[25] With the fragmental sculpture, Rodin's central interest in the movement of walking itself is even more forcefully stated than in the *St. John*.

NOTES

1. Also called *The Precursor* (Grappe, 1944, no. 40).
2. Bartlett (p. 99) tells us that at the end of the 1877 Salon, Rodin was still disturbed by the accusations that his *Age of Bronze* had been cast from the living model: ". . . he thought that the only way by which he could get it for himself was to make another statue, this time larger than life, and in the modeling of which he could not use or adapt reproductions from molds made on the living model . . . Selecting the subject of 'St. John Preaching,' he began a sketch half the size of what he intended the statue to be, working on it . . . during the mornings before he went to his daily labor, and long into the nights after he had left his employer's shop."
3. Cladel, 1950, p. 133; Dujardin-Beaumetz, p. 65; Lawton, p. 51.
4. According to Grappe, a man named Danielli, rather than Pignatelli, posed for the head of *St. John*

(1944, no. 40). However, Bartlett writes that "while Rodin was perfecting his sketch of 'St. John,' he made a bust of the same subject and from the same model, an Italian, about forty-two years of age, who was named Pagnitelli [sic]" (p. 100). Though this bust has not been identified, presumably it can be associated with the bronze bust exhibited in 1882 at the Royal Academy in London; ill. *Magazine of Art*, 6 (1883), p. 176. Several examples of the bust occur in various collections. A notable one is the bronze in the Metropolitan Museum of Art in New York, presented by George A. Lucas in 1893 (Paul B. Haviland, "Principal Accessions," *Bulletin of the Metropolitan Museum of Art*, V:5 [May, 1910], p. 126). A photograph of what may be a model for the bust is found in the Rodin albums in the Cabinet des Estampes at the Bibliothèque Nationale.

5. Salon of 1881, no. 4262; Exposition nationale des Beaux-Arts of 1883 ("Salon triennal"), no. 1107. In 1883, a tinted plaster cast of the figure was shown at the Dudley Gallery in London; "Art Chronicle," *Portfolio* (183), p. 145.

6. *On Art and Artists*, pp. 89-90.

7. This drawing is now in the Fogg Museum of Art, Cambridge; ill. *L'Art*, 22 (1880), p. 124. Another drawing by Rodin after the sculpture without the staff is in the Louvre.

8. On the critical acceptance of the *St. John*, see Lawton, p. 52 and 101; Bartlett, pp. 101 and 113; Cosmo Monkhouse, "Auguste Rodin," *Portfolio* (1887), p. 8; E. Bergerat, *Souvenirs d'un enfant de Paris*, Paris, 1911-12, pp. 251-52; Bénédite, "Propos sur Rodin," *L'Art et les Artistes*, 1 (1905), p. 31. For Rodin's defense, see Dujardin-Beaumetz, p. 66.

9. The drawing after the completed *St. John* shows the saint holding a cross with a streamer or scroll attached. This drawing may simply be an attempt to clarify the subject; however, Cladel states that Rodin originally placed a cross on *St. John*'s shoulders, and then removed it when he found it unsuitable to the composition (1917, p. 263).

10. Cladel, 1950, p. 133. The opposite view is offered by Bartlett (p. 99), who speaks of Rodin "selecting" the subject (see note 2).

11. A parallel tradition depicts St. John as a young boy. Such representations of the saint were common since the Renaissance and a striking example was created in the nineteenth century by Paul Dubois (Salons of 1863 and 1864). Apparently at some point Rodin also played with the idea of representing St. John as a youth, since Maillard illustrates a drawing of a boy's head as "Saint Jean-Baptiste enfant" (opposite p. 10) and Frisch/Shipley label Frisch's copy of a similar drawing "John the Baptist as a Child" (p. 37).

12. Dujardin-Beaumetz, p. 65.

13. Bartlett, p. 262.

14. Dujardin-Beaumetz, p. 65.

15. Cladel, 1950, p. 133; Dujardin-Beaumetz, p. 166.

16. "Le ton général de ses sermons était sévère et dur. Les expressions dont il se servait contre ses adversaires paraissent avoir été des plus violentes. C'était une rude et continuelle invective;" *Vie de Jésus* (1863) in *Oeuvres complètes de Ernest Renan*, v. IV, Paris, 1947, p. 150.

17. "Ses prunelles flamboyaient; sa voix rugissait; il levait les bras, comme pour arracher le tonnerre;" "Hérodias," *Trois Contes*, 1877, Lausanne, 1965, p. 101.

18. The contract, made for ten years, was not renewed when it lapsed in 1908 (C. Goldscheider, *Mostra di Augusto Rodin*, Rome, 1967, p. 24, no. 8). Though Goldscheider specifically says that casts in four sizes were made, she catalogues only three (*ibid.*). Jianou/Goldscheider list five Fumière casts of the ca.-80-cm, twelve of the ca.-50-cm and four of the ca.-20-cm versions (p. 86).

19. This cast is now in the Tate Gallery, no. 6046.

20. Casts of the bust correspond to the one illustrated in *Magazine of Art*, 6 (1883), p. 176. See note 4 for further discussion. Rodin may have also made separate casts of one of St. John's hands, since a "Main no. 23 (de Saint Jean-Baptiste)" is listed in the catalogue *Sculptures de Rodin*, Palais de la Méditerranée, Nice, Dec. 1961-Jan. 1962, no. 57.

21. Elsen has identified the torso with the bronze *Torse d'homme* in the Petit Palais, Paris, 53 x 27 x 24 cm, gifts of Sir Joseph Duveen, 1923 (*Rodin*, p. 32). This torso may be the one referred to by Bartlett as "the first sketch of 'The St. John'" (p. 250). It was reproduced in *L'Art Français*, Feb. 4, 1888.

22. Nearly 6 inches (15.3 cm) difference in length exists between the front and the back legs in *The Walking Man*. In comparison, the legs of the large *St. John* vary only by about an inch.

23. A reliable dating would help us to determine Rodin's intentions in regard to *The Walking Man*. Unfortunately, little historical evidence remains. The two versions of *The Walking Man* were exhibited only at the 1900 Rodin exhibition (ca.84-cm version) and at the Salon of 1907 (ca.168-cm version). However, many biographers date the work 1888 (Mauclair, p. 125; Cladel, 1908, p. 158; Coquiot, *Vrai Rodin*, p. 244; Frisch/Shipley, p. 423). This early dating may stem from the allegation sometimes made that *The Walking Man* was a sketch for one of *The Burghers* (Cladel, 1908, p. 158; Frisch/Shipley, p. 423; Maillard, p. 154). Several theories have been offered to explain that nature of *The Walking Man*. Besides the odd association with *The Burghers*, Cladel makes a dubious reference to the lost statue of *Joshua* (Cladel, 1950, p. 132). More frequently the piece is called a study for the *St. John* (1900 Rodin catalogue, no. 63 [ill.]; Lami, p. 163; 1902 Prague catalogue, no. 118; Grappe, 1944, no. 38). Modern scholars tend to see *The Walking Man* as a later assemblage of studies for the *St. John* (J. A. Schmoll gen. Eisenwerth, "Zur Genesis des Torso-Motivs und zur Deutung des fragmentarichen Stils bei Rodin" in *Das Unvollendete als Künstlerische Form*, Berne/Munich, 1959, p. 131; Leo Steinberg, "Introduction," in *Rodin, Sculptures and Drawings*, New York, 1963, p. 24; Albert E. Elsen, *The Partial Figure in Modern Sculpture*, Baltimore, 1969, p. 19). An account by Judith Cladel of how two studies for the *St. John* were assembled around 1900 gives weight to this theory:

> Parmi les Études préparatoires du *Saint Jean*, il en est une que Rodin avait 'poussée' jusqu'à la limite de son inexorable vouloir. A cette époque il travaillait à la Manufacture de Porcelaine de Sèvres . . . La plupart du temps, ne pouvant poursuivre ses créations personnelles que le soir, il s'éclairait d'une lampe ou d'une chandelle et fut amené, pour plus de facilité, à traiter son Étude en deux parties, le torse d'une part, les jambes de l'autre. Il se proposait de les raccorder un jour à venir. Ce ne fut que vingt ans après, aux environs de 1900, qu'il réalisa ce projet. Il organisait alors

l'exposition d'ensemble de son oeuvre au pavillon construit dans ce but place de l'Alma et tenait à y faire figurer ce splendide Essai. Malheureusement, il ne disposait plus de l'impressionnant modèle de 1878 et il eut une peine infinie à mener à bien le raccord. Se livrant à d'incessantes retouches, il faisait prendre chaque fois un estampage du nouvel état de sa figure et n'en était jamais content. Le plâtre qui en résulta eut près de deux mètres de haut et fut nommé *l'Homme qui marche* par les mouleurs de l'atelier (*Rodin*, Paris, 1948, pp. *xvi-xix*).

For further information on *The Walking Man*, see the articles by Elsen: "Rodin's 'Walking Man' as Seen by Henry Moore," *Studio*, 174 (July, 1967), pp. 26-31; and "Rodin's *The Walking Man*," *Massachusetts Review*, 7:2 (Spring, 1966), pp. 289-320.

24. "Le Paysan se déshabille, monte sur la table tournante comme s'il n'avait jamais posé . . . Le mouvement était si juste, si caractérisé et si vrai que je m'écriai: 'Mais c'est un homme qui marche!' Je résolus immédiatement de faire ce que j'avais vu." (Dujardin-Beaumetz, p. 65).

25. "C'est ainsi que j'ai fait successivement *l'Homme qui marche* et le *Saint Jean-Baptiste*. Je n'ai fait que copier le modèle que le hasard m'avait envoyé" (*ibid.*, p. 66).

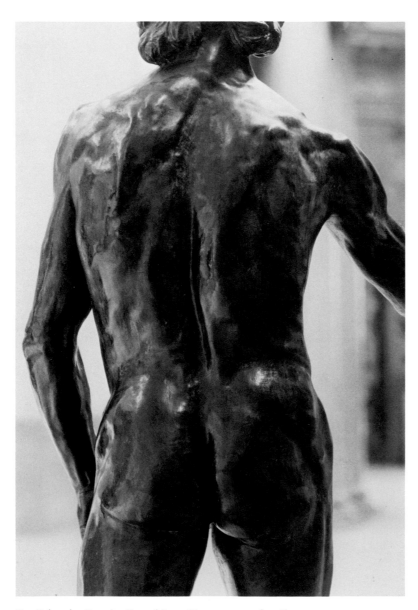

St. John the Baptist Preaching. Cat. no. 7, detail.

8

St. John the Baptist Preaching
(*Saint Jean-Baptiste prêchant*)

Bronze, dark brown patina; mounted on stone
7 1/2 x 2 x 4 1/8″ (19.1 x 5.1 x 10.5 cm)
Signed: A. Rodin (top of bronze base, right)
1941.34.1

This little *St. John* is a lilliputian version of the life-size statue (cat. no. 7). It is particularly striking for its base—a real rock, not a traditional pedestal—and follows the pattern of many of Rodin's sculptures where the figure is related to its natural environment. In this work, this relationship enhances Rodin's view of St. John as a man of nature.[1] The showing of the identity of man and nature, a prominent concern of artists at the turn of the century, took one of its most fascinating forms in the decorative arts which flourished at the time. Rodin repeatedly expressed his concern for the way sculpture interacted with its environment, whether natural or created by man.[2] Often he appended a suggestion of the proper setting to the actual sculpture.[3] He does so in the Spreckels' cast of the *St. John*, where he suggests the man preaching in the wilderness.

In the tiny version of the *St. John*, we no longer focus on the anatomy and movement of the figure; it is transformed into an exquisite statuette that continues the tradition of the small Renaissance bronzes much in favor at the time.[4] Statuettes, both unique works of fine craftsmanship and commercial editions, were increasingly popular throughout the nineteenth century. The careful workmanship, the small number of casts and the individualized base of the *St. John* link it to an original tendency of the decorative arts in the years around 1900 which distinguished the unique work, made with the painstaking care of the jeweller, from the mass-produced reductions.[5]

The reduced size of this version of the *St. John* expands our possible vantage points, allowing us to view it from above and below as well as from all sides. But the viewer must examine it at close range. The figure no longer partakes of our space, but we view it as if it belongs to a world of another scale. The observer is further separated from the figure by the large rock which seems to place St. John on an island apart; he thus becomes a symbol of the alienated man, a man alone in a lonely world.

1. Dujardin-Beaumetz, p. 65.
2. *Ibid.*, p. 77.
3. For example, the *Petit groupe à deux personnages*, C. Goldscheider, *Rodin Inconnu*, Paris, 1962, no. 126.
4. The nineteenth century delighted in small statues which could become part of decorative arrangements and could be handled as precious objects. The taste for antique and Renaissance statuettes was revived during this period. Examples were found in prominent collections and were discussed in art journals, for example, the Thiers collection; see Charles Blanc, "Le Cabinet de M. Thiers," *Gazette des Beaux-Arts*, ser. 2, 12 (April, 1862), pp. 289-320. We find this predilection for small bronzes reflected in the sculptures of Barye (for example, in his *Erymanthus Carrying His Boar*) and many other contemporary artists.

5. This interest in small bronzes was expressed by Paul Vitry ("La Petite Sculpture aux Salons," *Art et Décoration*, 12 [July-December, 1902], p. 40):

Voici plusieurs années que nous constatons un développement, plus accentué à chaque exposition nouvelle, de cette petite sculpture où certains artistes, comme Dampt, comme Théodore Rivière, ont déjà su se tailler un véritable domaine et s'imposer par des chefs-d'oeuvre à l'admiration unanime. Le temps est loin où les pontifes du grand art n'avaient que dédain pour Barye . . . et nous voyons aujourd'hui leurs authentiques successeurs descendre parfois des hauteurs académiques pour nous donner, sous un plus petit format et en des matières plus précieuses, des réductions de leurs grandes machines.

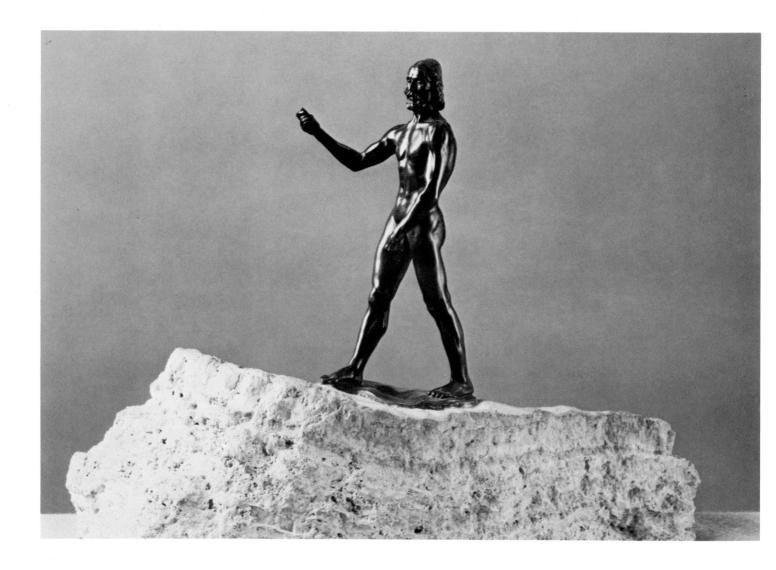

Above and Right: *St. John the Baptist Preaching*. Cat. no. 8.

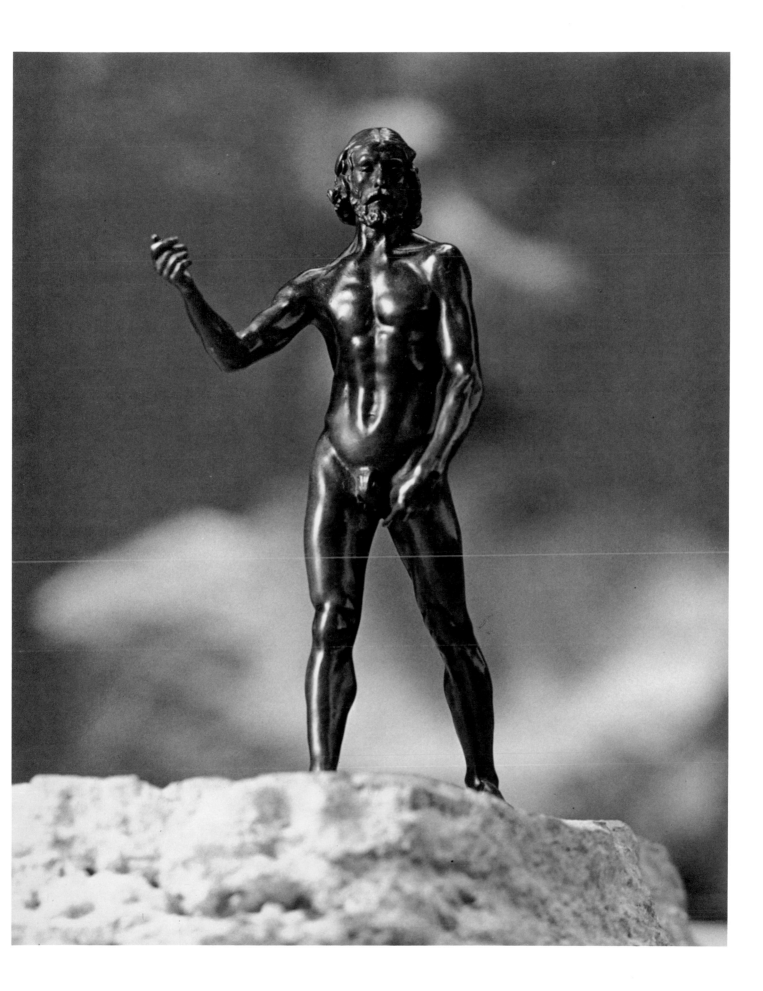

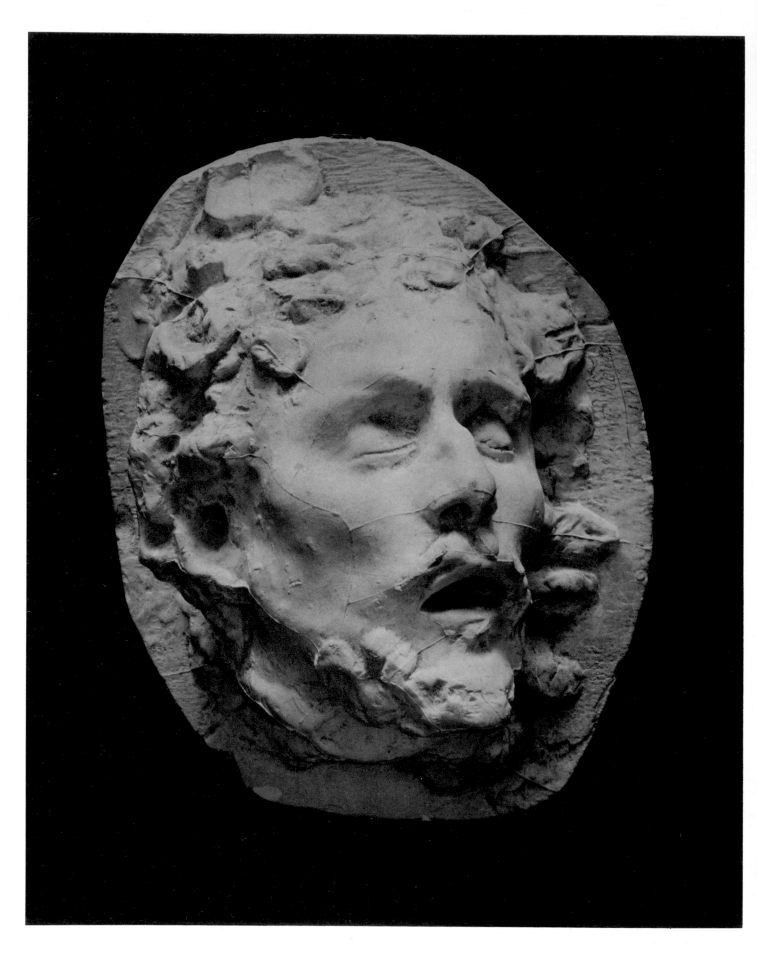

9

Severed Head of St. John the Baptist

(Tête de Saint Jean-Baptiste sur un Plat)

Untinted plaster; traces of piece mold
10 3/8 x 8 1/8 x 6 3/16" (26.3 x 20.6 x 15.7 cm)
Signed: Auguste Rodin / 1916 (in pencil, right side of plaque)
1933.12.6

An exquisite image of suffering, this disembodied head of St. John the Baptist equals the poignancy of late Gothic representations of the crucified Christ. Traces of pain mark the saint's face; the emaciated features bespeak a life of fasting and sacrifice. Rodin exaggerates the hollows and the projections of the face, creating undulating surfaces that seem to waver before us. This increases the illusion of a head which continues to feel pain even after separation from the body.

In his statues of St. John the Baptist (see cat. nos. 7 and 8), Rodin showed the saint as a vital, young preacher, the precursor of Christ. But in this work, in a macabre mood, he creates an evocation of St. John's martyrdom which has the flavor of a devotional image. This episode fascinated the nineteenth-century sensibility with its taste for the morbid.[1] St. John's beheading was an example of what a cruel woman could do to a man, and, as such, was an important element in the many treatments of the story of Salome by writers and artists of that time; outstanding are Flaubert's "Hérodias," published in 1877, and Moreau's series of Salome paintings, exhibited in the 1870s.[2] This theme continued to appeal to Symbolist writers, who were attracted by its cruelty, a prominent aspect of their aesthetic.[3] The popularity of this story probably explains Rodin's decision to depict the head of St. John, but the particular format revives a convention dating back to the Gothic era. Since that time representations in both painting and sculpture of the disembodied head resting on a platter were common in religious art, decorating altars to the saint and honoring him on St. John's day.[4] Rodin's interest in medieval art probably made him familiar with devotional objects, often severed members of saints or reproductions of painful realism. Thus, not surprisingly, Rodin created tiny versions of this work almost like portable relics.

Rodin created two versions of St. John's head, but which was first is uncertain. The Spreckels' plaster, bearing an inscribed date of 1916, is an example of the type which shows the head facing upwards; in the other version, the head lies cheek down. Rodin's biographers unanimously accept 1887 as the initial date for the work, but they leave us in doubt as to whether this applies to both versions or only one. A replica of the upright head appears on *The Gates of Hell*—it is not visible from the ground—but we have no way of knowing when it was attached.[5] Whether this version is the first is uncertain, for it exists in several media and sizes.

Left: *Severed Head of St. John the Baptist.* Cat. no. 9.

The sketchier appearance of these replicas suggests that this type preceded the one with the head turned on its side, but an example of the latter style existed by 1889.[6] This more finished version was made in only one size. Rodin must have been satisfied with both, since he frequently gave replicas of the two conceptions to friends.[7] He even mounted a small cast in a silver necklace for his early biographer, Judith Cladel. Another tiny replica was mounted with three hands and then framed to create a striking montage.[8]

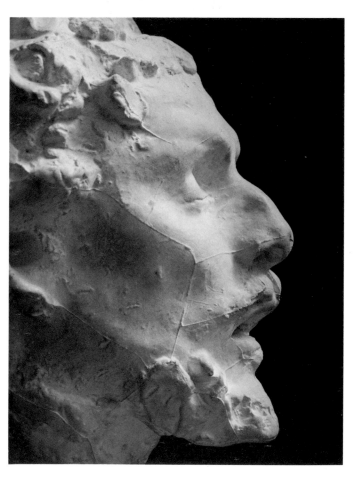

Severed Head of St. John the Baptist. Cat. no. 9, detail.

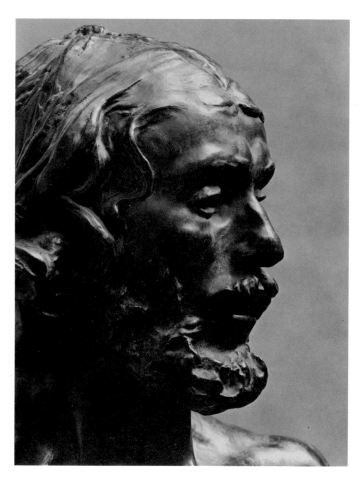

St. John the Baptist Preaching. Cat. no. 7, detail.

Inscription: *Severed Head of St. John the Baptist*, Cat. no. 9.

NOTES

1. Apparently the severed head is either a slightly altered version of the head of Rodin's earlier *St. John*, or it is after the same model. In a letter dated February 22, 1931, from P. A. Laurens, son of Rodin's painter-friend Jean-Paul Laurens, to the Des Moines Art Center, he states that the *Severed Head*—he refers to the one now in the Des Moines collection—is after the model for Rodin's statue. Similar heads are found in the *Poet and Love* (or *Christ in the Garden of Olives*) and the *Christ and the Magdalene* (see cat. no. 11). The Christlike appearance of this head explains the mis-labelling of this piece as *Tête de Christ* in a 1918 exhibition (Grappe, 1944, no. 178).

2. Space does not permit an exhaustive listing of this theme in literature and art. Such writers as Banville, Mallarmé, Laforgue and Oscar Wilde and artists like Puvis de Chavannes, Falguière, Rops and Aubrey Beardsley drew upon the story of Salome and St. John.

3. Moreau's representations of Salome were especially important for Symbolist writers; the impact of Moreau's paintings on Huysmans is well known. For a more lengthy discussion of Moreau's influence, see André Fontainas, *Mes Souvenirs du Symbolisme*, Paris, 1928, p. 96.

4. For more information on this tradition, see Hugo Daffner, *Salome. Ihre Gestalt in Geschichte und Kunst*, Munich, 1912; and Alexandre Masseron, *Saint Jean-Baptiste dans l'art*, n. p., 1957. A mid-nineteenth-century example by sculptor Vicenzo Consani is in the collection of the Palazzo Pitti (*Cultura neoclassica e romantica nella Toscana granducale*, Florence, 1972, p. 147).

5. Ill. Descharnes/Chabrun, p. 85.

6. This version was exhibited in the Monet-Rodin show as "Tête de Saint Jean" (no. 17). It is illustrated, as "Saint Jean-Baptiste" by Gustave Geffroy, "Le Statuaire Rodin," *Les Lettres et les Arts* (September 1, 1889), opposite p. 296.

7. A replica presented to Jean-Paul Laurens is now in the Des Moines Art Center; one given to Cosmo Monkhouse is now in the David Sellin collection and one presented to John W. Simpson is now in the National Gallery, Washington. In addition, Cladel mentions that a plaster cast of this head was presented to her father, Léon Cladel (1950, p. 36).

8. Illustrated in Descharnes/Chabrun, p. 241.

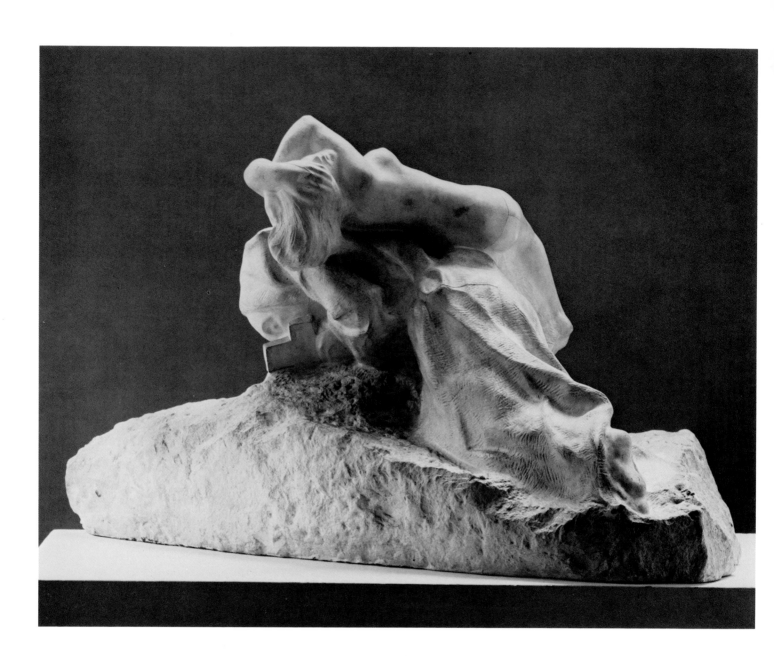

10

The Temptation of St. Anthony
(*La Tentation de Saint-Antoine*)

Grayish-white plaster; traces of piece mold
24 3/8 x 38 1/2 x 29 1/2" (61.9 x 97.8 x 75 cm)
Signed: Rodin (base, beneath saint's left shoulder)
1962.27

In this little-known group, Rodin uses two characters favored by nineteenth-century artists and writers, the temptress and St. Anthony. Contrary to his custom, Rodin identifies the saint by his specific attributes of habit and cross. The voluptuous nude woman stretched across the back of the prostrate monk creates an arrangement not easily read. This kind of acrobatic interaction of two figures placed back to back is typical of many groups by Rodin; it is especially prevalent in *The Gates of Hell*. A remarkable aspect of *The Temptation* is the base, which seems disproportionately large and which suggests a segment of landscape. Many of Rodin's sculptures of the 1880s and 1890s share this unconventional construction.[1]

Rodin's *Temptation* is unusually specific in its allusions to a narrative and probably expresses his interest in Gustave Flaubert's well-known *Temptation of St. Anthony* (1874).[2] In Flaubert's novel, the saint repeatedly throws himself to the ground to resist his temptations, which occur so often in the form of a seductive woman. In this instance, Rodin's depiction of such an episode is far less imaginative than some of those by his contemporaries.[3] Rodin shows the saint passionately kissing the cross, as if transferring his desires to the religious object, and one cannot say whether the expression on his emaciated face is caused by religious or sensual ecstasy. The woman's face shows equal passion, though her voluptuous pose leaves no doubt about its nature. Curiously, though, she does not embrace the hermit but drifts across his body like a manifestation of the monk's lustful thoughts.

The notably smaller scale of the woman in comparison to the man is evidence that Rodin has again combined figures conceived separately to create a new composition. Indeed, the woman derives from *The Gates of Hell*.[4] This origin of the nude gives weight to the 1889 dating for the group proposed by some biographers.[5] From the marble were made two plaster casts, including the one in the Legion of Honor.[6] The marble was certainly executed by 1902, when it or one of the plaster replicas was exhibited in Prague.[7]

The plasters must have been executed before the marble was acquired by the Musée des Beaux-Arts in Lyon in 1903.[8]

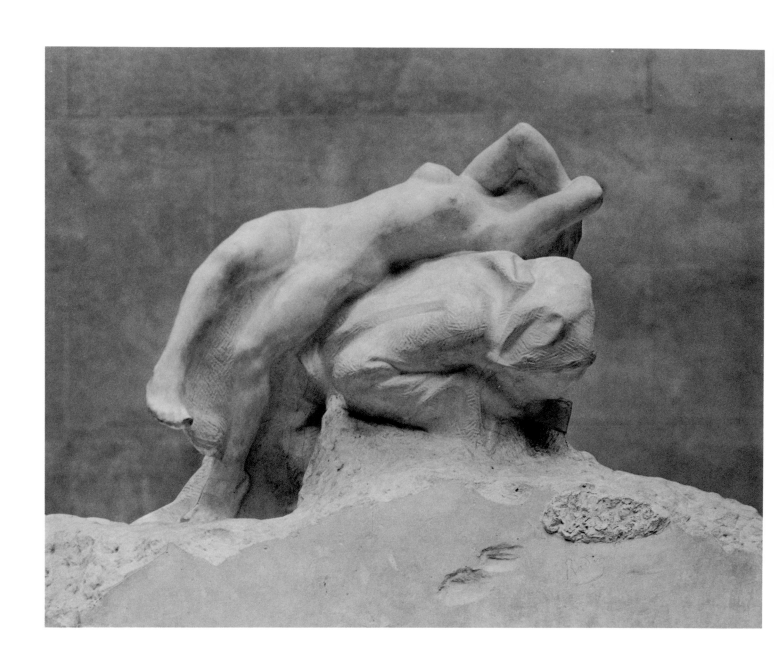

NOTES

1. Among the many examples of such sculptures, we can point to *The Fallen Angel* and the *Christ and the Magdalene* (cat. nos. 4 and 11).

2. In his introduction to the catalogue for the 1889 Rodin–Monet exhibition, Geffroy included Flaubert among Rodin's literary preferences (p. 83).

3. An example is *The Temptation* by Félicien Rops. When exhibited at the *Les Vingt* exhibition of 1884, this work caused a great scandal. An engraving after Rops' painting is reproduced in the special Rops number of *La Plume*, June 15, 1896, p. 418.

4. This figure can be seen in the right wing of the door, near the center and beneath the couple emerging almost at right angles to the background. It is used again in *L'Amour emportant ses voiles*, which Grappe dates ca. 1885 (1944, no. 120).

5. Grappe dates the piece 1889 (1944, no. 232). The group was exhibited at the 1900 Rodin exhibition (no. 110). Unless this piece was a study and not the definitive group, Cladel's dating of the marble to 1902 would be precluded (1908, p. 159).

6. The Spreckels' plaster entered the CPLH in 1924, although it was purchased in 1919. It is mentioned in a letter from Loïe Fuller to Mrs. McGuire, May 9, 1919 (ms. in Lincoln Center Library, New York). The medium from which it was cast is evident in the traces of chisel marks and rough areas of the base and the filled-in sections between the woman's legs and between her left leg and the saint's body.

7. Prague Rodin exhibition catalogue, no. 155. *The Temptation* can be seen in a photograph of the Prague installation; reproduced in Descharnes/Chabrun, p. 193.

8. In addition to the sculptured version of St. Anthony, Rodin executed a drawing, showing a very miniscule saint in the lower right corner, with the much larger nude woman floating above him in the center of the page. Both figures are in positions similar to those found in the sculpture, though whether this drawing is a study for the marble group or simply a later contemplation of the same subject is uncertain. The subject is clearly identified by the inscription in the lower right corner, "tentation/d'Antoine"; illustrated in Coquiot, *Rodin à l'Hôtel de Biron*, opposite p. 78. The 32-x-25-cm drawing appeared in the Zoubaloff sale at the Galerie Georges Petit, June 16 and 17, 1927 (no. 79), but its present location is unknown.

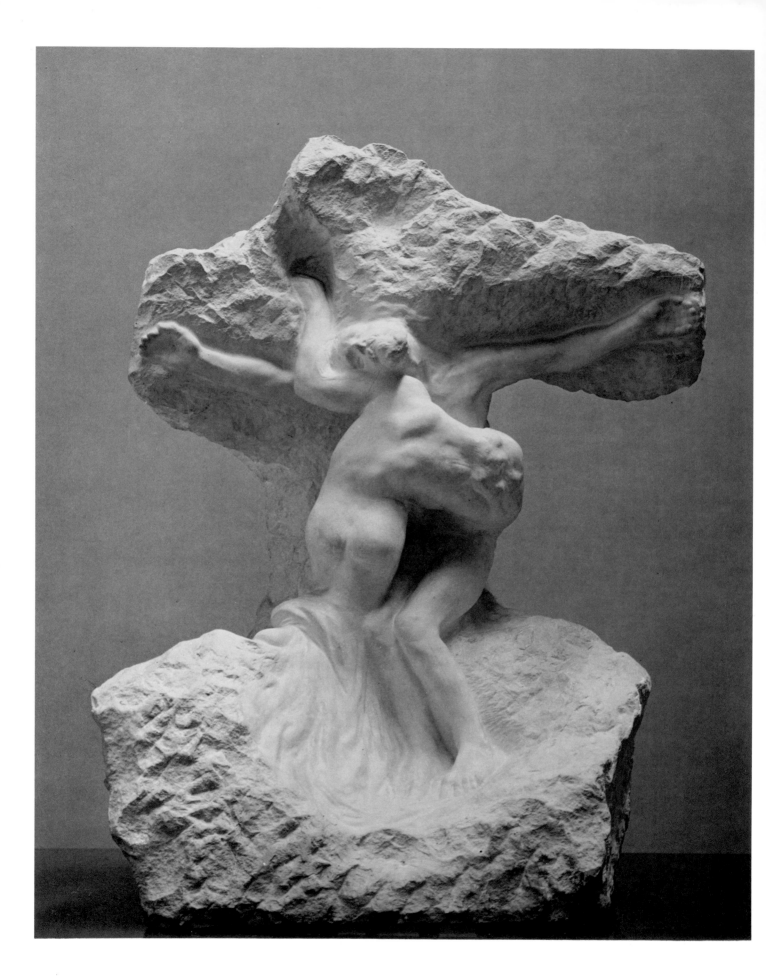

11

Christ and the Magdalene

(Le Christ et la Madeleine)

Untinted plaster
41 x 23 x 27" (104.2 x 58.5 x 68.6 cm)
Inscribed: A. Rodin (base, front beneath Christ's feet)
1949.18

This modern interpretation of the Crucifixion is one of Rodin's few sculptures bearing religious implications, though these works are of the most personal nature. He represents a dead or dying Christ nailed to a rocky cross and mourned by a swooning Magdalene. Pressed closely together, the tortuous figures form a compact and complex group. They sink into a background, both cave and cross, that envelopes them in a world of their own.

Though the group was known by other titles during Rodin's lifetime, it was apparently first called *Christ and the Magdalene*, and artistic prototypes identify the group most closely with this theme. The twisted, meager body of Christ recalls medieval crucifixes. The woman continues the long tradition of voluptuous Magdalenes especially popular in the nineteenth century.[1] The motif of Christ being mourned by the Magdalene is also traditional, but the sensuous juxtaposition of the two naked figures gives it an erotic twist. This strange mixing of sacred and profane is an important theme of nineteenth-century art and literature, but its roots are in the Middle Ages, when spiritual and sexual ecstasy were frequently confused.[2] The relationship between Christ and the Magdalene was one biblical alliance popularly conceived as having quasi-erotic overtones. A remark attributed to the Magdalene in one Italian account comes curiously close to the Rodin sculpture in its erotic and morbid allusions:

> O, most blessed Cross! Would I had been in Thy stead, and that my Lord had been crucified in mine arms, my hands nailed against His, . . . so that I had died with Him, and thus neither in life or death ever departed from Him.[3]

Apart from this almost satanic juxtaposition of sacred and profane, Rodin's *Christ and the Magdalene* must be seen in light of the spiritual revival taking place at the end of the nineteenth century.[4] Mystical and religious experience was increasingly a preoccupation with artists and writers.[5] Among many painters of religious themes were Puvis de Chavannes, Odilon Redon, and Paul Gauguin. This tendency in art culminated with Maurice Denis, who wrote of the new emphasis on Christianity in the 1890s:

> . . . we are all preoccupied with God. Today, Christ is living. It is the favorable time. There has not been for a long time a more passionate epoch than ours for religious Beauty, and if it has come as a fashion, of which one complains, it is that something true is manifested also.[6]

Left: *Christ and the Magdalene.* Cat. no. 11.

93

Denis put his finger on a common aim of radical and conservative artists alike. The need to give a new, personal relevance to Christianity was the subject of paintings by artists as dissimilar as Gauguin and his circle, Ensor, the Rosicrucians, Maurice Denis and the conventional painters who followed the lead of Lhermitte and Fritz von Uhde.[7]

Rodin's close relationship to these developments is evident in the personal significances of the *Christ and the Magdalene*. The self-concept of the late-nineteenth-century artist naturally included an identification with Christ. Gauguin, for one, had repeatedly painted himself as Christ.[8] Rodin's intentional use of Christ as a type for the man of genius in this group is elucidated by alternative titles for the work, *Prometheus and an Oceanid* and *Prometheus Bound*.[9] Throughout the century Prometheus, who was frequently identified with artists, was also associated with Christ.[10] Both were superior men who suffered for mankind. The artist and poet frequently saw themselves in this light, and on more than one occasion Rodin compared himself with the Greek hero and a sympathetic woman with the Oceanid, who consoled Prometheus in Aeschylus' play.[11] The identification of the crucified man is made even more obvious by a third title for the work, *Genius and Pity*, and by a fragment of a poem from Laurent Tailhade's *Le Jardin des Rêves* appended to a reproduction of the group in 1907:

> For one evening he bent towards you his head
> For when his great soul was ready to take flight
> You received at his feet his immortal farewell.[12]

Seen in this context, then, the *Christ and the Magdalene* seems to be one more of Rodin's speculations on the nature of genius and the role of the artist (cf. cat. nos. 2 and 6). If the work can be associated in the most general sense with the suffering man of genius and his consoling muse or lover, the associations with Christ and Prometheus suggest subtle shades of meaning that enrich the essential idea.

When this group was created has not been firmly established, but most date it 1894. Some evidence suggests that the two figures derive from earlier works. According to one biographer, the figure of Christ existed in the 1880s.[13] The pose of the woman, for which Camille Claudel is said to have modelled, clearly derives from earlier figures; her swaying posture is used in several sculptures, probably for the first time in the tympanum of *The Gates of Hell*.[14] Despite their origin as individual figures, the plaster sketch of the group at the Musée Rodin, Meudon, indicates that they were reworked and conceived as part of a whole. The woman's position has been altered to accord with the male figure so that no trace of assemblage is evident.

The plaster sketch of this group is the basis for the two marble versions, which are expectedly more refined in details but similar in general conception. The plaster casts in the Legion of Honor and in the Maryhill Museum of Fine Arts in Maryhill, Washington, were cast from the marble today in the Thyssen Bornemisza collection, Villa Favorita, Castagnola.[15] The second marble, offered for sale at Sotheby's on April 29, 1964, is identical to the Thyssen marble except for its more massive background.

Mrs. Spreckels purchased the *Christ and the Magdalene* in 1919.[16] It entered the Legion of Honor in 1924.

Right: *Christ and the Magdalene*. Cat. no. 11.

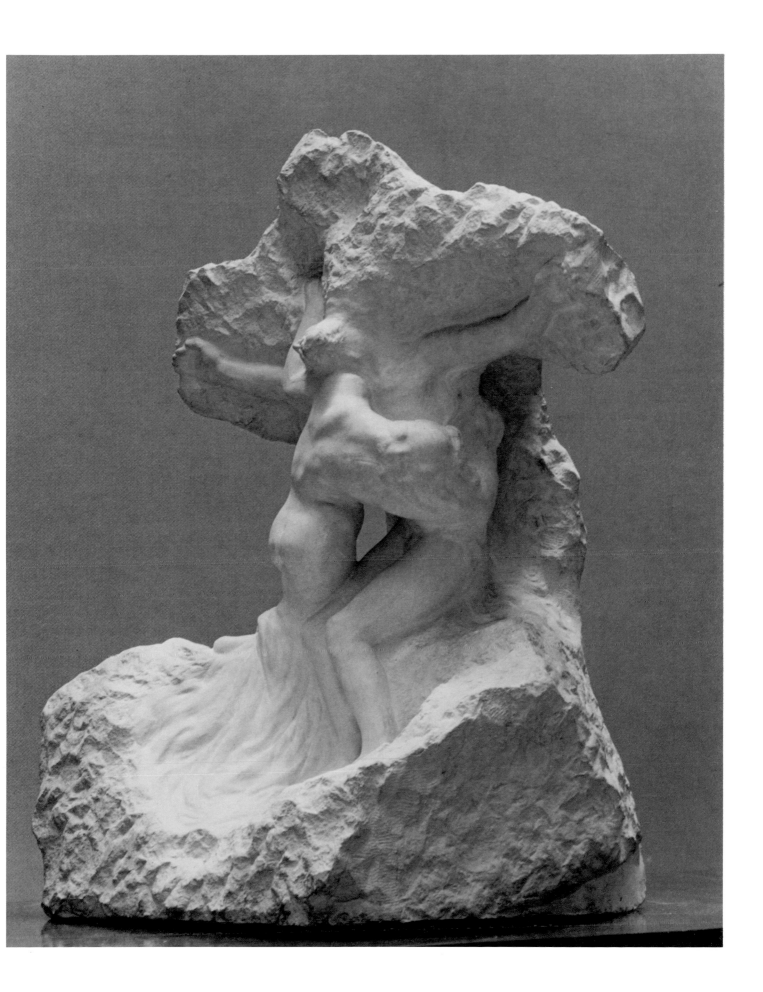

1. One outstanding and influential example of this type of Magdalene is the famous statute by Canova (1796). A similar quasi-erotic Magdalene is found in Balzac's *La Torpille* (1838), where the repentant prostitute, Esther, is strongly associated with the saint (*Splendeurs et Misères des Courtisanes* in *Oeuvres complètes de H. de Balzac*, Paris, 1900, vol. 14, pp. 47-51).

2. Religion and eroticism frequently intermix in the work of Félicien Rops. For example, in his frontispiece for *L'Amante du Christ* by Rodolphe Darzens, a voluptuous Magdalene mourns at the feet of a bleeding Christ. A famous example of this phenomenon in nineteenth-century literature is Flaubert's *Madame Bovary*, a work publicly reproached in its trial for obscenity in 1857 for mixing the religious and the sensual. In the writer's defense at that legal proceeding, examples of earlier religious writings, including the ecstatic account of Saint Teresa, were cited. On the medieval and Renaissance erotic associations of the Magdalene, see Leo Steinberg, "The Metaphors of Love and Birth in Michelangelo's *Pietàs*," in *Studies in Erotic Art*, New York and London, 1970, pp. 247-48, 277-80.

3. Quoted in Leo Steinberg, "Michelangelo's Florentine Pictà: the Missing Leg," *Art Bulletin*, 50:4 (December, 1968), p. 345.

4. Many have seen this religious revival as a reaction to scientism and positivism that had dominated intellectual thinking for years and have linked it closely with the Symbolist movement.

5. Huysmans was the most influential of the neo-Catholic writers, but Paul Verlaine and Paul Bourget cannot be ignored.

6. ". . . nous sommes tous préoccupés de Dieu. Aujourd'hui, le Christ est vivant. C'est le temps favorable. Il n'y eut pas depuis longtemps d'époque plus passionnée que la nôtre pour la Beauté religieuse, et s'il en est venu comme une mode, dont on se plaint, c'est que quelque chose de vrai se manifeste ainsi" ("Notes sur la Peinture Religieuse," *L'Art et la Vie*, October, 1896; republished in *Théories*, Paris, 1920, p. 31).

7. The attempt by writers as well as artists to contemporize biblical situations was distinctly described in 1901 by Louis Dumur in a review of Saint-Georges de Bouhelier's *Tragédie du nouveau Christ*:

> Some eight or ten years ago, several young writers competed for a title and an idea. The title was: *A Prophet*, the idea was to bring Christ back to earth, in the midst of contemporary society. It was in the air, apparently, since for several months, the gossip columns of the *Mercure* resounded with claims of authors all sick with the same child. Each edition brought a new one. There were, in the works, a half-dozen novels and as many dramatic poems. Painting had taken the lead. It was the time of Uhde, when L'Hermitte and others were winning resounding success with modern Christs, in the midst of workers, of school children, etc. (Il y a quelque huit ou dix ans, plusieurs jeunes écrivains se disputèrent un titre et une

idée. Le titre était: *Un Prophète*, l'idée était de faire revenir le Christ sur la terre, au milieu de la société contemporaine. C'était dans l'air, il faut croire, car, plusieurs mois durant, les échos du *Mercure* retentirent de réclamations d'auteurs tous en mal du même enfant. Chaque numéro en apportait un nouveau. Il y avait, en espérance, une demi-douzaine de romans et autant de poèmes dramatiques. La peinture, elle, avait pris de l'avance. C'était l'époque où Uhde, L'Hermitte et d'autres remportaient de retentissants succès avec des Christ modernes, au milieu d'ouvriers, d'enfants dans une école, etc. . . .; "Revue du mois: Théâtre, *Mercure de France*, 38:136 [April, 1901] p. 198).

Though critical, Gustave Geffroy acknowledged the importance of "la formule néo-chrétienne" in painting at the Salon of 1892 ("Le Christ au Salon," *La Vie Artistique*, II, pp. 300-305). In the same Salon, the reviewer Claude Phillips noted "a regular epidemic of religious subjects painted from Uhde's standpoint, but with an artifice and a manifest desire to astonish which place them outside the category of serious effort" ("The Summer Exhibitions at Home and Abroad," III, *Art Journal*, n.s., v. 44 [1892], p. 244). On Uhde see Hans Rosenhagen, *Uhde, des Meisters Gemälde*, Stuttgart & Leipzig, 1908.

8. Gaugin's self-portraits as Christ are too numerous to list, but one well-known example is *Christ on Mount Olive* (1889). Rodin also depicted this subject and revealed its significance in the various titles for the group: *Le Poète et l'Amour*, *Le Jardin des Oliviers de l'Homme de génie*, *Christ au Jardin des Oliviers* and *Le Héros* (Grappe, 1944, no. 281). On one occasion Rodin grouped Christ with men of genius, including Orpheus, and spoke of his poetic nature (Cladel, 1903, pp. 100-101). The similar conceptions of Rodin and Gauguin raise the question of their relationship, which has never been clarified. We know that from 1890 both Gauguin and Rodin were among those who attended the literary gatherings held on Mondays at the Café Voltaire (Jean de Rotonchamp, *Paul Gauguin*, Weimar/Paris, 1906, pp. 70-71). According to Rotonchamp, Rodin would have attended Gauguin's "Saturdays" in 1889-1891 (p. 81). They had many friends in common, including Charles Morice and Fritz Thaulow, who was married to the painter's sister-in-law. The Morice article on Rodin in 1917 hints at a misunderstanding between the two artists: ". . . he [Rodin] knew well that at the same time that I defended him, I also defended Gauguin Suffice it that the name of Gauguin was not pronounced before me by Rodin, nor Rodin's by Gauguin" (". . . il savait bien que, dans la même heure où je le défendais, je défendais aussi Gauguin Et il suffisait que le nom de Gauguin ne fut pas prononcé, devant moi, par Rodin, ni celui de Rodin par Gauguin"); "Rodin," *Mercure de France*, 124:468 (Dec. 16, 1917), p. 578. Helene von Nostitz mentions seeing pictures by Gauguin at Meudon in 1900 (*Dialogues with Rodin*, New York, 1931, p. 26).

Marcelle Tirel also says that Rodin had owned a Gauguin, but when she looked for it at the Hôtel Biron, she could not find it (*The Last Years of Rodin*, New York, 1925, p. 82). So far as we know, no trace of these paintings remains today in the Musée Rodin.

9. Grappe, 1944, no. 273; Lawton, p. 268. Rodin seems to have been fascinated by Prometheus, as many in the nineteenth century had been. Besides spoken references to this hero, his name appears on certain drawings—for example, on plates no. 45 and 47 in *Les Dessins de Auguste Rodin*, Paris, Goupil, 1897. We do not know whether this fascination was inspired by Aeschylus' *Prometheus Bound*, although we do know that Rodin was reading the works of that author by the 1880s (Bartlett, p. 285).

10. Raymond Trousson, *Le Thème de Prométhée dans la littérature européenne*, Geneva, 1964, I, pp. 74–75 and II, pp. 297, 351–64, 422–25.

11. In 1900 Rodin remarked: "I would like to know how many years remain for me to admire Nature, now that I know I love it . . . I am like a Prometheus unbound, I speak with the Oceanid" ("Je voudrais savoir combien d'années il me reste pour admirer la Nature, maintenant que je sais l'aimer . . . Je suis comme un Prométhée déchaîné, je cause avec l'Océanide"); Cladel, 1903, p. 106. About the same time, Rodin said to Cladel and her companion, Claire, who had been patiently waiting for him one day in his studio: " . . . you are the Oceanids who bring consolation and charm to Prometheus" (" . . . vous êtes les Océanides qui apportez la consolation et la grâce à Prométhée"); *ibid.*, pp. 26 and 106.

12. "Car il avait un soir vers toi penché la tête/Car lorsqu'à s'envoler sa grande âme fut prête/Tu reçus à ses pieds son immortel adieu"; *L'Art et les artistes*, IV (February, 1907), 404. Tailhade was well known for his liturgical imagery, which made his verse a logical choice to append to Rodin's sculpture.

13. Cladel, 1950, pp. 145–46.

14. Frisch/Shipley, p. 429. A somewhat altered and independent figure, this woman is known as *Méditation* or *La Voix intérieure* (Grappe, 1944, nos. 127 and 128).

15. For further discussion of the differences between the plaster sketch and the Thyssen marble, see Athena Tacha Spear, *Allen Memorial Art Museum Bulletin*, 22:1 (Fall, 1964), p. 33. A photograph of what appears to be the Thyssen marble in an unfinished state appears in *World's Work*, 1904, p. 6827. Markings on this marble indicate how the drapery over the Magdalene's legs was to be carved.

16. The purchase is mentioned in a letter from Loïe Fuller to Mrs. McGuire, May 9, 1919 (ms. in Lincoln Center Library, New York).

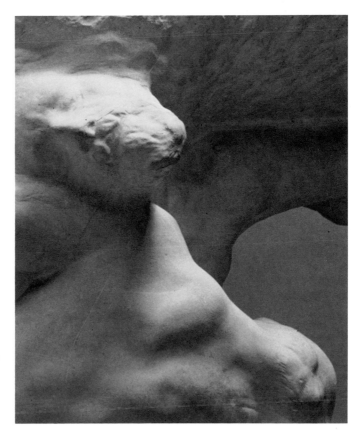

Christ and the Magdalene.
Cat. no. 11, detail.

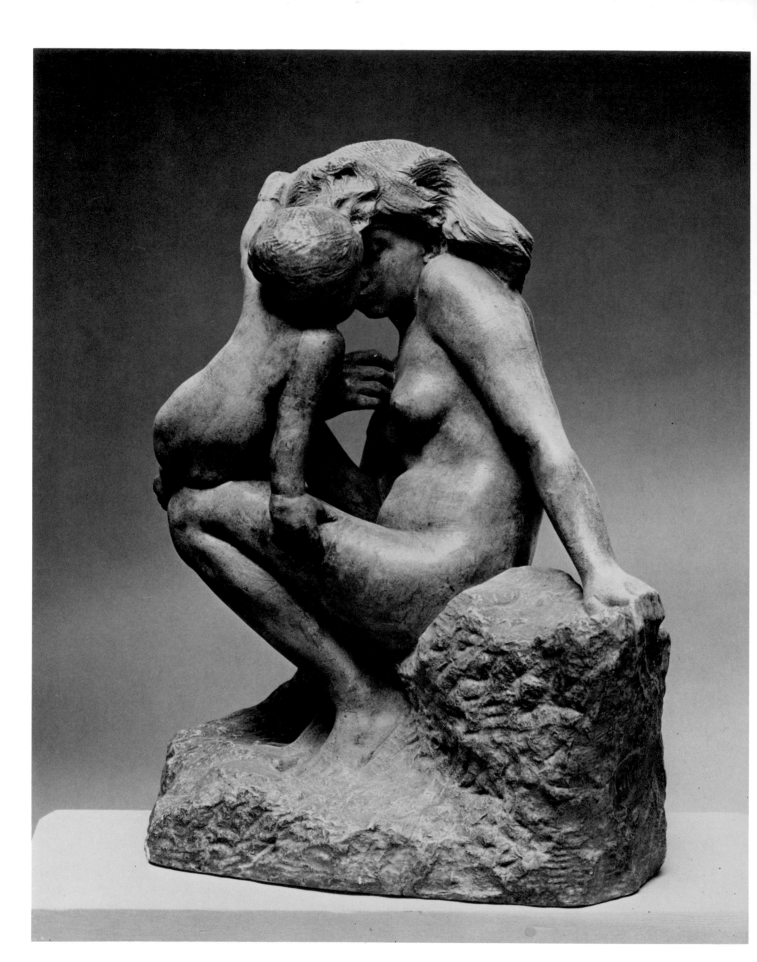

12

Mother and Child
(*La Jeune Mère*)

Plaster, tinted light brown
15 3/8 x 14 5/8 x 9 5/16″ (39 x 37.1 x 23.6 cm)
Signed: A. Rodin (base, right)
 Modele/[sic] pour le Bronze (bottom in blue pencil)
1947.17

This group, composed of a young woman with a baby balanced on her knees, is one of the few depictions of the theme of mother and child in Rodin's art.[1] He places the figures in close juxtaposition so that their curvaceous forms flow together and cause the viewer's eye to circulate continuously from woman to child. On the right side, the parallel diagonals of the woman's left arm and leg enliven the group, preventing it from becoming too static or too confined. The compact arrangement of these two tender figures creates a unity more symbolic than psychological; the woman withdraws into herself, unaware of the infant who affectionately strokes her hair and kisses her cheek. Instead of returning his caresses, she draws her right hand to her own breast and steadies herself with her left arm. Her expressionless face reveals no trace of emotion, as if she were lost in a deep trance, severed completely from her surroundings.

If we interpret this group as a mother and child, the woman's apparent lack of concern for the baby is puzzling. Artistic depictions of maternity and of the related theme of charity throughout the nineteenth century usually portray a close union of mother and child; this union is clearly exemplified in the sculpture of Carpeaux, where this subject occurs frequently. Rodin, however, departs from this tradition and introduces new psychological subtleties and nuances. A clue to Rodin's intended meaning is found in the original title, *Woman and Love*.[2] This label could indicate that Rodin meant the baby to be seen as an allegorical figure, like a putto or cupid. As a symbol of love, the child seems to act out the amorous thoughts in the woman's mind. The use of the putto as an emblem of love links this work with traditional representations of Venus and Amor, a theme from Rodin's early work.[3] The woman, however, is no goddess but a contemporary model, and even the child is more like a real baby than a putto. By combining the real and the allegorical—in itself no new invention—Rodin creates a new poetic statement that transcends both the triviality of contemporary portrayals of mothers with children and the trite theme of Venus and Cupid.

The *Mother and Child* group, which existed in 1885,[4] is one of four variations on this motif, perhaps indicating Rodin's interest in a very marketable subject at that time.

Left: *Mother and Child*. Cat. no. 12.

Numerous casts of the *Mother and Child* exist in bronze, but the Legion of Honor replica seems to be a unique plaster. A pencilled inscription on the bottom indicates that the plaster served as a model for the bronzes. A variation known as *Young Mother in the Grotto* is approximately the same as the *Mother and Child* except for the addition of a background, which changes the group into a high relief, with minor variations in the woman and the altered position of the baby.[5] In *Love that Passes* the woman is the same as in the *Mother and Child*, but the putto that flies by with his back to her is different.[6] In *Love*, it is absolutely clear that the baby is a symbol of love, rather than a real child, and the piece seems to be a comment on the inconstancy of love. An apparently unique example of a fourth version, called the *Young Mother* or *Love the Conqueror*, is located in the National Galleries of Scotland, Edinburgh.[7] In that version the position of the woman is much altered and a different child is used; the mother grasps the baby's leg and kisses the infant. The effect is more intimate and less symbolic than in the *Mother and Child*.

The plaster cast of the *Mother and Child* in the Legion of Honor was given by Mrs. Spreckels in 1947, but was on loan by 1937.[8]

NOTES

1. Though no major sculpture depicting mother and child is found in Rodin's work, the theme appeared sporadically until the early twentieth century. In his early sculptures, we find examples of this subject handled in the manner of Carrier-Belleuse; for instance, his *Jeune femme et enfant* (Grappe, 1944, no. 12; 1865-1870) and *Tendresse Maternelle* (Grappe, 1944, no. 24; 1873). Occasional mothers and children appear in his Sèvres vases (probably representing Venus and Amor) and in *The Gates of Hell*, where we find, for example, a group similar to the *Mother and Child* at the base of the left pilaster (see cat. no. 29). After creating the *Mother and Child* and its variants, as well as the *Brother and Sister*, Rodin apparently dropped the theme for independent groups until receiving a commission for a tomb sculpture in 1908 from Mrs. Thomas Merrill, who lost a young daughter.

2. Grappe, 1944, no. 130. This group has also been called *Young Mother* (*La Jeune Mère*), *Maternity* (*Maternité*) and *Woman and Child* (*La Femme et l'enfant*).

3. See, for instance, *Vénus et l'Amour* (Grappe, 1944, no. 25, ca. 1873) and the related work called *La Source* (Grappe, 1944, no. 26, 1873). Another work sometimes known as *Vénus et l'Amour* (also called *Iris éveillant une nymphe*) was created around the time of the *Mother and Child* (Grappe, 1944, no. 145), though in it an older child replaces the putto.

4. Early Rodin biographers date this piece 1891; however Grappe has pointed out that in 1885 Rodin offered it for a lottery organized by the committee planning to erect a statue to Claude Lorrain (1944, no. 130).

5. Grappe dates this work 1885 (1944, no. 132). It was reproduced in *L'Art Français*, I:41 (Feb. 1, 1888) [p. 3]. The catalogue for the 1900 Rodin exhibition refers to this piece as *La Jeune Mère* (no. 92). In 1901 a replica was exhibited at the International Exhibition in Glasgow as *Maternal Love*. Cladel labelled a reproduction of it *Frère et Soeur* in her 1908 biography (opposite p. 24).

6. Grappe dates this work 1885 (1944, no. 131). Coquiot calls a reproduction of this group "Maternité" (*Rodin à l'Hôtel de Biron*, unnumbered plate in appendix). The bronze cast of this version in the Walker Art Gallery in Liverpool, where it is known as *Nymph and Child*, was purchased by James Smith from Alex Reid in 1899, giving an outside date for the bronze casts (letter to authors from Edward Morris, Keeper of Foreign Art, Walker Art Gallery, September 22, 1970).

7. This marble is recorded as having been purchased from Rodin's studio before 1906 by Mrs. Craig Sellar, who lent it to the R.S.A., 1908 (no. 307); letter to authors from David Baxandall, Director of the National Galleries of Scotland, November 30, 1970.

8. CPLH archives. In an album in the CPLH library with photographs of most of the donations of 1933, the reproduction of *Mother and Child* is labelled "Amour fugitif." It appears as "Group: Fleeting Love" on the list of gifts for December 19, 1933. The use of this unusual title has caused some confusion of the museum records over the years.

Inscription: *Mother and Child*. Cat. no. 12.

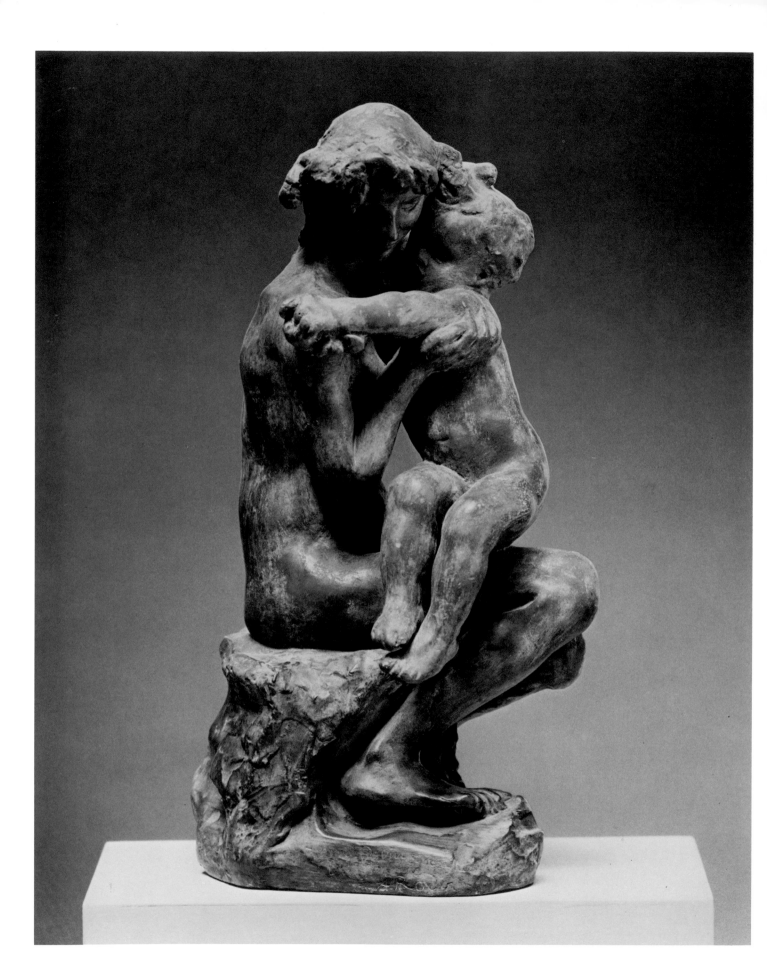

13

Brother and Sister
(*Le Frère et la Soeur*)

Plaster, tinted brown
15 1/4 x 7 5/16 x 8 9/16" (38.7 x 18.6 x 21.7 cm)
Inscribed: Hommage de Vive Sympathie / A. Rodin (left side)
1924.18.2

In this fine plaster cast, Rodin expands the theme of mother and child (see cat. no. 12) to include the love of an older sister for her infant brother.[1] The plump, squirming baby who sits on his sister's leg typifies Rodin's depiction of infants since the 1860s, but the elongated proportions of the adolescent girl are not characteristic of the type of model he usually preferred. Rodin's schematic treatment and the emphasis on angles in this figure lend a primitive flavor, a quality advocated by Gauguin and his circle in the 1880s and 1890s as by Picasso around the turn of the century. Unlike these younger artists, however, Rodin is faithful to the unusual proportions of his model and uses them in achieving the mood he sought, instead of distorting the model's body to fit a preconceived pattern. The rigid position of the girl and her self-involvement create a sense of timeless tranquility, while her active brother seeks to attract her attention. She muses quietly perhaps on her own emerging womanhood and on her future role as a mother. Despite the psychological barriers separating the two figures, this tender group conveys intimacy and charm, without the sentimentality of many contemporaneous treatments of the theme of adult and child.

The *Brother and Sister* is usually dated around 1890, which would accord with stylistic evidence.[2] The girl is a variant of the marble called *Galatea* (or *Youth*) and of the headless study of this same woman seated; the *Galatea* was completed by 1888.[3] The sister differs from the isolated figures primarily in her attenuated proportions and in the placing of her right hand, which has been moved from her shoulder to accommodate the child.

Rodin made only one bronze version of the *Brother and Sister* and more than twenty casts exist. A marble replica was completed in 1905;[4] it differs little from the bronze version. The Spreckels' cast, acquired in August, 1915, from Loïe Fuller, is a rare example in plaster.[5]

Inscription: *Brother and Sister*. Cat. no. 13.

NOTES

1. This group should not be confused with the sculpture sometimes called *Little Brother and Sister*, which is comprised of two infants (Grappe, 1944, no. 71). This title is used for the bronze in the Art Institute of Chicago. Grappe dates it 1881. Rodin treated the theme of the infant brother and adult sister in a group dating from 1865-1870 (Grappe, 1944, no. 12). A strange account of this group is given by Frisch; he says that he was told by Rodin that the group "sprang of his desire to set into marble his memory of his beloved sister" (Frisch/Shipley, p. 411). Rodin's older sister, Maria, who died in 1862, was only two years older than Rodin, so the assertion by Frisch seems unlikely. In fact, this group is obviously related to Rodin's depictions of mother and child.

2. The *Brother and Sister* is dated 1890 by Maillard, p. 155; Mauclair, p. 125. Frisch/Shipley, p. 411; and Grappe, 1944, no. 254. René Chéruy dates it 1891 (Cladel, 1908, p. 158). It was included in the 1900 Rodin exhibition (no. 29), and a photograph of the group appeared in the special Rodin issue of *La Plume* in the same year (p. 23).

3. The *Galatea* is reproduced in *L'Art Français*, Feb. 4, 1888. The marble is illustrated again in *Les Lettres et les Arts* (September 1, 1889, p. 304).

4. Cladel, 1908, p. 160.

5. A copy of the contract between Mrs. Spreckels and Loïe Fuller was owned by Miss Jean Scott Frickelton, Palo Alto. Lami (p. 171) mentions a plaster cast of this group in the Musée Rodin, but none of the catalogues for this museum mentions it.

14

Faun and Nymph
(*Faune et Nymphe*)

Bronze, black patina with traces of green and blue
12 7/8 x 8 1/2 x 11 11/16″ (32.7 x 21.6 x 29.7 cm)
Inscribed: A. Rodin. (base, right side)
Stamped: A. Rodin (inside rear), and: ALEXIS RUDIER / Fondeur PARIS (left side)
1942.42

This leering faun accosting a reluctant nymph seems to come out of the erotic and idyllic world of Ovid and Clodion, a world increasingly popular throughout the nineteenth century in French art and poetry. Rodin delighted in the mythological creatures of antiquity and frequently introduced them into his sculptures (see cat. nos. 2, 16, 17, 26, 27). In *Faun and Nymph* he draws on the long artistic tradition of the faun, a creature half-goat, half-man associated with woodland deities. Rodin accentuated the colorful contrast of the hairy faun and the sleek, voluptuous woman. If the subject is close to the mythological groups of the eighteenth-century sculptor, Clodion, clearly Rodin's compositional techniques and mood are entirely different. The sinuous, nervous forms of Rodin's group are unlike the full, rounded figures characteristic of Clodion. Furthermore, Rodin introduces a deliberate clumsiness—note particularly the awkward angle of the woman's right foot—which is a denial of the harmonious poses expected in traditional art but adds a new human note. Rodin has exchanged the light-hearted play of Clodion's personages for greater tension and drama.

The preference of Clodion and other eighteenth-century artists for erotic, mythological subjects continued throughout the nineteenth century; the themes were prevalent in the work of Rodin's employer, Carrier-Belleuse, and elsewhere. The theme of the faun attacking a nymph dates from Hellenistic times and was frequently used in subsequent periods.[1] Rodin's group reflects his reading of Ovid's *Metamorphoses*, from which he frequently borrowed characters during the 1880s and early 1890s.[2] The *Faun and Nymph*, usually dated around 1886,[3] reflects the mood of eroticism in Ovid's stories rather than any specific narrative. Indeed, Rodin seems to have been unconcerned with a single reading of this work, which stresses the more sensual nature of man in earlier times.[4] Rather Rodin used various titles to evoke a mythological eroticism and the contrast between beast and beauty. His indifference to the exact interpretation of the group is expressed in a conversation with Paul Gsell, regarding Gsell's confusion about this strange flexibility in titles:

> To sum it up . . . you must not attribute too much importance to the themes that you interpret. Without doubt, they have their value and help to charm the public; but the principal care of the artist should be to form living muscles. The rest matters little.[5]

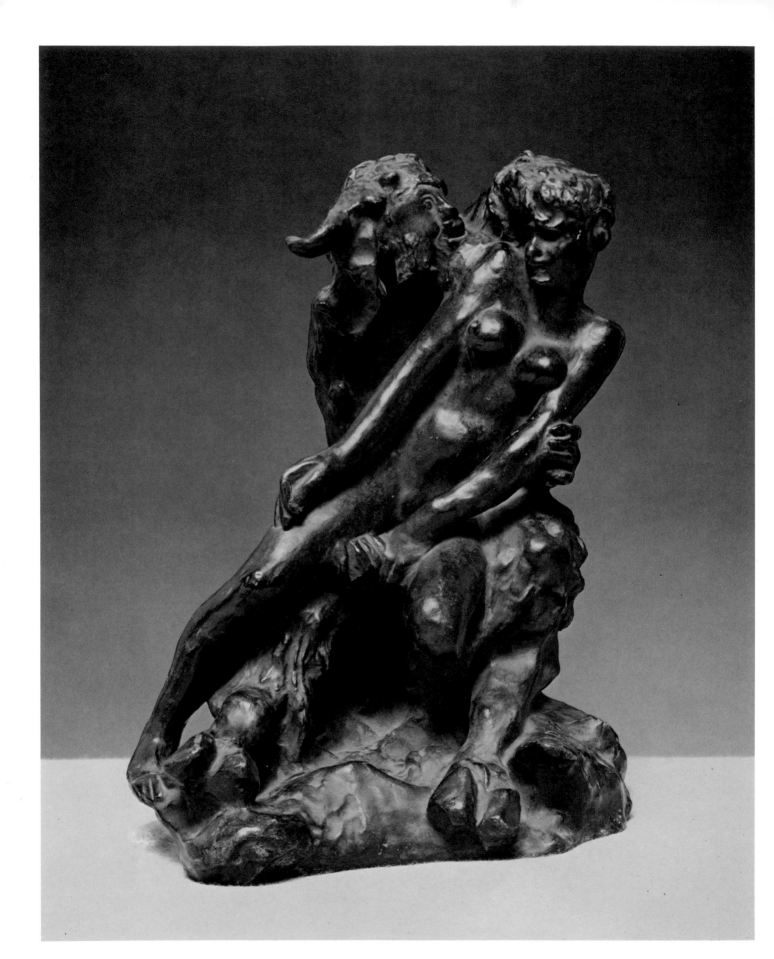

Rodin's own lascivious instincts have been perhaps too frequently pointed out, but nonetheless the personal significance of the group should not be overlooked.[6] Rodin was often seen as a satyr or faun by his contemporaries; a cartoon of 1913 shows him with goatish head and legs.[7] One biographer suggests that Rodin personally enacted the incident portrayed in the *Faun and Nymph* with a "beautiful society girl" as his model, who could not imagine what it was like to be assaulted by a faun:

> From my height I heard a scream. Looking down, I saw Rodin, one arm around her, one between her legs, lift the struggling girl and set her on the couch. He released her, and she half rose, as though to flee. "That's it!" he exclaimed. "That's the expression! Now you know how it feels."[8]

The lustful Rodin could not but identify with his confrere, the faun, whom he described as misunderstood to Judith Cladel and her companion, Claire, in the 1903 biography:

(*Rodin*) Fauns are despised personages in the life of today. For women even, they represent evil.
(*Claire*) In appearance perhaps, but at heart they think the opposite.
(*Rodin*) It is true. Besides, their force, the force of love, is what has created all, the arts, religions. It is the pivot of the world[9]

The Spreckels' cast of the *Faun and Nymph* was loaned to the Legion of Honor in 1933 by Mrs. Spreckels, who had formerly kept it in her home. The exact date of purchase is unknown. The piece is one of several examples in this size (ca. 34 cm high) in bronze and in plaster. Replicas were owned by several contemporary writers who appreciated the erotic: Edmond de Goncourt, Octave Mirbeau and Catulle Mendès.[10] In addition a larger version (ca. 51 cm high) was executed in marble, probably around the turn of the century.[11]

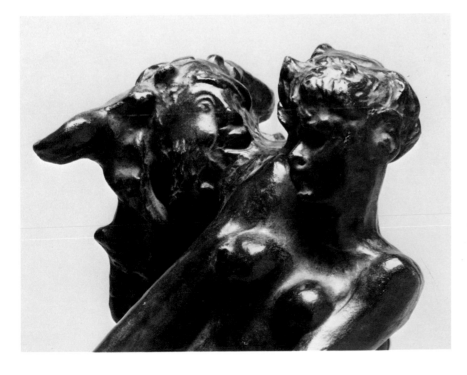

Faun and Nymph.
Cat. no. 14, detail.

Left: *Faun and Nymph*. Cat. no. 14.

1. In the nineteenth century, we find sculptures of this subject by Pradier (*Satyre lutinant une bacchante*, marble, Salon of 1834), Gustave Crauk (*Bacchante et satyre*, marble, Salon of 1859) and Clésinger, *Faune et Faunesse* (Hôtel Drouot sale, 1870), and others.

2. Rodin's interest in Ovid is discussed by Georges Grappe, "Ovide et Rodin," *L'Amour de l'Art*, XVII:6 (June, 1936), pp. 203-208. He tells us that Rodin owned a copy of the Panckoucke edition of the complete works of Ovid, now in the Musée Rodin, which shows frequent use (p. 206). Another indication of the sculptor's interest in the Latin author is his illustrations for Ovid's *Les Elégies Amoureuses*, translated into French by Abbé Bazzin (Paris, Editions Gonin, n.d.). On the last page of this edition, Grappe dates these drawings around 1900. The drawings, all of women, stress the sensual elements of Ovid.

3. Grappe says that the work had been purchased by 1886 (1944, no. 160). In 1889 it was described by Gustave Geffroy in his introduction to the catalogue of the Monet-Rodin exhibition, though it is uncertain whether it was exhibited at this time (p. 66).

4. Rodin might have been referring to the idea of the loss of virginity in his preferred title, *Le Minotaure*. This title appears in the 1900 catalogue (no. 32) and in Maillard's monograph of 1899 (pp. 33, 157). In the catalogue of the Antony Roux sale, it is called *Nymphe et Faune* (Galerie Georges Petit, May 19 and 20, 1914, no. 140). The catalogue for the Octave Mirbeau sale lists the work as *Le Faune* (Galerie Durand-Ruel, February 24, 1919, no. 76). Other titles for the group are *Jupiter taureau* and *Le Faune et la Femme* (cited in Grappe, 1944, no. 160).

5. *On Art and Artists*, p. 176.

6. The dancer, Isadora Duncan, describes Rodin's attempt to seduce her (*My Life*, New York, 1927, p. 91). A similar account is given by another dancer, Ruth St. Denis (*An Unfinished Life*, New York and London, 1939, p. 86). Another very strange story is told by René Gimpel: "Aubry [George Aubry, an art dealer] related that the sensuality of the sculptor was so lively that while speaking, he kneaded in his hands breasts and phalluses, which he crushed" ("Aubry raconte que la sensualité du sculpteur était si vive qu'en parlant il pétrissait dans sa main des seins et des phallus qu'il écrasait"); *Journal d'un collectionneur marchand de Tableaux*, Paris, 1963, p. 396.

7. Goncourt records Mirbeau's comment on Rodin in his *Journal*, writing that ". . . he is capable of anything, of a crime for a woman, he is the brute satyr that he puts in his erotic groups. And Mirbeau told me that at a dinner at Monet's, who has four very beautiful daughters, he spent dinner by looking at them, but looking at them in such a way that one by one, each of the four girls was obliged to rise and leave the table" (". . . il est capable de tout, d'un crime pour une femme, il est le satyre brute qu'il met dans ses groupes érotiques. Et Mirbeau me raconte qu'à un dîner chez Monet, qui a quatre grandes belles filles, il passa le dîner à les regarder, mais à les regarder de telle façon que, tour à tour, chacune des quatre filles fut obligée de se lever et de sortir de table"), entry for July 3, 1889, XVI, p. 102. Georges Rouault titles his discussion of Rodin "Le Grand Pan," a reference to the lascivious master of the faun and the satyr; "Trois artistes . . . Le Grand Pan (Rodin)," *Mercure de France*, 83 (November 16, 1910), pp. 658-59. A cartoon by Sem showing Rodin as a faun is illustrated by Descharnes/Chabrun, p. 216.

8. Frisch/Shipley, p. 354.

9. Cladel, 1903, p. 97.

10. The replica belonging to Goncourt was shown at the 1900 Rodin exhibition (no. 32). According to Lawton (p. 34), Goncourt attached great value to his first proof, which was later purchased by Count Robert de Montesquiou. The present location of this cast is unknown. The plaster cast formerly owned by Octave Mirbeau is likewise unlocated. The Mendès plaster is now in the Museo Nacional de Bellas Artes, Buenos Aires. Another cast may have been in the collection of Stéphane Mallarmé (C. Mauclair, *Servitude et Grandeur Littéraires*, Paris, 1922, p. 29). The Roux sale catalogue credits Mallarmé's poem, "L'Après-midi d'un faune" (1876, 1877) with inspiring Rodin's group (*op. cit.*). A bronze work entitled *L'Après-midi d'un Faune* appears in the catalogue of the 1902 Prague Rodin exhibition (no. 14), but it is impossible to identify it on the basis of the title alone.

11. The marble now in the Museum Folkwang in Essen was acquired from the Folkwang Museum at Hagen in 1906-1907 (letter to authors from Dr. F. Mellinghoff of the Museum Folkwang, Essen, March 2, 1971).

15
Embracing Figures, Damned Group

Plaster, tinted flesh color
10 x 19 5/8 x 12″ (25.4 x 49.8 x 30.5 cm)
No inscription
1933.12.4

Rodin was greatly fascinated by lesbian love and frequently represented it in his sculptures and drawings. In *Embracing Figures, Damned Group*[1] the relationship is more explicit than in the *Bacchantes Embracing*; the passionate coupling of the entwined bodies far surpasses the almost innocent kiss of the other group. Unlike the two Bacchantes, these figures show the spontaneous union of real lovers, their fluent, natural movements anticipating Rodin's later drawings of embracing women.

Despite the similarity between this group and drawings executed around the turn of the century, the *Embracing Figures* probably dates from the 1880s and may be a study for *The Gates of Hell*.[2] Both subject and style correspond to other works of that decade.[3]

Though Rodin's studies of lesbians are usually associated with the poetry of Baudelaire, this theme was widespread in the literature and art of nineteenth-century France.[4] Modelled after the ancient Greek poet, Sappho, and modern women like Mme de Staël and George Sand, the lesbian became an increasingly familiar character as the century progressed; she was the subject not only of artistic, but also scientific study.[5] Rodin's representations of female relationships come when this interest was at its height, when lesbian love was made a public spectacle in popular plays.[6] His interest in sapphism should not be seen in isolation, but as part of a general interest in things erotic, which Rodin shared with his contemporaries.[7]

The Spreckels' cast of the *Embracing Figures* is perhaps a unique plaster.[8] Only one bronze cast has been located.

NOTES

1. The work is called *L'Etreinte* (*The Embrace*) in the Sotheby sale of July 3, 1968 (no. 52.

2. The Sotheby catalogue dates the *Embracing Figures* ca. 1880-1885, and describes it as a possible study for *The Gates of Hell*, though no evidence is given.

3. We find similar horizontal arrangements of figures in the 1880s, for example, *Daphnis and Lycenion*, the *Metamorphoses of Ovid*, *Fugit Amor* (see cat. no. 25) and *Paolo and Francesca*. The upper figure of the *Embracing Figures* is particularly close to the heavy figure of *Earth*. We can compare specifically the sketchy treatment of the heads and the sagging necks.

Grappe informs us that according to a practitioner *Earth* was finished by 1884 (1944, no. 105).

4. Though only three poems in Baudelaire's *Les Fleurs du Mal* deal specifically with lesbianism, the work is strongly associated with this theme. That Baudelaire first planned to call this work *Les Lesbiennes* is well known. After its publication he was persecuted for dealing with "morally offensive" subjects; two of the poems treating lesbianism were condemned. Significantly, Rodin illustrated for Paul Gallimard one of Baudelaire's three sapphic poems ("Femmes Damnées") with an embracing couple not

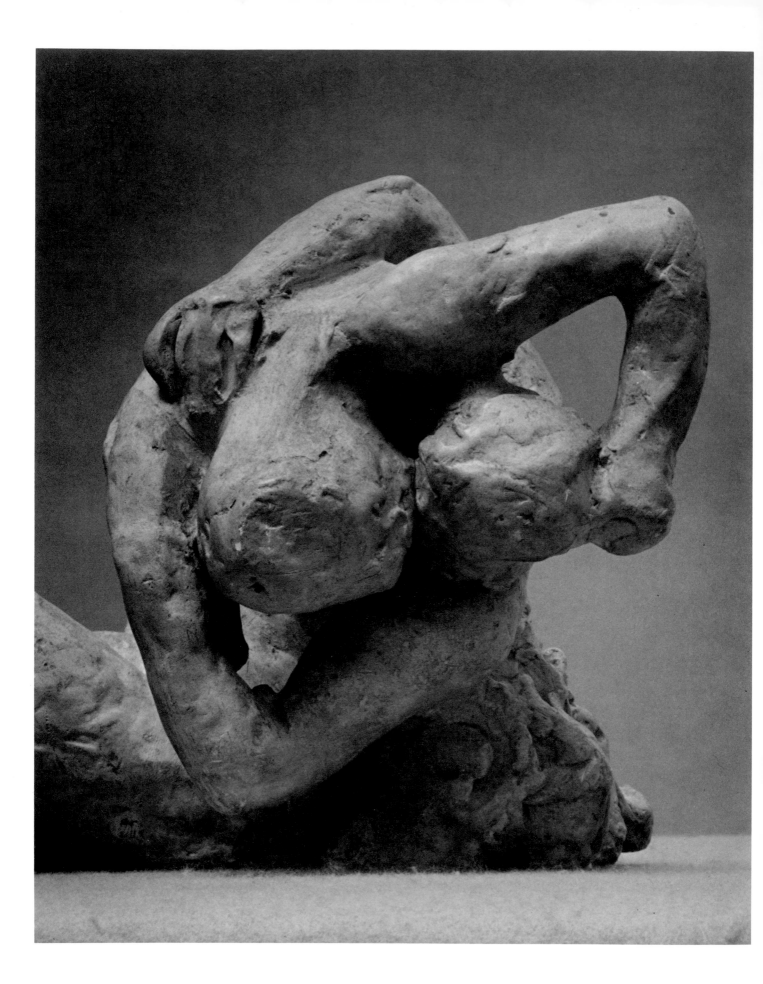

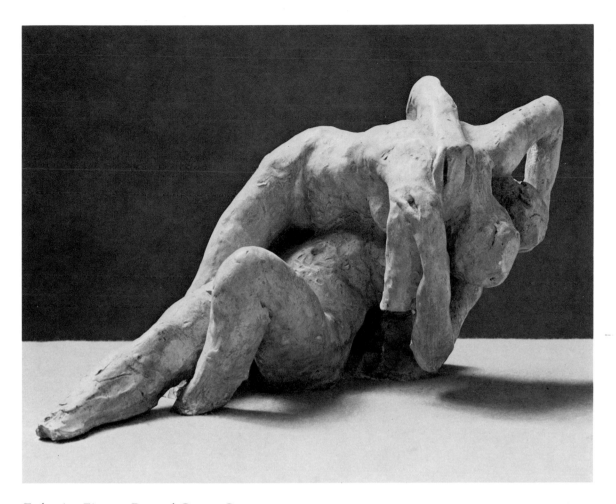

Embracing Figures, Damned Group. Cat. no. 15.

unlike the *Embracing Figures*. Despite these Baudelairean associations, we must not forget those well-known literary treatments of lesbian love earlier in the century by Gautier (*Mademoiselle de Maupin*) and Balzac (*La fille aux yeux d'or*). Until the last years of the nineteenth century, we find fewer examples of lesbianism in art than in literature, though the theme existed in the paintings of Courbet and in small erotic sculptures popular at the time. An allusion to this subject is evident in the many sculptures of Sappho created in the mid-nineteenth century by Clésinger, Duret, Feuchère, Marochetti, Rude and Triqueti, among others less well known.

5. Late nineteenth-century erotic art is replete with illustrations of lesbian love, and this theme is amply prolific in literature. Krafft-Ebing was among the first, and certainly the most widely read in the late nineteenth century, to treat homosexuality seriously. For a discussion of scientific studies of homosexuality in the nineteenth century, see Arno Karlen, *Sexuality and Homosexuality, a New View*, New York, 1971, pp. 181-96.

6. In 1908 a lawsuit was brought against those involved in the pantomime *Griserie d'Ether*, which included a partially nude scene of lesbian love (Patrick Waldberg, *Eros in la Belle Epoque*, New York, 1969).

7. On the general interest in eroticism of the period, see Waldberg, *op. cit.*

8. The original titles used for the group in this collection were *L'Enlacement* and *Group: Embracing*.

Left: *Embracing Figures, Damned Group*. Cat. no. 15, detail.

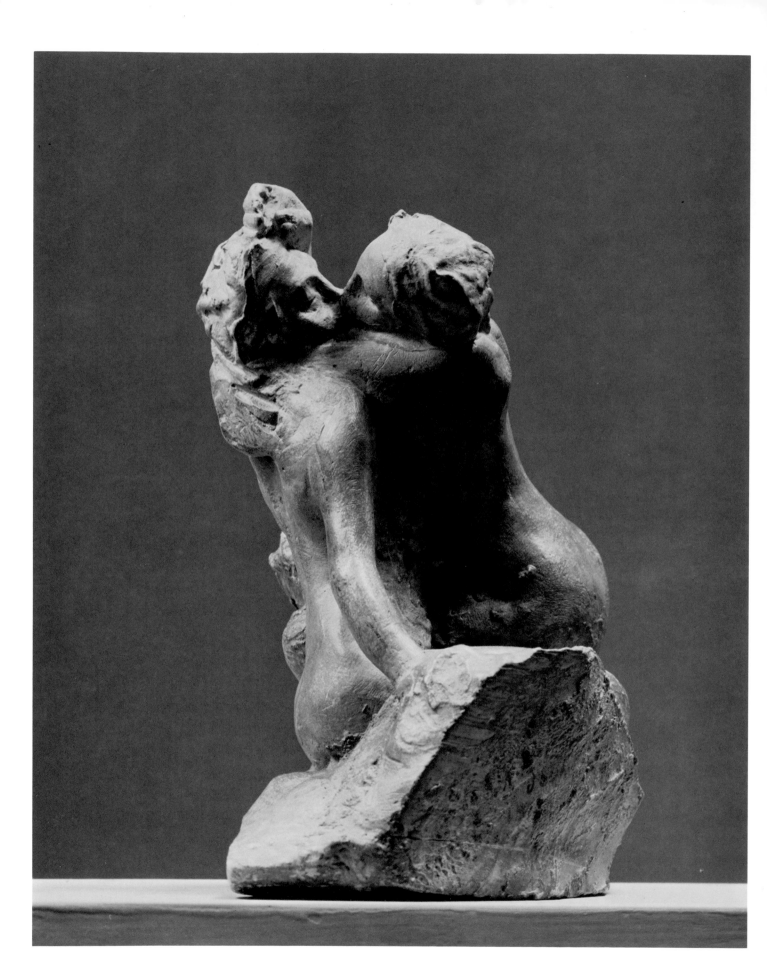

16
Bacchantes Embracing

Plaster, tinted beige; faint traces of piece mold; holes for keying mold on bottom
6 1/4 x 3 1/4 x 5 7/8″ (15.9 x 8.3 x 14.9 cm)
Signed: deux/. . . . [illegible] (in pencil on base)
1933.12.18

Bacchantes Embracing[1] provides another example of Rodin's fascination with all aspects of the embrace, including the amorous pairing of two women. In this group we see one woman delighting in the attentions of another, without returning her partner's affection. To some extent this unreciprocal situation results from Rodin's favored method of composing by joining figures in an acceptable arrangement after modelling them separately, a method which also explains the floating position of the embracing figure. Since this plaster is a sketch for the more finished versions, Rodin has not even disguised the unworked areas of clay linking the two figures. Later these two figures will be joined by a third to become the group called *The Oceanides*.[2]

Along with a series of groups on the same theme,[3] the *Bacchantes Embracing* is usually dated around 1910. A photograph of Rodin's studio at Meudon published in 1905 which shows this work among other sculptures proves this dating incorrect.[4] Indeed, comparing these curvaceous figures with certain sculptures of the 1880s suggests a date considerably earlier than any accepted previously.[5]

The very few known replicas of this group exist in two sizes: a ca.-18-cm version and a ca.-40-cm version. The Legion of Honor cast appears to be a unique plaster.

NOTES

1. In his 1909 monograph, Gustave Kahn calls this sculpture *La Nature* (*Auguste Rodin*, London/Leipzig, p. 43). Grappe adds another alternative title, *Deux Soeurs* (1944, no. 408). In the O. Mirbeau sale this piece was called *Jeux de Nymphes* (Galerie Durand-Ruel, February 24, 1919, no. 75). The CPLH archives show the first titles used for this group in this collection were *Les Damnées* and *Group: Damned*.

2. Grappe, 1944, nos. 409 and 410.

3. Grappe, 1944, no. 408; Frisch/Shipley, p. 439.

4. A plaster or marble version is reproduced in this illustration in Mauclair, 1905, opposite p. 108. A finished version is reproduced in bronze by O. Grautoff, *Auguste Rodin*, Bielefeld/Leipzig, 1908, p. 54.

5. Similar figures appear in *Sirens* (Grappe, 1944,

no. 186, dated before 1888) and in a less-known group called *Adolescence*, which is reproduced by Cladel, 1917, p. 102. According to Frisch/Shipley, the latter group dates from 1889; Frisch adds that the models for it were two inseparable lesbian dancers from the Paris Opera recommended to Rodin by Degas. Frisch also says that this couple posed for *Ovid's Metamorphoses, Cupid and Psyche* and *Daphnis and Lycenion* (pp. 420 and 425). Grappe dates these three groups before 1886 (1944, nos. 151, 155 and 156). Perhaps the same two models posed for the *Bacchantes Embracing*, a work which belongs stylistically to these embracing couples from the 1880s. The kneeling figure with one arm raised over her head and the other at her side is close to the type represented by the *Toilette de Vénus*, which Grappe also dates before 1886 (1944, no. 159).

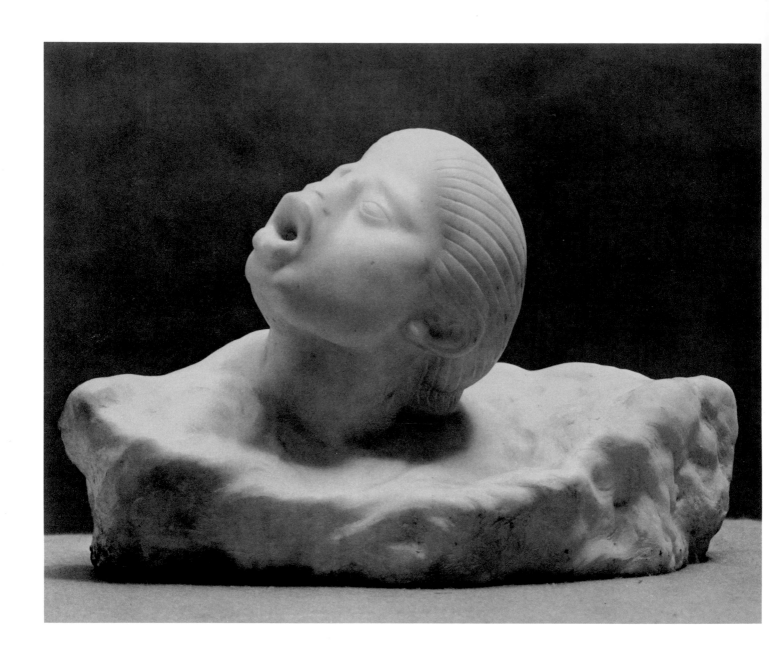

17

The Siren of the Sea

(Femme-poisson)

White marble; some plaster adhering to bottom and sides
10 13/16 x 11 1/2 x 18 5/16″ (27.5 x 29.2 x 46.5 cm)
Inscribed: A. Rodin (base, left side)
1941.34.16

The Siren of the Sea is another study of the pathos of the soul, still an important theme in Rodin's sculpture in the early years of the twentieth century when this work was created.[1] The extreme simplification of the finely worked marble is characteristic of many works from this period. The eyes, nose and mouth melting together give the features a veiled appearance. Even the hair is strikingly minimized; it is suggested by a few parallel incisions. The features suggest a being midway between woman and fish; this metamorphosis is emphasized by the most common title for the work, *Femme-Poisson (Woman-Fish)*. The mouth opens with a fishlike protrusion of the lips, and the eyes bulge, while the unfishlike nose is minimized. This physiognomical study of a siren or a mermaid is new and original with Rodin. The piscine character of such creatures was usually suggested by a fishlike tail, but Rodin improvises by redirecting this quality to the mouth, so that the essence of woman and fish are condensed in the head alone.

This head may have been created to serve as a fountain,[2] but this function need not preclude the spiritual intentions of the work. It is first of all a study in psychological mood, continuing the dolorous temper of *The Gates of Hell*, where parts of bodies frequently emerge from the background. In his meditation on Dante at the time Rodin undertook that work, he was perhaps struck by the recurrent motif of emerging heads in *The Inferno*.[3] Is *The Siren* striving upward to release herself from an inescapable bond or is she "coming up for air," seeking momentary relief from another, unendurable world? The nightmarish quality of the face recalls Rodin's world of fantasy where heads float disembodied. The head of *The Siren* emerging from the water indicates transition from one state to another; this placement also suggests upward striving, another frequent theme in Rodin's work and a symbol of the desire for spiritual flight. As is commonly the case, no single explanation takes precedence.

The Siren of the Sea in the Legion of Honor was part of Mrs. Spreckels' initial purchase of Rodin's sculpture; she acquired it from Rodin through Loïe Fuller. The work was exhibited in the 1915 Panama Pacific Exposition in San Francisco before Mrs. Spreckels took it to her home where it was displayed until she loaned it to the museum in 1924.[4] This piece is one of three known replicas in marble and plaster; apparently this sculpture was never cast in bronze. A terracotta study for the work shows a torso whose facial features are quite similar.[5] The contorted torso makes the anguished state more apparent than it is in the head alone.

NOTES

1. Grappe dates this work 1906 (1944, no. 359).

2. Grappe thinks that this sculpture was made to serve as a fountain ornament and that water would spout from the lips (*ibid.*).

3. See Cantos X, XVIII and XXXII. The latter canto is particularly important; in it, the head of Ugolino, a character who greatly attracted Rodin, appears gnawing on the skull of Archbishop Ruggieri. Both emerge along with other heads from a sheet of ice.

4. Occasionally the Spreckels' marble has been erroneously referred to as a small figure, as in the 1915 Panama Pacific Exposition catalogue (Fine Arts. *French Section. Catalogue*, no. 96). This error has led to some confusion about the exact date of its acquisition.

However, the contract between Loïe Fuller and Rodin, which describes it as a "petite tête," clears up any confusion. This "petite tête en marbre" is also mentioned in a letter to M. Guioché, Rodin's caster, dated "Rome 31 Dec. 1914" and signed "Aug. Rodin." In this letter Guioché is asked to make an *estampage* (impression) of *The Siren* and informed that Loïe Fuller will pick up the marble. In another undated letter to Guioché, signed "Auguste Rodin," the caster is informed that the marble siren will leave in about ten days with Loïe Fuller for America. Both letters were formerly in the Ernst Durig collection and are now in the Musée Rodin, Paris.

5. Marcel Aubert and Roger Gobert, *Rodin inconnu*, Paris, 1950, unnumbered plate.

18

The Wounded Lion
(*Lion Blessé*)

Bronze, black patina with some green; cast with a bronze base
11 1/16 x 9 5/8 x 11 1/8" (28.1 x 24.5 x 33.3 cm)
Signed: A. Rodin (base, top left)
Stamped: Rudier. Fondeur. Paris (base, right rear)
Inscribed: 21 MAI 1881/GARDE BIEN (base, top front)
1942.40

The Wounded Lion[1] is one of the few animal sculptures found in Rodin's work and, though it is without flaw and ably modelled, is less inventive than his figures.[2] The work was reportedly commissioned to adorn a tomb; the ribbon lying on the base bears the device, "Garde Bien," of a titled family.[3] The commission may have required a lion as part of the heraldic symbolism of the family of the deceased or as a traditional funerary attribute; as an emblem of vigilance, lions had long guarded tombs, monuments and public buildings.[4] In the nineteenth century, animal sculpture was raised to an important genre, and lions appear repeatedly, particularly in the work of Antoine-Louis Barye.

Though *The Wounded Lion* was compared to Barye's sculpture by one of Rodin's contemporaries, this comparison was probably just a means of adulation.[5] The generalized musculature and abbreviated treatment of Rodin's lion has little in common with Barye's scientific and highly finished renderings. Through the entire body, Barye expressed emotions proper to animals, whereas Rodin's lion shows an anthropomorphic emphasis on the face and gestures of the forepaws, which convey a mood of anger or agony or both.

Rodin, though out of his realm when he turned from the human figure, must have been satisfied with this rare evocation of feline anatomy: he sent it several times to exhibitions of animal sculpture, where he competed with specialists,[6] and he displayed a replica in the Grand Atelier at the Hôtel Biron.[7]

The Spreckels' cast of *The Wounded Lion* entered the museum in 1924; nothing is known of its previous history. This cast bears the full inscription pertaining to the person for whom the monument was intended, while some of the various bronze and plaster casts bear only part of the words and date.[8]

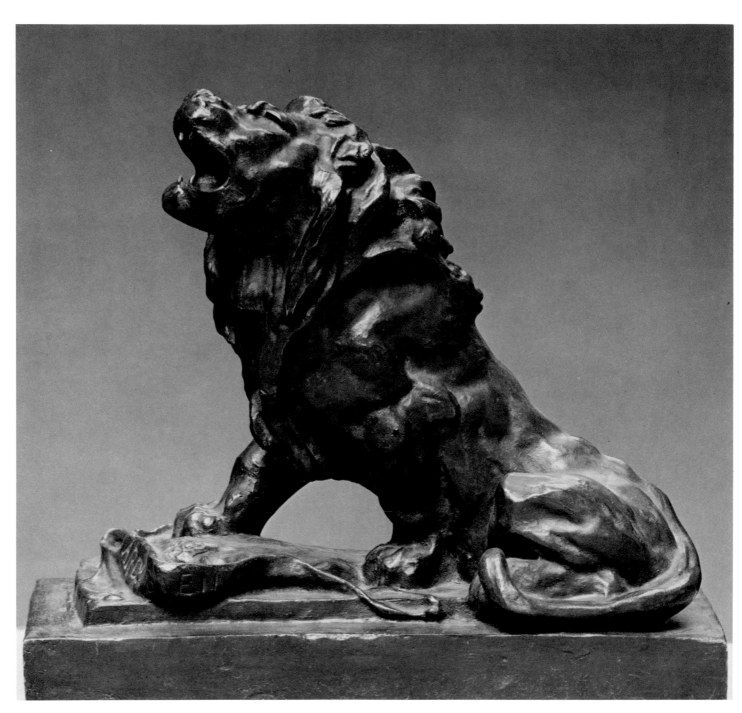

The Wounded Lion. Cat. no. 18.

1. The piece is also called *Le Lion qui pleure* and *Lion rugissant* (Grappe, 1944, no. 62).

2. Though Rodin is known to have studied animal anatomy at the Museum of Natural History in the Jardin des Plantes under Barye, probably in the late 1850s or early 1860s, the nature of his relationship with Barye and the impact of his studies has not been determined. Certain early drawings evidence Rodin's youthful interest in animals. Numerous sketches of various kinds of animals are found in a sketchbook now in the collection of Mrs. Jefferson Dickson, Beverly Hills, California. These sketches are discussed in J. de Caso's "Rodin's Mastbaum Album," *Master Drawings*, 10:2 (Summer, 1972), pp. 155-61. Cf. illustrations in Descharnes/Chabrun, pp. 24 and 25.

3. Grappe says "l'oeuvre orne le tombeau d'une famille illustre" (1944, no. 62). According to Bénédite, the lion was placed above the arms and device of the Montgomery family, to which Mme Edmond Turquet belonged (*Rodin*, 1927, p. 17). If he is correct in implying that the lion commemorated the death of Turquet's first wife, the date inscribed on the sculpture (May 21, 1881) is inaccurate since she died on May 23, 1881 (see obituary in "Echos de Paris," *Le Figaro*, May 24, 1881, p. 1).

4. For a discussion of the tradition of the lion in funerary contexts, see Henriette Eugenie S'Jacob, *Idealism and Realism: a Study of Sepulchral Symbolism*, Leiden, 1954, p. 22. As a memorial sculpture, a famous example was created just prior to the commission of *The Wounded Lion*. The model for Bartholdi's *Lion de Belfort*, a symbol of the city and a memorial to those who died defending it in 1870, was exhibited in the Salon of 1878.

5. G. Kahn, "Art," *Mercure de France*, 102:379 (April 1, 1913), p. 635.

6. Grappe, 1944, no. 62. In 1913 it was sent to the first *Salon des Artistes animaliers* (Kahn, *loc. cit.*).

7. This replica is seen in a photograph reproduced in Coquiot, *Rodin à l' Hôtel de Biron*, opposite p. 32.

8. Frisch/Shipley tell of Rodin's discovery of a spurious bronze and marble of this piece, both then in a German museum, and how the counterfeits were eventually traced to his own plaster casters [the Montagutelli brothers] (pp. 389-90). The present location of these replicas is unknown.

Inscription. *The Wounded Lion*. Cat. no. 18.

THE GATES OF HELL

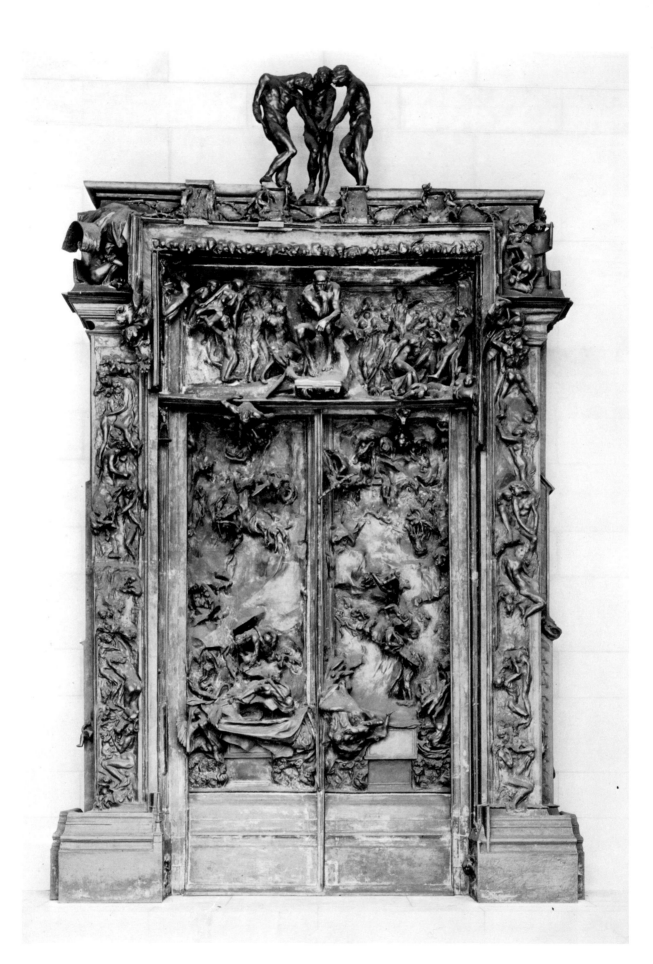

Introduction

When in 1880 Rodin was asked to create a door (inspired unexpectedly by Dante's *Divine Comedy*) for the planned and long-awaited Museum of Decorative Arts, he little suspected that this work was not only to become a lifelong project but that it would never be cast or installed during his lifetime. Yet this project, which began with a frenzy of activity, soon became little more than a pretext for endless artistic experimentation. *The Gates of Hell* should not be construed simply as a folly; from it, Rodin extracted many figures and groups which were subsequently cast and carved as separate sculptures. These pieces constitute a great proportion of Rodin's work and include many of his most famous sculptures, such as *The Thinker, The Kiss* and *The Prodigal Son*. Such derivatives of *The Gates* comprise a significant part of the California Palace of the Legion of Honor Rodin collection.

In creating *The Gates of Hell*, Rodin became for the first time not only a sculptor but an architect. His first architectural venture is at once conventional and unorthodox. The format of the door as we see it today generally follows traditional French patterns, with elements inherited from Gothic and Renaissance periods. The scheme of cornice and pilasters framing a central tympanum and double door conform to standard contemporary formulae. However, the architectural portions are disconcerting in their lack of consistency. Moldings terminate abruptly or are overlapped by sculptures so that the organizational and containing functions of the frame are disturbed. This lack of regularity is also seen in the use of differing elements on opposite sides of the door; for example, the capitals of either pilaster differ, and the fluted side of the right pilaster is not repeated on the left. Elements from architecture of various periods are combined in a haphazard and unorthodox way to further complicate this framework—more a sculptural than an architectural conception.

The sculpture also contributes to the nonarchitectonic and dynamic qualities of *The Gates*. Rodin has not attached the figures so that they echo the rectilinear boundaries of the door but rather applies them in seemingly random fashion; thus they appear to defy those boundaries. The figures nearly burst the architectural frame, as if their pulsating energy is almost too much to be contained. The swirling and writhing masses of figures, not subject to the laws of gravity, create an immediate impression of chaos and disorder.

Left: *The Gates of Hell*, bronze, 250¾" high. Philadelphia Museum of Art. 123

Though he was criticized for the lack of a clear, orderly composition,[1] Rodin was not the first to prefer a more dynamic and less contrived effect. Many parallels, for example, can be drawn between Rodin's composition and typical renderings of Dante's *Inferno* and of the Last Judgment, particularly the famous fresco by Michelangelo.[2] We find similar masses of figures in expressive poses in the paintings of Rubens and Delacroix. Rodin may have been familiar with Gustave Doré's monumental bronze vase, *The Vintage* (1877-78), where we find figures similarly disposed to create a tumultuous effect.[3]

If Rodin's more conservative contemporaries found the lack of a clear compositional pattern disturbing, they must have been equally appalled at the illegibility of the mass of figures. The great number of figures and heads—more than 150—and the huge dimensions of the door (7.5 x 3.96 m) render impossible the deciphering of the figures from the ground. Furthermore, the unexpected poses of the tangled figures sometimes make difficult the isolation of individuals. Even more unorthodox is Rodin's inclusion of partial figures, as bodies emerge and submerge from the undefined but turbulent background. How Rodin rejected accepted notions of a decorated door is seen not only by the architectural inconsistencies and the compositional arrangement but also in his daring conception of "relief" sculpture that proceeds from very low relief to figures in the round, from miniscule to large forms, all with shocking rapidity. No longer do the degree of relief and size define an intelligible space. Rather they suggest distance in a world without normal dimensions, a world outside of space and time as we know them.

Even before receiving the governmental commission for *The Gates of Hell* in August of 1880, Rodin had set to work making drawings and terracotta sketches for the door. Compared with the version we know today, these sketches reveal a dramatic shift in conception. The first studies indicate a predilection for an architectonic composition, gradually loosening until Rodin arrived at the free interplay of architecture and sculpture that we see today. Analyzing the various steps of this transformation as it occurred in *The Gates* itself is a more difficult task, largely due to Rodin's working methods but due also to the lack of documentation. Rodin did not proceed in a methodical way, but by trial and error, adding new figures and taking off old ones, as his eye dictated.[4] Thus, *The Gates* was continually in a state of flux, though certain sculptures applied early seem to have been retained to the end. Usually figures were developed specifically for *The Gates*, but at times sculptures created for other purposes were also added. Thus, we find a reworked version of the *Man with the Broken Nose*, a sketch for the woman in *The Eternal Idol* and a tiny cast of the *Severed Head of St. John* among the crowds on *The Gates*. On other occasions, Rodin seemed to have been so pleased with an individual figure or fragment that he repeated it.

The few available documents do allow a very sketchy view of the development of *The Gates* as a sculptural monument. The original letter of commission called for bas-reliefs on the door, but Rodin soon decided to include "many figures almost in the round."[5] He also hoped to include two colossal figures of Adam and Eve to stand at either side of *The Gates*, but since these figures were not part of the original agreement, his request to include them was denied.[6] It is difficult to say exactly what part of *The Gates* Rodin worked on first, but likely among the earliest figures were those that correspond to his vase designs for the Sèvres manufactory in 1880.[7] We know from Rodin's correspondence, from visual documents (see p. 126) and from accounts of visitors to his studio that much of the work on *The Gates* was completed in the first few years after the commission.[8]

By the late 1880s, plans to construct a Museum of Decorative Arts had been dropped, and

official interest in Rodin's monumental door came to an end.[9] Despite the government's abandoning of the project, Rodin continued to work on *The Gates*, making minor variations over the years.[10] He probably slackened his pace during most of the 1890s, while he was deeply involved with the *Balzac*, but by 1898 he was planning to finish *The Gates* for exhibition in the 1900 International Exposition at Paris.[11] Nevertheless, the plaster *Gates* were shown to the public for the first time in an incomplete state; the figures in high relief were not attached, giving the door a barren appearance.[12] From 1900 on, Rodin repeatedly made plans to reassemble *The Gates* and have it cast in bronze, but it was reassembled and cast only after his death in 1917.[13]

The Gates of Hell, with all its ambiguities and complexities, has understandably generated endless and diverse speculations about Rodin's intentions in creating it. The very personal nature of the monument defies exact appraisal. Some have attempted to explain the work partly in terms of styles of the past—Gothic, Renaissance, Baroque, Romantic. While *The Gates* has certain elements in common with all of these styles, such an analysis simply points out the work's eclectic character, a quality that links it with nineteenth-century artistic preferences but fails to elucidate its true meanings. For Rodin's achievement was to transcend historicism to create a convincing and revealing statement about himself, his age and mankind.

Working as he did over a long period of time on *The Gates*, Rodin gradually changed his intentions for the monument as it developed. Statements by the sculptor and his contemporaries, and the earliest figures created for *The Gates* (for example, *The Thinker* and *The Three Shades*), indicate that Rodin took Dante's *Divine Comedy* and the art of Michelangelo as starting points for his monument. Both sources offered poignant examples of dramatic action. Rodin's interest in the writer reflects not only the nineteenth-century predilection for Dante's writings but also Rodin's conviction that Dante spoke directly to modern man. Though early drawings indicate that Rodin was interested in specific characters in *The Divine Comedy*, from the beginning the doors took on a more general meaning. Emphatic movement, a constant element in *The Gates*, was used as a means of psychological expression and not as an allusion to specific episodes in Dante's text.[14] The intense emotions of the personages, expressed through their extreme and unusual postures, convey attitudes toward life that Rodin shared with his contemporaries and immediate predecessors.[15]

In the variety of subjects, the insistence on a program of great complexity and the panoramic view of humanity, Rodin aligns himself with the tradition of art as a didactic statement on human history that Baudelaire coined *l'art philosophique*. In taking up this comprehensive program, though in a more allusive way, Rodin impinges on an area more frequently illustrated in painting than in sculpture. We first perceive *The Gates* as a great sigh of despair, a forceful display of pessimism. The figures reveal new tensions and frustrations of nineteenth-century life so frequently expressed in literature of the period. An interpretation of life as suffering, so predominant in philosophies like Schopenhauer's, is also an important theme in *The Gates of Hell*. Despite the surrounding throngs in the work, each individual suffers alone, without comfort, alienated from others. These pessimistic notions are part of the nineteenth-century belief in human degeneration.[16] For many, and perhaps for Rodin, Paris—representing the world as they knew it best—became a symbol of this decadence. One writer called *The Gates of Hell* "a Frieze of Paris."[17] Frequently, as in Rodin's *Gates*, decline was revealed not only through suffering but also through passion, so that the two become indistinguishable. Many of Rodin's figures move mysteriously as if in a dream; it is unclear whether they experience pain or ecstasy, despair or lassitude, ennui or hopelessness, frustra-

tion or satiety.[18] The force that engenders these sensations is as ambiguous as the emotions themselves; nothing acts on the figures. Rather the stimulus comes from within.

If the pessimistic tone dominates, hopeful notes still emerge; struggle is apparent in figures like *The Prodigal Son*, who questions his fate, or the man attempting to climb into the tympanum in the left door.[19] The temporarily static *Thinker* holds potential for action. Ultimately, Rodin's statement is not specific, but universal: the figures, like the actions, are not identified or defined; individual actions do not take place in chronological order or in a particular place. Rather, in true epic fashion, all mankind is represented, unified by common experiences of love and pain which are compressed into a timeless and spaceless world.

Above all, Rodin depicts the psychological life of the human, a growing concern of his contemporaries.[20] At the same time he summarizes his own inner development, which colored his vision of the world. Certainly the ideas expressed in *The Gates* are not new, but they do constitute a major philosophical statement about the human condition, expressed with a fresh energy and in an unprecedented formal context.

Ch. Paillet, Caricature of Rodin Carrying *The Gates of Hell*, watercolor, signed and dated 1884 (Album Paillet, Manufacture Nationale de Sèvres, Bibliothèque). Courtesy of Manufacture de Sèvres, Bibliothèque.

NOTES

1. For example, Charles Morice, "Rodin," *Mercure de France*, 124:468 (December 16, 1917), 589. Perhaps Rodin's free composition is related to his work with decorative objects, such as vases, where figures are attached to an artificial ground with little need to take into account the forces of gravity or a pictorial space.

2. *The Gates* are related in format to representations of the Last Judgment, with *The Thinker* replacing Christ above the turbulent masses below. However, Rodin has secularized and humanized this scheme not only by the substitution of Christ but also by the elimination of orthodox theological references: no demons inflict pain, no trumpeting angels occur, no division is made between damned and saved.

3. The work is in the California Palace of the Legion of Honor.

4. Rodin's unique method of composing groups is aptly described by Maillard, p. 83: "Such a process that relates a part to the whole, but which also allows the separation of the part from the whole, is peculiar to Rodin. This shows how truthful is Rodin's method, which he has drawn from Nature. There any grouping is the result of chance encounters of beings. They unite. They can separate." ("Cette assimilation à un ensemble, ce retranchement possible également, sont des traits bien particuliers à Rodin, car ils donnent la vérité de la méthode qu'il emploie et qu'il a puisée dans la Nature, où les groupes ne sont que des conditions accidentelles de réunion d'êtres. Ils se sont joints. Ils peuvent se séparer.")

5. Quoted in translation by Elsen, *Gates*, p. 67.

6. Cladel, 1950, p. 140.

7. The figures in the pilasters are close in style to Rodin's vases of 1880, although comparison with the examples reproduced by Roger Marx (*Rodin céramiste*, Paris, 1907) shows that exact correspondence was rare. A notable exception is a composition on the vase *Les Limbes*; see *Fragment of the Left Pilaster of the Gates of Hell* (cat. no. 29). When Rodin created the bas-reliefs to cover the panels with masks at the bottom of *The Gates*, he returned to some of the Sèvres compositions.

8. In December, 1881, Rodin solicited the Beaux-Arts commission for the price of casting the door in bronze, adding that "I am hastening to complete the work to which I consecrate all of my efforts and all of my time" (quoted in translation by Elsen, *Gates*, pp. 70-71). Probably the background of the two leaves as we know them was completed by this time, since Rodin describes them as "so chiseled and so hollowed out" that only bronze could capture this effect. This remark, along with Rodin's description of the divisions of the door, indicates that the architectural frame was also completed at this time. It was certainly erected by 1882 or 1883 when, according to Bartlett, journalists visiting Rodin's studio wrote of its colossal proportions (p. 223). Furthermore, Roger

Ballu, inspector for the Beaux-Arts Ministry, reported on January 23, 1883: "Je ne puis prévoir l'effet que feront sur le massif plan de la grande porte ces compositions toutes en Haut-relief" (C. Goldscheider, "Rodin, Influence de la gravure anglaise sur le projet primitif de la 'Porte de l'Enfer,'" *Bulletin de la Société de l'Histoire de l'art français*, 1950, p. 49). In 1885, Rodin informed the commission that "the model in plaster will be finished in about six months" (quoted in translation by Elsen, *Gates*, p. 71). Probably by this time *The Gates* looked substantially as they do today, with *The Three Shades*, the tympanum (including *The Thinker*), the pilasters and much of the two doors completed. See the descriptions in "Current Art," *Magazine of Art*, 6 (1883), p. 176; F. Champsaur, "Celui qui revient de l'Enfer: Auguste Rodin," *Le Figaro* supp., January 16, 1886; Goncourt, *Journal*, entry for April 17, 1886, 14, pp. 115-16; Bartlett, p. 223; photo in *L'Art Français*, February 4, 1888. A primary difference between *The Gates* as it existed at this time and as it exists today was the inclusion at the bottom of the doors of two panels illustrating bacchanalian scenes with masks. These panels remained on *The Gates* until sometime after the turn of the century, when they were replaced by two tomblike draped panels and small crowded figures in bas-relief. See the entries on *Crying Girl Dishevelled* (cat. nos. 30-32).

9. Rodin received his last payment for *The Gates* in 1888 (Elsen, *Gates*, pp. 149-50, n. 29). *The Gates of Hell* still remains an obscure project, since so little is known about the projected Museum of Decorative Arts for which it was planned. Though construction of the museum was proposed by 1880 when the call went out for a national public subscription to underwrite its construction, doubtless the museum never got beyond the planning stage, except for Rodin's door (*L'Art*, 21, 1880, pp. 236-37). Since the Museum of Decorative Arts apparently was never realized, the reasons for commissioning a monumental gate from Rodin in 1880 are unclear. The various plans for housing the decorative arts collection are outlined concisely by A. Proust (*L'Art sous la République*, Paris, 1892, pp. 215-76). The checkered progress of the museum can be traced in *La Revue des Arts Décoratifs*, the organ of the sponsoring organizations of the museum—the *Société de l'Union Centrale des arts appliqués à l'industrie* and the *Musée des arts décoratifs*. Surprisingly, seemingly no mention is made of Rodin's *Gates*. During the 1880s, the decorative arts collection was housed in various public buildings until, in 1887, it was once again relocated in a section of the Louvre, where it still exists today; *La Revue générale de l'Architecture*, 44 (1887), pp. 72-76. Another unanswered question is what the subject of the monument might be.

10. Contemporary photographs show that minor changes were made in the tympanum, for example.

An illustration in *L'Art Français* (February 4, 1888) shows slight differences in the background figures and the figures in the cornice from *The Gates* as we know it today. We also find variations in another illustration of the tympanum published by Bartlett (p. 224). Incidentally, Bartlett is incorrect in saying that the illustration he reproduces is taken from *L'Art Français* (p. 223). The row of heads above the tympanum were not present in the earliest stages of *The Gates*, as contemporary illustrations show; they do appear in a photograph in the catalogue of the 1900 Rodin exhibition.

11. Rodin said in an interview with Charles Chincholle: "Je suis pressé d'achever tout cela . . . et ma 'Porte de l'Enfer' aussi, cette porte à laquelle je travaille depuis quinze ans et que je compte exposer in 1900 . . ." ("La Vente de la Statue de Balzac," *Le Figaro*, May 12, 1898, p. 3). Cf. E. Rod, "L'Atelier de M. Rodin," *Gazette des Beaux Arts*, ser. 3, v. 17 (May 1898), p. 421; H. Frantz, "Great New Doorway by Rodin," *Magazine of Art*, 21(1898), p. 274; Maillard, p. 82.

12. A. France, "La Porte de l'Enfer," *Le Figaro*, June 7, 1900; R. Cortissoz, "Work of Rodin," *Current Literature*, 29(December, 1900), p. 704.

13. Bronze casts of *The Gates* are housed in the Musée Rodin, Paris; the Rodin Museum, Philadelphia; the National Museum of Western Art, Tokyo; and the Kunsthaus, Zurich. In a recent article on the intervention in the arts by the Nazis during World War II, Yvon Bizardel states that Hitler had a bronze replica of *The Gates of Hell* cast for the Linz Museum ("Les statues parisiennes fondues sous l'occupation: 1940-1944," *Gazette des Beaux-Arts*, 6 per., 83:1262, March, 1974, p. 134). The present location of this cast is unknown.

Endless speculations have been made as to why Rodin did not complete *The Gates* during his lifetime. Perhaps the simplest and most accurate explanation was offered by Rodin in 1917 to Gustave Coquiot: "Will I finish *The Gates* someday? It is improbable! Nevertheless, I would only need a few months, perhaps two or three at most, to finish it. You know that all the casts are ready, labeled, for the day when I am asked for the final conclusion. But will this day ever come? The government would have to pay me more money, which is so greatly necessary for all sculptors who await commissions Bah! I have dispersed a little everywhere the details of my *Gates*; it is perhaps well so! Consider. To finish the *Gates*, it would have to be cast in bronze and about a hundred thousand francs would be necessary. Do you think the government would grant this to me!" ("La terminerai-je, un jour, cette *Porte*? C'est bien improbable! Et pourtant, il ne me faudrait que quelques mois, peut-être, deux ou trois au plus, pour l'achever. Vous savez que tous les moulages sont prêts, étiquetés, pour le jour qu'il plairait d'en demander le complet achèvement. Mais ce jour viendra-t-il jamais? Ce seraient de nouvelles sommes d'argent que devraient me verser les bureaux, et elles leur sont fort

nécessaires pour tous les sculpteurs qui attendent des commandes . . . Bah! J'ai dispersé un peu partout les détails de ma *Porte*; cela est peut-être aussi bien, ainsi! Songez, qu'achevée, elle devrait être fondue en bronze; et la centaine de mille francs nécessaire, vous pensez bien que les bureaux ne me l'accorderaient jamais!" Quoted by Coquiot, *Rodin à l'Hôtel de Biron*, p. 103).

14. Like so many of his predecessors, including Delacroix, Ingres, Ary Scheffer and Carpeaux, Rodin was primarily attracted by the first book of *The Divine Comedy*. His preoccupation with *The Inferno* is evident in the earliest studies, which depict well-known characters like Ugolino, Paolo and Francesca, Mohammed and Guidon. When this selection first became manifest in the title *La Porte de l'Enfer* is uncertain, though that title was apparently common by the 1890s; Maillard repeatedly uses this name in his 1899 monograph. However, it was already evident in the 1880s that Dante's *Inferno* was Rodin's point of departure (O. Mirbeau, *Le Salon de 1885*, Paris, p. 26). Bartlett described why Rodin selected the subject and how he used it: "Although the door is generally understood [to be] and popularly called, for description's sake, an illustration of Dante's *Inferno*, it is only true to a limited degree. Of its design and the thoughts and sentiments that have actuated the sculptor, [Rodin] says: 'I had no idea of interpreting Dante, though I was glad to accept *The Inferno* as a starting point, because I wished to do something in small, nude figures. I had been accused of using casts from nature in the execution of my work, and I made the *St. John* to refute this, but it only partially succeeded. To completely prove that I could model from life as well as other sculptors, I determined . . . to make the sculpture on the door of figures smaller than life. My sole idea is simply one of *color* and *effect*. There is no intention of classification or method of subject, no scheme of illustration or intended moral purpose. I followed my imagination, my own sense of arrangement, movement and composition. It has been from the beginning, and will be to the end, simply and solely a matter of personal pleasure. Dante is more profound and has more fire than I have been able to represent. He is a literary sculptor. He speaks in gestures as well as in words; is precise and comprehensive not only in sentiment and idea, but in the movement of the body. I have always admired Dante, and have read him a great deal, but it is very difficult for me to express in words just what I think of him, or have done on the door'" (Bartlett, p. 223). On Rodin's purposeful selection of small figures, see his later statement in Coquiot, *Rodin à l'Hôtel de Biron*, pp. 101-102. Edouard Rod wrote that Rodin selected *The Inferno* for the range of dynamic subjects: "For there is, in this grandiose and tragic dream of the greatest of modern poets, all the attitudes, all the passions, all the sadnesses, in a word all the *movements*" ("Car il y a, dans ce rêve grandiose et tragique du plus grand des poètes modernes, toutes les at-

titudes, toutes les passions, toutes les douleurs, en un mot, tous les mouvements''; *op. cit.*, p. 422.) Cf. Maillard, p. 80; Cladel, 1917, p. 270. Rodin was not the first to see a viable comparison between Dante's hell and modern society; Balzac and Hugo were among those writers who emulated the medieval poet. In his *La Fille aux Yeux d'Or*, Balzac describes Parisian society as a series of spheres patterned after Dante's *Inferno* (*Oeuvres complètes*, Paris, Les Bibliophiles de l'Originale [n.d.], pp. 236-49. We find a similar description in Hugo's *Les Misérables* (''Marius,'' Book VII, Ch. II). Hugo described his intentions in writing this book, which could almost be Rodin's: ''Dante . . . made an Inferno out of poetry; I have tried to make one out of reality'' (''Dante . . . a fait un enfer avec de la poésie; moi j'ai essayé de faire un enfer avec de la réalité''); Edmond and Jules de Goncourt, *Journal*, 4 (July 11, 1861), p. 217.

15. Frequently the *Gates* are related to Baudelaire, a comparison initiated by Rodin's contemporaries, who often viewed the poet as forefather of the Symbolist movement; see C. Monkhouse, ''Auguste Rodin,'' *Portfolio*, 1887, p. 9; Mauclair, 1905, p. 22; Lawton, p. 112; A. Symons, ''Notes on Auguste Rodin,'' *Apollo*, 14 (August, 1931), nos. 80, 94. This analogy persists today (see Elsen, *Gates*, *passim*, and Sutton, pp. 51-52). Certainly a basis exists for this relationship in Rodin's admiration for the nineteenth-century poet and in the ''community of spirit'' that Bartlett tells us Rodin saw between Baudelaire and Dante (p. 249). However, the attitudes expressed in Rodin's *Gates* were common to a great many during this period. Delight in detailed descriptions of violence, torture and suffering were common elements of literature throughout the century. Victor Hugo, whom Rodin much admired, has been overlooked in discussions of *The Gates*; for example, a comparison could be made between Hugo's poem, ''Ce qu'on entend sur la montagne.'' Significantly, Hugo's name appears along with Ugolino and Guidon in one sketch for *The Gates* (Elsen, *Gates*, p. 53). The importance of Hugo's writings for Rodin remains to be assessed and promises to be revealing.

16. In 1860, E. and G. Goncourt wrote: ''*Charles Demailly* exemplifies this attitude: 'And anemia is taking hold of us, that is the positive fact. The human type is degenerating. Stretching from family to species there is the wasting away which royal races undergo at the end of dynasties' '' (''Et l'anémie nous gagne, voilà le fait positif. Il y a dégénérescence du type humain. C'est, étendu des familles à l'espèce, le dépérissement des races royales à la fin des dynasties'') Paris, 1893, p. 283.

17. ''This Gate, a Frieze of Paris, as deeply significant of modern inspiration and sorrow as the Parthenon Frieze is the symbol of the great clear beauty of Hellas'' (J. Huneker, ''Introduction,'' Cladel, 1917, pp. *xi-xii*). This view of Paris was a commonplace by the time Rodin created *The Gates of Hell*.

18. The importance of the love motif in *The Gates* has been frequently overlooked in Rodin literature, yet Rodin himself stressed it: ''See these lovers, condemned to eternal suffering; they have given me the inspiration to represent love in the different phases and poses where it appeared in our imagination. I mean passion, since, above all the work must be living.'' (''Voyez ces amants, condamnés aux peines éternelles; ils m'ont donné l'inspiration de représenter l'amour dans les phases et les poses différentes où il apparaît à notre imagination. Je veux dire la passion, car, avant tout, l'oeuvre doit être vivante.'') In W. G. C. Byvanck, *Un Hollandais à Paris*, Paris, 1891, p. 8. Cf. Bartlett, p. 249; Maillard, pp. 83-84.

19. The significance for Rodin of struggle, an attitude so frequently demonstrated in his approach to his art, was pointed out by him in 1907: ''[The artist] must celebrate that poignant struggle which is the basis of our existence and which brings to grips the body and the soul. Nothing is more moving than the maddened beast, perishing in lust and begging vainly for mercy from an insatiable passion'' (from *Antée*, June 1, 1907, quoted in translation by Elsen, *Gates*, p. 79).

20. The psychological implications of *The Gates* were recognized by Rodin's contemporaries. In 1906, Lawton (p. 113) wrote: ''In his composition, Rodin has illustrated Milton's definition: 'The mind is its own place, and in itself/Can make a heaven of hell, a hell of heaven.'''

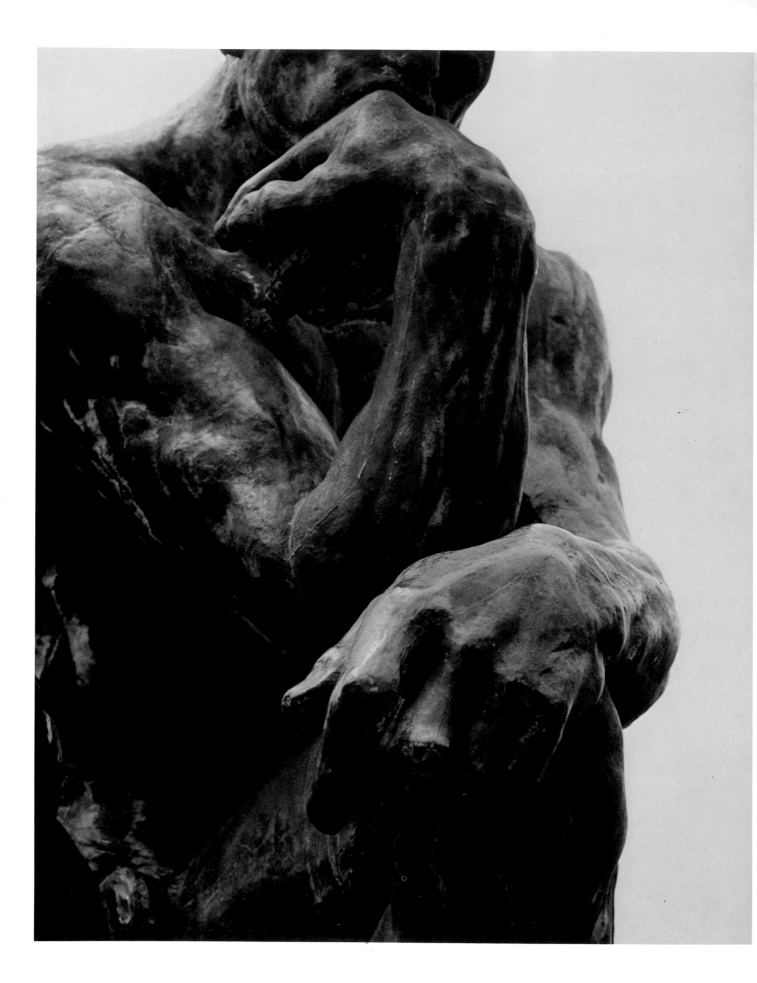

19

The Thinker
(*Le Penseur*)

Bronze, dark brown patina (weathered); on a marble base
78 x 51 x 52 3/4″ (198 x 129.5 x 133.9 cm)
Signed: A. Rodin (right side)
Stamped: A. Rudier / Fondeur. Paris. (rear, lower right)
1924.18.1

The Thinker, Rodin's most celebrated sculpture, must today be seen as a major artistic statement, rich in a variety of meanings and indicative of the new direction Rodin's art took around 1880. Since the end of the nineteenth century, the work has symbolized Rodin and his art, and, indeed, intellectual activity itself.

Despite the allusion to mental functions, Rodin has chosen to depict a surprisingly athletic man. As if the body were a metaphor for the turmoil within the man, leg and arm muscles are tensed and protrude almost as if the skin had been stripped away. Rodin insisted that he did not pose his models;[1] however, the position of *The Thinker* is obviously calculated to allude to earlier artistic prototypes and to accentuate muscular interaction and stress. The emphatic twisting and flexing of every part of the body reflects those powerful figures of Michelangelo. This lack of repose is seen even in the attitude of the figure, which is not really static, as a seated figure should be, but precarious, about to topple forward. This quality is more apparent in the enlarged figure than in the smaller *Thinker*, which originally sat atop *The Gates of Hell* where it projects forward, the better to be seen by the viewer several feet below.[2]

Rodin originally conceived *The Thinker* for this focal position in the center of the tympanum of *The Gates*. Strangely enough, the first ca.-68.5-cm version probably evolved from Rodin's many studies from the mid-1870s onward of the Ugolino theme from Dante's *Inferno*.[3] First conceived as a seated figure, this type appears over and over in the early studies for *The Gates*, including an early clay model where a seated Ugolino occupies a prominent position.[4]

The final conception of *The Thinker* was in place by the early 1880s. But from a very early date Rodin considered it to be an independent work and exhibited it alone for the first time in 1888 in Copenhagen. Only in 1889 was the soon-to-be-famous figure revealed to the Parisian public at the Rodin-Monet exhibition at the Galerie Georges Petit.

Like several other figures from *The Gates of Hell*, *The Thinker* was enlarged soon after the turn of the century. A twice-life-size version was exhibited at the Salon de la Société Nationale (no. 2079) in 1904.[5] As usual, this new figure brought severe attacks from Rodin's opponents.

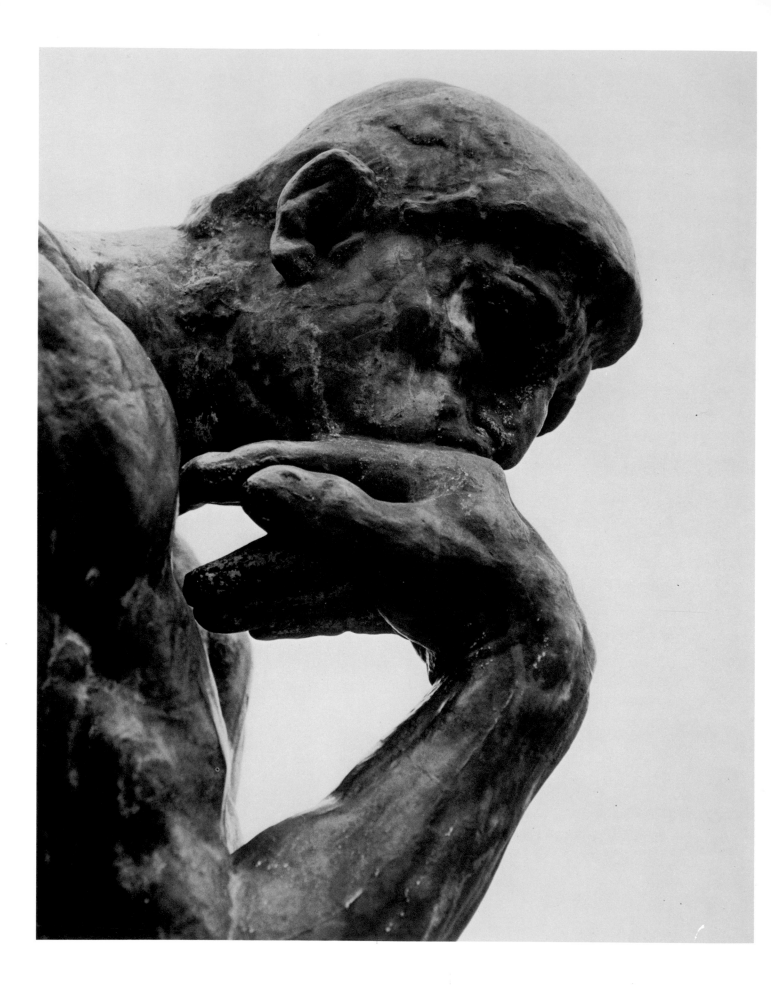

In reaction, Rodin's friends launched a subscription campaign to acquire a bronze cast of the enlarged *Thinker* for the city of Paris. It was installed in 1906 and today can be seen outside the Musée Rodin in Paris.[6]

The Thinker has always raised as many questions as it has answered. From its first viewing, the work has both fascinated and puzzled the beholder, due in part to its ambiguity, its lack of anecdotal clues, which leaves it forever open to speculation. These features were not accidental. Rodin wanted his sculptures to be individually interpreted, and he must have smiled inwardly at the multitude of explanations of *The Thinker* offered by his contemporaries.[7] Then, too, *The Thinker*, more than any other work by Rodin, is loaded with allusions to the past. Its many links with literary and artistic traditions make it a rich field for the art historian in search of precedents. Certainly we must avoid playing academic games with *The Thinker*, and yet the traditions that Rodin drew so strongly upon must be considered in attempting to discover what meanings he might have had in mind when he conceived this sculpture.

Because of its original place in *The Gates of Hell*, Rodin and his early biographers have naturally associated *The Thinker* with Dante.[8] This interpretation is not inconsistent with the dual title given to this piece in the catalogue for the 1889 exhibition: *Le Penseur; le Poète* (*The Thinker; the Poet*).[9] In fact, this link between thinker and poet may reflect a traditional view of Dante as both philosopher and artist.[10] Whether Rodin was aware of these interpretations we cannot say. The title also reflects a broader significance that goes beyond the example of Dante alone. This urge to a general conception probably occurred to Rodin in the very act of creation, even with Dante so strongly in mind. The representation of the figure as a nude removes it from any particular time, and the Promethean physique hardly agrees with traditional representations of Dante as a lean and ascetic man. A later comment by Rodin indicates that this reorientation was deliberate:

> *The Thinker* has a story. In the days long gone by, I conceived the idea of *The Gates of Hell*. Before the door, seated on a rock, Dante, thinking of the plan of his poem. Behind him, Ugolino, Francesca, Paolo, all the characters of *The Divine Comedy*. This project was not realized. Thin, ascetic, Dante separated from the whole would have been without meaning. Guided by my first inspiration I conceived another thinker, a naked man, seated upon a rock, his feet drawn under him, his fist against his teeth, he dreams. The fertile thought slowly elaborates itself within his brain. He is no longer dreamer, he is creator.[11]

What was probably originally conceived of as Dante, then, becomes a general symbol of "the poet," or creative genius, in the final conception. But why did Rodin break with the most popular nineteenth-century image of the poet or artist as a slender, pining figure and substitute this titanic man? Probably for a man who expressed his thoughts physically and directly in a plastic medium, a passive Romantic hero was no more a symbol of human creativity than was a railroad tycoon. So Rodin looked to other models, such as the heroes of Victor Hugo, which combined both physical and mental acumen. By exaggerating the physical development of his *Thinker*, Rodin stressed the vitality and power of the creative mind:

> What makes my *Thinker* think is that he thinks not only with his brain, with his knitted brow, his distended nostrils and compressed lips, but with every muscle of his arms, back and legs, with his clenched fist and gripping toes.[12]

While Rodin changed the physical appearance of his poet-hero, he retained the dejected,

head-in-hand pose typically associated with men of genius. He thereby was able to keep meanings long associated with such figures. From ancient times, these gestures had been metaphors for melancholy, brooding thought and dreaming. *The Thinker*'s pose was thus an appropriate symbol for the alienated and suffering but intellectually superior man popularized by Romantic artists and writers. In fact, during the first half of the nineteenth century, such heroes were the projected self-image of the artist of no matter what art, who saw himself as an outcast and as unappreciated by his society. An important example of this type was offered by Carpeaux's *Ugolino*; *The Thinker* grew out of Rodin's own studies of this mistreated and imprisoned character from *The Divine Comedy*.[13] In *The Thinker*, then, Rodin shows that he shared this conception of the man of genius, and most likely the sculpture is also an expression of his image of himself as an artist.

But this work is a conception of genius, presenting not a man licking wounds inflicted by a hostile society, but a man capable of bursting into action at any moment. This statement of surprising energy and optimism is seemingly at odds with the usual views of the 1880s, a period too often associated with decadence, pessimism and inaction. On the contrary, during these years of revitalization the Romantic ideal of a man of both thought and action took on new relevance. In artistic, social and political life, increasing demand arose for change and hope for a bright, new future. We find this spirit in *The Thinker*, despite its seated posture, which is not really restful, and the brooding countenance, which reveals the momentary substitution of mental for physical action. This conception of a vigorous creator has obvious personal connotations for Rodin. Because of his deep personal identity with the ideas that lie behind *The Thinker*, Rodin selected this sculpture from all his others to guard his tomb at Meudon, where it still sits contemplating the death of its creator.

The great number of casts of *The Thinker* occur in three sizes, attesting to the sculpture's enormous and continuing appeal. Though the technical history of the different versions of *The Thinker* remains rather obscure, some fresh information has recently come to light. Bronze casts of the original version seem to have been in production in the 1890s.[14] More is known about the over-life-size version. The enlarging process probably began in 1902.[15] By late 1903, the new version was ready to be cast in bronze by Hébrard, using the *cire perdue* process.[16] This method did not prove entirely satisfactory for such a large sculpture; subsequent casts were therefore made by Alexis Rudier and his successors, using sand molds.[17] We have little specific information regarding the reduced ca.-39-cm version of *The Thinker*. Presumably the reduction took place during Rodin's lifetime, for the plaster in the Maryhill Museum of Fine Arts bears a dedication by Rodin to Loïe Fuller. Information on the bronze casts is yet to be found. The story of the various casts of *The Thinker* is further complicated by an edition of counterfeits in bronzed plaster made apparently around 1911; none of these has been identified.[18]

When Mrs. Spreckels purchased a bronze cast of the enlarged version from Rodin through Loïe Fuller in 1915, the work was already well known in the United States—it had been exhibited at the 1904 Louisiana Purchase Exposition in St. Louis and widely reproduced in photographs. So familiar was *The Thinker* to San Franciscans that the Emporium department store advertised in the *San Francisco Examiner* of January 10, 1915, using the image of the statue as a symbol of the Panama-Pacific International Exhibition, where the Spreckels' cast was on view. At the end of the exposition, the sculpture was placed on public view in San Francisco's Golden Gate Park. The bronze was transferred to the California Palace of the Legion of Honor in 1924, where it occupies the courtyard.[19]

Right: *The Thinker*. Cat. no. 19.

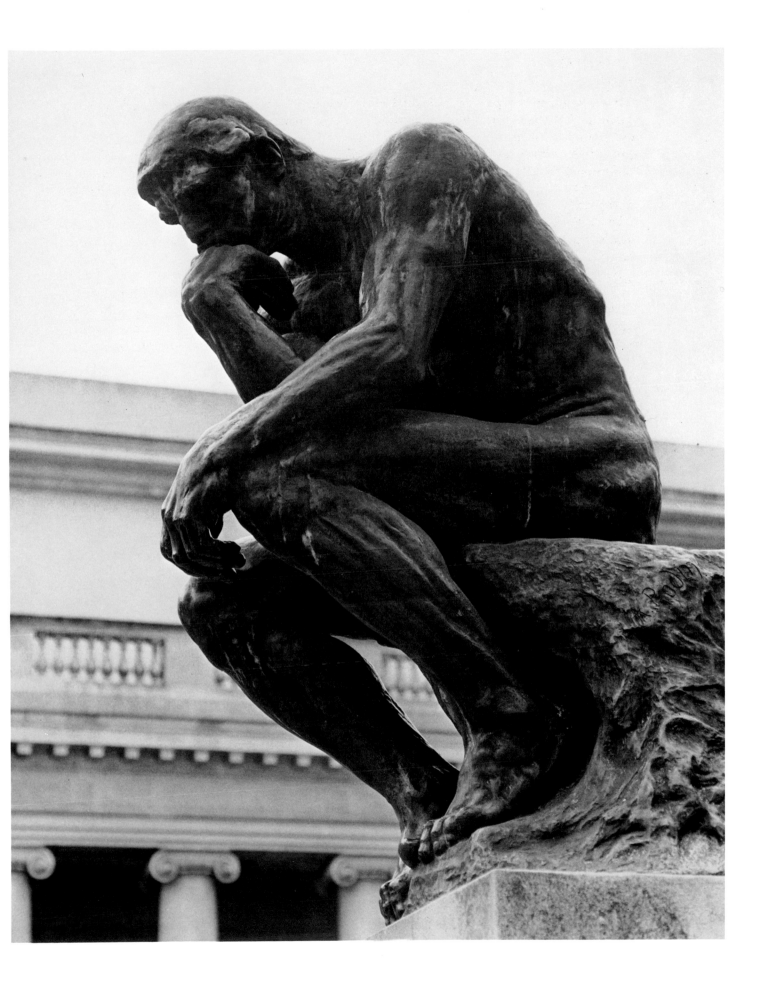

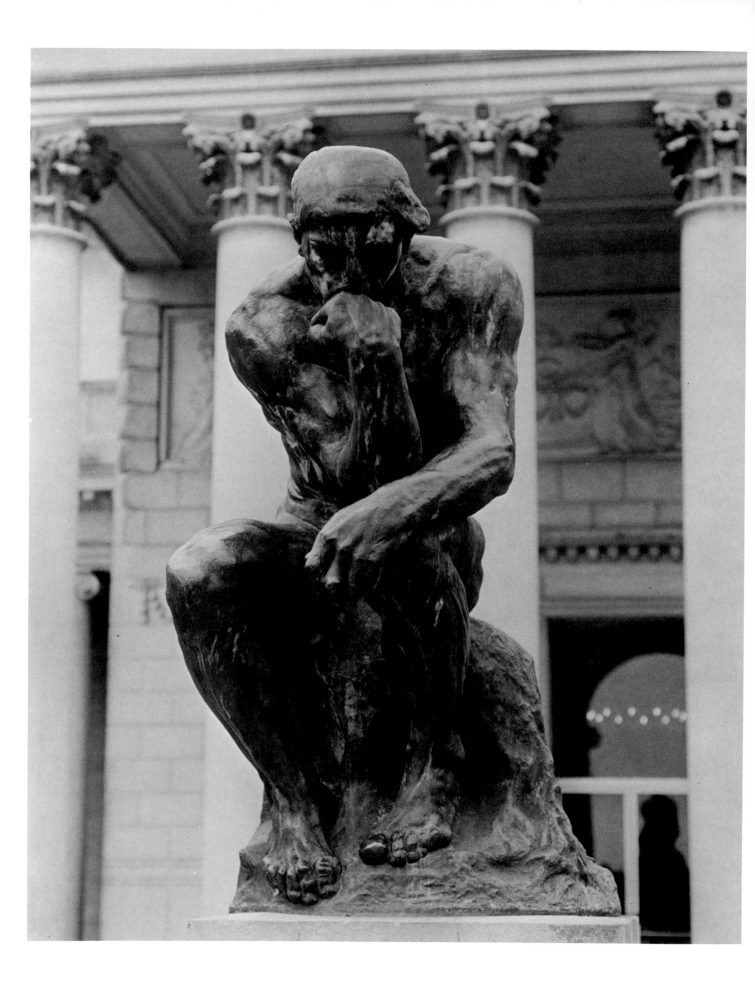

NOTES

1. See, for example, *On Art and Artists*, pp. 45-47.

2. This quality is discussed by Elsen (*Gates*, p. 79).

3. Little specific evidence remains to date *The Thinker*, though Grappe places it, no doubt correctly, in 1880 (1944, no. 55). We know that it was completed by the early 1880s since an eyewitness account of 1883 refers to a "super-human Dante" on *The Gate*; "Current Art," *Magazine of Art*, 6 (1883), p. 176.

4. Illustrated in Elsen (*Gates*, pl. 43 and 44). The *Thinker*-like posture of this figure is further proof of an early dating for *The Thinker*.

5. Rodin's assistant, Victor Frisch, seemed to think that the sculptor reworked *The Thinker* at the time of its enlargement; however, since no apparent difference occurs between the 27" and over-life-size versions, more likely Rodin had a mechanical enlargement made, as Stanislas Lami contends (p. 173).

6. The history of this 1904 campaign can be traced in detail in Gustave Mourey's *Les Arts de la Vie*, beginning with the May issue, pp. 267-70.

7. Rodin frequently asked visitors to his studio to suggest titles for his pieces of sculpture. One such incident is described by Gustave Kahn; "Notes sur Rodin," *Mercure de France*, 172:623 (June 1, 1924), p. 314. *The Thinker* was seen by Rodin's contemporaries as a kind of superman, or seer, or as man's intellect triumphing over his passions. The frequent association of *The Thinker* with prehistoric man reveals the fascination at the turn of the century with primitive man and human origins. For a variety of comments and interpretations, see "Le Penseur de Rodin offert par Souscription publique au Peuple de Paris: Lettres d'adhésion," *Les Arts de la Vie*, 1:6 (June 1904), pp. 334-39.

8. Bartlett, pp. 223, 224, 225; Geffroy, preface to catalogue of the exposition *Claude Monet. A. Rodin*, Paris, 1889, pp. 48-49; Maillard, pp. 81-82; Lawton, p. 248; Cladel, 1917, p. 279; Frisch/Shipley, p. 413.

9. Rodin's association of *The Thinker* with the poet is again reflected in a drawing after this sculpture which he made to accompany Baudelaire's "Les Bijoux" for the illustrated version of the *Fleurs du Mal* commissioned by Paul Gallimard around 1887. This poem describes the isolation of the poet whose soul "*calme et solitaire*," sat on the "*rocher de cristal*," an image clearly evoking Rodin's *Thinker*. In both, detachment and the imminent danger of falling are significant elements.

10. We see this interpretation, for example, in the dedication to Henry IV by Abbé Grangier in his translation of *The Divine Comedy*: " . . . En ce noble poëme, il se découvre un poëte excellent, un philosophe profond et un théologien judicieux" (quoted in M. A. F. Ozanam, *Dante et la philosophie catholique au treizième siècle*, Paris, 1845, p. 4). The concern that Dante be appreciated not only for his poetry, but also for his philosophy was still voiced in the nineteenth century (*ibid.*, pp. 4-7).

11. Letter to Marcel Adam, published in an article in *Gil Blas* (Paris, July 7, 1904), translated and quoted in Elsen (*Gates*, p. 96).

12. Statement by Rodin, *Saturday Night* (Toronto), Dec. 1, 1917, quoted in Elsen (*Rodin*, p. 52). Cf. Rilke, *Auguste Rodin*, Leipzig, 1920, p. 42.

13. Charles Seymour has pointed out that Rodin owned a cast of a small sketch for Carpeaux's *Ugolino* ("Ideas on sculpture," *Baltimore Museum of Art News*, 17:4 [April, 1954], p. 12). If this sketch is the one that is kept today at the Musée Rodin, it is a cast made after the plaster model of Carpeaux's *Ugolino* at the Villa Medici in Rome; Ill. in A. Braunwald and A. M. Wagner, "Jean-Baptiste Carpeaux," *Metamorphoses in Nineteenth Century Sculpture*, p. 114-15, fig. 4. The circumstances of Rodin's acquisition of this sketch are unknown.

14. The bronze cast in the Musée d'Art et d'Histoire in Geneva was acquired in 1896.

15. René Chéruy, Rodin's secretary between 1902 and 1908, believes that Le Bossé began to enlarge *The Thinker* in 1902 (letter of June 9, 1957, Tate Gallery archives).

16. An announcement of the casting to take place at Hébrard's foundry appeared in *Art et Décoration*, supp., 14 (December, 1903), pp. 5-6:

> Il nous a été donné d'admirer il y a quelques jours l'oeuvre que le grand sculpteur Rodin va envoyer à l'exposition de Saint-Louis. Ce n'est pas à proprement parler une oeuvre entièrement nouvelle, mais bien la modification et le développement du Penseur qui surmontait sa porte d'Enfer . . .
>
> Ce Nouveau Penseur est de tous points admirable. Nu, assis sur un rocher, et les pieds crispés s'y appuyant fortement, l'homme a le corps comme projeté en avant, à la poursuite de la pensée profonde. Sur le poing fermé s'appuie la tête puissante, superbe d'expression concentrée.
>
> Les dimensions du sujet sont imposantes, et rendent plus intéressantes en même temps que plus ardue, la tâche du fondeur. M. Hébrard, en effet, va fondre à cire perdue cette oeuvre, l'une des plus belles du maître. La cire en est achevée et réussie de tous points.

This cast was made for the 1904 Louisiana Purchase Exposition. It was purchased at that time by Henry Walters, founder of the Walters Art Gallery in Baltimore, and is now on loan to the University of Louisville. The painstaking preparation of the molds for this cast, a process lasting more than six weeks, is described by Louis Vauxcelles in "La Fonte à Cire perdue," *Art et Décoration*, 18(1905), p. 193.

17. Rodin's dissatisfaction with the Hébrard cast is expressed in a letter of April 23, 1904, to André Saglio, then Commissaire Général des Expositions, in which he asked that the bronze be removed from the St. Louis exposition: "Conformément aux entretiens que j'ai eus avec vous avant votre départ et ensuite avec Monsieur Horteloup, j'ai l'honneur de vous rap-

peler que je désire que mon oeuvre le ''Penseur'' ne soit pas exposée en bronze, mais que le plâtre que j'ai ensuite envoyé lui soit substitué ainsi qu'il a été convenu. La fonte du bronze envoyé à Saint-Louis ne m'ayant pas satisfait, je désire expressement que ce bronze ne soit pas exposé et qu'il soit remplacé par le plâtre . . .'' (courtesy of Princeton University Library). According to Cécile Goldscheider, Hébrard made two monumental casts of *The Thinker*, but we have located only one (Jianou/Goldscheider, p. 82). For a detailed account of the casting of the enlarged version, see Justus Bier, ''The Thinker,'' *Courier-Journal Magazine* (Louisville), Jan. 16, 1949. Jean-René Carrière, son of Rodin's friend Eugène Carrière, has described dramatically the casting of *The Thinker* in a single pour in Alexis Rudier's foundry (*De la Vie d'Eugène Carrière*, Toulouse, 1966, pp. 28-29).

18. The counterfeit edition is referred to in a letter of November 9, 1911, from Rodin to Mme Charlotte Jacques Meunier (typescript, Philadelphia Museum of Art Library, no. 120). Casts of unorthodox dimensions and of varying quality sometimes appear on the art market; for instance, Christie's on July 3, 1970, offered *Le Penseur*, bronze, signed, inscribed ''Moreau. Paris,'' and dated ''1935'' (58.5 cm, no.

232). In addition to the three well-known versions, a bronze cast identified as a working model for *The Thinker* has recently appeared on the art market (Parke-Bernet sale, May 18, 1972, no. 81). According to the catalogue for this sale this cast is presumed to be the first of three done in Rodin's private foundry by the lost-wax process from a working model for *The Thinker*; this identification is made by Dr. Boris Blai, who studied with Rodin.

19. The presentation of *The Thinker* to the city of San Francisco and its subsequent removal to Golden Gate Park is recorded in the minutes of the Recreation and Park Commission for April 6, 1916: ''Supt. McLaren reported that during the month the great statue 'The Thinker' by Rodin was presented to Golden Gate Park by Mr. and Mrs. A. B. Spreckels and was placed on 'Favorite Point' on a pedestal of red rock of the Peninsula. The statue was unveiled by Master and the Misses Spreckels on Tuesday, March 21st, 1916.'' In an account of her trip to Europe in 1914, Mrs. Spreckels wrote that *The Thinker* she purchased was originally ordered by Switzerland (typescript formerly in the collection of Miss Jean Scott Frickelton, Palo Alto). We have been unable to confirm this information.

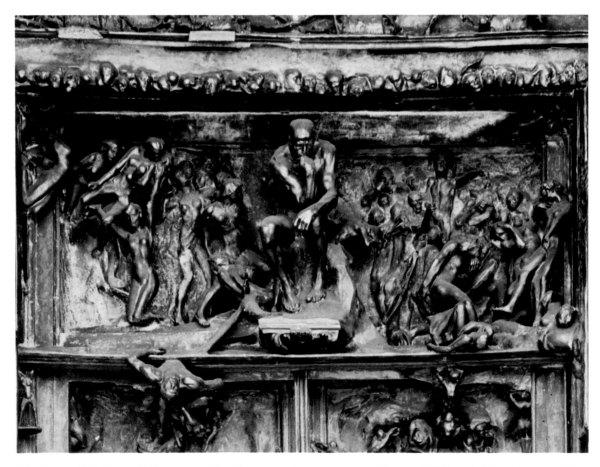

The Gates of Hell, detail, showing *The Thinker* in the tympanum. Bronze, Philadelphia Museum of Art.

20

The Three Shades
(*Les Trois Ombres*)

Bronze, black to green patina
75 1/2 x 73 1/2 x 41 1/2" (190.5 x 185.5 x 105.5 cm)
Inscribed: A. Rodin (base, right side)
Stamped: ALEXIS RUDIER/ Fondeur. PARIS. (base, back, lower right)
Property of the City and County of San Francisco
(displayed near the fountain opposite the California Palace of the Legion of Honor)

The hopelessness of *The Three Shades*[1] has caused some to see in this somber trio, which was created to crown *The Gates of Hell*, the embodiment of the dire warning that greeted Dante as he reached the entrance to Inferno: "All hope abandon ye who enter in."[2] Since Rodin frequently depicted groups of three shades in the drawings that preceded *The Gates of Hell*, this group may also stand for the anonymous souls that populated Dante's Hades. More specifically, the medieval poet describes three shades who danced in a circle as they related their tale of woe (*The Inferno*, Canto XVI).[3] The repetition of the same figure three times in Rodin's group suggests the movement of a dance; it also allows us to see the sculptural component from different points of view, without walking around it. In this work, Rodin is simulating in sculpture a concern of early photography: the sequential movement of man in space.[4] The usual method of composing by repetition of the same element may also have been suggested to Rodin through his long exposure to decorative arts, where construction by means of separate components is common, especially in vases, clocks, candelabra and the like. Rodin's employer, Carrier-Belleuse, frequently used this technique. In *The Three Shades* Rodin avoids static symmetry, which could easily result from this practice, by varying the distance between the figures.

The Three Shades, like many of Rodin's sculptures executed around 1880, reflects contemporary preference for Renaissance art.[5] The relationship of this group to Michelangelo's sculpture is obvious and has been repeatedly discussed. The contorted, despondent pose and exaggerated musculature of the repeated figures relate them very closely to Rodin's *Adam*, which was begun soon after the sculptor's trip to Italy in 1875.

The several versions of *The Three Shades* show noticeable differences. In the first ca.-98-cm group which surmounted *The Gates*, we have an early example of Rodin's interest in fragmental sculpture (the right arm of each figure is truncated and the left hands remain unarticulated). By 1905, Rodin had made a ca.-190-cm enlargement of the group, where the arms are still incomplete.[6] But in other, possibly later enlargements, the limbs were finished; the San Francisco bronze belongs to this category. In this version, the left hand is held in a manner much like the teaching gesture (*vitarka mudrā*) of Hindu and Buddhist sculptures,

139

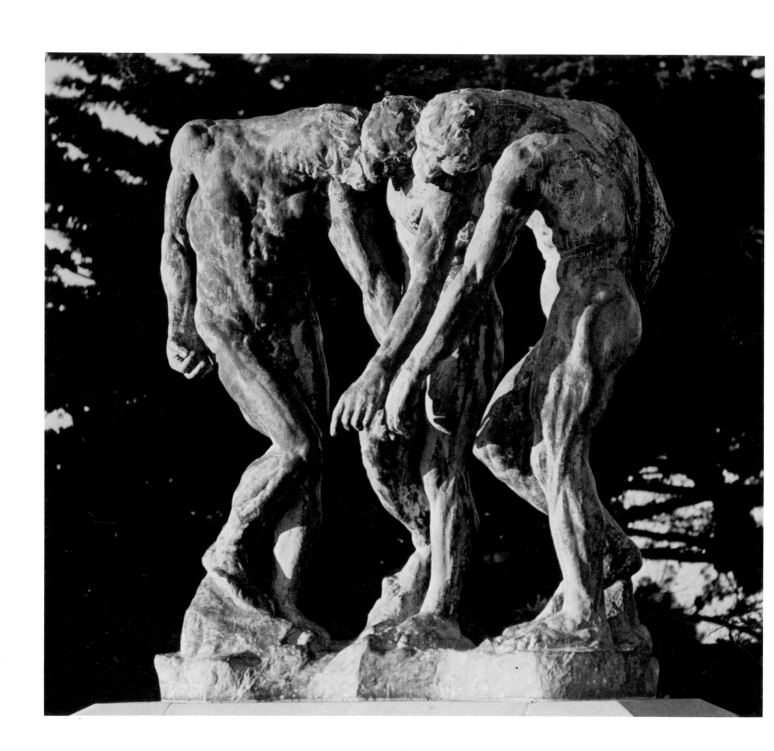

while the right hand points vaguely downward.[7] Besides the group of *Shades*, Rodin also had the component cast as a single figure in both original and enlarged sizes as in the groups. Three separate casts of the enlarged figure were exhibited at the Salon of 1902.[8] Each figure was isolated on a separate base, allowing maximum flexibility of grouping, yet Rodin placed them in nearly their original positions. The original figures standing on the same base stressed the group as an inalterable arrangement; the 1902 figures asserted the autonomy of the component elements. Compared to the relatively small number of casts of the group known to exist at the present time, numerous casts of the single figure are held in public and private collections. In addition to the groups and isolated figures, Rodin had the detached head of the *Shade* cast.[9]

The cast of *The Three Shades* in Lincoln Park was acquired by the people of San Francisco through public subscription in memory of the philanthropist and prominent businessman Raphael Weill (1837-1920).[10] In 1924, the Board of the Park Commission resolved to erect the cast in its present location.[11]

NOTES

1. The group was exhibited as *Les Vaincus* (no. 148) at the 1900 Rodin exhibition. In 1898 it was called *Génies de la Douleur* (Cladel, 1903, p. 52). When it was first known as *Les Trois Ombres* is uncertain, but in the 1900 Rodin catalogue a photograph of a single shade is captioned: "Une des Ombres de la 'Porte de l'Enfer.'" At the 1902 Salon they were called *Ombres*.

2. *The Inferno*, III:9. Edouard Rod wrote of Rodin's group: "Leur geste signifie les paroles fameuses: *Vous qui entrez, quittez toute espérance*" ("L'Atelier de M. Rodin," *Gazette des Beaux-Arts*, ser. 3, 17 [May, 1898], p. 426). In 1886, Félicien Champsaur indicated that the three figures were the incarnation of the phrase written on the pediment: "Dominant le tout, trois personnages semblent incarner la phrase qu'ils montrent écrite sur le fronton *Lasciate ogni speranza voi ch'entrate*" (*Le Figaro* supp., January 16, 1886). However, Grappe says that as far as he knows a banderole with these words from Dante was never present (1944, no. 58).

3. The comparison of *The Three Shades* and this episode from Dante was noted by Mireille Garcia de Franca, *Rodin y Zola*, Havana, 1946, pp. 123-26.

4. Rodin was among the subscribers to Muybridge's photographic study of human and animal movement, *Animal Locomotion*, 1887 (Aaron Scharf, *Art and Photography*, London, 1968, p. 168).

5. The idea for a group of three figures atop *The*

Gates of Hell may have derived from the three statues by Andrea Sansovino surmounting Ghiberti's *Gates of Paradise* in Florence, to which Rodin's *Gates* have frequently been compared (William Harlan Hale, *The World of Rodin*, New York, 1969, p. 89).

6. Ill. *Kunst für Alle*, 11 (1905), p. 311.

7. Rodin owned two seated Buddhas, but it is uncertain when he acquired them. His interest in Oriental art is also attested to by his article on Indian sculpture of 1913, "La Danse de Civa," *Ars Asiatica*, III (Sculptures Civaïtes), Brussels/Paris, 1921. This version of *The Three Shades* suggests that Indian sculpture had some impact on his own art.

8. Lami says the figures were mechanically enlarged (p. 172). Ill. *Gazette des Beaux-Arts*, ser. 3, 28 (August, 1902), p. 129.

9. Ill. *Die Kunst*, 23 (October 15, 1910), p. 42. We do not know the location of casts of the head in modern collections.

10. Inter-Departmental Memorandum, Office of the Recreation and Park Department, San Francisco, October 19, 1962, to Mr. Rolph from Martin Snipper; Recreation and Park Commission archives.

11. Excerpt from the minutes of the Board of the Park Commission, November 28, 1924, in a letter of November 7, 1962, from M. B. Connolly to all Commissioners; *ibid.*

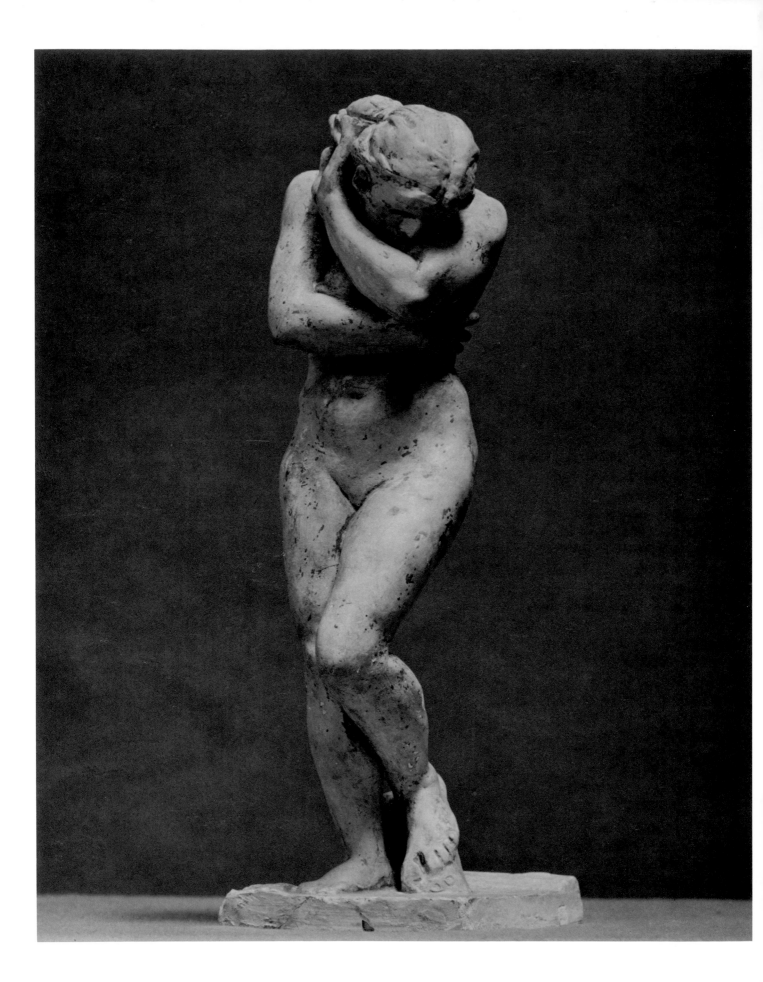

21
Eve

Plaster, tinted flesh color with specks of clay and patches of yellow-green; traces of piece mold
30 x 11 3/8 x 9 1/4" (76.2 x 28.9 x 23.5 cm)
Signed: Modèle pour le bronze (in ink, base, top right front) and Eve [?] [illegible] Rodin/
 Rodin (base, top left)
1949.15

Rodin's touching depiction of Eve comments upon the consequences of human frailty and expresses one of his attitudes on the condition of woman. Most of the figure is carefully and smoothly modelled, but certain details, like the flattened right foot, remain unrefined. Her weight rests on her right leg; her left leg is bent, the foot resting on a raised wedge.[1] As if for protection, Eve tightly clasps her breasts and hides her bent head in her arms. The cowering pose and raised arms signify the shame and remorse appropriate to the biblical originator of sin.

This work is unusual in the clarity of the subject; it has never been associated with anyone but Eve. Rodin's choice of Eve as a theme for a large figure reflects the subject's popularity in the Salons after 1850. Representations of Eve frequently recur in Rodin's work, probably a result of his meditation on sin while creating *The Gates of Hell*.[2]

Though not copying specifics, Rodin found in earlier representations of Eve examples which he used to fortify his own conception. The heavy figure of *Eve* with its peculiar rippling muscles recalls Michelangelo's Eve being driven from Eden, on the Sistine Chapel ceiling. The enigmatic turned-out left hand of Rodin's figure could reflect a similar gesture made by Michelangelo's expelled Adam, who thus attempts to ward off the angel's driving sword.[3] The position of the legs—also found in Rodin's *Adam*—echoes a feature typical of Michelangelo's sculpture.

Eve can be seen as the archetype of the fallen woman who is responsible for the sins of mankind—a view still current in Rodin's time. Still, nothing in Rodin's sculpture suggests that she is in herself, evil. A curious self-sufficiency surrounds her as she withdraws languidly into herself; she seems to be both judge and victim. The artist's sympathetic treatment may be a result of his veneration for womankind, that all-pervasive concern of nineteenth-century artists. This general preoccupation with the female gave special importance to the first woman. Balzac considered woman superior because of her later creation:

> Last-issued from the hands that shaped the worlds, she must be the purest expression of the divine thought. Then she is not, as man is, taken from the primordial granite which was soft clay in the fingers of God; no, drawn from the supple and yielding substance of the side of man, she is a transitory creation between man and angel. So you see her as strong as a man and as delicately intelligent because of her sentiment as an angel. Was it not necessary that the two

natures be united in her in order that she be entrusted with always bearing the species in her heart? A child, for her, is it not all humanity?[4]

Balzac's statement is one of many in which Eve is extolled as the first example of the special qualities of woman. Rodin's conception is particularly close to Hugo's eulogy:

Eve offered to the blue sky her holy nudity;
Blond Eve admired the dawn, her rosy sister.
Flesh of woman! ideal clay! oh marvel!
Oh sublime penetration of the spirit
Into the loam that the ineffable Being kneaded!
Matter where the soul shines through its shroud!
Mud where one sees the fingers of the divine sculptor.[5]

In fact, Rodin's own comment on Eve parallels Hugo's poem: "Venus, Eve, weak terms for expressing the beauty of woman."[6]

Because of her biblical role as the originator of sin, it is not surprising that Rodin once considered using *Eve*, with her counterpart, *Adam*, as prominent appendages to *The Gates of Hell*.[7] Rodin sought official permission to add these to his door, but his request was not granted. This incident helps to ascertain the date of the work, since the letter of request was written in 1881.[8]

We are uncertain which of the several versions of *Eve* now existing corresponds to the first conception. Examination of the vast number of casts and marbles reveals two basic types: one corresponds to the Legion of Honor's half-life-size version (ca. 76) another to the life-size version (ca. 170 cm). The substantial differences between the two indicate a probable change of models and considerable reworking. Indeed, anecdotes about Rodin's relationship to his model describe both an Italian and an English sitter.[9] The small version has smoother modelling, more stylized hair—with a chignon on either side of the head—and different proportions than the life-size version. The larger *Eve* has sleeker lines, less-finished modelling and a bunch of hair only on the right side of her head. The two types also differ in the position of the left hand and left foot. In the large version, the thumb of the left hand rests on the shoulder with the fingers placed flat against the head. In the smaller *Eve*, the thumb is raised from the shoulder to join the fingers, the ring finger moves forward and the index and middle fingers are hidden in her hair. Finally, the left foot of the larger version is placed somewhat higher than in the small figure. The physical appearance of these two types does not, in itself, suggest their order of creation, though indications suggest that the small version exemplified by the Spreckels' cast came first. An illustration in a periodical of 1889 shows this type.[10] Furthermore, a half-life-size version was exhibited in London in 1883, and the first marble acquired by Auguste Vacquerie in 1886 also was half-life-size.[11] The large *Eve* was exhibited only in 1899, but we cannot be sure that it was not created earlier. Certainly the small *Eve*, with its smoother modelling and exaggerated musculature, seems closer to Rodin's sculptures of the 1870s—for example, the female figure in *The Call to Arms* (cat. no. 36) and *Bellone*—and the large *Eve* more like the freer treatment which develops several years later.[12] Unless further information becomes available, the question of which version was first must remain unsolved.

No mechanical enlargements and reductions of *Eve* have been recorded: the two types remain in distinct sizes. The first bronze casts were made in the 1880s, but the version cannot be identified.[13] The small version was edited by Griffoul and Lorge, a foundry which cast for

144

Right: *Eve*. Cat. no. 21.

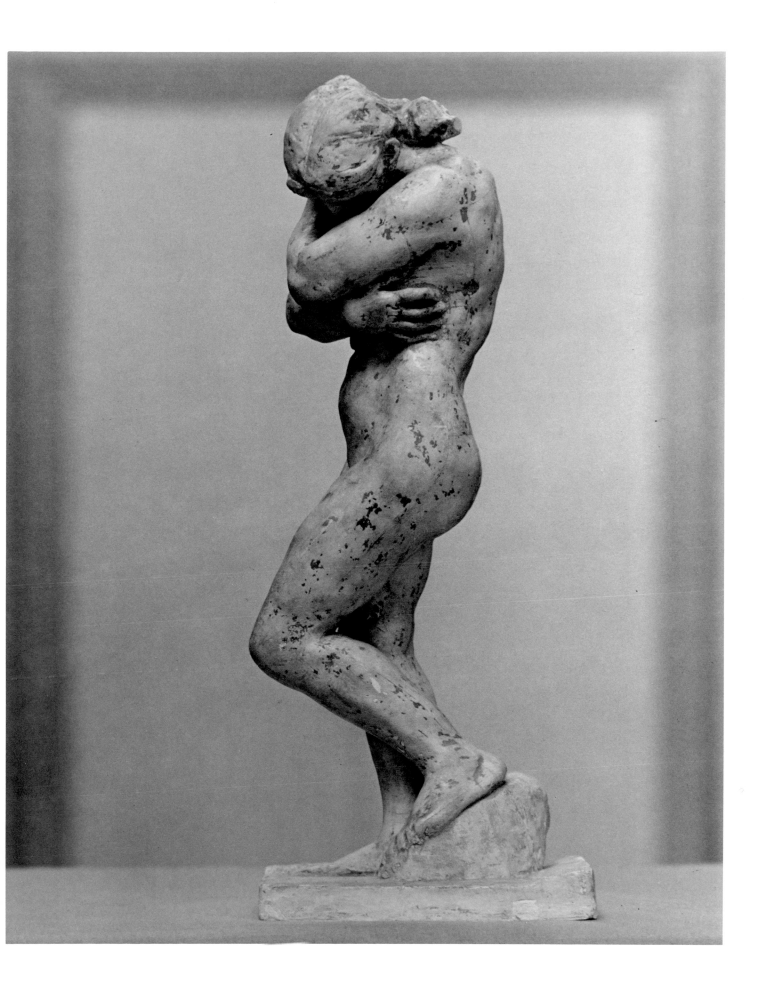

Rodin between 1887 and 1895.[14] Subsequent casts of this version were made by Alexis Rudier, beginning at least by 1905,[15] and, after 1954, by Georges Rudier. According to the inscription on the museum's plaster, this piece is the model for one of the bronze editions. Numerous marble versions were based on the half-life-size *Eve*; from these, bronze casts have been made. One edition of such bronzes was made by L. Perzinka, Rodin's founder from 1896 to 1901.[16] Of the large version, bronze editions are known by Alexis Rudier (at least by 1906)[17] and by Georges Rudier. Several marbles exist which correspond in size to the life-size bronze.[18]

Before loaning the plaster *Eve* to the Legion of Honor in 1924, Mrs. Spreckels kept it in her home.[19]

NOTES

1. This wedge is the remnant of the *talonnière* that models used to help them keep their bent leg in position. Sometimes sculptors modelled this object as a means of strengthening their sculptures.

2. Other works related to this theme include *Eve et le Serpent*, 1885 (Grappe, 1944, no. 121); *Adam et Eve*, ca. 1884 (Grappe, 1944, no. 119); *The Hand of God* (see cat. no. 6); *Création de la Femme*, 1905 (Grappe, 1944, no. 344). A drawing entitled "Eve," related to the sculpture only in the *contrapposto* stance and lowered head, is illustrated by Maillard (p. 17).

Inscription: *Eve*. Cat. no. 21.

3. The same gesture as well as the *contrapposto* stance is used by a figure at the right side of the tympanum of *The Gates of Hell*. Since *The Gates* figure is the early forerunner of the various versions of the piece (usually known as *Méditation* or *Voix intérieure*), it is interesting that the later versions are sometimes associated with *Eve*. Writing in 1913 W. Francklyn Paris calls a marble version of *Méditation* then in production *Eve* ("Rodin as a Symbolist," *International Studio*, XLIX, p. *xliv*). A photo-montage by Bulloz of the *Shade* and *Meditation* is referred to as *Adam et Eve* by Coquiot (*Rodin à l'Hôtel de Biron*, opposite 126). The cowering pose of Rodin's *Eve* has been compared with Houdon's *Hiver* or *Frileuse* of 1783 (Louis Réau, *Houdon, sa vie et son oeuvre*, I, Paris, 1964, p. 244). Rodin probably knew one of the several replicas of this work—one of which entered the Louvre in 1881—or one of the later interpretations by other sculptors.

4. " . . . Sortie la dernière des mains qui façonnaient les mondes, elle doit exprimer plus purement que toute autre la pensée divine. Aussi n'est-elle pas, ainsi que l'homme, prise dans le granit primordial devenu mol argile sous les doigts de Dieu; non, tirée des flancs de l'homme, matière souple et ductile, elle est une création transitoire entre l'homme et l'ange. Aussi la voyez-vous forte autant que l'homme est fort, et délicatement intelligente par le sentiment comme est l'ange. Ne fallait-il pas unir en elle ces deux natures pour la charger de toujours porter l'espèce en son coeur. Un enfant, pour elle, n'est-il pas toute l'humanité?" (*Eugénie Grandet, Oeuvres Complètes de H. de Balzac*, Paris, 1900, pp. 263-64).

5. Eve offrait au ciel bleu sa sainte nudité;
 Eve blonde admirait l'aube, sa soeur vermeille.
 Chair de la femme! argile idéale! o merveille!
 O pénétration sublime de l'esprit
 Dans le limon que l'Etre ineffable pétrit!
 Matière où l'âme brille à travers son suaire!
 Boue où l'on voit les doigts du divin statuaire.

("La Conscience," *Oeuvres Complètes de Victor Hugo: La Légende des Siècles*, I, Paris, 1968, pp. 30-31, 144-50).

6. "Venus, Eve, termes faibles pour exprimer la beauté de la femme" (Coquiot, *Rodin à l'Hôtel de Biron*, p. 65).

7. Biographers differ as to where the *Adam* and *Eve* were originally located (Maillard, p. 118; Rilke, *Auguste Rodin*, Leipzig, 1920, p. 30; Mauclair, p. 22; Cladel, 1950, p. 140).

8. "Rendez-moi le service de lui [M. Turquet] parler . . . de ces deux figures qui sont autour de ma Porte et qui ne sont pas officiellement commandées, ni signées" (Cladel, 1950, p. 140). Elsen reports the date of this letter, which is in the National Archives, October 20, 1881 (*Gates*, p. 67).

9. She is described as a beautiful Italian, whom Rodin liked to call a "panther" because of her elastic muscles and feline grace (Cladel, 1950, p. 142; Goncourt, *Journal*, XIV, entry for April 17, 1886, p. 115; Dujardin-Beaumetz, p. 64). Reference to an English model is made by Anthony M. Ludovici (*Personal Reminiscences of Auguste Rodin*, Philadelphia/London, 1926, p. 122) and Frisch/Shipley (p. 128-29). Most accounts relate how she became pregnant and had to stop posing for Rodin.

10. Bartlett, p. 198.

11. *Ibid.*, p. 113; Rudolf Dircks, "The 'International' at the New Gallery," *Art Journal*, LXVI (February, 1904), p. 37. The marble *Eve* owned by Vacquerie was exhibited at the Galerie Georges Petit in 1887 (Bartlett, p. 200; Grappe, 1944, no. 65). The present location of this marble is not known.

12. The large version of *Eve* is strikingly close to Rodin's *Earth*, which Grappe dates according to a practitioner, who testified that it was completed by 1884 (1944, no. 105). This date would imply that the two versions of *Eve* were created in rather close chronological succession. Unfortunately Rodin's biographers do not help us with this problem of versions, since they present conflicting points of view. Frisch, who claims to have been present when Rodin modelled a life-size *Eve* after an English girl, says that this version was executed around 1895 and that the small figure was made in 1881 (Frisch/Shipley, pp. 128-31, 415). He adds that "Eve after the sin" was written on the original plaster, though a cast with this inscription has not been found. On the other hand, Maillard indicates that the large version exhibited at the 1899 Salon was the first created, calling it "la grande figure originelle" and stating that "Eve . . . resta dans la forme première, dans son ingénuité et dans sa ligne caressante et formidable . . . ; c'était bien celle qui avait été exposée au Salon" (pp. 118-19).

13. The *Eve* exhibited at the Dudley Gallery in 1883 was a bronze ("Art Chronicle," *Portfolio*, 1883, p. 145).

14. Jianou/Goldscheider, p. 82. One of these casts is in the Joslyn Art Museum, Omaha.

15. An Alexis Rudier cast (75 cm), reportedly acquired from the artist in 1909, appeared in the Parke-Bernet sale of February 26, 1970, no. 23.

16. Jianou/Goldscheider, p. 82.

17. The Rudier cast in the Musée des Beaux-Arts, Lyon, was acquired from the sculptor in 1906.

18. Marbles were illicitly produced after Rodin's death. A marble *Eve* was seized in 1919 when a number of spurious Rodins were discovered (Georges Montorgueil, "L'Affaire des faux Rodin," *L'Illustration*, 153 [February 8, 1919], pp. 160-61).

19. A photograph showing the *Eve* in Mrs. Spreckels' home was owned by Miss Jean Scott Frickelton, Palo Alto.

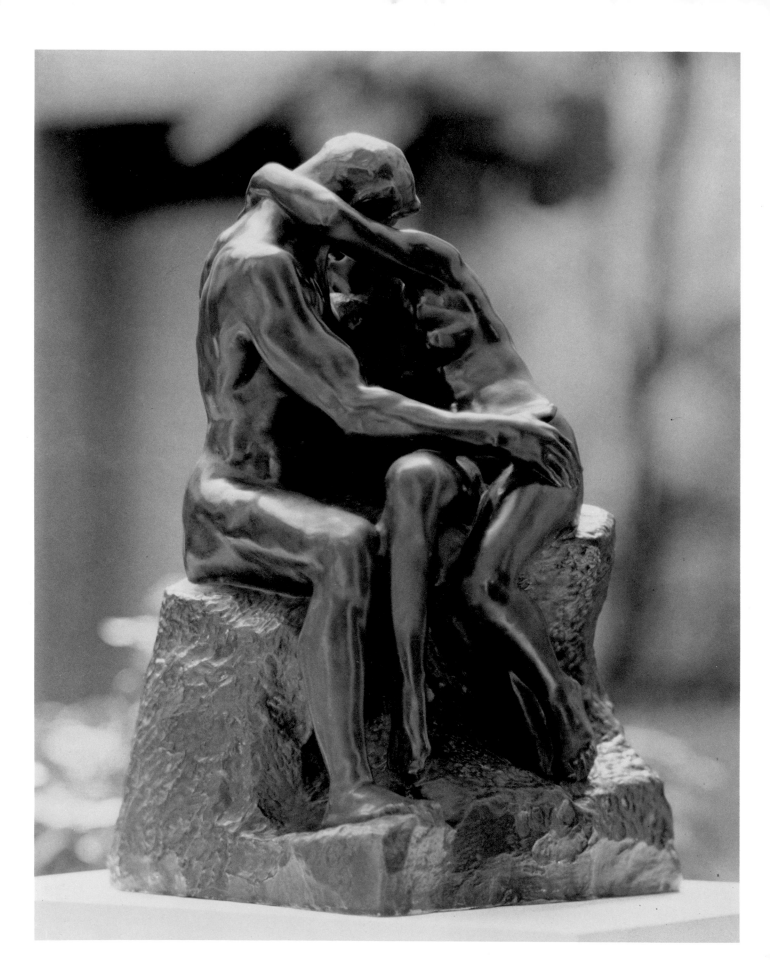

22

The Kiss
(*Le Baiser*)

Bronze, dark brown patina, traces of green and rust color
23 1/4 x 14 1/4 x 14 15/16″ (59.1 x 36.2 x 37.9 cm)
Signed: Rodin (right front, below woman's right hip)
1941.34.8

Originally conceived for *The Gates of Hell*, *The Kiss*[1] has become, as an independent sculpture, one of Rodin's most famous groups. In it, the artist examines the embrace, a frequently repeated theme in his work, concentrating on the inception of love. *The Kiss* appears mild by today's standards, but it was greeted with shock in Rodin's time; its association with Dante's tale of Paolo and Francesca did not, in the eyes of Rodin's contemporaries, justify the portrayal of the two nude protagonists. Its exhibition in Brussels in 1887 provoked comments like this one: "What! make them naked. Who ever heard of such a thing? It's dreadful."[2] When Rodin sent *The Kiss* to the 1893 Chicago Exhibition, it was branded pornographic and placed in a private room with admission by special application only.[3] On the other hand, Edward Perry Warren had to specifically request the inclusion of male genitals when he ordered a marble replica of *The Kiss* from Rodin in 1900.[4] As late as 1957, the sculpture was considered "too sexy" to appear on a poster planned for the London subway.[5] If *The Kiss* has lost its shock value for most contemporary viewers, it is still considered an appropriate symbol for sexual play, and it appears frequently in sex manuals and other erotic literature.[6]

Despite its direct presentation of a specific emotional state—the initiation of love—*The Kiss* is unexpectedly complex. Rodin contrasts the masculine and feminine nature of the partners, emphasizing the angular and muscular, yet passive figure of the man and the smooth form of the more active woman. The stiff, contorted pose of the man in juxtaposition to the feline grace of the woman approaches the incongruous. Still, man and woman are united by their intertwining embrace, suggesting movement and passion. This intricate arrangement is controlled by the pyramidal arrangement of the group as a whole.[7] Such contained compositions were typical of Rodin, though he frequently produced more striking results than *The Kiss*. Seen in hindsight, the work appears to be rather conventional. Its conventional nature was apparent to the artist when he placed a marble version beside his *Balzac*, as he did in the 1898 Salon:

> . . . I was not dissatisfied with the simplified vigour of that group [*The Kiss*], to which I had already applied these experiments. But I saw that it looked slack, that it did not hold its place beside the *Balzac* as Michelangelo's torso does not beside a fine antique, and then I understood that I was in the right path[8]

Left: *The Kiss*. Cat. no. 22.

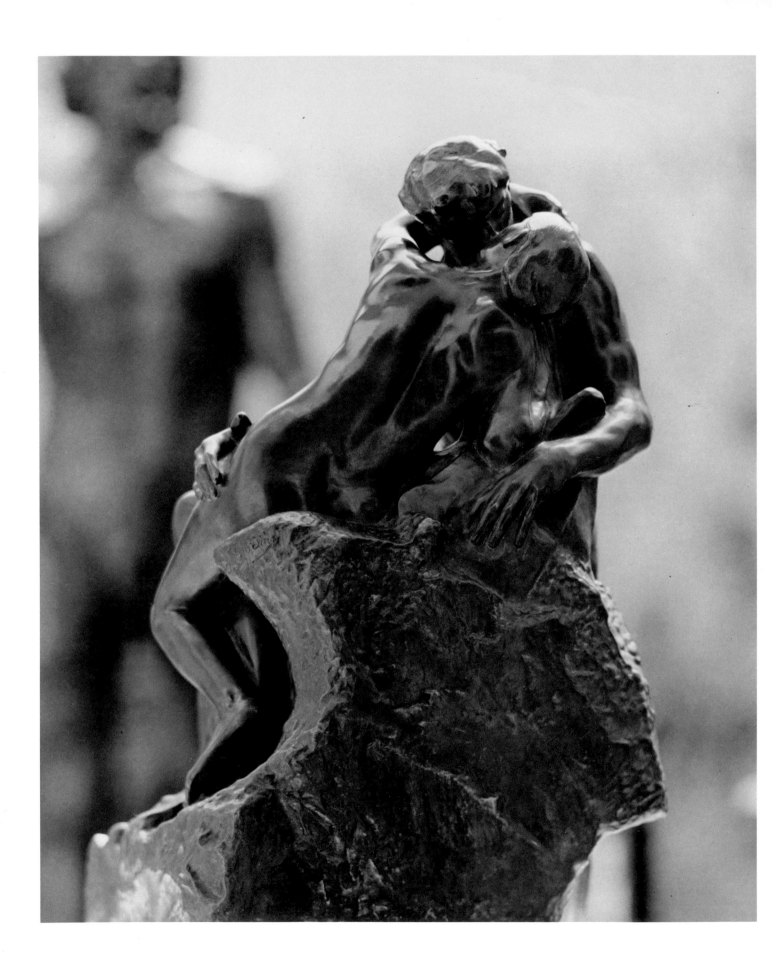

Rodin also commented about the work:

> . . . without doubt the interlacing of *The Kiss* is pretty, but in this group I did not find anything. It is a theme treated according to the tradition of the School: a subject complete in itself and artificially isolated from the world which surrounds it.[9]

When Rodin conceived *The Kiss* for *The Gates of Hell*, he was illustrating Dante's tale of Paolo and Francesca, those star-crossed lovers who so greatly appealed to the nineteenth-century sensibility and who were the subject of several other sculptures.[10] Rodin chose not the vision of the tormented lovers in hell, but the adulterous scene described by Francesca to Dante:

> One day we reading were for our delight
> Of Launcelot, how Love did him enthral.
> Alone we were and without any fear.
> Full many a time our eyes together drew
> That reading, and drove the colour from our faces;
> But one point only was it that o'ercame us.
> When as we read of the much-longed-for smile
> Being by such a noble lover kissed,
> This one, who ne'er from me shall be divided,
> Kissed me upon the mouth all palpitating.
> Galleotto was the book and he who wrote it.
> That day no farther did we read therein.
> (*The Inferno*, V: 127-38)[11]

Rodin's intention to depict the moment of Paolo and Francesca's first kiss is evident; the usually unnoticed book which the man still holds in his left hand (more visible in the original version than in the marbles or bronzes made after the marbles) clearly links the group with this episode.

Though the group was first identified with Dante's *Inferno*, Rodin endowed *The Kiss* with a broader significance. The attributes are kept to a minimum. The nude man and woman follow no traditional types; they wear no historical costumes. The woman's leg slung over the man's was a traditional symbol of sexual union,[12] yet Rodin dared to use it without explicit allegorical or literary references. An embracing couple was not new in sculpture—very likely Rodin's group received its name from Houdon's *Kiss*—but Rodin's contemporaries were confronted with two undressed people of their own era engaged in an act of love.[13] He did not justify their nudity or their actions with references to mythological narratives or classical models. With such figures, Rodin contributed to a new conception of the nude. For him the nude became a symbol of untarnished, primal nature; the act of kissing was the prelude to mankind's participation in the generative forces of the universe.

When *The Kiss* was conceived is uncertain. It was first exhibited simultaneously in Paris and Brussels in 1887; hence its usual dating of 1886.[14] Evidence suggests, however, that it was executed earlier. A similar group of intertwined lovers representing Paolo and Francesca appears in a clay model for *The Gates of Hell*; it must have been executed shortly after the commission in 1880.[15] The rigid movement and emphatic musculature of the man are related to drawings and sculptures executed at this time. The close thematic and stylistic relationship to Rodin's *Eternal Spring* also is significant, since this piece was completed by 1884.[16] Even more important, a little-noticed article published as early as 1884 refers to a group which can

only be identified as *The Kiss*.[17] Originally attached to *The Gates*, the group was considered by Rodin to be too large for use in this work, and at some point he removed it.[18]

The original ca.-86-cm version was used later for the first enlarged marble, commissioned by the French government in the 1880s; it was exhibited at the Salon in 1898. Two other marbles followed. All three were carved by practitioners.[19] Significant differences in mood and in impact can be observed between the original model and the series of marbles. Casts after Rodin's model preserve the more rigorous modelling and texture of the clay, qualities lost in the marbles. In the original conception, the man's right hand hovers over the woman's thigh, but in the marbles it is placed directly on her leg. The marble versions of *The Kiss* greatly attracted Rodin's admirers. Perhaps for this reason, most bronze and plaster casts are based on one of them. Such casts proliferated, especially after Rodin gave the well-known art bronze firm of Barbedienne the right to reproduce *The Kiss* and the *Eternal Spring*. From 1898 to 1918, Barbedienne edited *The Kiss* in four sizes, issuing 319 bronzes in all.[20]

The founder and the casting date of the Spreckels' bronze are unknown. But the bronze was purchased by Mrs. Spreckels from Loïe Fuller in 1915 and was loaned to the Legion of Honor in 1924. The imprecise rendering of details and the dull patina prevent this bronze from being ranked with the best casts of this work.

NOTES

1. *The Kiss* was first called *La Foi*, and *Francesca et Paolo*; in 1887, it was called *Les Amoureux*. It was also called *Le Baiser*, and later *Intimité* and *Adam et Eve* (Grappe, 1944, no. 166).

2. Quoted in Bartlett, p. 225.

3. Lawton, p. 219; L. Weinberg, *The Art of Rodin*, New York, 1918, p. 18.

4. Osbert Burdett and E. H. Goddard, *Edward Perry Warren*, London, 1941, p. 259.

5. Descharnes/Chabrun, p. 133.

6. William Harlan Hale, *The World of Rodin*, New York, 1969, p. 15. Recently a bronze cast of *The Kiss* appeared on the cover of Julius Fast's *The New Sexual Fulfillment*, Berkeley, 1972.

7. Rodin pointed this composition out to Helene von Nostitz, following a discussion of movement in the figures of Raphael and Michelangelo: "But I have added a third movement, the triangle, into which I compose my group *The Kiss*" (*Dialogues with Rodin*, New York, 1931, p. 14). This point is illustrated by a drawing on page 15.

8. Mauclair, p. 73.

9. *La Revue*, November 1, 1907, p. 105 (quoted in Elsen, *Gates*, p. 88).

10. A different group representing Paolo and Francesca appears in the lower portion of the left door of *The Gates of Hell* (Grappe, 1944, nos. 183 and 184). The story of Paolo and Francesca continued to inspire later works by Rodin (Grappe, 1944, nos. 269 and 342). Indeed, the theme was so important in Rodin's *oeuvre* that many writers use it almost interchangeably with "lovers." The *Je suis belle* group, the *Metamorphoses of Ovid*, *The Eternal Idol* and the *Eternal Spring* have all been associated with Paolo and Francesca.

11. Dante, *The Divine Comedy*, trans. Henry Wadsworth Longfellow, Boston/New York, 1913, p. 19.

12. For a long discussion of this tradition, see Leo Steinberg, "Michelangelo's Florentine *Pietà*: The Missing Leg," *Art Bulletin*, L:4 (December, 1968), pp. 343-53. This compositional arrangement along with its connotations survived into the nineteenth century,

when it was a common part of the artistic vocabulary. Countless examples are represented in sculpture. On the general iconography of the kissing theme, see Nicolas J. Perella, *The Kiss, Sacred and Profane*, Berkeley/Los Angeles, 1969.

13. Alfred de Lostalot, writing in the *Gazette des Beaux-Arts*, described the work as "a group in bronze that Houdon would have called 'The Kiss'" (ser. 2, 25[June, 1887], p. 527). The models for the group were the popular Parisian model, Carmen Zenobia Viconti, and Liberio Nardone (Alley, p. 225; Emil Waldmann, *Auguste Rodin*, Vienna, 1945, p. 76).

14. Grappe, 1944, no. 166. In Paris *The Kiss* was exhibited at the Galerie Georges Petit and in Brussels at the Exposition Générale des Beaux-Arts (Bartlett, pp. 200, 224). According to Sommerville Story, ". . . a group of admirers contributed in 1886 for the casting of 'The Kiss' " (*Rodin*, London, 1961, p. 9).

15. Elsen, *Gates*, pl. 43.

16. Rodin offered a cast of the *Eternal Spring* to Robert Louis Stevenson in 1884 (Cladel, 1950, p. 147).

17. An anonymous writer includes a *Paolo and Francesca*, a "lovely and affecting" group, among the works already existing in the round for *The Gates* ("Current Art," *Magazine of Art*, VI [1883], 176). The following year Julia Cartwright mentioned a sculpture in the round for *The Gates* which showed "the very instant of the kiss, and that with such a union of purity and passion of lofty art and intense humanity" ("Francesca da Rimini," *Magazine of Art*, VII [1884], 139).

18. Bartlett, p. 224. Exactly when the group was removed is uncertain. It seems to have been present still in January, 1886, when it was described as being in the panel opposite the *Ugolino* by Félicien Champsaur ("Celui qui revient de l'Enfer: Auguste Rodin," *Le Figaro* supp., January 16, 1886).

19. Alley, p. 225. Rodin probably received the commission for the first marble shortly after Roger Marx, who helped him obtain it, became secretary to Castagnary, then director of the Fine Arts department (Lawton, pp. 62–63). In 1888 Rodin discussed the commission with Goncourt, saying that, unlike his usual practice, he would not be able to make a larger-than-life-size version before the marble would be executed (*Journal*, entry for February 26, 1888, v. XV, p. 86). The model was reproduced and enlarged by a mechanical technique and carved in marble by Turcan (Lami, p. 171; letter from René Chéruy, September 5, 1955; Alley, p. 225). The marble replica now in the Tate Gallery in London was commissioned in 1900 by Edward Perry Warren through the Carfax Gallery, and it was completed by 1904 (Burdett and Goddard, *op. cit.*, p. 258. See n.4). A third marble, now in the Ny Carlsberg Glyptotek, was commissioned by Carl Jacobsen in 1902. It was carved by Dolivet (Alley, p. 226). The posthumous marble in the Rodin Museum, Philadelphia, has not been included in this historical discussion, because it was carved after Rodin's death.

20. Jianou/Goldscheider, pp. 82, 100. Rodin reserved the right to have casts of different sizes made by the sand-casting method. Apparently Rodin gave his approval to a commercial reproduction as well. A reduction by the mechanical process developed by A. Collas in the National Gallery, Washington, bears the dedication "Hommage à Madame Kate Simpson en/ souvenir des heures d'atelier, Sept. 1902. A. Rodin."

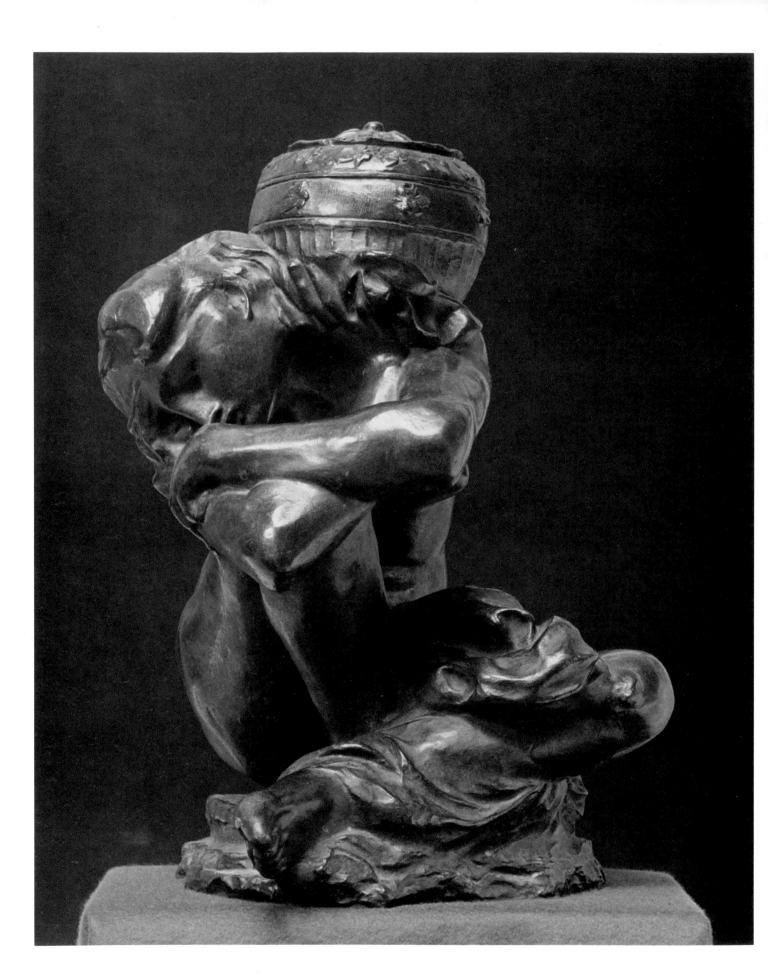

23

Fallen Caryatid Carrying an Urn

(*Cariatide Tombée Portant une Urne*)

Bronze, dark brown to dark green patina with traces of natural bronze
16 x 10 7/8 x .9 5/8″ (40.7 x 27.6 x 24.4 cm)
Signed: A. Rodin No. 2 (base, right side)
Stamped: A. Rodin (inside), and Alexis. Rudier. / Fondeur. PARIS. (base, rear, bottom)
1950.60

In his *Fallen Caryatid Carrying an Urn*, Rodin invigorates a type of supportive figure long used in architecture, transforming a decorative device into a sculpture. Unlike the erect caryatids of ancient Greece or the collapsing ones of the Baroque period, Rodin's slender nude has languorously succumbed to her burden, though her limbs are drawn inward in a last halfhearted effort to support it. This contracted figure was originally located in the upper left corner of *The Gates of Hell*, in the manner of those contorted supportive figures on medieval doorways. Closer to hand was Carpeaux's series of stooping figures which continue a sculptural tradition going back to antiquity. This figural type was common not only with the fine arts in the mid-nineteenth century but also in decorative arts. Rodin was certainly aware of striking examples by Alfred Stevens and Jules Dalou.[1]

With artists like Stevens and Dalou, what had once been small decorative motifs became nearly independent sculptural elements. This treatment was part of a general tendency in the decorative arts of the second half of the nineteenth century on which Rodin capitalized.[2] He uses the collapsing posture of the supportive figure to evoke a pervasive mood of despondence. The urn carried by Rodin's caryatid still reminds the spectator of the *objets d'art* fashionable in those years; without the lid it could serve as a *jardinière*. In this work, the urn takes on a deeper significance. Its funereal associations, together with the figure's pose, evoke unequivocally a mood of despair and mourning. The urn carried by the crouching caryatid may allude to Racine's *"urne fatale"* (*Phaedra*, IV:6), which contains the destiny of mortals sent to hell in eternal perdition. The gloomy associations of the urn also made it a fitting symbol of bereavement, and this statue is said to have been used as a tomb ornament.[3]

The associations with fatality are reinforced by another version of this sculpture, the *Fallen Caryatid Carrying Her Stone*. With this attribute, the *Fallen Caryatid* appears to be one of those souls in Dante's purgatory who expiate their sins by carrying huge stones on their back. In a broader sense, the stone is a symbol of the caryatid's mental suffering, of the burden life condemned her to carry.[4] This motif also makes her the female counterpart of Sisyphus, who was fated to eternally roll and reroll his stone up a hill in Hades.[5]

Besides the numerous replicas in bronze, plaster and terracotta of the *Fallen Caryatid*

Left: *Fallen Caryatid Carrying an Urn*. Cat. no. 23.

Carrying Her Stone and the *Fallen Caryatid Carrying an Urn* in the size of the original figure on *The Gates* (ca. 41-43 cm), Rodin made enlargements of these two variants.[6] Still another variant shows the same caryatid holding an orb.[7] The figures in all three are much the same, though slight differences are apparent in the bases. The three marble versions of the stone-bearing caryatid vary in the shape of the stone and of the base as well as in the treatment of the stone. Later an altered version of the caryatid was combined with a second figure to form the group known as *The Fallen Angel* (see cat. no. 4).

Mrs. Spreckels acquired the *Fallen Caryatid Carrying an Urn* from Eugène Rudier in 1949 and donated it to the Legion of Honor the following year.[8]

NOTES

1. Stevens' caryatids which supported a chimney at a private London residence (Dorchester House, commissioned around 1858 by R. S. Holford) are particularly close to Rodin's caryatid in their contorted postures. Rodin probably saw the plaster models for these caryatids when he traveled to England in 1881, since they were then at the Victoria and Albert Museum at South Kensington, an institution that any artist would certainly have visited, particularly Rodin, who was interested in the decorative arts as well as sculpture. In addition, the painter, Alphonse Legros, with whom Rodin stayed during his visit to England, was a friend of Stevens and worked to achieve Stevens' lasting fame after the sculptor's death in 1875 (see Kenneth Romney Towndrow, *Alfred Stevens, Architectural Sculpture*, London, 1939, pp. *xvii*, 2 and pl. 9). As an admirer of Stevens and as a former professor at the South Kensington School of Art, Legros would likely have told Rodin of Steven's caryatids, if Rodin did not already know of them through French publications. Stevens' crouching nudes, along with many other of his works, were reproduced in Walter Armstrong's series of articles on the sculpture in *L 'Art*, v. IV (1880), pp. 150-52. Dalou, whom Rodin had known since the 1850s, created several crouching figures to serve supportive and decorative functions for the newly built (1864) Hôtel de Païva. On Rodin's participation in Second Empire architectural programs, see: J. de Caso, "Ein vergessenes Frühwerk Rodins. Die Skulpturen an der Loggia des Théâtre des Gobelins," *Beiträge zum Problem des Stilpluralismus. Studien zur Kunst des neunzehnten Jahrhunderts*, vol. 38, Prestel-Verlag, Munich, 1977, pp. 149-58.

2. One aspect of Rodin's involvement with the decorative arts is discussed in H. W. Janson, "Rodin and Carrier-Belleuse: the Vase des Titans," *Art Bulletin*, L:3 (September, 1968), pp. 278-80.

3. Frisch/Shipley, p. 414. Nothing more is known of this project. When the *Fallen Caryatid Carrying Her Stone* was exhibited at the 1909 Salon d'Automne, it was indicated that three identical figures were intended to support a tomb slab, a project that was never realized (Grappe, 1944, no. 64). Grappe dates the caryatid with stone 1881 and the figure with urn 1883 (1944, nos. 63 and 91). He also informs us that the

stone-bearing caryatid was exhibited at the Galerie des Arts Libéraux in Paris in 1883. Although the *Fallen Caryatid* may well have been created in the early 1880s, the date of its addition to *The Gates* is not certain. In his 1889 article, Bartlett describes a mother and child group where the *Caryatid* is now located on *The Gates* (p. 249).

4. Dante, *Purgatorio*, Cantos X and XI. The Dantesque associations of the *Fallen Caryatid* have been previously overlooked, yet the poet's comparison of these burdened souls to caryatids makes it particularly compelling: "As to sustain a ceiling or a roof,/In place of corbel, oftentimes a figure/Is seen to join its knees unto its breast,/Which makes of the unreal real anguish/Arise in him who sees it" (Canto X:130-32, Henry Wadsworth Longfellow trans., Boston and New York, 1913, p. 281). Rodin may have known Flaxman's illustration of this scene with six male figures bent low beneath their squarish stones (illustrations for *The Divine Comedy* [1793], pl. 50). Rodin owned a copy of Flaxman's *Divine Comedy*, engraved by Revoil, although we do not know when he acquired it (C. Goldscheider, "Rodin: Influence de la gravure anglaise sur le projet primitif de la 'Porte de l'Enfer,'" *Bulletin de la Société d'Histoire de l'Art français* [1950], pp. 51-52). The use of the stone to illustrate life's burdens may have had personal connotations for Rodin; certainly the stone has special symbolic significance for the sculptor. In a letter to Helene von Nostitz, Rodin used the metaphor in describing his own life: "Greet Apollo, the king of the sea, as we did, the while I shall shift my stone to the other shoulder and I shall remember the Italian life anew" (Helene von Nostitz, *Dialogues with Rodin*, New York, 1931, pp. 71-72).

5. Sisyphus was evoked by French poets as an image of struggle in the face of futility, of courage and of suffering. In his *Sagesse*, Verlaine laments: "J'avais peiné comme Sisyphe" (II: 1; *Oeuvres complètes*, v. 1 [n. p.], 1959, p. 284). Baudelaire wrote in his "Le Guignon" (which incidently was one of the poems illustrated by Rodin for Paul Gallimard): "Pour soulever un poids si lourd,/Sisyphe, il faudrait ton courage!" (*Fleurs du Mal*, XI: pp. 1-2). Aside from their common interest in such images, a more general

association between sculptor and poet was suggested by Bartlett (p. 249), who said a figure of *Sorrow* was inspired by Baudelaire. From his description we recognize this as the *Fallen Caryatid*: ". . . a young girl pressed down by a weight upon her shoulder"

6. The enlarged *Fallen Caryatid Carrying Her Stone* was exhibited at the Salon d'Automne of 1909 as *Destinée* (Grappe, 1944, no. 64). Apparently casts of the small version were already being produced in quantity during the 1880s, if we correctly identify Bartlett's *Sorrow* with the *Fallen Caryatid* (see n. 2). Of the *Sorrow*, Bartlett (p. 249) wrote: "This supple little creature, not more than eighteen inches high, is regarded by the sculptor and his friends as one of his very best compositions, and many copies of it have been made for the latter in both marble and bronze. Its commercial success was cut short at the beginning, for the first duplicate was ordered by an art dealer, who after it was completed, decided that he did not like it."

7. The caryatid carrying a sphere was completed at least by 1908, when it was illustrated by Otto Grautoff (*Auguste Rodin*, Bielefeld/Leipzig, p. 67). Besides these three variants, Frisch/Shipley say that a figure with no burden was in Argentina (p. 414). The location of such a figure is not known. Possibly Emil Waldmann refers to the same figure when he discusses an enlarged version of the *Fallen Caryatid Carrying Her Stone* decorating the façade of a house in Buenos Aires (*Auguste Rodin*, Vienna, 1945, 75. Cf. Grappe, 1944, no. 64).

8. The list of Rodin sculptures purchased by Mrs. Spreckels from Eugène Rudier in October, 1949, was formerly in the collection of Miss Jean Scott Frickelton, Palo Alto.

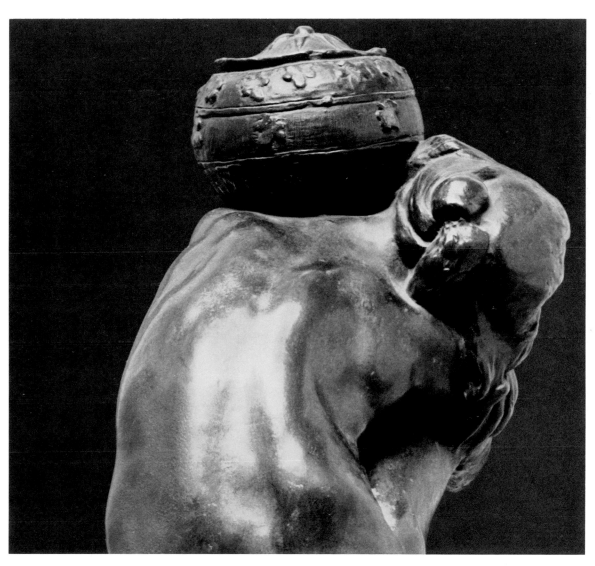

Fallen Caryatid Carrying an Urn. Cat. no. 23, detail.

157

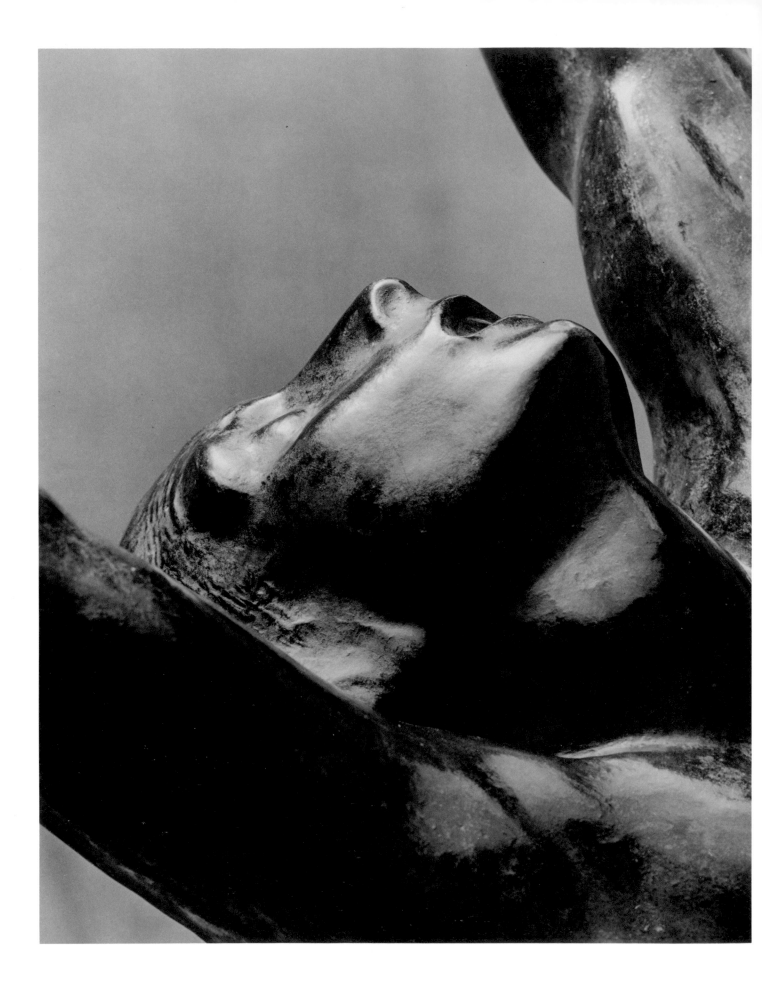

24

The Prodigal Son

(L'Enfant Prodigue)

Bronze, black patina with traces of green, red, blue, and natural bronze
54 x 28 x 34 1/2" (137.2 x 71.2 x 87.6 cm)
Signed: A. Rodin (base, top right front corner)
Stamped: A. Rodin (inside, rear), and: Ais RUDIER. Fondeur. PARIS. (rear, right)
1940.137

This kneeling figure, whose entire body proclaims the intensity of his passions, is one of Rodin's most convincing portrayals of suffering and longing. The simple gesture of the body conveys the idea of anguish with unequivocal directness. The extreme stretching reproduces in the viewer the intensity of the figure's striving, perhaps the spiritual striving described by so many in the nineteenth century.[1] Furthermore, in torso and legs the asymmetrical distribution of the muscles, conflicting in their movements,[2] augments the expression of anxiety, as Rodin himself explained: "I have accented the swelling of the muscles which express distress. I have exaggerated the straining of the tendons which indicate the outburst of prayer."[3]

Few before Rodin had achieved such a simple expression of the paroxysms of emotion. Artists had long used the gesture of the arms raised over the head as an expression of intense sorrow and despair; for instance, the kneeling woman in Blake's "Plague" (*Europe*) approaches the pithiness and poignancy of Rodin's figure.[4] Rodin raised this formal arrangement to a new level, altering it, endowing it with force, to confront us not only with a sculptural manifestation of an extreme psychological state but with an image of supreme beauty.

Rodin evokes the emotion of the moment of the biblical anecdote when the son-turned-swineherd decided to ask his father for forgiveness and kneels in prayer.[5] However, Rodin removes any specific references to the parable and presents instead simply a personage stripped of all restraint, his emotions laid bare. Thus Rodin's concise and telling image of human despair lends itself to a variety of interpretations as indicated by its many titles. It has been called *Child of the Age* (a reflection of a common attitude toward the nineteenth century as a period of despair and alienation), *Prayer*, *Invocation*, the *Supreme Appeal* and the *Prayer of the Abandoned Child*, as well as two unexpected titles referring to war, *Vae Victis* (Woe to the Defeated) and *Dying Warrior*.[6]

The Prodigal Son's general expression of despair and hopelessness—Rodin saw the figure's exertions as futile since his cries were "lost in the heavens"[7]—made this figure an appropriate one to join the others on *The Gates of Hell*. In that work, it is attached to a female figure, forming the group known as *Fugit Amor* (see cat. no. 25).

Left: *The Prodigal Son*. Cat. no. 24, detail. 159

The Prodigal Son strikingly demonstrates the adaptability and reusability of Rodin's sculptures. He continually improvised new compositions from the large stock of surplus casts, whole or dismembered, that crowded his studios. As if hoping to extract the fullest content from *The Prodigal Son*, he used and reused the entire figure and its parts, thereby creating new images and suggesting new meanings. The figure of *The Prodigal Son* seems to have been first used in the *Fugit Amor* group, executed before 1887.[8] This figure appears twice on *The Gates of Hell*. Separated from his female partner, the small ca. 58.5 cm figure was placed vertically on a base, so that he appears about to topple forward. Enlarged, the isolated figure leans backward, as in the Spreckels' cast.[9] Since the head of *The Prodigal Son* is used for at least two other figures found on *The Gates*—one of Ugolino's sons and the man in the Paolo and Francesca group—it is uncertain in which context it was first employed. At some point, Rodin realized the potential of this ecstatic head and had it separately cast and carved in three sizes (h. ca. 7.5 cm, ca. 23 cm, and ca. 43 cm). Rodin even reworked the large head, using the famous Italian tragedienne, Eleanora Duse, for his model.[10] Usually called *The Head of Sorrow*, another version of this head with wooden faggots emerging from the base is entitled *Joan of Arc*.[11] Besides these reuses of *The Prodigal Son*, Rodin detached the left arm; two casts of it emerge from the chaos of *The Gates of Hell*.[12] Even the torsos and heads of *Orpheus* and *The Centauress* may be further reworkings of *The Prodigal Son*.[13]

The Spreckels' cast, purchased from Rodin in 1914 by Loïe Fuller and transferred to Mrs. Spreckels the following year, is one of several based on the stone replica by the Ny Carlsberg Glyptotek.[14] The marblelike texture of the base and the traces of chisel marks indicate the original material from which this bronze was cast. The unmodelled areas on the back reveal the original location of struts which support the stone figure in two places. These struts, which French sculptors called *tenons*, were used to strengthen the stone or marble sculpture during the carving process. Usually, they were later removed, although they were sometimes retained in figures which were moved about. Possibly the extreme pose of *The Prodigal Son* necessitated permanent retention of the struts, though these were not needed in bronze casts. Two open areas of the base allow us to observe how the separately cast figure was attached to the base with bolts.

Right: *The Prodigal Son*. Cat. no. 24.

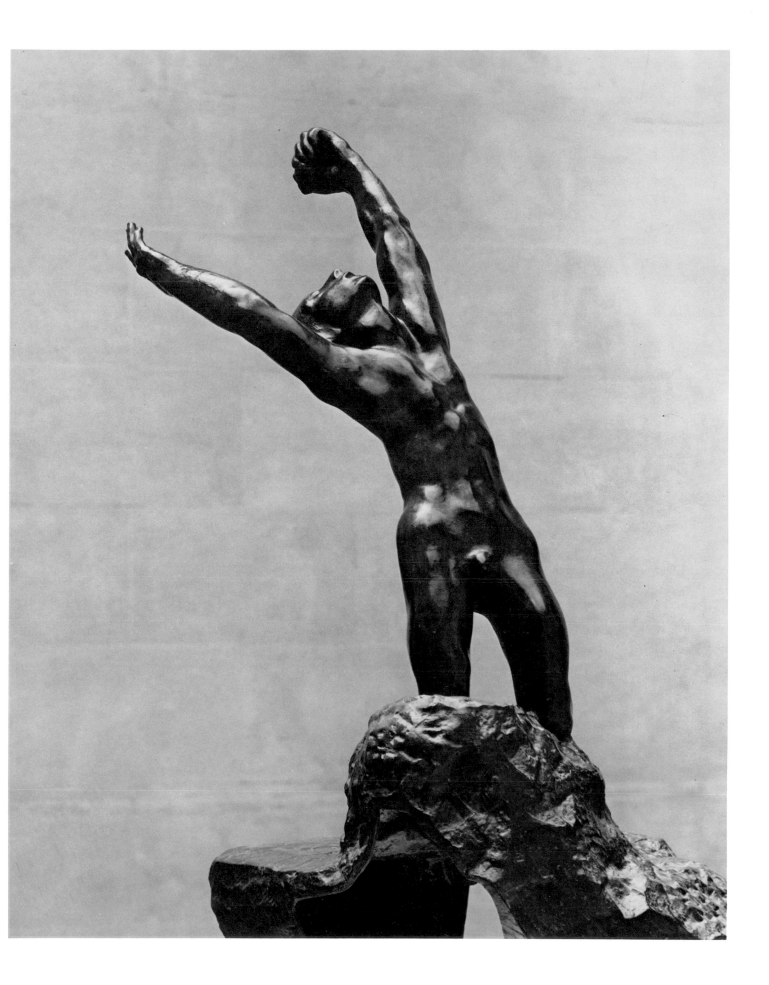

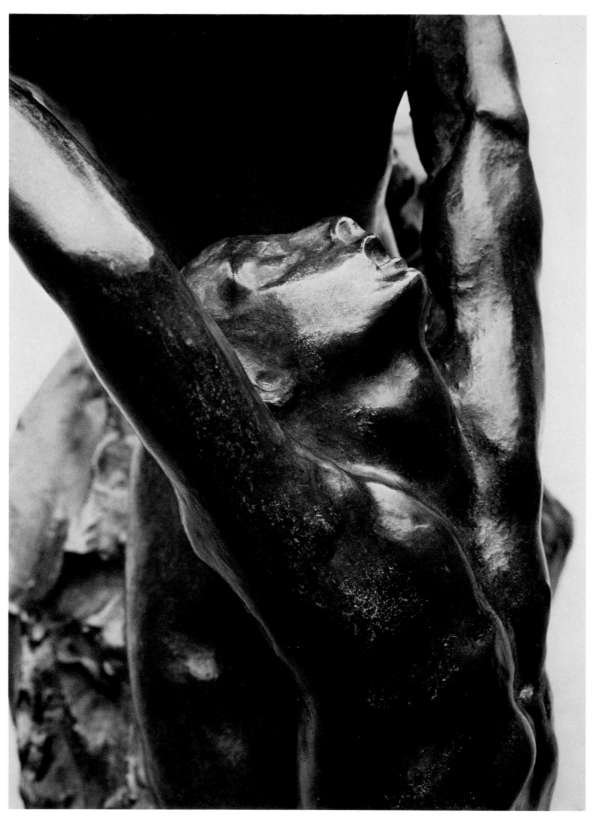

Fugit Amor. Cat. no. 25, detail.

1. Artists and writers frequently expressed the desire for spiritual flight, to rise above the common lot of man. Balzac's *Louis Lambert* is but one example among many.

2. Athena Tacha Spear has pointed out that the left arm, from arm pit to elbow, is actually 1 1/2'' (3.3 cm) longer than the same area of the right arm and that the left thigh, measured from the back, is almost 1'' (2.6 cm) longer than the right thigh ("The Prodigal Son: Some New Aspects of Rodin's Sculpture," *Allen Memorial Art Museum Bulletin* [Oberlin College], 22:1 [Fall, 1964], p. 38).

3. *On Art and Artists*, p. 48.

4. Since it has not yet been established that Rodin was familiar with Blake in the 1880s, it is uncertain whether he actually saw the striking illustration for *Europe*. It was republished in the *Works of William Blake* (1876), which he could have seen in a private collection, either in France or on his visit to England in 1881. See Cécile Goldscheider, "Rodin: l'influence de la gravure anglaise sur le projet primitif de la Porte de l'Enfer," *Bulletin de la Société de l'Histoire de l'Art Français*, 1950, pp. 49-52.

5. This moment (Luke 15: 11-32) is portrayed in Dürer's famous engraving, well known in the nineteenth century.

6. As usual, we have little information about precisely when these various titles were first used and whether they were the inventions of Rodin or of others. This figure was first exhibited at the Salon held by the literary journal *La Plume* in 1894 and was then called *Child of the Age* (Alley, p. 212; Grappe, 1944, no. 210). It was exhibited the following year in the same Salon with *l'Enfant Prodigue*, and one reviewer said that the sculptor described it as a *de produndis* (Yvanhoë Rambosson, "Le Salon des Cent," *La Plume*, no. 144 [April 15, 1895] p. 178). This title immediately became the most common designation for this sculpture. Maillard used it in his 1899 monograph (caption for ill. on p. 117), and in his 1903 essay, Rainer Maria Rilke wrote: "Rodin has called this figure 'The Prodigal Son,' but it has recently received the name—from whom or in what manner no one knows—of 'Prière'" ("Rodin hat diese Figure *Der verlorene Sohn* genannt, aber sie hat, man weiss nicht woher, auf einmal den Namen *Prière*."); *Auguste Rodin*, Leipzig, 1920, pp. 66-67. Rilke might have been referring to the illustration caption in the 1900 Rodin issue of *La Plume* (p. 70), where the sculpture is titled "Prière." Whether he selected this title or not, Rodin seems to have given it his approval, for it was used again in the 1902 Prague exhibition (catalogue no. 144). According to Grappe the piece was exhibited at the 1905 Salon d'Automne (hors catalogue) as *Vae Victis* but was seen by critics as *Le Guerrier Expirant*.

Grappe also lists other titles for the work: *Invocation*, *l'Appel suprême* and *La Prière de l'Enfant abandonné* (1944, no. 210).

7. Frisch/Shipley, p. 424.

8. The *Fugit Amor* group was exhibited at the Galerie Georges Petit in 1887, though when the male figure was detached is uncertain (Bartlett, p. 200).

9. The first enlarged version was the limestone that is now in the Ny Carlsberg Glyptotek, executed by 1899 when it was illustrated by Maillard (p. 117). Maillard indicates that Rodin still wanted to retouch it (p. 120).

10. Frisch/Shipley, p. 415. If Frisch's allegation is correct, this reworking would have taken place no later than 1907, when a photograph of Rodin and Eleanora Duse appeared in *Current Literature* with the following caption: "The great French sculptor was recently visited in the garden of his Paris atelier by Duse, whose portrait he is to execute in marble" ("The Secret of Rodin's Power," 43 [November, 1907], p. 512).

11. According to Grappe, Rodin reused this work in 1913 for a monument to Joan of Arc to be erected in the United States (1944, no. 76). He may refer to the statue to the saint planned for New York City; the committee for this undertaking included two of Rodin's friends, Gabriel Hanotaux and Pierre Loti ("Big Exhibition in Honor of Joan of Arc," *New York Times*, January 5, 1913, V.9: 1). Incidentally, another work, *The Martyr*, was designated for another Joan of Arc project in 1907 (Grappe, 1944, no. 146). The head has been known by still other titles. The marble version presented to the Dusseldorf Kunstmuseum in 1904 is called *Dernier Soupir*. The tortoise shell carved behind the head suggests a relationship to two other names for this work: *Head of Orpheus* and *Sappho*. Other titles include: *Agony*, *Head of Medusa*, *Inquietude*, *Medea*, *Mother* and *Eternal Unrest* (Grappe, 1944, no. 76, and Frisch/Shipley, p. 415).

12. One is located just above the *Fugit Amor* group in the lower right corner of the right panel, and another is just beneath the *Fugit Amor* group near the center of the same door.

13. For much of this information on versions, fragments and variations, we are indebted to Athena Spear's "A Note on Rodin's *Prodigal Son* and on the Relationship of Rodin's Marbles and Bronzes," *Allen Memorial Art Museum Bulletin* (Oberlin College), 27:1 (Fall, 1969), pp. 25-36.

14. Copies of the contracts between Loïe Fuller and Rodin and between Loïe Fuller and Mrs. Spreckels were owned by Miss Jean Scott Frickelton, Palo Alto. Mrs. Spreckels first loaned *The Prodigal Son* to the CPLH in 1924.

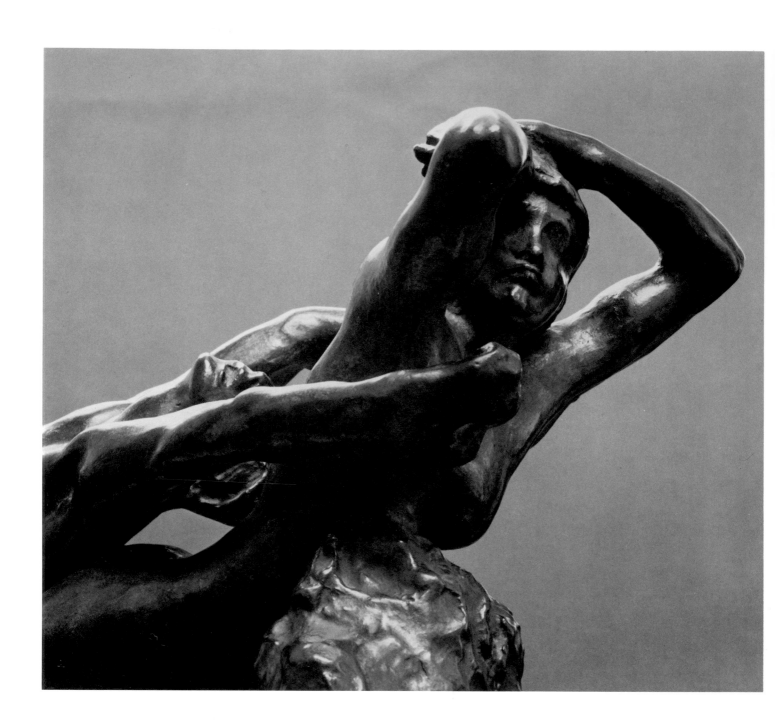

25
Fugit Amor

Bronze, dark brown to green patina with traces of rust color
14 1/2 x 7 5/8 x 17 1/2" (36.8 x 19.4 x 44.4 cm)
Inscribed: A. Rodin (base, front)
Stamped: A. Rodin (inside, rear), and: Alexis RUDIER. / Fondeur. PARIS. (base, right rear)
1942.41

This streamlined pair jet through space carried by some unseen force. Like fish the sinuous couple floats, ignoring the laws of gravity. Despite the subtle joining of the two graceful figures, their torment cannot be mistaken. The two lovers from Dante's circle of the adulterers can never escape the infernal wind. Joined back to back, their momentary union is of the most tenuous sort. The man, whom we recognize as *The Prodigal Son* (see cat. no. 24), desperately reaches out to hold fast to his female partner as he gradually slips from her back, while the woman hysterically grasps her head in fear. Gradually the two drift apart in measureless space, perhaps never to meet again.

Though specifically related to the Second Circle of Dante's hell (*The Inferno* V) and recalling traditional depictions of this subject,[1] Rodin's *Fugit Amor* has many general connotations as well which reflect common nineteenth-century attitudes towards woman. Many of the titles Rodin attached to this group have a Baudelairan flavor and suggest a characterization of woman as evil and enigmatic. The original name, *Course to the Abyss*, suggests that woman can lead to man's downfall, a theme which enjoyed great popularity in nineteenth-century literature. Other titles refer to the elusive qualities of woman and of love: *Fugit Amor* (Latin for "flight of love"), *La Sphinge*, *Dream*, *Love that Passes*, the *Chimera* and *Evocation*.[2] This enigmatic woman is most "dangerous," as Gabriel Mourey pointed out in his 1898 description of the group:

> *La Chimère* shows a woman with cold, indifferent, impassive face, her eyes looking straight in front of her. She is bearing away in her flight the poet captured by her fascinations. He clings to her, and, frail as she is, her strength is enough to carry him off. His face drawn with half-voluptuous pain, he gazes on her yearningly, as if to fathom the enigma of her being, and his whole body writhes in torture. But she flies along, listless and disdainful, her lips curling with a smile of victorious witchery.[3]

How closely Mourey's description corresponds to what we actually see is questionable; it does indicate what men of his generation expected to see in such a group. This view, of course, is of the utmost importance in understanding Rodin's own intentions. From such

Left: *Fugit Amor*. Cat. no. 25, detail.

interpretations and from Rodin's titles for the group, we realize that Rodin is less concerned with illustrating a scene from Dante than he is with using a Dantesque image to suggest the psychological barrier between man and woman, from the standpoint of a man's inability to comprehend woman, who forever seems to elude his grasp.

Several versions of the *Fugit Amor* group were made by Rodin, but we cannot ascertain the order of creation. A version existed by 1887, when a plaster was exhibited at the Georges Petit Gallery.[4] This plaster may have been one of the two versions that appear in the right panel of *The Gates of Hell*.[5] At least by the 1890s Rodin had made a small (ca. 40 cm) isolated version of the group, like the one in the Spreckels collection, which differs slightly from those attached to *The Gates*. Bronze casts of the small version have been made by Griffoul and Lorge (Rodin's founder from 1887 to 1895), by L. Perzinka (Rodin's founder from 1896 to 1901), by Alexis Rudier (Rodin's founder from ca. 1902) and by Georges Rudier.[6] The numerous casts of this size vary little except in the shape of their bases. Rodin also made a larger version in marble and in bronze. The (w. ca. 79 cm) bronze appears to be cast from one of the marbles. These carved versions differ in the size and the shape of the base as well as in certain details.[7]

Mrs. Spreckels loaned her cast of *Fugit Amor* to the Legion of Honor in 1933, prior to which it had been in her home for an undetermined amount of time.

NOTES

1. Whirlwinds of damned adulterers were depicted by John Flaxman, William Blake and Gustave Doré in their illustrations of Dante's *Inferno*. The theme and composition also relate *Fugit Amor* to Paolo and Francesca. Elsewhere on *The Gates*, Rodin depicted this pair as a similar horizontal group, an arrangement used much earlier by the famous Romantic painter Ary Scheffer in his *Françoise de Rimini* (1822).

2. Besides these titles, Grappe lists several general ones, which were probably the result of mere whims: *La Nuit*, *L'Aurore* and *Voici venir* (1944, no. 174). The work was called *Le Rêve* in the 1889 Monet-Rodin exhibition, according to Grappe (1944, no. 173). The title, *La Sphinge*, is an intriguing one. One of the most common alternative titles for the group, it is an archaic and rare form of the word "sphinx," which was revived by certain late-nineteenth-century poets, including Huysmans. The names *L'Amour qui passe* and *Le Songe* were used by Maillard in his 1899 biography (p. 158; caption 131).

3. "The Work of Auguste Rodin," *The Studio*, XIII:62 (May, 1898), p. 221.

4. Bartlett, p. 200. The group is said to have been mentioned in Paul Bourget's novel, *Mensonges*, published in the same year (Grappe, 1944, no. 173).

5. One group is located in the lower right of the right door. The other group is somewhat higher, in the center of the panel, where it juts out from the surface at right angles.

6. A Griffoul and Lorge cast was exhibited at the Feingarten Galleries, March 2 to April 10, 1971 (*Arp. Rodin*, Los Angeles, 1971, no. 40). A Perzinka cast is in the collection of Miss Julia Strachey and Professor Lawrence Gowing, New York.

7. For detailed discussions of the various versions of *Fugit Amor*, see two articles by Athena Tacha Spear: "The Prodigal Son: Some New Aspects of Rodin's Sculpture," *Allen Memorial Art Museum Bulletin*, XXII:1 (Fall, 1964), pp. 25-27, and "A Note on Rodin's *Prodigal Son* and on the Relationship of Rodin's Marbles and Bronzes," *Allen Memorial Art Museum Bulletin*, XXVII:1 (Fall, 1969), pp. 32-33.

Right: *Fugit Amor*. Cat. no. 25.

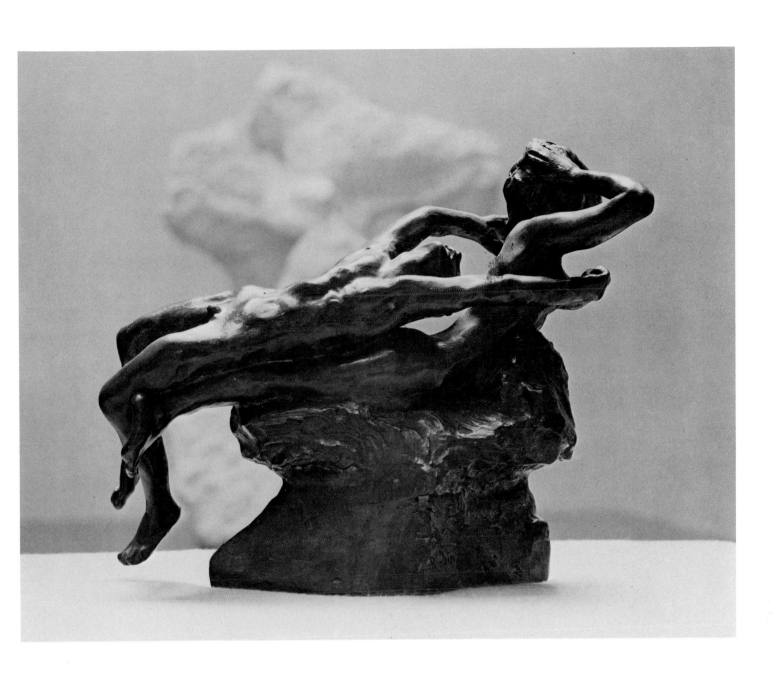

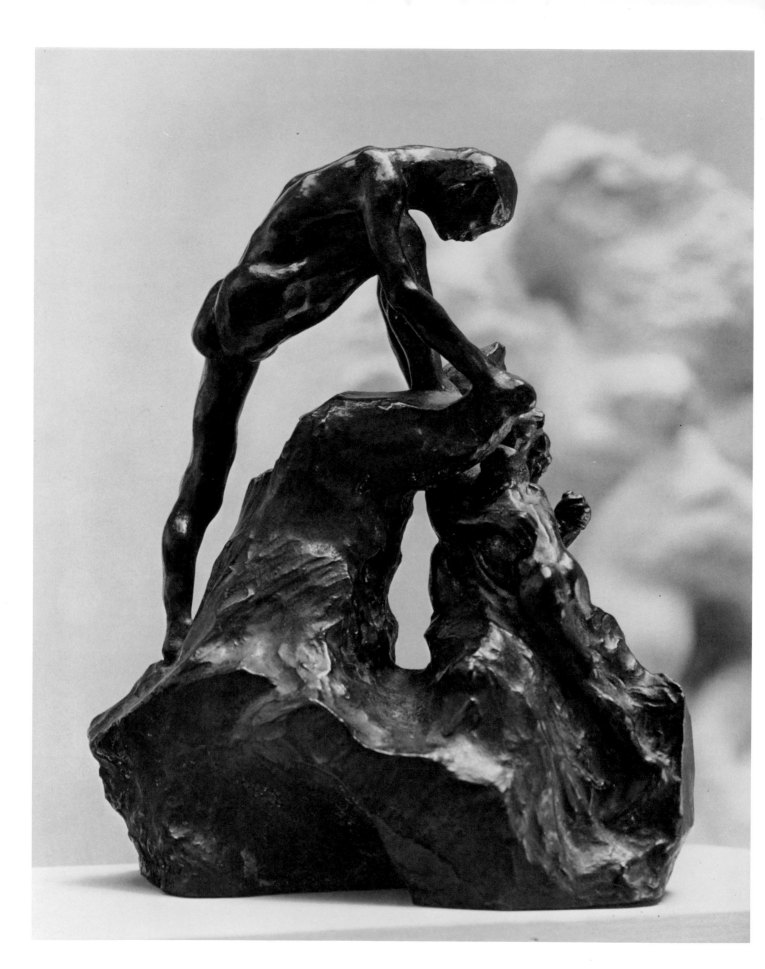

26

Polyphemus and Acis
(*Polyphème et Acis*)

Bronze, dark brown to black patina with traces of green
11 1/8 x 5 7/8 x 8 7/8″ (28.2 x 14.9 x 22.5 cm)
Signed: A. Rodin No [9 or 2] (base, side beneath Polyphemus's left foot)
Stamped: A Rodin (inside), and: Alexis Rudier / Fondeur. PARIS. (base, edge, beneath
 Polyphemus's left foot)
1950.58

Rodin draws on a favorite literary work, Ovid's *Metamorphoses*, for the theme of this group,
which represents the gigantic Cyclops, Polyphemus, jealously observing his adored Galatea
embracing Acis, her lover.[1] The triangular group is organized around the soaring, ogival
body of the giant. The sculptor emphasizes this forceful thrust by elongating the figure to
insectlike attenuation. Both the acrobatic pose and the nervous modelling express the inner
tension of the Cyclops. Body and emotions are stretched to the breaking point.

 As if uncertain about the appropriateness of the pair of lovers from the beginning, Rodin
sketchily defines Acis and Galatea, who are just emerging from their original clay matrix.
Characteristically Rodin generalizes his figures so that Ovid's one-eyed monster becomes a
two-eyed man, allowing it to become merely another damned soul on *The Gates*, the lovers
no longer present.[2] Certainly this decision was fortuitous; without the subordinate group, the
forceful rhythms of Polyphemus can be more fully appreciated.

 Separate casts of *Polyphemus and Acis* and Polyphemus alone, usually dated 1888, were
made during Rodin's lifetime.[3] Slight differences in the position of the head and in the
modelling can be observed in the two versions of *Polyphemus*. One version was later enlarged
and included in a marble, known as *Day and Night*.[4]

 Mrs. Spreckels purchased the bronze cast of *Polyphemus and Acis* from Eugène Rudier in
1949.[5]

NOTES

1. Ovid, *Metamorphoses*, XIII. On Rodin's interest in Ovid, see G. Grappe, "Ovide et Rodin," *L'Amour de l'Art*, no. 6 (June, 1936), pp. 203-208. Ovid's tale of the mythological love triangle had long inspired French artists—examples appear in the work of Claude Lorrain and Watteau—and continued to be an important theme in the nineteenth century. The theme appeared frequently at the Salon. Among sculptures inspired by the Polyphemus theme were Pradier's group *Polyphème lançant un rocher* and Ottin's sculpture of Polyphemus gazing down on Galatea and Acis, which was installed in a prominent location in the Luxembourg garden (Salons of 1852, no. 1504, and 1855, no. 4521). As an ornament to the Medici fountain, Ottin's sculpture was one of the more noticeable works of decorative sculpture in the nineteenth century. Later in the century we find important representations of the same theme by Moreau (*Galatée*, Salon of 1880) and Alexandre Falguière (relief, *Acis et Galatée surpris par Polyphème*; painting, *Acis et Galatée*).

2. The Polyphemus figure, minus the base found in separate casts, appears twice in the upper half of the right panel of *The Gates of Hell*, near the right edge (Elsen, *Gates*, pl. 66). Frisch/Shipley (p. 422) tell us that the group of Galatea and Acis was eliminated from *The Gates* because Rodin was dissatisfied with it.

3. The date of 1888 is given by Grappe, 1944, nos. 200-202, and Frisch/Shipley, p. 422. A cast of the *Polyphemus and Acis* is illustrated in *Art Journal*, 64 (1902), p. 122. The version of Polyphemus alone seems to have been cast during Rodin's lifetime since the cast in the Maryhill Museum of Fine Arts in Maryhill, Washington, was presented to Theodore Spicer-Simpson by the artist, according to the former director, C. R. Dolph. In addition to these two versions, Frisch/Shipley (p. 422) mention that studies of the Polyphemus in five different attitudes still exist. Two of these may correspond to plasters catalogued by Grappe (1944, nos. 202 and 203). What may be a third study is reproduced by Otto Grautoff (*Auguste Rodin*, Bielefeld/Leipzig, 1908, p. 76). This version differs from the definitive casts of *Polyphemus* in the shape of the base and in the proportions.

4. Grappe, 1944, no. 367. The mechanically enlarged plaster of *Polyphemus* mentioned by Lami (p. 171) may have been used for this marble.

5. The list of sculpture purchased from Eugène Rudier in October, 1949, was in the collection of Miss Jean Scott Frickelton, Palo Alto.

Left: *Polyphemus and Acis*. Cat. no. 26, detail.

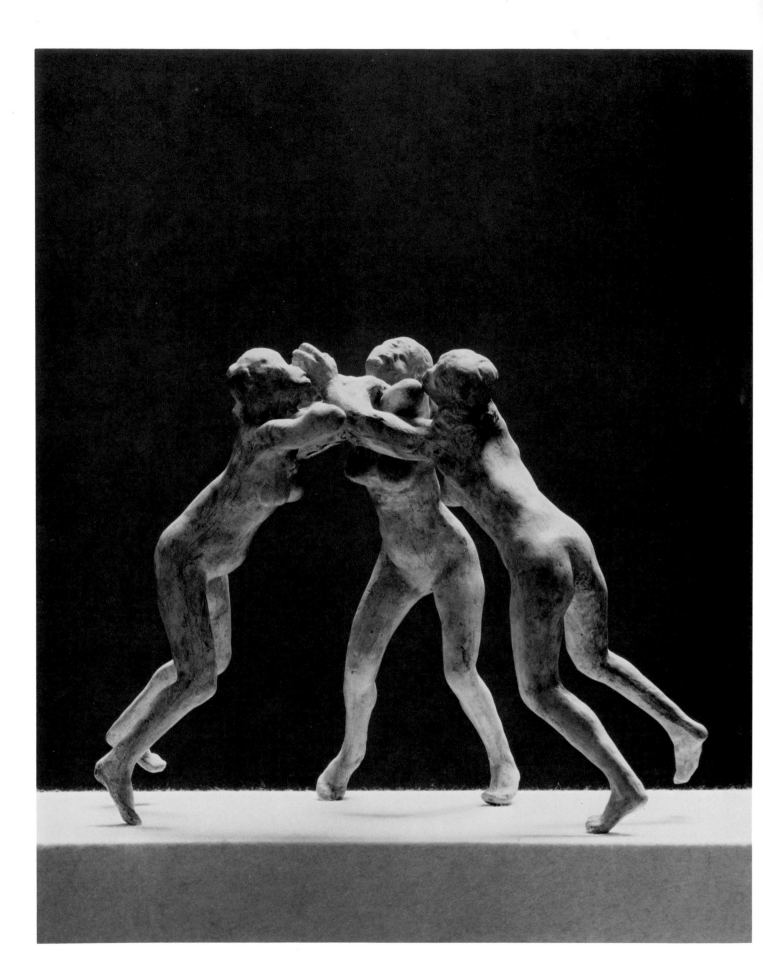

27
Three Faunesses
(*Les Trois Faunesses*)

Plaster, tinted light brown
9 3/8 x 12 5/16 x 6 1/2" (23.8 x 31.3 x 16.5 cm)
No inscription
1933.12.5

Repeating the compositional technique used for *The Three Shades*, Rodin joined three casts of the same supple figure to create the sprightly group, the *Three Faunesses*.[1] The three women lean inward, mutually supporting each other, to form a tripod recalling figural groups used to support vases and other decorative objects. If related in composition to such decorative devices, the *Three Faunesses* is entirely different in mood; Rodin's women lack the graceful, stable movements usually associated with these supportive figures. Instead of standing quietly, the romping figures seem to spin in a frantic dance. They are not ideal images of woman, but woman in her private moments when all restraint is thrown aside. The faunesses toss their heads back and cry in ecstasy like the ancient maenads; they stamp their feet and frolic like primitive creatures, moving with the freedom of wild animals.

The passionate carousing of the three women relates this group to the recurrent theme of pagan eroticism in Rodin's art. The enigmatic round dance brings to mind a bacchanalian revel or some magical ritual, while the untamed movements interpret woman as beastlike and erotic, qualities reinforced by the designation of the figures as the female counterparts of the faun (see cat. no. 14).[2] Such a conception of woman as primitive, instinctual and animallike was a product of Romantic literature, but it became prominent in art only in the second half of the century.[3] Many artists used animal associations to show woman as an evil creature who used her feminine charms to bring about man's downfall. For Rodin, as we see in this group, eroticism and sin were not necessarily linked. His primitive, unsophisticated faunesses are symbols of primal emotions which long ago linked man more closely to nature:

> The pagan *volupté* . . . developed free from all prejudice, and all constraint, directly from nature. Today *volupté* hides, being depraved and libertine[4]

The title for the single fauness alone, the *Little Breton Woman* (*La Petite Bretonne*) is revealing.[5] It stresses the primitive nature of the figure, since Brittany was associated in the nineteenth century with a way of life less refined and more instinctual than life in the city; for this reason, Gauguin and his circle were drawn to this province in the late nineteenth century. In uniting three casts of the *Little Breton Woman*, Rodin seems to conjure the rituals of the archaic religions of Brittany.

Left: *Three Faunesses*. Cat. no. 27.

The single figure was developed for *The Gates of Hell*, where it appears in three different locations.[6] The figure itself is stylistically close to sculptures of the 1880s,[7] but it is not known exactly when Rodin joined three casts to produce the *Three Faunesses*. The joining was done by 1900, when a replica was shown at the Rodin exhibition (no. 111).

Several replicas of the *Three Faunesses* in bronze and in plaster exist. These casts are of two sizes: one ca. 24 cm, like the Spreckels' cast, and another ca. 15-16 cm. Bronze casts of the *Little Breton Woman* have also been made. This single figure became the basis for several new sculptures besides the *Three Faunesses*. By attaching casts of the *Little Breton Woman* and the *Little Shade* to a tall base, Rodin created a work called *Beauty*.[8] In another variant, Rodin placed the female figure inside an antique vase.[9] When placed before a much larger faun, the same figure formed part of the *Group with Faun*.[10]

NOTES

1. This group has also been called *Three Nymphs*, *The Three Graces Dancing* and the *Three Breton Women*. The title, *Les Trois Faunesses*, appeared in the 1900 Rodin exhibition catalogue; no. 111.

2. This conception of the fauness lacks the pointed ears and goat tail and legs. The fauness was one of many hybrid creatures with animal associations found in Rodin's art of the 1880s: for example, we also find sculptures of satyresses and sphinxes at this time. The many sculptures of the fauness indicate that they were consistently used as a vehicle for expressing the bestial nature of woman; this use is clear not only from the works themselves but also from contemporary comments, where faunesses are described as primitive, bestial and ferocious. The 1900 Rodin catalogue describes the *Three Faunesses* as "graciles et sauvages" (no. 111). In some works, like the *Ascendency* (*L'Emprise*), where the woman possesses a tail, man becomes the prey of this savage creature (Grappe, 1944, no. 189). In others, for instance the *Fauness, Legs Separated* (*Faunesse, les jambes écartées*), where the woman crouches like a frog, animal poses are utilized to suggest primitive life and emotions. Elsewhere, as in the *Fauness and Satyr* (Grappe, 1944, no. 196), the erotic is uppermost.

3. We find an abundance of "animal-women" in the art of Degas, Rops and Moreau.

4. Rodin, quoted by Frisch/Shipley, p. 356.

5. We have not been able to determine whether this title was actually used by Rodin.

6. One cast appears on a platform before the left jamb and just beneath the tympanum (this cast is not present in all photographs of *The Gates of Hell*). Another is attached to the dentil at the extreme right of the cornice. A third cast is emerging from the background in the center of the right door, just above the *Fugit Amor* group and next to the *Woman Seated with Her Foot in the Air*.

7. The figure type and pose can be compared to *Eve and the Serpent* (Grappe, 1944, no. 121; ca. 1885), the *Kneeling Fauness* (Grappe, 1944, no. 109; 1884) and the *Standing Fauness* (Grappe, 1944, no. 110; 1884).

8. Illustrated by O. Grautoff, *Auguste Rodin*, Bielefeld/Leipzig, 1908, p. 64. *Beauty*'s present location is unknown.

9. Illustrated by M. P. Grand, "Rodin: Genius with Giblets," *Art News*, LX:3 (May, 1963), fig. 5. This group is now in the Musée Rodin, Paris.

10. Rainer Maria Rilke, *Auguste Rodin*, Leipzig, 1920, pl. 27. The present location of this group is unknown.

28

Woman Seated with Her Foot in the Air

White marble
8 3/16 x 4 x 3 1/2" (20.8 x 10.2 x 8.9 cm)
No inscription
1950.54

In this little marble, Rodin expands his vocabulary of poses to explore various emotional states. Seated on a tall rocky base, this slender adolescent girl contorts her body with the agility of an acrobat. Her forehead effortlessly touches her left leg. The pose emphasizes the angularity of the figure, particularly noticeable when viewed in profile, where we are aware of the abrupt bending of the left leg at the hip and the impossible angle of the left foot. The unconvincing anatomy and the crude handling of details like the hands and breasts become more apparent when the figure is seen alone than when it is viewed as part of the pulsating masses of *The Gates of Hell*, where Rodin used it three times.[1] The uninspired execution of the Spreckels' marble (note particularly the hands and feet) casts doubt on the extent of Rodin's personal supervision of the carving.

Rodin's experimentation with unconventional poses partakes of a new direction in late-nineteenth-century art. The unexpected movements of everyday life are common in the art of Degas, Renoir and Dalou. Seeking even more unusual bodily contortions, Rodin hired clowns, gymnasts and acrobats as models.[2] His amplified vocabulary of poses allowed him to explore more deeply the human psyche, as the postures reveal ambiguous emotions. Through the contraction of the seated woman, Rodin expresses extreme introspection and tension. Several titles for this work allude to despair, giving more specific definition to the psychological meaning of this pose.[3] Rodin's preoccupation with such mental states parallels research by contemporary scientists, who reexamined the interrelationship of emotions and the body; consequently, Rodin replaced the academic categories of passions with an expanded apprehension of man's emotions. He substituted a limited repertory of facial expressions and gestures for the boundless potentialities of the entire body.

This figure is one of several acrobatic figures symbolizing despair which are usually dated 1890.[4] However, its similarity to other slightly awkward and angular figures in *The Gates of Hell* may point to an earlier dating, perhaps even in the early 1880s.[5]

The marble version found in the Spreckels collection differs little from the small number of plaster and bronze replicas except for the filling in of the space between breast, abdomen and leg and the slight modification of the base, which is somewhat higher and more regular.[6] The date of purchase of the marble is unknown.[7]

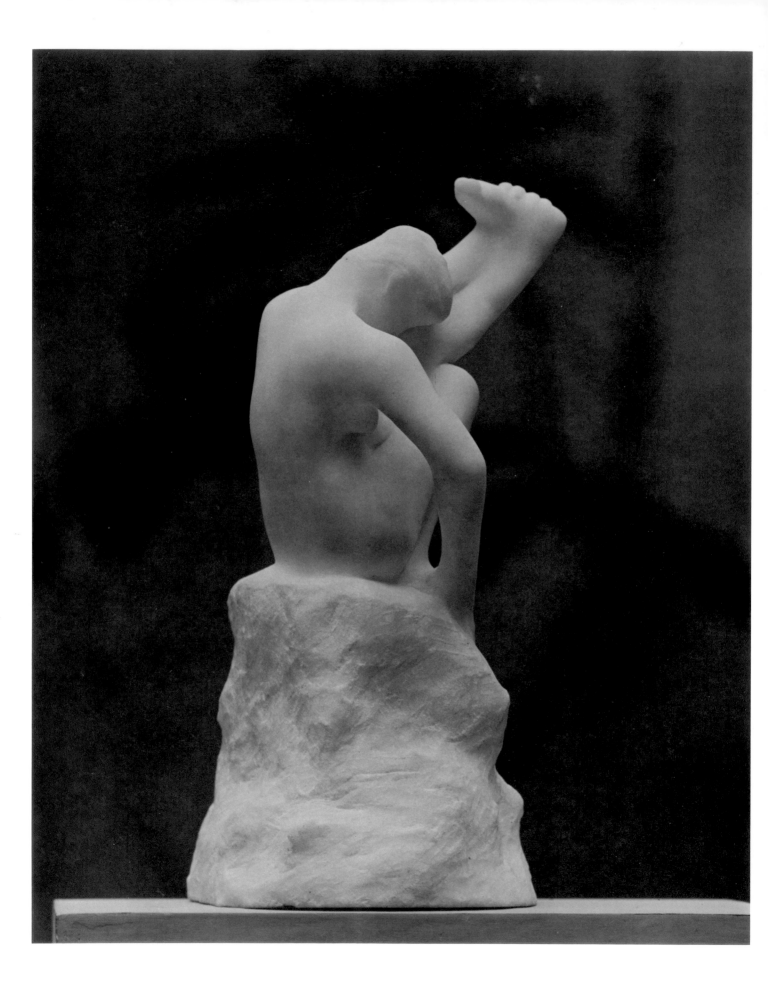

1. We find three casts of this piece in the right wing of *The Gates*: towards the upper left corner, just beneath the man with outstretched arms; further down just above the *Fugit Amor* group; and to the left and just below the *Fugit Amor* group (see Elsen, *Gates*, pls. 54, 76 and 79).

2. Grappe, 1944, no. 426.

3. Grappe calls it *Le Désespoir de la Porte* (1944, no. 244). In the catalogue for the Rodin exhibition at the Museum of Western Art in Tokyo, it is entitled *La Douleur* (no. 35). These modern designations are confirmed by a related work, which was called *Désespoir* in the 1900 Rodin exhibition (no. 55). A close connection between this figure and the *Woman Seated* in the Spreckels collection is suggested by the title of the latter piece in the collection of Antony Roux, who purchased a bronze cast from Rodin, where it is called *Etude pour le Désespoir* (Galerie Georges Petit, May 19 and 20, 1914, no. 130).

4. Grappe, 1944, no. 244.

5. It can be compared, for instance, with the *Standing Fauness* and the *Kneeling Fauness*, both located in the tympanum of *The Gates* and both dated 1884 by Grappe on the basis of a dated cast of the *Kneeling Fauness* (nos. 109 and 110).

6. The possible existence of a silver cast is indicated by the Roux catalogue: "Il existe à la connaissance des vendeurs une épreuve en argent. Cette assertion ne pourra, néanmoins, leur être imputée comme une garantie" (*op. cit.*, no. 130). A drawing in the Maryhill Museum of Fine Arts (Maryhill, Washington) is referred to in that collection as a study for the sculpture. However, the substantial differences in pose and the obviously later date of the drawing on stylistic grounds indicate that this drawing is not a study.

7. The history of the Spreckels' marble is confused by the record of another unidentified marble donated by Mrs. Spreckels called *Female Nude Seated* (8 1/2 x 10 1/2 x 7″). One of the marbles entered the museum in 1926.

Left: *Woman Seated with Her Foot in the Air*. Cat. no. 28.

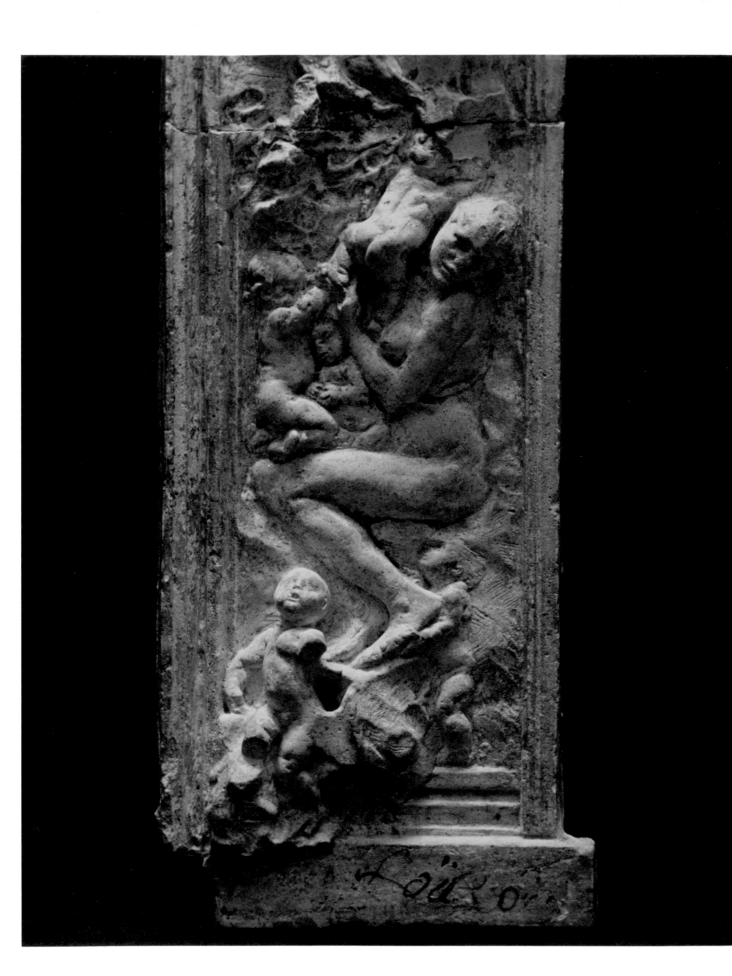

29

Fragment of the Left Pilaster of The Gates of Hell

Plaster, tinted light brown

11 1/16 x 2 11/16 x 11/16″ (28.2 x 6.4 x 2.6 cm)

Inscribed: (original): Modéle [sic] d'après la reduction [sic] Guiochè [sic] mouleur (in ink, left
 side); and: Modèle en réduction exécuté par Mon Père Henri Le Bossé R. Le Bossé
 (right edge); and: L'aurore (front bottom)

1933.12.21

This plaster relief showing nude women and putti distributed vertically and compressed into an architectural frame like a Romanesque relief is a reduction of the lower half of the left pilaster of *The Gates of Hell*. The writhing, twisting and floating figures set against a fluctuating background and sometimes interrupting the border give an impression of suffering and movement, which accords with the rest of *The Gates*. Though figures had appeared in pilasters since antiquity, Rodin is apparently the first in modern times to use them without registers or architectural divisions.[1] Traditionally they had been a part of ornamentation, but Rodin uses the figures for an expressive purpose. This piling up is probably a result of Rodin's method of composing by adding figures arbitrarily rather than creating them to fit an ensemble, a method characteristic of *The Gates* as a whole. Later, similar compositional arrangements were to be advocated by Art Nouveau artists.

Despite the change in context, the similarity between the figural arrangements in this relief and those Rodin was creating for vases at the Sèvres porcelain factory between 1880 and 1882 suggests that the figures in the pilasters were among Rodin's first conceptions for *The Gates of Hell*.[2] The woman surrounded by putti is generally related in style and subject matter to vases like *La Nuit* of 1881,[3] while the upper group, showing an old and a young woman with an infant floating above, is taken directly from a vase of 1880.[4] The title of this vase, *Limbo*, is a clue to the meaning of the left pilaster and further indicates the close interrelationship of Rodin's early work on *The Gates of Hell* and his vase designs at Sèvres. The numerous infants in the pilasters of *The Gates* show that Rodin was thinking of the first circle of Dante's hell, where innocents, such as unbaptized babies, were not punished yet were separated from God.[5] Rodin's contemporaries frequently referred to one or both panels as representations of limbo.[6]

The Spreckels' plaster fragment is one of several segments abstracted from the pilasters of *The Gates*, a practice also followed with figures in other parts of the portal. Separate casts were made of all portions of the two pilasters except for the group at the top of the right panel, which was cast as a free-standing sculpture called *Je suis belle*. These fragments vary in size, since they were abstracted according to groupings. Some were left in their original scale,

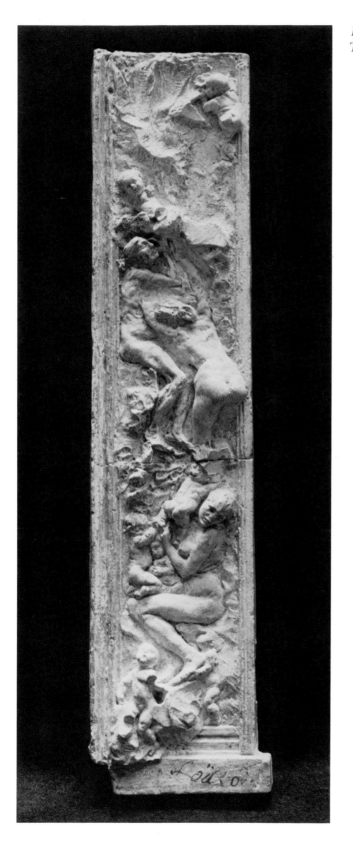

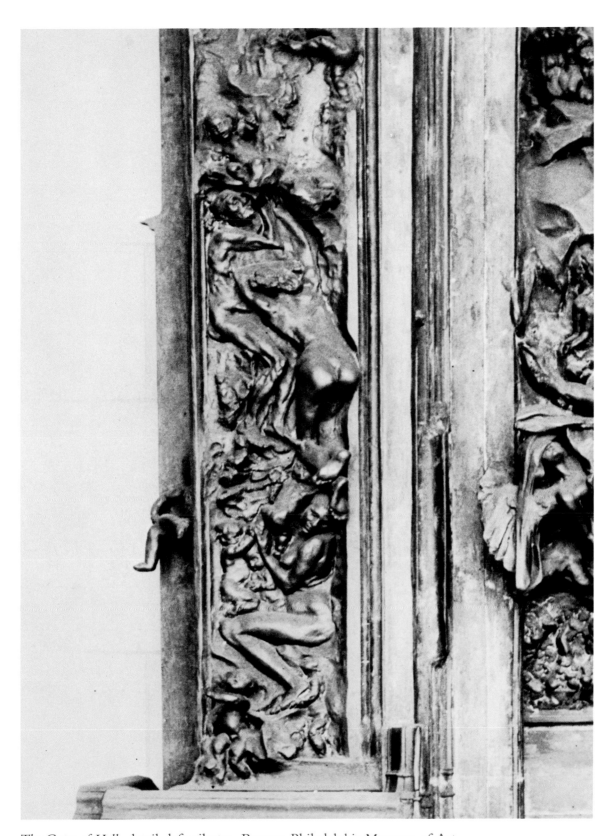

The Gates of Hell, detail, left pilaster. Bronze, Philadelphia Museum of Art.

while others, like the Spreckels' cast, were reduced. Rodin frequently had skilled artisans alter the scale of his sculptures, and this relief is a particularly fine example of a reduction made not by machine, but by the perceptive eye of the reducer, Le Bossé. Some of the fragments of the pilasters of *The Gates of Hell* exist in different versions, representing variations after their removal from the portal of the changing stages of *The Gates* itself. These fragments from *The Gates* are a further example of how Rodin made the most of the potential content of his sculptures.

The Spreckels' cast bears inscriptions which tell the story of the reduction and casting of this particular section of *The Gates*. An inscription signed "R. Le Bossé" informs us that it was his father, Henri, who made the reduction.[7] This casting was probably not done until around the turn of the century, since it duplicates the lower left pilaster as it looked at that time, with several of the projecting limbs removed.[8] A second inscription credits Guioché with the casting of the reduction.[9]

NOTES

1. Though not a pilaster decoration, or even a relief, Gustave Doré's *Acrobats*, which shows figures piled on top of one another in a somewhat irregular manner, may have influenced the compositional arrangement of Rodin's pilasters. A bronze cast of Doré's work (127 x 25 x 26 cm) is in the Florida Ringling Museum of Arts.

2. We know that the pilasters were completed at least by 1886 when they were described by Félicien Champsaur ("Celui qui revient de l'Enfer: Auguste Rodin," *Le Figaro* supp., January 16, 1886).

3. R. Marx, *Rodin céramiste*, Paris, 1907, p. 44; ill. pl. xv.

4. *Ibid*., p. 43; ill. pl. xvii.

5. *The Inferno*, Canto IV.

6. Bartlett associates the right panel with limbo and the left with the "circle of love" (p. 249). However, since babies and groups of lovers occur in both panels, this arbitrary division is difficult to understand. Geffroy indicates that both reliefs represent limbo (introduction to the 1889 Monet-Rodin catalogue, p. 58).

Cf. Edouard Rod, "L'Atelier de M. Rodin," *Gazette des Beaux Arts*, ser. 3, 17 (May, 1898), p. 426.

7. René Chéruy, Rodin's secretary between 1902 and 1908, informs us that Henri Le Bossé began making enlargements for Rodin in 1902, though he had made reductions for him earlier (Letter from René Chéruy, 6/9/57, Tate Gallery archives).

8. In a reproduction of this section of *The Gates* in 1898, the limbs are complete as in modern bronze casts (Henri Frantz, "Great New Doorway by Rodin," *Magazine of Art*, v. 21, p. 275). A photograph of *The Gates* showing the limbs cut off is reproduced by Paul Gsell, "Chez Rodin," *L'Art et les Artistes*, 4 (February, 1907), p. 397.

9. The "Guilloché" described by Cladel as Rodin's caster for twenty-eight years is undoubtedly the same man (*Rodin*, New York, 1937, p. x). Twenty-one letters from Rodin to Guioché, dating from March 11, 1911, to December 31, 1914, were sold at Sotheby (April 27, 1971, no. 356); they are now in the Musée Rodin, Paris.

Left: Inscriptions on edges of *Fragment of the Left Pilaster of The Gates of Hell*. Cat. no. 29.

183

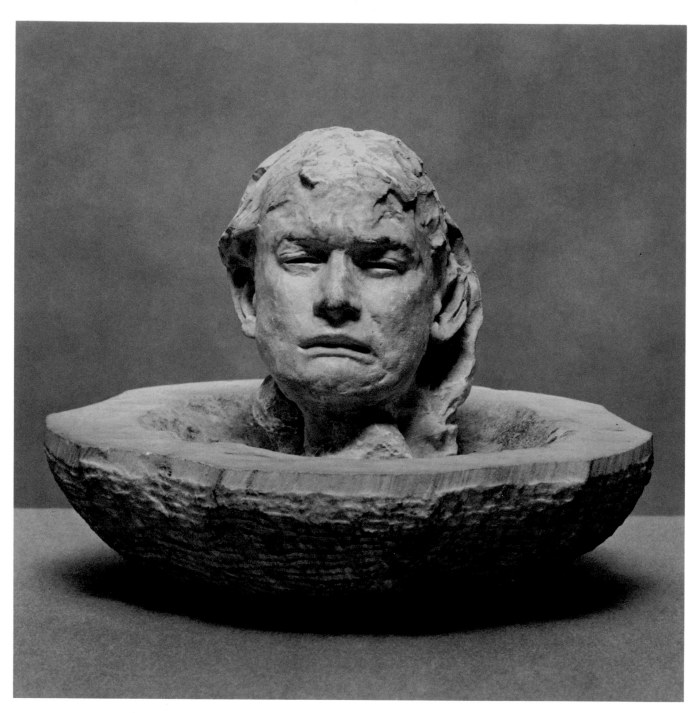

Crying Girl Dishevelled. Cat. no. 30.

30
Crying Girl Dishevelled

Untinted plaster in a marble basin; traces of piece mold
8 1/2 x 6 1/8 x 5 7/8" (21.6 x 15.5 x 15 cm)
Inscribed: RODIN (lower rear of head)
1949.17

Crying Girl Dishevelled,[1] a finely executed image of grief driven to tears, reflects Rodin's preoccupation with states of despair in his conception of hell. Sorrow contorts the androgynous face that emerges from a partly finished marble basin, indicating total abandonment to emotion; the dishevelled hair enhances this evocation of unrestrained woe. This facial expression is no conventional one; the sensitive portraitlike head is observed in a moment of passion.

This head is probably a study for the mask in high relief attached to a panel, one of a pair, used in an early stage of *The Gates of Hell* and then located at the bottom of the right wing.[2] The flattening at the back of the head bespeaks its original purpose. Few changes were made in the head itself when it was attached to the panel, but the hair was more precisely defined and swept wildly about the head. The two panels had the same composition: the weeping masks were placed prominently in the center, flanked by figures of a smaller scale. When these panels were created and attached to *The Gates* is uncertain, but they were present by early 1886, when they are described in an article.[3] Sometime after the turn of the century, they were replaced by figures in low relief and two enigmatic rectangular plaques.[4]

The reason for the presence of the two crying masks in *The Gates of Hell* and their intended meaning are not immediately clear. Several traditions seem to have played a part in Rodin's conception. Masks had been a prominent motif in decorative and architectural ornament since the Renaissance, though usually such masks were separated from figures or ornamental detail by a molding or some other decorative device. Rodin has broken down these barriers so that masks and figures exist within the same space.[5]

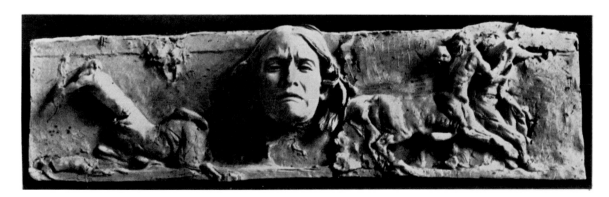

Relief for *The Gates of Hell*. (*Die Kunst für Alle*, XXVI, October 15, 1910.)

If the formal aspects of Rodin's panels are enigmatic, the iconographic meaning is even more so. Crying figures had long been used in funerary monuments—a source we could expect Rodin to have explored when planning *The Gates of Hell*. Medallion heads, a type revived particularly in the nineteenth century, were commonly used on tombs; a well-known example of this type was Préault's *Masque funéraire* or *Silence* (Salon of 1849) for the tomb of Jacob Roblès in Père-Lachaise. Rodin may well have found such funerary portraits appropriate models for images depicting the woes of hell. Further clues to the symbolism of the panels are the figures appearing to the sides of the faces. These represent centaurs abducting nymphs, a favorite bacchanalian scene. Rodin was familiar with ancient and modern depictions of such scenes, for they occur on vases he designed while employed at the Manufacture Nationale de Sèvres (1879-1882); this similarity in iconography may indicate a very early dating for the two panels. At that time Rodin probably examined in the Louvre the ancient vases and reliefs which illustrated Dionysiac scenes, where masks usually occur, either as incidental paraphernalia or as immense heads.[6] This iconography seems to have been the basis for the general scheme of the two panels, although Rodin rejects the traditional masks in favor of more personalized heads, a concept entirely new in the decorative use of the mask.

Why Rodin drew on bacchic iconography for *The Gates of Hell* is unclear. Certainly the weeping masks are related in mood. Rodin's interest in facial types and expressions may have prompted his selection. Placed in prominent positions on *The Gates* and large in scale, these heads offer an alternative means of expression; what in other parts of *The Gates* is expressed by the entire body is conveyed in the heads through a sensitive and personal rendering of the face. The portraitlike quality of the heads may indicate that they were meant to represent particular personages (perhaps Dante and Virgil?). Or like Balzac in the opening paragraphs to his *La Fille aux yeux d'or*, Rodin may have intended the masks to stand for the condition of mankind.[7] Whether portrait or symbol, these heads are poignant images of lasting despair.

Though several versions and variants of the companion head known as *La Pleureuse* exist,[8] relatively few casts of the *Crying Girl Dishevelled* are known; only two—one plaster, one bronze—besides the Spreckels' plaster have been located. The Spreckels' replica, a cast of high quality, entered the Legion of Honor in 1924.

NOTES

1. Usually known as *Crying Girl Dishevelled*, the two masks on *The Gates* are referred to in an early account as "masks of Pain" (Marie van Vorst, "Rodin the Sculptor," *Pall Mall Magazine*, XXIII:93 [January, 1901], p. 24). Despite the common association of the two heads with young women, this definition is not immediately apparent from the heads themselves. In fact, the Spreckels' cast was first called *Crying Boy* in this collection. On the other hand, Frisch tells us that a Russian woman named Bosnouskaya posed for *The Weeping Woman*, possibly the same sculpture found in the CPLH (Frisch/Shipley, p. 422).

2. Casts of one version of these panels are found in the Musée Rodin at Meudon (each plaster panel measures 30.5 x 137.2 x 20.4 cm) and in the Rodin Museum at Philadelphia (bronze; left panel: 31.7 x 104.1 x 15.9 cm; right panel: 31.7 x 104.1 x 14.6 cm).

These casts are framed by a molding and show a seated female figure beneath the central mask of the right panel. Another version of the two reliefs is illustrated by Otto Grautoff in 1910; these lack frames and show the figure to the right of the central mask in a different pose ("Auguste Rodin," *Die Kunst für Alle*, XXVI [October 15, 1910], p. 25). The present location of these panels is unknown.

3. F. Champsaur, "Celui qui revient de l'Enfer: Auguste Rodin," *Le Figaro* supp., January 16, 1886. The two reliefs were reproduced *in situ* by Bartlett; article of June 15, 1889, no. 703, unpaginated (N.B. photograph is printed in reverse).

4. Contemporary accounts indicate that the relief panels were still present in the first years of the twentieth century. They are described by Marie van Vorst in 1901 (*op. cit.*, p. 24) and by Lawton in 1906 (p. 112).

A photograph published in 1907 shows the panels partially covered by new designs (Paul Gsell, "Chez Rodin," *L'Art et les Artistes*, IV [February, 1907], p. 397).

5. A similar composition is used by Blake for his "Heads of the Poets," a series of painted rectangular canvases, designed to ornament the library of William Hayley. These panels show the portrait heads of famous poets, surrounded by wreaths and flanked by figures representing episodes relating to their works or lives. The panel depicting the head of Dante next to the imprisoned Ugolino would have been of particular interest to Rodin. Perhaps a friend, knowing of his recently commissioned *Gates of Hell*, would have endeavored to help Rodin gain access to this panel on his visit to England in 1881, when it was in the collection of William Russell. This painting, along with four others of the series, was shown in the Blake exhibition at Burlington Fine Arts in 1876, so the possible presence of a reproduction should not be dismissed. If Rodin did see the Dante picture or any of the others in the "Poets" series, his viewing may help explain the presence of similar panels in Rodin's *Gates of Hell*.

6. If Bartlett is correct in identifying the subject of the reliefs as "the festival of Thetis and Peleus when invaded by the Centaurs" (p. 225), Rodin has certainly interpreted classical mythology very loosely. The ancient writers tell of the marriage celebration of Peleus and Thetis, which centaurs attended, but no mention is made of centaurs abducting women.

7. In this novel, Balzac, who was not alone in his literary use of mask imagery in the nineteenth century, described the populace of Paris as "not faces, but many masks: masks of weakness, masks of force, masks of misery, masks of joy, masks of hypocrisy" (" . . . non pas des visages, mais bien des masques: masques de faiblesse, masques de force, masques de misère, masques de joie, masques d'hypocrisie" (*Oeuvres complètes*, Paris, n.d., IX, p. 236).

8. Bronze casts of the large version (ca. 30 cm) are in the Musée Rodin, Paris, in the Rodin Museum, Philadelphia, and in the Arthur Stoll Collection, Basel. A smaller bronze (20.5 cm), with the head cleanly severed a little below the chin, is at the Musée de Dijon (gift of Baron Alphonse de Rothschild, 1891). Rodin also produced at least three marble versions. The version in the Museum of Western Art in Tokyo shows the head encased in a marble block. In the Musée Rodin, Paris (Grappe, 1944, no. 218), a marble (35 cm) head sits atop a carved rectangular base. The 1900 Rodin exhibition catalogue lists still another version, with the marble head on a high pedestal. The location of this third marble is unknown.

Inscription: *Crying Girl Dishevelled*. Cat. no. 30.

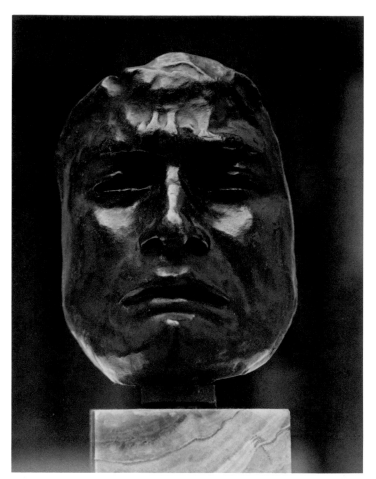

Mask of a Crying Girl Dishevelled.
Cat. no. 31.

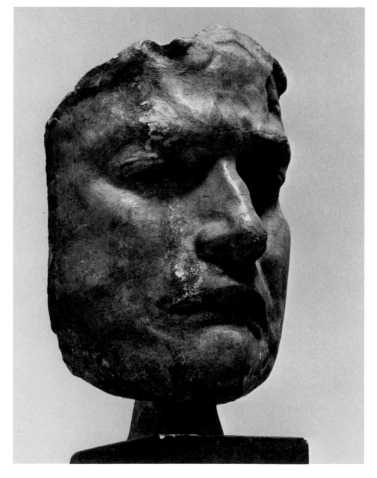

Mask of a Crying Girl Dishevelled.
Cat. no. 32.

31

Mask of a Crying Girl Dishevelled

Bronze, black patina; on a tan marble base
6 x 4 x 2 1/2" (15.3 x 10.2 x 6.4 cm)
Signed: A. Rodin No. 1 (lower right side)
1950.56

32

Mask of a Crying Girl Dishevelled

Plaster, tinted pink; on a brown plaster base (some paint peeled away); traces of piece mold
5 7/16 x 4 x 2 5/8" (13.8 x 10.2 x 6.7 cm)
No inscription
1933.12.13

These identical bronze and plaster masks derive from the *Crying Girl Dishevelled* (cat. no. 30); the top edge of the mask, which closely follows the irregular hairline of the head, shows that Rodin merely cut out the face to create a flat mask and a new work. The *Crying Girl Dishevelled* was closer to the traditional form of the mask used in decorative art, which showed the peripheral details of the head, like the hair and the ears.

In these two examples Rodin creates an abbreviated form of the mask by reducing the face to its essentials. He focuses our attention on the momentary expression of suffering of a soul that is hardly identifiable as male or female. The ambiguous sexuality and the simple treatment of the faces does not mean that Rodin sacrificed the individual expression of his model. Rather he created a new shorthand form of portraiture that goes far beyond what had been done with the mask previously; Rodin's innovation was to be taken up around the turn of the century by other sculptors.[1] Moreover, Rodin's reduced version of the mask also anticipates the trend toward minimal sculpture that emerged in the first decades of the twentieth century.

When Rodin conceived of the new mask form of the *Crying Girl Dishevelled* is uncertain. To date, the two casts in the Spreckels collection are the only ones known to exist. The bronze, then called *Mask of Sorrow*, was purchased from Eugène Rudier by Mrs. Spreckels in 1949.[2]

NOTES

1. Two examples of this type of portrait are discussed by Paul Vitry: Bartholomé's mask-portrait of M. Hayashi and Bourdelle's famous *Mask of Beethoven* (begun in 1888); "Masques," *Art et Décoration*, XIV (1903), pp. 348 and 352.

2. List of purchases from Eugène Rudier, October, 1949, formerly in the collection of Miss Jean Scott Frickelton, Palo Alto.

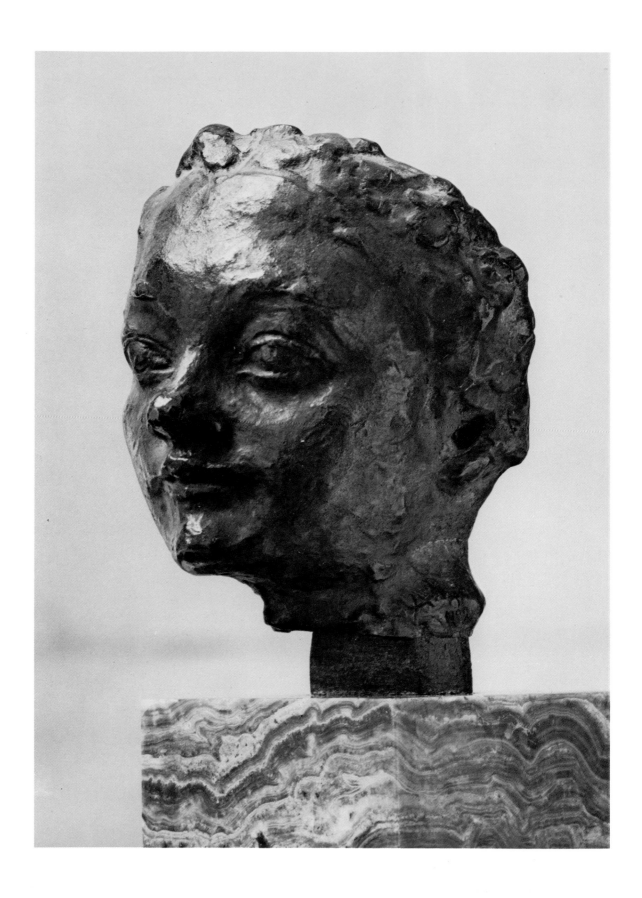

33
Mask of a Woman with a Turned-up Nose

Bronze, green patina; on a brown marble base
4 1/2 x 4 1/2 x 3 1/8" (11.5 x 11.5 x 7.9 cm)
Signed: A. Rodin/No. 2 (lower right side)
Stamped: A. Rodin (inside)
1950.57

34
Mask of a Woman with a Turned-up Nose

Plaster, tinted light brown; on a painted wooden base
5 1/16 x 4 1/2 x 3 1/4" (12.8 x 11.5 x 8.3 cm)
No inscription
1933.12.3

These engaging heads[1] are further examples of Rodin's concern with a variety of physiognomic types such as we find in *The Gates of Hell*. The sculptor's accurate rendering of a model with unrefined features suggests that he shared the Impressionists' objective approach to unidealized, everyday reality. The large, bulging eyes, the heavy turned-up nose and the heart-shaped face have the sensitivity and immediacy of a portrait.

Though traditionally associated with *The Gates of Hell*, this head is difficult to identify among the masses of figures.[2] On stylistic evidence we can date this mask in the 1880s. The flattened features, the abbreviated modelling and the linear treatment of the eyes are comparable to many of Rodin's portraits from the 1880s on.[3] The broad facial structure can be compared with the *Head of the Martyr*, also from that decade.[4]

Several bronze casts and a terracotta of this head are known, but the Spreckels' plaster seems to be unique in this medium. The plaster varies slightly from the Spreckels' bronze.

Several versions of this work exist in addition to the two represented in the Spreckels collection.[5] The most noticeable difference between the Spreckels' casts is the position of the heads: in the bronze, the head is held erect; in the plaster, it is tilted back. This difference occurs because the bases of the two casts vary; an additional section is added to the plaster cast to produce its tipped attitude. Another difference can be discerned in the hairstyle which extends further down the neck in the plaster head. These minor variations aside, the features and modelling remain essentially the same in both examples. Another version (an example of which is found in the Kaiser-Wilhelm Museum, Krefeld) shows the head tilted and attached to a base like the one in the Spreckels' plaster, but with an additional projection in the lower left portion of the coiffure.

Left: *Mask of a Woman with a Turned-up Nose*. Cat. no. 33.

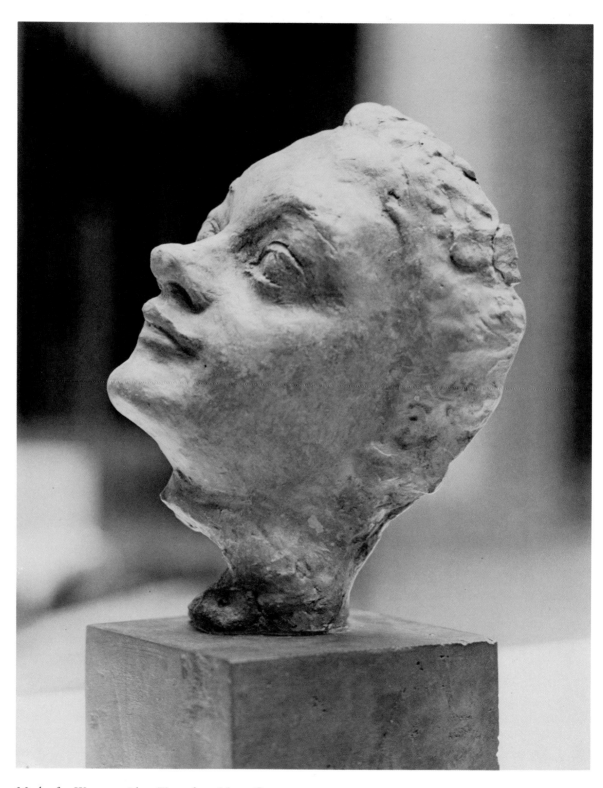

Mask of a Woman with a Turned-up Nose. Cat. no. 34.

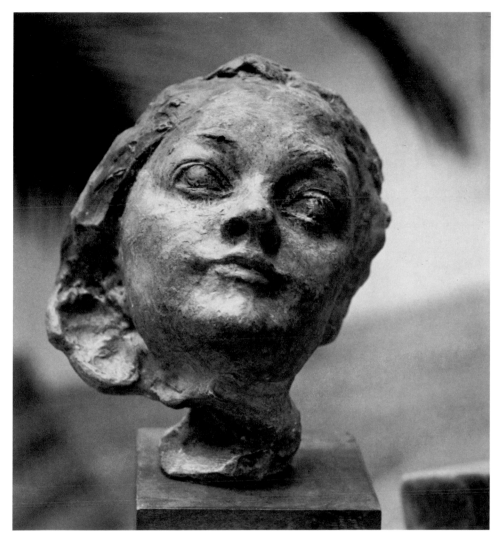

Mask of a Woman with a Turned-up Nose. Cat. no. 34.

NOTES

1. The bronze version is called *Masque de Jeune Femme* in Octave Mirbeau sale, Galerie Durand-Ruel, February 24, 1919, no. 71.

2. Grappe states that this head was used for various figures in *The Gates*, notably in the tympanum among the damned souls grouped around *The Thinker* (1944, no. 150). However, it is impossible to identify this specific head from photographs or from the viewer's normal vantage point.

3. Examples of this type of portrait are the *Bust of Camille Claudel* (Grappe, 1944, no. 107, dated 1884), *Bust of Octave Mirbeau* (Grappe, 1944, no. 230, dated 1889) and *Bust of Baudelaire* (commissioned, 1892).

4. According to correspondence among the Rodin papers, the figure of the *Martyr* from which this head was taken was completed in 1885 (Grappe, 1944, no. 146). Grappe also dates the *Mask of a Woman with a Turned-up Nose* to 1885 (1944, no. 150). Little historical evidence exists to date the work more precisely, though an illustration of the mask in *Pan*, 3 (1897), p. 196, gives an outside date.

5. The bronze version was acquired by Mrs. Spreckels from Eugène Rudier in 1949 and given to the CPLH in the following year (list of works acquired from E. Rudier in 1949 ex-collection of Miss Jean Scott Frickelton, Palo Alto).

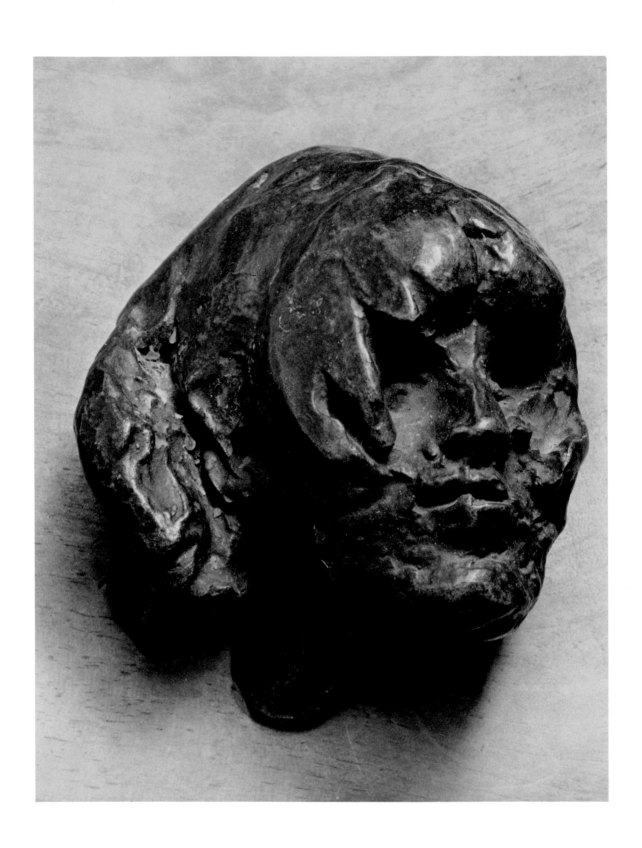

35

Little Head of a Damned Soul
(*Petite Tête de Damnée*)

Bronze, natural bronze to black patina; on wood base
3 1/2 x 2 3/4 x 3" (8.9 x 7 x 7.7 cm)
Signed: Rodin/No 1 (left side)
1950.55

Instead of physiognomic expression, Rodin used the richness and pliability of clay to create this image of suffering. Like many nineteenth-century artists, Rodin exploits the poignancy of decay and the morbid. The mouth and nose are twisted to one side, the face pockmarked and eroded, the squinting eyes pushed into the face, the hair whipped forward. All the features evoke a soul ravaged by hellish torments.

This head has frequently been associated with *The Gates of Hell*, and certainly it is akin in mood to other sufferers on that portal.[1] Still other titles for this piece suggest different meanings and sexes; it has been variously known as *The Hawker*, *The Parisian Street Urchin*, *The Drunken Woman* and *The Jeerer*.[2] These titles all refer to persons of the lower classes, a group whose afflictions were sympathetically viewed by nineteenth-century writers and artists.

Usually dated 1885, it is only known to have been exhibited in Rotterdam in 1899.[3]

The Spreckels' bronze head is one of an apparently small edition. Mrs. Spreckels purchased it from Eugène Rudier in 1949.[4]

NOTES

1. Grappe calls it "une étude destinée à faire nombre parmi les 'Damnées' de la *Porte de l'Enfer*" (1944, no. 142).

2. Grappe tells us that it was exhibited as *Gavroche Parisien* in Japan and then as *Le Crieur* in Rotterdam, and that it was called *La Femme ivre* in the 1932 Haviland sale (1944, no. 142). Jianou/Goldscheider add the title *La Goualeuse* (p. 91).

3. Grappe, 1944, no. 142. Grappe incorrectly dates the Rotterdam exhibition 1889 in the 1944 catalogue. He gives the correct date in the 1931 edition (no. 165).

4. List of sculpture acquired from Eugène Rudier (where it is listed as "Head of a Woman") in October, 1949; ex-collection of Miss Jean Scott Frickelton, Palo Alto.

Left: *Little Head of a Damned Soul*. Cat. no. 35.

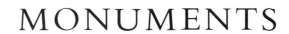

MONUMENTS

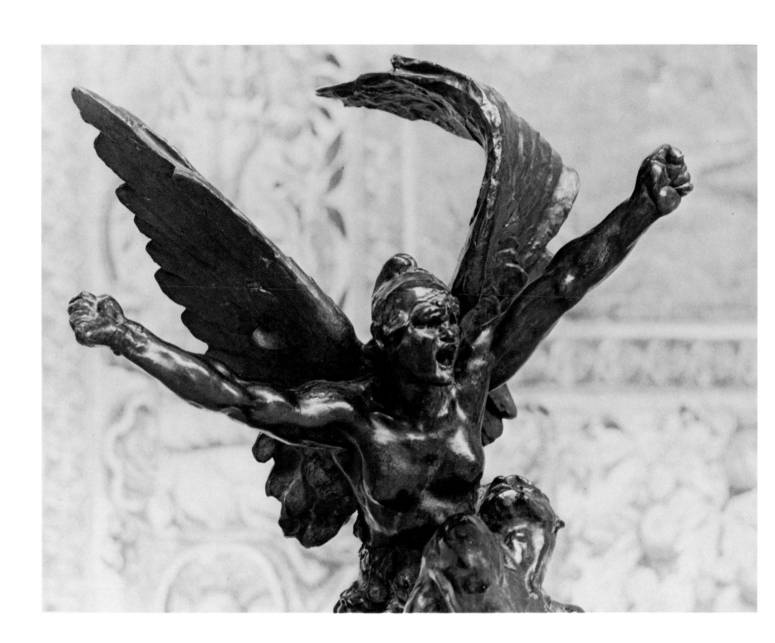

36

The Call to Arms

(*L'Appel aux Armes*)

Bronze, black patina and traces of green and red; traces of piece mold on man's right arm
44 1/2 x 22 3/4 x 15 15/16″ (110.5 x 57.8 x 40.5 cm) (including base)
Signed: A. Rodin. (base, right side)
Stamped: ALEXIS RUDIER. / FONDEUR. PARIS. (left rear)
1940.138

The Call to Arms,[1] one of Rodin's first conceptions for a public monument, is a sketch entered in a competition, which we can now definitively date 1879.[2] This little-known contest for a memorial to the defense of Paris during the Franco-Prussian War (1870-1871) required a sketch 80 cm high without base to be composed of two figures. Rodin did not receive even an honorable mention. He later attributed this loss to his rejection of accepted standards:

> . . . there were then at least sixty sculptors competing; but despite all my efforts, despite the life which, I believe, animates my group, *The Call to Arms*, I was not even considered. Therefore, I, who have such a profound admiration for Delacroix and who consequently knew by heart his famous letter on contests, ask myself often still why the hell I ever entered. Indeed, I could not challenge Barrias and Mercié. My group must have appeared too violent, too intense. So little progress has been made since the *Marseillaise* by Rude, which also cries with all its strength.[3]

Rodin realized that his audacious group had little chance against more conventional sculptors like Barrias, who won the 1879 contest, and Mercié, whose *Gloria Victis* (Salon of 1874) was widely acclaimed in the 1870s.[4]

Barrias, Mercié and Rodin exploited a popular composition for monuments, the figures placed vertically à la Cellini.[5] Rodin innovated boldly in arresting and diverting the ascensional thrust and with it the calmness and dignity expected in a civic sculpture. The woman, her arms outflung, her face frozen in an eternal cry—a peasant offspring of Rude's *Marseillaise*—hisses the spirit of revenge and anger with a rawness and poignancy never before met in a public square. The soldier, slumped in Michelangelesque inaction, slips from the blood-thirsty world of the Genius of War, who rises like a Phoenix behind the dying warrior,[6] demanding an unmediated response. Such a sculpture might have a place in a private collection but certainly not on the busy streets of workaday Paris.

Not surprisingly, *The Call to Arms* was not accepted for many years as a public war memorial. Now replicas of this sculpture stand as monuments to those who died in the defense of Verdun and to the famous Chilean war hero Arturo Prat (1848-1879). In the 1940s one of the trustees of the Legion of Honor even considered enlarging the Spreckels' cast to serve as a memorial in France to members of his family who died in World War II, a project that apparently was never realized.[7]

Left: *The Call to Arms*. Cat. no. 36, detail.

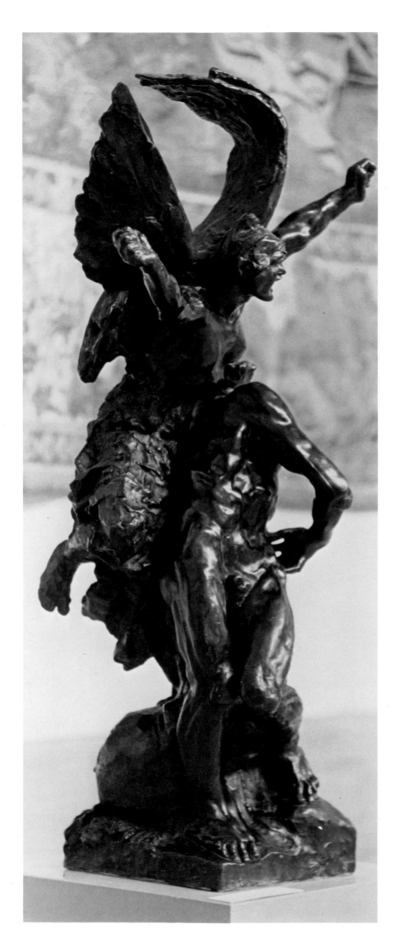

Left: *The Call to Arms*. Cat. no. 36.

Right: *The Call to Arms*. Cat. no. 36, detail.

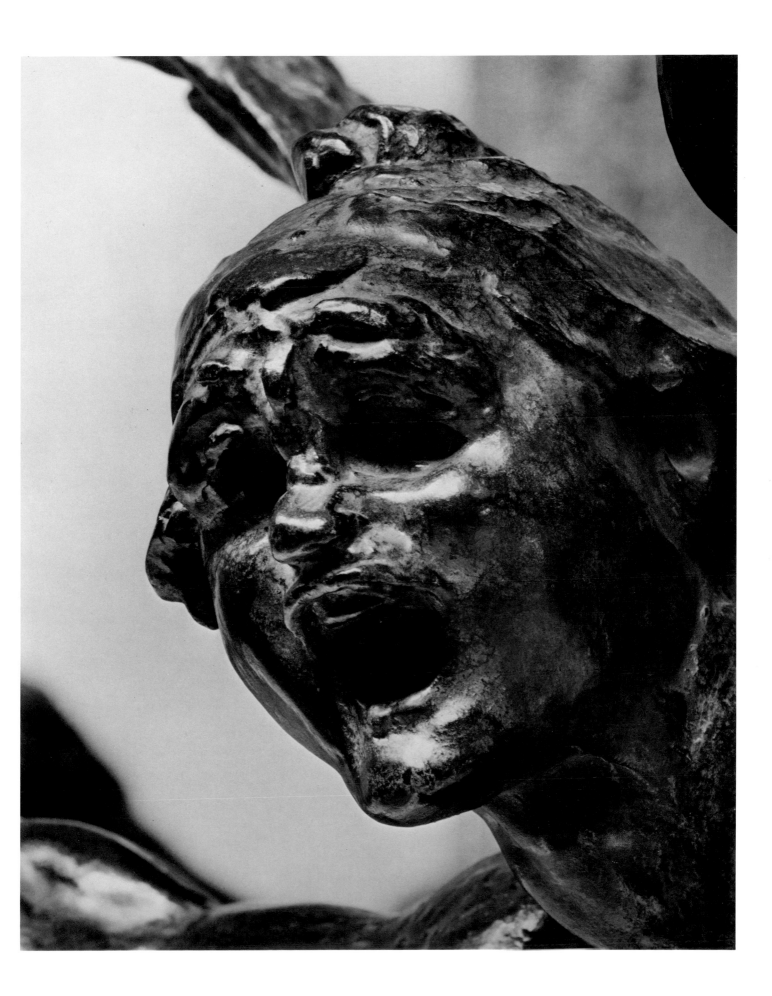

The Call to Arms exists in several sizes; since the contest of 1879 required a small sketch, the 113-cm. version must have been the first. Bronze casts of this version date from the 1880s or 1890s; a replica in the National Gallery in Edinburgh was cast by Griffoul and Lorge, Rodin's founders from 1887-1895. In 1912, it was enlarged, probably to ca. 235 cm.[8] When commissioned in 1916 to erect a replica of the group to commemorate the battle of Verdun, Rodin increased the work to colossal proportions.[9] After creating the initial group, he continued to experiment with the two figures. At some time the Genius of War was cast alone, and individual castings of her head were made as well. Rodin created another group consisting of the warrior on a rock and another female figure above him.

The bronze cast of The Call to Arms in the Legion of Honor was one of the first pieces of Rodin sculpture acquired by Mrs. Spreckels. It was purchased in 1915 from Loïe Fuller and entered the Museum in 1924 as a loan.[10]

NOTES

1. Several other titles for the group evoke the original intentions to comment on war and resistance. In his 1899 monograph, Maillard says that The Call to Arms is an allegory for La Patrie vaincue, a title used subsequently. It was called War (La Guerre) in the catalogue of the 1900 Rodin exhibition (no. 70). Two other titles are given by Grappe: Genius of War (Le Génie de la Guerre) and The Défense (La Défense); 1944, no. 42.

2. A variety of dates have been given for Rodin's work. The exact circumstances of the contest are reported in the Gazette des Architectes et du Bâtiment of 1879 (ser. 2, a. 8, pp. 126-27, 220 and 295). The decision to erect an allegorical monument was made in 1878, and the program was outlined on April 29, 1879; it called for a monument four meters high (including the base) to consist of two figures. It was first announced that the model, including pedestal, was to be one-fifth of the final size, but later this requirement was changed to exclude the base in the required dimension; this meant that the group itself should be 80 cm. The sketch was to be submitted on November 5, 1879, to the jury. From the entries, three would be chosen to be doubled and resubmitted. From the enlarged sketches, the final project would be selected. The artist chosen to execute the definitive work would receive 15,000 francs, the runners-up being awarded 3,000 francs for second place and 2,000 francs for third. The definitive sculpture would be cast in bronze at the expense of the government, but the sculptor would be responsible for supervising the cast-

ing. The first three sketches selected were by Barrias, Alexandre Lequien and Mathurin Moreau.

3. ". . . Nous étions là une bonne soixantaine de sculpteurs à concourir; mais, malgré tous mes efforts, malgré la vie qui anime, je crois, mon groupe, L'Appel aux armes, je ne fus même pas retenu. Aussi, moi, qui ai pour Delacroix une admiration si profonde et qui connaissais par conséquent par coeur sa fameuse lettre sur les concours, je me demande bien encore souvent ce que j'étais allé faire dans cette galère. Vraiment, je ne pouvais lutter contre Barrias et Mercié. Mon groupe dut paraître trop violent, trop vibrant. On a fait si peu de chemin depuis la Marseillaise, de Rude, qui, elle aussi, crie de toutes ses forces" (Coquiot, Rodin à l'Hôtel de Biron, p. 107).

4. See Louis Gonse, "Salon de 1874," Gazette des Beaux-Arts, ser. 2, 10 (August 1, 1874), p. 156.

5. Other examples of this vertical format in sculpture are Gustave Doré's La Gloire (Salon of 1878), Gustave Moreau's Jacob et l'ange (1878?) and Barrias's Quand Même (Salon of 1882).

6. The features of the Genius of War have been reported to be based on those of Rose Beuret (Cladel, 1950, p. 129).

7. Letter from Thomas C. Howe to Henri Marceau, April 16, 1947 (CPLH archives).

8. Grappe, 1944, no. 437.

9. Ibid. The plaster enlargement was made by Henri Le Bossé (Lami, p. 166).

10. This sculpture appeared in the 1924-1925 catalogue as War Genius (no. 163).

Right: The Call to Arms. Cat. no. 36, detail.

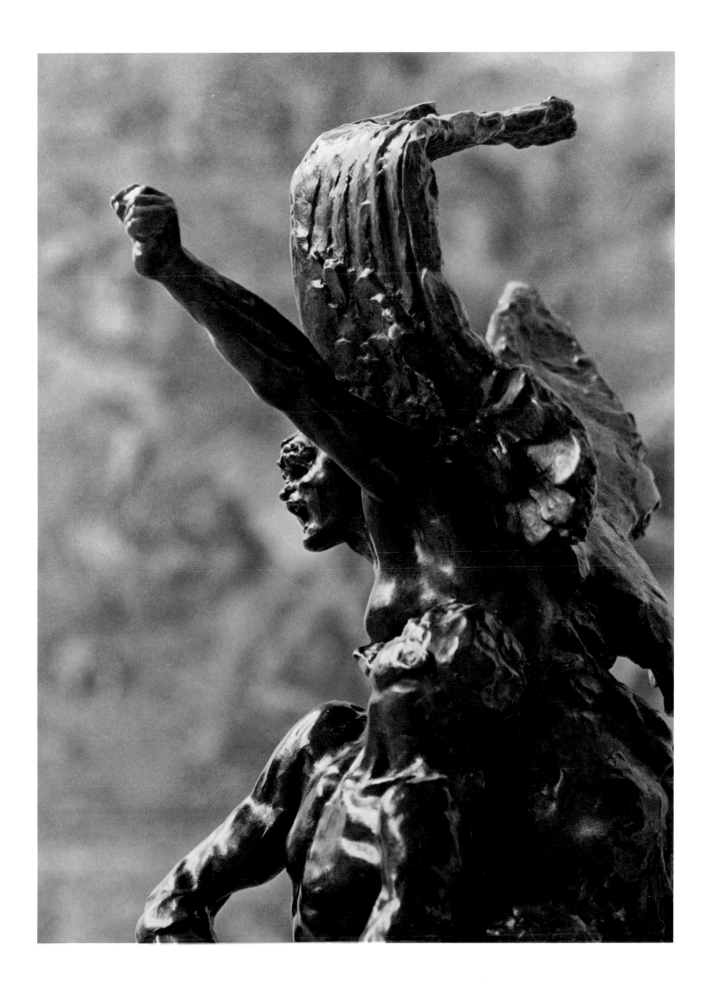

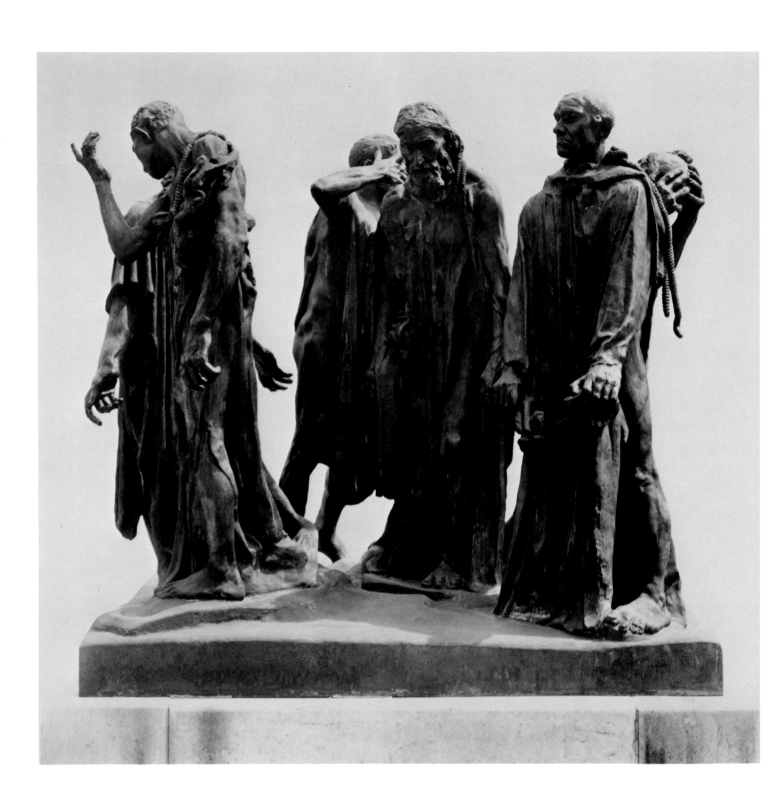

The Burghers of Calais

Introduction

Several works in the California Palace of the Legion of Honor are related to *The Burghers of Calais*, justly recognized as one of Rodin's masterpieces (cat. nos. 37-44). In the large group, Rodin represents an episode from the annals of medieval history which attested to the patriotism and self-sacrifice of six heroic men.[1] Early in the Hundred Years' War, when King Edward III of England was attempting to gain mastery over France, he laid siege to the fortified city of Calais. In 1347, after several months of privation, the city asked the king for clemency. He agreed, on condition that six chief burgesses of the city should yield themselves to him. Six brave men volunteered and went before the king, who would have killed them on the spot but for the intercession of his wife, Queen Phillipa.

In this moving representation, the burghers, having made their difficult resolution, are just leaving the city. Rodin evokes the effects of this moment of truth on each of the men. Their slow-moving gait gives the whole group a somber air, while the variety of gestures and facial expressions as well as postures reflect the responses of each. Rodin heightens the pathos of the situation with the torn and shredded draperies which scantily clothe the emaciated figures.[2] He did not hesitate to exaggerate anatomical features to further increase the emotional impact of this group: muscles bulge unnaturally, hands and feet swell beyond normal limits. The figures wander at random, as in a dream, a result of Rodin's emphasis on the individual participants in this drama rather than the group as a whole. Rodin defended its lack of a predetermined composition, for which he has been frequently criticized: "Nature composes, I do not need to compose."[3] Traces of the bases on which the separate figures stood still make the modern viewer aware that Rodin played with various arrangements after the figures were executed. Rodin's experimental method of composing reinforces the group's strong impact, which allows the viewer to relive the sacrifice of these secular martyrs.

The history of Rodin's *Burghers of Calais* commission, awarded at the end of 1884, is marked by constant difficulties and setbacks.[4] Criticisms of the conception as well as financial problems plagued Rodin during the ten years needed to bring the monument to completion. The original commission called only for a statue of Eustache de Saint-Pierre, the first burgher to offer his life for his city, but after studying the medieval chronicle of Froissart, describing the historical event, Rodin decided to depict all six of the Calaisian heroes.[5] In his first plaster sketch completed in November, 1884, Rodin depicts six closely grouped figures wearing tattered clothes, with Eustache holding the keys to the city and pointing the way with his outstretched arm.[6] This sketch included an elaborate base which Rodin visualized as a triumphal arch—a highly unusual conception of a base.[7] As in *The Gates of Hell* and in the *Tower of Labor*, Rodin assumed the role of architect in designing this base, a function not normally performed by the sculptor in the nineteenth century. Several months later Rodin submitted a second and more-developed plaster sketch from which the triumphal base is absent.[8] The monument committee criticized this study for not glorifying the burghers, for

its lack of decorum and for placing all of the figures on the same level.[9] Rodin had dared to break with conventional formulae and to depict these heroes as ordinary human beings, who were not exempt from mortal frailties.

Despite these murmurs of dissatisfaction, Rodin had already proceeded too far to consider changing his concept. Studies for the definitive figures were already well under way by mid-1885, first developed as nude figures on a small scale and then enlarged and draped.[10] The life-size clay models were completed, and the group itself—thanks in part to Rodin's assistants—was nearly finished by 1886.[11] In 1889 the entire group was assembled at the Monet-Rodin exhibition. Though largely finished by this time, Rodin seems to have continued making minor changes as the Calais committee delayed installation of the group.[12]

When the bronze cast was finally inaugurated in 1895, Rodin no longer wanted the group placed on a tall pedestal as originally conceived, but now requested a low base—a request denied by the committee.[13] Rodin's new concept implies a major reorientation in his attitude toward *The Burghers*. The removal of architectural elements places all emphasis on the figures themselves. Furthermore, removal of the statues from the pedestal means they are no longer above, but made one with the crowd, which was more consistent with Rodin's intentions:

> I have not grouped them in triumphant apotheosis: for such a glorification of their heroism would correspond to nothing real. On the contrary, I have strung them one behind the other, because, in the indecision of the last interior combat which takes place between their devotion to their city and their fear of death, each of them is as if isolated in the face of his conscience. They still interrogate themselves to know if they would have the force to accomplish the supreme sacrifice Their soul pushes them forward and their feet refuse to walk. They are led painfully as much because of their feebleness to which the famine has reduced them, as because of the dread of execution[14]

In another statement, Rodin expands on his choice of a low base and indicates that this idea was inspired by religious sculpture:

> . . . I had thought that placed very low the group became more familiar, and made the public enter more into the aspect of misery and of sacrifice, of the drama As your sketch [apparently a suggestion sent to Rodin by Dewavrin] shows the monument, it seems to me that it will stand out against the sky, having at its right the post office, and at its left the square. This will be fine; much better than if it is placed before the trees of the garden; in this case, the profile would not stand out, and I would return to my idea of having it very low in order to allow the public to penetrate the heart of the subject, as in the entombments of churches, where the group is almost on the floor.[15]

Though Rodin specifically mentions entombment groups, he was probably also aware, from visits to various cathedrals and churches, of seventeenth- and eighteenth-century funerary sculpture that often was presented in the form of groups placed on low pedestals or directly on the floor in immediate proximity of the viewer. He must also have seen processional groups, which would have had particular importance for *The Burghers*.[16] This tradition of "tableau vivant" sculptures—which included secular as well as religious subjects—was the starting point of one of Rodin's greatest sculptures, whose realism and psychological impact still strike the viewer of today.

The popularity of Rodin's *Burghers of Calais* is evidenced by the large number of casts related to it: more than 250 replicas include the original group, studies, reductions, isolated figures and parts of figures.[17]

Right: First sketch for *The Burghers of Calais*, plaster, 23½" high, Musée Rodin, Paris.

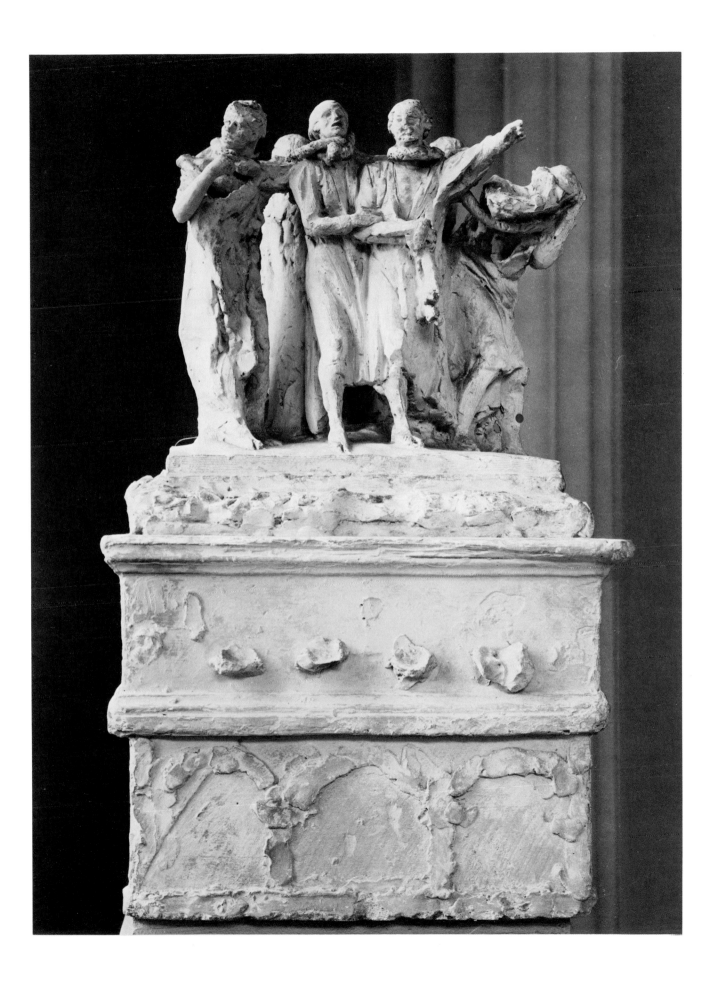

NOTES

1. Plaster cast: Musée Rodin, Paris. Bronze casts: Calais, Place d'Armes (first cast); Ny Carlsberg Glyptotek, Copenhagen (cast in 1903); Mariemont Park, Brussels (cast in 1905-1906); Gardens of the Houses of Parliament, London (cast in 1908; installed in 1913); Rodin Museum, Philadelphia; Musée Rodin, Paris; Öffentliche Kunstsammlung, Basel; National Museum of Western Art, Tokyo; Coll. Joseph H. Hirshhorn, New York; Coll. Norton Simon, Inc., Museum of Art, Los Angeles (posthumous cast, dated 1969).

2. In his discussion of *The Burghers* with Paul Gsell in 1907, Rodin pointed out how the costume reveals the inner state of the figure: "It is then for the artist to reduce the costume and its essential elements, to its basic logical lines and to make sure that the exterior envelope in its smallest folds translates still the movement of the personage and even the habits of his soul . . ." ("C'est donc à l'artiste de réduire le costume à ses éléments essentiels, à ses grandes lignes logiques et de trouver que l'enveloppe extérieure dans ses moindres replis traduise encore le mouvement du personnage et même les habitudes de son âme . . .") ("Chez Rodin," *L'Art et Les Artistes*, 4 [February, 1907], p. 410).

3. "La nature compose, je n'ai pas besoin de composer" (Goncourt, *Journal*, entry of July 4, 1894, v. 20, p. 93). According to Frisch/Shipley, the grouping never pleased Rodin, and he felt that he had not fully achieved what he sought (p. 213). Jacob Epstein is among those who have criticized the lack of unity in *The Burghers* (*The Sculptor Speaks*, London, 1931, p. 127).

4. The history of the commission is documented in the fifty-six letters Rodin wrote, mostly to Omer Dewavrin, mayor of Calais during the years Rodin worked on the monument. Some have been published by Cladel (1950, pp. 153-62), but the original complete set is to be found in the archives of city of Calais. We have used a typescript of the letters in the Philadelphia Museum of Art library.

5. Coquiot, *Rodin à l'Hôtel de Biron*, pp. 104-105. A copy of Froissart's *Grandes Chroniques* is in Rodin's library; C. Goldscheider, *Rodin inconnu*, Paris, 1962, p. 24. Important precedents of this subject occur in painting, A. Scheffer (Salon of 1819) and by Fragonard *fils* (Salon of 1822).

6. Ill. Descharnes/Chabrun, p. 110. The plaster cast is in the Musée Rodin at Meudon. This sketch is clearly identified through a description by Rodin in a letter to Mayor Dewavrin: "The idea seems to me completely original, from the standpoint of the architecture and of the sculpture. Moreover the subject itself which is original, and which demands an heroic conception, and the grouping of the six figures sacrificing themselves has an expression and an emotion, which can be easily shared. The pedestal is triumphal, and has the rudiments of an arch of triumph, in order to carry, not a quadriga, but human patriotism, abnegation, virtue." ("L'Idée me semble complètement originale, au point de vue de l'architecture et de la sculpture. Du reste c'est le sujet lui-même qui l'est, et qui impose une conception héroïque; et l'ensemble des six figures se sacrifiant a une expression et une émotion communicative. Le piédestal est triomphal, et a les rudiments d'un arc de triomphe, pour porter, non un quadrige, mais le patriotisme humain, l'abnégation, la vertu"); letter of November 20, 1884.

7. An earlier nineteenth-century example of a monument with a triumphal base is Alfred Stevens' famous Wellington monument in St. Paul's, London. Possibly Rodin had this work in mind when planning his own monument to the burghers of Calais, since he undoubtedly was familiar with the Englishman's prototype. In 1902, when John Tweed, Rodin's pupil, was commissioned to complete the Wellington monument, left unfinished at Stevens' death, Rodin urged him to accept. Tweed's son later recalled that Rodin had pointed out the exquisite detail and noble proportions of the equestrian monument. Significantly, Rodin later compared the base of his *Burghers of Calais* to equestrian monuments, referring to examples by artists well-known and long-dead—Verrocchio's *Colleone* and Donatello's *Gattamelata*; Coquiot, *Rodin à l'Hôtel de Biron*, p. 106. From the tradition of equestrian sculptures, Rodin also borrowed the raised arm of the conquering hero for the figure of Eustache de Saint-Pierre in the first sketch for *The Burghers*.

8. Cladel, 1950, pp. 155-56. Rodin briefly described the second enlarged study in his letter to Mayor Dewavrin of July 14, 1885: "It is made taking into account the execution [of the monument], therefore, there is a certain neglect of detail which should not surprise you, since practically all the draperies will be recommenced in the large scale [figures]; the modeling of the folds varying, the figure on which the drapery is thrown does not yield the same thing twice." ("Il est fait dans le but de l'exécution, aussi il y a des négligences de détail qui n'ont pas lieu d'étonner, car, en général, toutes les draperies seront recommencées en grand; le modèle de plis variant, le mannequin sur lequel on jette la draperie ne donne pas deux fois la même chose.") Cf. Cécile Goldscheider, "La Nouvelle salle des Bourgeois de Calais au Musée Rodin," *La Revue du Louvre*, 21:3 (1971), p. 169 and pl. 3.

9. Léonce Bénédite, *Rodin*, 1927, pp. 34-36.

10. Rodin spoke of the nude figures in his letter of July 14, 1885: "I have my nudes, that is to say the underpart which is made, and that I will have pointed [mechanical method of enlarging, reducing or duplicating sculptures] in order not to lose time. You will see that it is what one does not see and which is the

principal thing, which is finished." ("J'ai mes nus, c'est-à-dire le dessous qui est fait, et que je fais mettre au point pour ne pas perdre de temps. Vous voyez que c'est ce que l'on ne voit pas, et qui est le principal, qui est terminé.") Since several of the figures have draperies which cling to their backs, it appears that Rodin applied draperies to the nude figures, stiffening the draperies with liquid clay or plaster. He utilized this technique when developing his Balzac (M. Morhardt, "La Bataille du Balzac," *Mercure de France*, 157:879 [December 15, 1934], p. 467).

11. Goncourt, *Journal*, 14, entry for April 17, 1886, p. 115. Exactly what part Rodin's assistants played in the development of the monument has never been investigated. When he visited Rodin's studio in the 1880s, Cosmo Monkhouse noticed full-size figures for the *Burghers'* monument "being built up in clay by his assistants" ("Auguste Rodin," *Portfolio*, 1887, p. 11). We also know that Rodin's pupil, Miss Jessie Lipscombe, did part of the modelling under the artist's direction (A. L. Sells, "Auguste Rodin and His English Friends," *College Art Journal*, 15:2 [Winter, 1956], p. 144).

12. Bartlett wrote in 1889, at the time of the Monet-Rodin exhibition: "They are still in plaster, a little over life size, and not quite completed" (p. 250). Several years later Goncourt described the feet and hands as still not finished (*Journal*, 20, entry for July 4, 1894, p. 93). The grouping of the figures also seems to have been subject to last-minute alterations. The group exhibited in 1889 was apparently somewhat different from the group as it exists today. In his introduction to the catalogue, Geffroy said that Eustache de Saint-Pierre stood at the head of the procession and the burgher with the key at the end (80). Today these two figures stand side by side. Rodin's continuing reevaluation of the grouping is also implied in his undated letter to Dewavrin in which he refers to the resumption of the subscription campaign (September, 1893): "You ask me for a drawing, I could give you one which would not give you exactly my idea and which would give birth to bad impressions. But as soon as I have reassembled the large figures I will have them photographed, and will send them to you." ("Vous me demandez un dessin, j'en pourrais donner un qui ne donnerait pas exactement mon idée et ferait naître de mauvaises impressions. Mais sitôt que j'aurai rassemblé les grandes figures je les ferai photographier, et vous les donnerai" (Philadelphia typescript, no. 43).

13. The version installed in 1895 was cast by Leblanc-Barbedienne, the foundry settled on by Rodin after much deliberation. He had first considered Thiébaut, then Griffoul, finally agreeing on the large firm of Leblanc-Barbedienne, which gave the lowest bid and which was willing to cast the figures in one piece (letters of July 3, 1888, and September 23, 1894; Cladel, 1950, pp. 161-62). Rodin was forced to

accept a base of medium height. Only in 1924 was the group transferred to the Place d'Armes, before the old Hôtel de Ville, and placed nearly on the level of the ground (Cladel, 1950, p. 164).

14. "Je ne les ai pas groupés en une apothéose triomphante: car une telle glorification de leur héroïsme n'aurait correspondu à rien de réel. Au contraire, je les ai comme égrenés les uns derrière les autres, parce que, dans l'indécision du dernier combat intérieur qui se livre entre leur dévouement à leur cité et leur peur de mourir, chacun d'eux est comme isolé en face de sa conscience. Ils s'interrogent encore pour savoir s'ils auront la force d'accomplir le suprême sacrifice . . . Leur âme les pousse en avant et leurs pieds refusent de marcher. Ils se traînent péniblement, autant à cause de la faiblesse à laquelle les a réduits la famine, qu'à cause de l'épouvante du supplice . . ." (P. Gsell, *op. cit.*, p. 409; see n. 1).

15. ". . . J'avais pensé que placé très bas le groupe devenait plus familier, et faisait entrer le public mieux dans l'aspect de la misère et du sacrifice, du drame Tel que votre croquis me montre le monument, il me semble qu'il se découpera sur le ciel, ayant à sa droite l'hôtel des postes, et à sa gauche le square, ce sera bien: beaucoup mieux que s'il se trouvait devant les arbres du jardin; dans ce cas, il ne se profilerait pas, et je retournerais à mon idée de l'avoir très bas pour laisser au public pénétrer le coeur du sujet, comme dans les mises au tombeau d'églises, ou le groupe est presque par terre" (letter from Rodin to Dewavrin, December 8, 1893).

16. An example of such groups is the early-fifteenth-century Flemish sculpture showing Christ carrying the cross, now in the Musée de Cluny, Paris (ill. Theodor Müller, *Sculpture in the Netherlands, Germany, France, and Spain, 1400 to 1500*, Harmondsworth, Middlesex, 1966, pl. 15a). Another medieval processional group, the "*pleurants*" of the *Tomb of Phillippe Pot*, has recently been discussed by H. W. Janson as a possible source for *The Burghers* ("Une source négligée des Bourgeois de Calais," *Revue de l'Art*, 5 [1969], pp. 69-70). Rodin's lasting interest in sculptures of medieval mourners is illustrated by his sketches after the tomb of Philip the Bold in the ex-Claude Roger-Marx Collection, now in the Philadelphia Museum of Art (J. de Caso, "Rodin and the Cult of Balzac," *Burlington Magazine*, 106:735 [June, 1964], p. 282).

17. Again the collector must be aware of the possible existence of illicit casts. Frisch/Shipley relate one instance of forgery: "A doctor whose services Rodin had rewarded, in addition to the regular fee, with the gift of a plaster of one of *The Burghers of Calais*, went into the business of selling reproductions of the figure. By the time he was brought to task, he had made more from the enterprise than from his whole honest lifetime of medical practice" (p. 395).

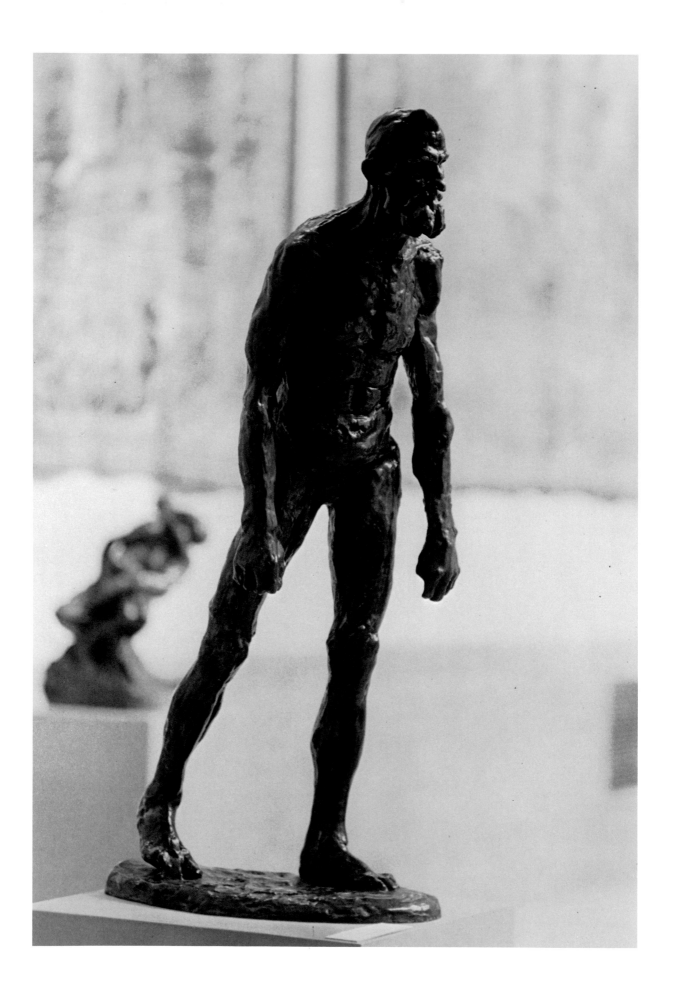

37

Nude Study for Eustache de Saint-Pierre

Bronze, black to green patina
38 1/2 x 12 1/2 x 15″ (97.8 x 31.7 x 38.1 cm)
Signed: A Rodin/No. 4 (base, top behind left foot)
Stamped: Georges Rudier / Fondeur. Paris. (Base, side, behind right foot)
Inscribed: © by Musée Rodin 1965 (base, right side)
Gift of B. Gerald Cantor, 1968
1968.7

Before proceeding to the definitive figures of *The Burghers of Calais*, Rodin made numerous studies of them, both nude and clothed. This study for Eustache de Saint-Pierre is one of several made of this very important personage. It differs slightly from the definitive figure, though the similar facial features and skeletal body suggest that the same model was used for both. The unnatural rigidity present in the right leg of the study is replaced by a bent leg in the final work. The awkward stance of the figure is partly due to the different lengths of the legs,[1] which resulted when Rodin grafted a portion of another leg to the lower left leg of this sketch. This process explains the curious appearance of two knees, one above the other, in the left leg, which is also distinguished by the more finished appearance of the added lower section. Similar anatomical inaccuracies can be seen in the arms, which vary in length,[2] the rigid abdominal muscles which are not correctly disposed for the movement of the figure and the neck which is off center to the left. These discrepancies create a much more precarious posture than that of the final figure.

Very little is known about the casting history of this study. Only a few casts are known, but they provide no clues about when they were first made. In order to understand Rodin's attitude toward a study of this type, it must be determined whether it was cast during his lifetime or only posthumously and whether it was exhibited while he was alive. Lacking this information, it is impossible to know whether Rodin considered this a unique work of art or only a sketch.

NOTES

1. From the bottom of the heel to the bottom of the buttock, the right leg measures 16 3/4″ (42.5 cm), the left leg 18 3/8″ (46.5 cm).
2. On the inside from the elbow to the wrist, the right arm measures 6 1/2″ (16.5 cm) and the left 5 1/4″ (13.5 cm). According to Cécile Goldscheider, Pignatelli, the model for the *St. John*, posed for this study ("La Nouvelle salle des Bourgeois de Calais au Musée Rodin," *La Revue du Louvre*, 21:3 [1971], p. 170).

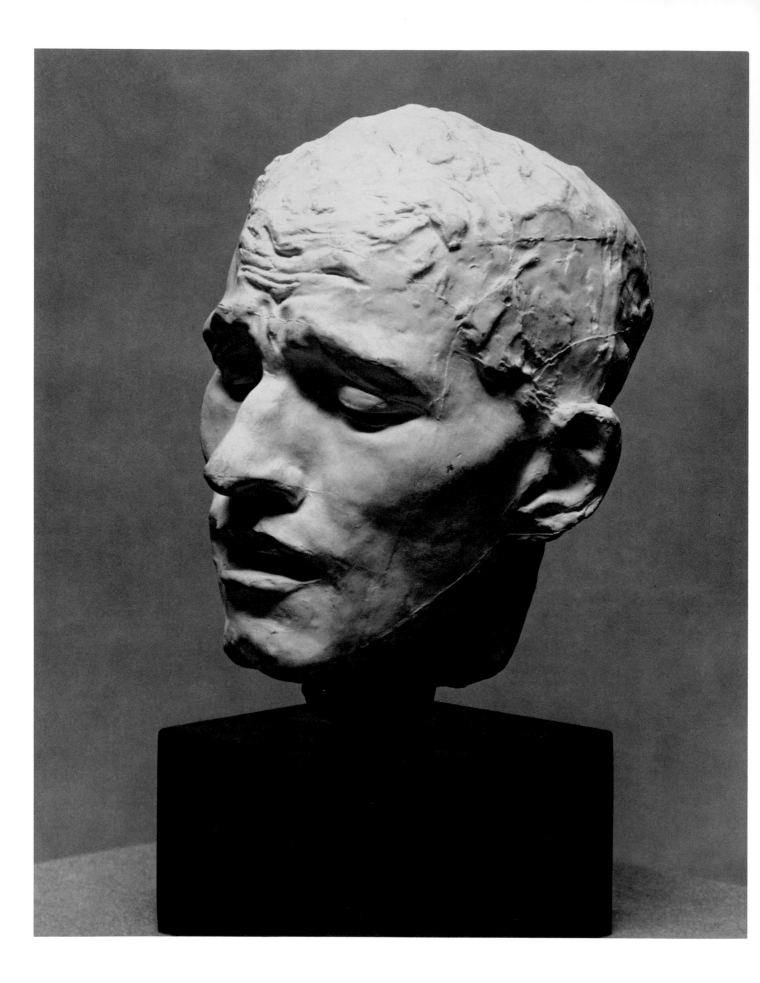

38
Head of Pierre de Wiessant

Untinted plaster; traces of piece mold; on a black marble base
11 3/8 x 8 5/8 x 9 9/16" (28.9 x 21.9 x 24.3 cm)
No inscription
1933.12.11

Besides making figure studies, Rodin prepared for the final group by making studies of the individual heads of *The Burghers* which reveal a portraitlike interest in physiognomy. The emaciated features and closed eyes of the head of Pierre de Wiessant, severed at the neck, bring to mind death masks, though the knit brow gives it a pained appearance, much as we find in the *Severed Head of St. John* (see cat. no. 9).

Rodin's deep interest in the head of this figure is revealed in a number of studies differing in size (from ca. 8 cm to ca. 86.5 cm), media, details and degree of finish. In some versions, the neck is included and the head is shown tilted to one side, increasing the sense of pathos.

The Legion of Honor cast may be a unique plaster cast of this particular version.

Left: *Head of Pierre de Wiessant*. Cat. no. 38.

Reductions of
The Burghers of Calais

39
Andrieu d'Andres (or Ardres)
Bronze, light brown to dark brown with green patina
15 15/16 x 8 5/8 x 9 3/4" (40.5 x 21.9 x 24.8 cm)
Signed: A. Rodin (top of back, center left)
Stamped: A. Rodin (inside), and: ALEXIS. RUDIER. FONDEUR PARIS
1941.34.14

40
Jean d'Aire
Bronze, dark brown to green patina
18 3/8 x 6 3/4 x 6 3/16" (46.7 x 17.1 x 15.7 cm)
Signed: A. Rodin (lower left side)
Stamped: A. Rodin (inside front), and: Alexis. Rudier./Fondeur. Paris (base, back right)
1941.34.13

41
Jean d'Aire
Untinted plaster, traces of piece mold
18 1/16 x 6 7/16 x 5 3/4" (47.1 x 16.3 x 14.6 cm)
Signed: à loïe /Rodin (lower rear, in pencil), and: 1906 (bottom, in ink)
1933.12.1

42
Jean de Fiennes
Bronze, dark brown to bluish-black patina, with traces of green and red
18 3/16 x 11 3/8 x 6 3/8" (46.2 x 28.9 x 16.2 cm)
Signed: A. Rodin (base, top, back left corner)
Stamped: A. Rodin (inside), and: Alexis Rudier./ Fondeur Paris. (base, right rear)
1941.34.11

43

Eustache de Saint-Pierre

Bronze, bluish-gray to black patina
18 5/8 x 14 1/2 x 8 1/8″ (47.3 x 36.8 x 46 cm)
Signed: A. Rodin (base, back right corner)
Stamped: A. Rodin (inside), and: ALEXIS RUDIER. FONDEUR PARIS. (base, right rear)
1941.34.12

44

Pierre de Wiessant

Bronze, dark brown to green patina
17 3/4 x 8 5/16 x 8 5/16″ (45 x 22.5 x 22.5 cm)
Signed: A. Rodin (base, top, back right corner)
Stamped: A. Rodin (inside, front), and: ALEXIS. RUDIER. / FONDEUR. PARIS (base, right rear)
1941.34.15

Around the turn of the century, Rodin decided to cast reductions of five of the six *Burghers of Calais*.[1] A complete set, plus a rare plaster of Jean d'Aire, inscribed 1906 and dedicated to Loïe Fuller, were assembled by Mrs. Spreckels by the 1930s.[2] The curious exclusion from this series of the sixth burgher, Jacques de Wiessant, has been explained as Rodin's desire to prevent the reassembling of all six figures in this reduced scale.[3] Presumably Rodin thought the group would lose its visual and aesthetic impact if composed of smaller figures, and indeed, the diminished force of the personages themselves in the reduced scale is evident.

Whether or not Rodin identified each of these figures with specific personalities is uncertain, but the names typically assigned them are helpful for discussion.[4] Eustache de Saint-Pierre is usually associated with the oldest, bearded man.[5] This figure for which Pignatelli, the model for the *St. John*, is said to have posed,[6] walks forward with great difficulty, as if weighed down by a heavy burden, reminiscent of Christ on the road to Calvary. His angular, emaciated arms hang limp, his head is downcast. "He is not afraid, he walks steadily with his eyes closed in holy communion," said Rodin of this figure.[7]

Jean d'Aire, one of the most popular burghers, is usually identified as the man holding the key.[8] Rodin's son, Auguste Beuret, is said to have posed for the head of this figure, and in it the sloping and jutting Rodin forehead is easily recognizable.[9] This figure steels himself against his inevitable fate; his determined erectness is reflected in the vertical folds of his garment. The monkish robe, with cowllike folds resting on his shoulders, gives him the appearance of a Christian martyr, bravely facing the trial to come.

The youngest hero, Jean de Fiennes, is represented as a long-haired adolescent. His youthful innocence is accentuated by the neat choir-boy robe, which contrasts with the longer, tattered garments of his companions. The arms outstretched in a gesture of helpless

yielding or bewildered questioning can be found in countless representations of holy figures at least since the Renaissance.[10] Rodin later described the emotional condition of this representation as "still undecided."[11]

The man who looks over his shoulder and raises his right arm is usually called Pierre de Wiessant. His tall emaciated body and loose drapery, which slips off as if alien to the figure, are reminiscent of Donatello's *Zucconi*. Very different are his graceful dancelike movements, suspended and unresolved. The details of the reduction differ slightly from the full-scale figure since a bit of rope over the left shoulder is missing.

The fifth man who clutches his head in his hands, a gesture of despair that in art predates the Christian era, is associated with Andrieu d'Andres (or Ardres). He is somewhat less successful than the other figures; the swirling pattern of the draperies and the smooth triangular area between the legs seem contrived and the movement is awkward. Though he leans forward, he is poised in this position rather than actually walking since his left leg rests on a raised area, immobilized. The cringing gesture of the shoulders, arms and head is more convincing, if somewhat melodramatic. In this small version, unlike the large figure, the little finger of the left hand is missing.

In each figure Rodin depicts a unique character study, both of physical type and in psychological response to impending death. We can study a variety of emotions differing in intensity and nature. The separate casting of the figures emphasizes this individuality, though the impact of the emotions loses something in the reduction.

Numerous casts exist of each of the figures, but the *Jean d'Aire* seems to have been the most popular, since many more casts in bronze and plaster were made of this figure than of the others.[12]

NOTES

1. Some confusion exists about the actual date when the first reductions of *The Burghers* were cast. In 1967, Cécile Goldscheider wrote that these were first made in 1899 by the founder, Perzinka (*Mostra di Augusto Rodin*, Rome, p. 25). More recently, she wrote that they were begun in 1895, the same year the monument was inaugurated ("La Nouvelle salle des Bourgeois de Calais au Musée Rodin," *La Revue du Louvre*, 21:3 [1971], p. 174). An outside date for the first casts is suggested by two casts of the reduced *Eustache de Saint-Pierre* allegedly dated 1907 (Sotheby sale, December 1, 1965, no. 56; Sotheby sale, November 29, 1967, no. 15).

2. Mrs. Spreckels purchased the set of five bronze *Burghers* from Eugène Rudier in 1929; Rudier claimed to have owned them since about 1914 and called them a second replica. A copy of this contract was owned by Miss Jean Scott Frickelton, Palo Alto. Mrs. Spreckels gave the plaster *Jean d'Aire* to the Museum in 1933 but had probably kept it in her home for an indefinite period of time previously.

3. Letter from Marcel Aubert (former director of the Musée Rodin) to Nasjonalgalleriet, Oslo, September 19, 1949; Nasjonalgalleriet archives.

4. Froissart gave the names of only four burghers; Jean de Fiennes and Andrieu d'Andres were identified only with the discovery of the Vatican manuscript edited by Lettenhove (R. Dircks, *Auguste Rodin*, London, 1909, p. 51).

5. Rodin identified this figure himself in an interview with Delia Austrian: "The figure in the center is Eustache de St.-Pierre, his bowed head with venerable hair attracting attention" ("Rodin as I Knew Him," *International Studio*, 68 [September, 1919] pp. li-lii). In light of this statement, the occasional association of Eustache de Saint-Pierre with the burgher holding the key is incorrect.

6. See cat. nos. 7-8.

7. D. Austrian, *op. cit.*, p. lii.

8. Grappe, 1944, no. 167-A.

9. Cladel, 1950, p. 159.

10. Examples of this gesture in art are too numerous to list. A prominent example from Rodin's own time is Puvis de Chavannes's *Saint John the Baptist*, exhibited at the Salon of 1870 and at that time considered an outrage; see Jean Laran and André Michel, *Puvis de Chavannes*, Paris, 1911, pp. 49-50.

11. D. Austrian, *op. cit.*, p. lii.

12. Jianou/Goldscheider tell us that twelve bronze casts of each figure exist (pp. 97-99). However, in our research we have located far more than this number for *Jean d'Aire*.

Inscriptions: *Jean d'Aire*. Cat. no. 41.

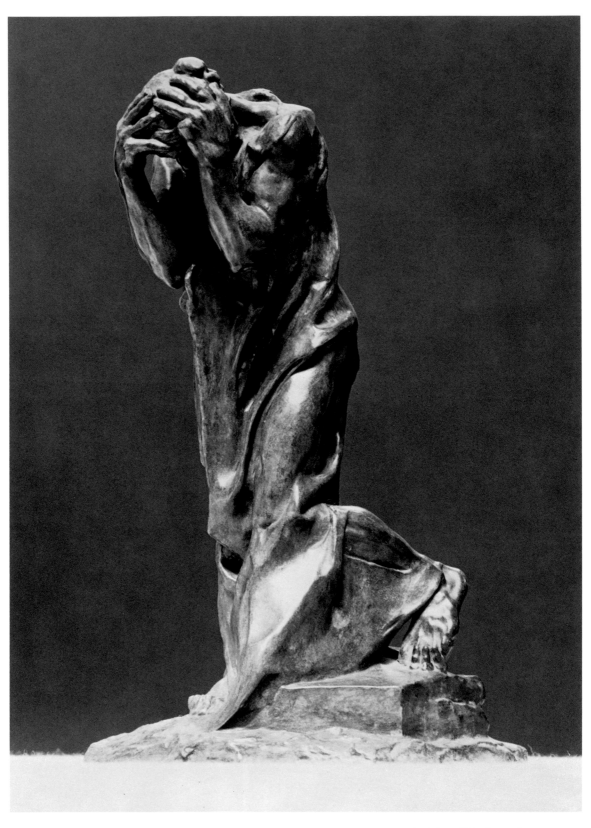

Andrieu d'Andres. Cat. no. 39.

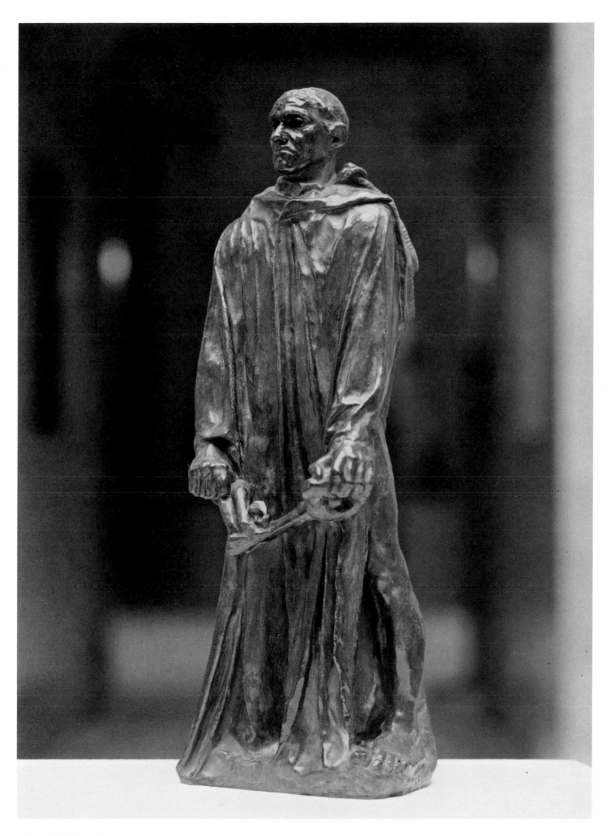

Jean d'Aire. Cat. no. 40.

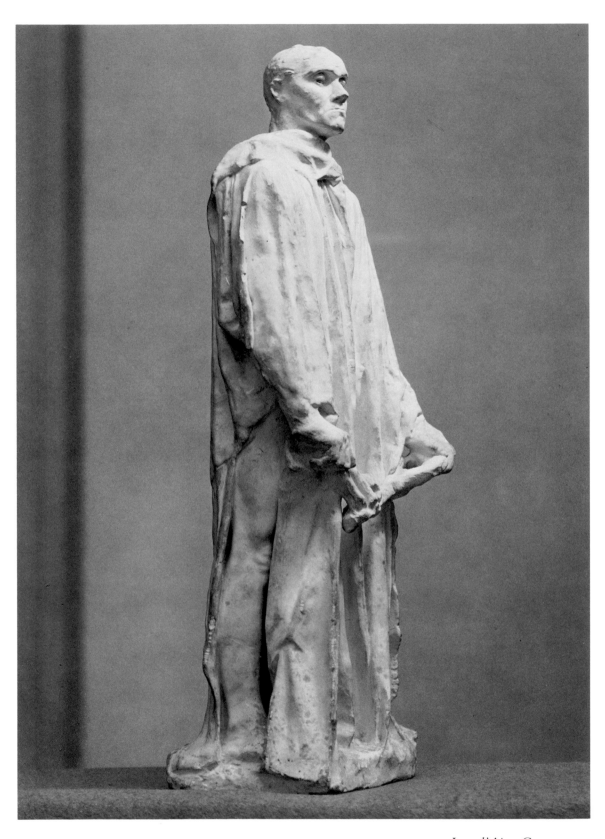

Jean d'Aire. Cat. no. 41.

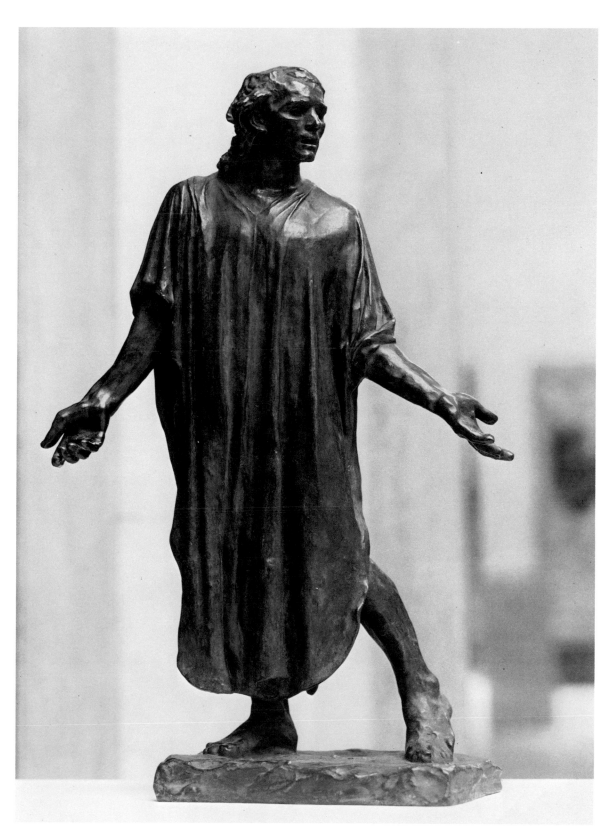

Jean de Fiennes. Cat. no. 42.

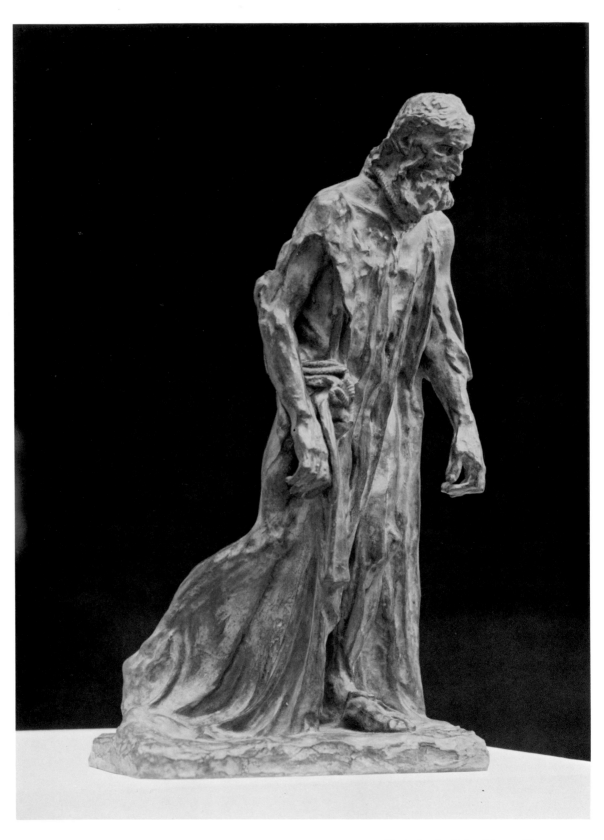

Eustache de Saint-Pierre. Cat. no. 43.

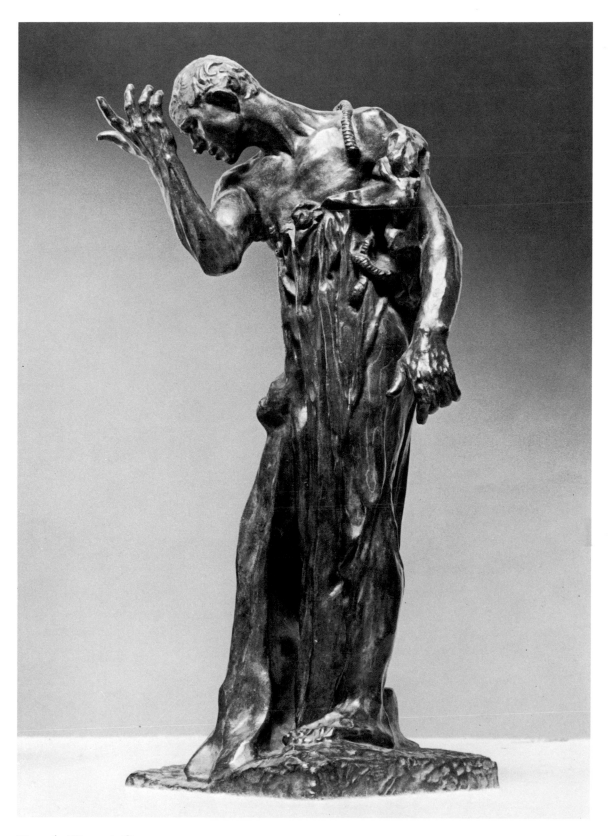

Pierre de Wiessant. Cat. no. 44.

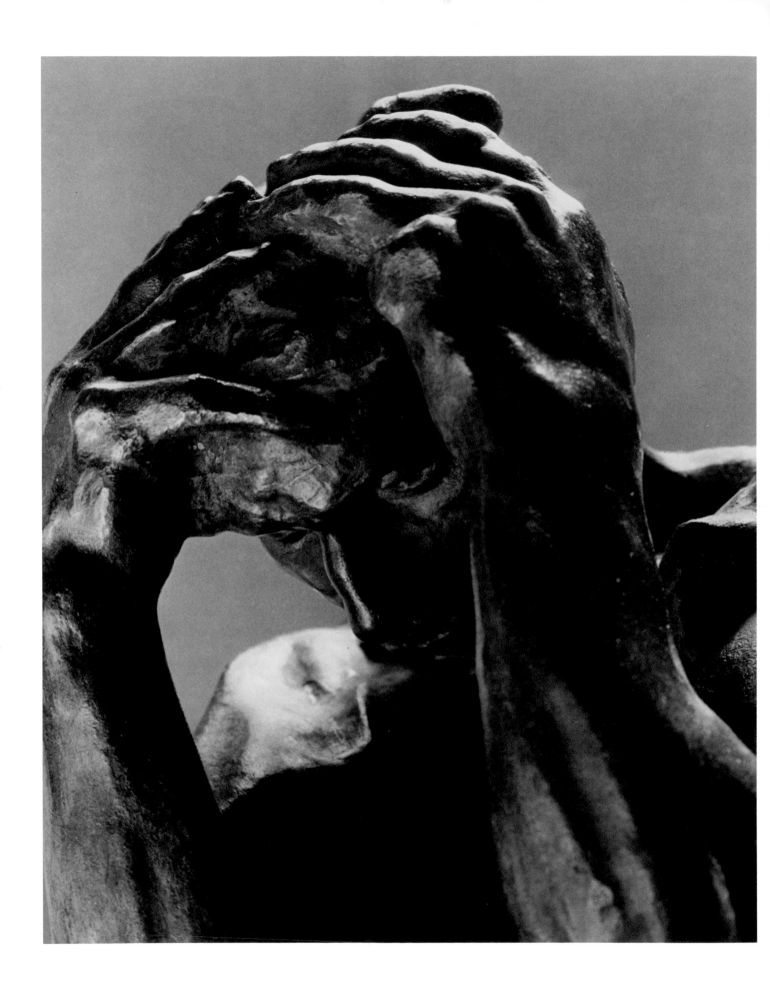

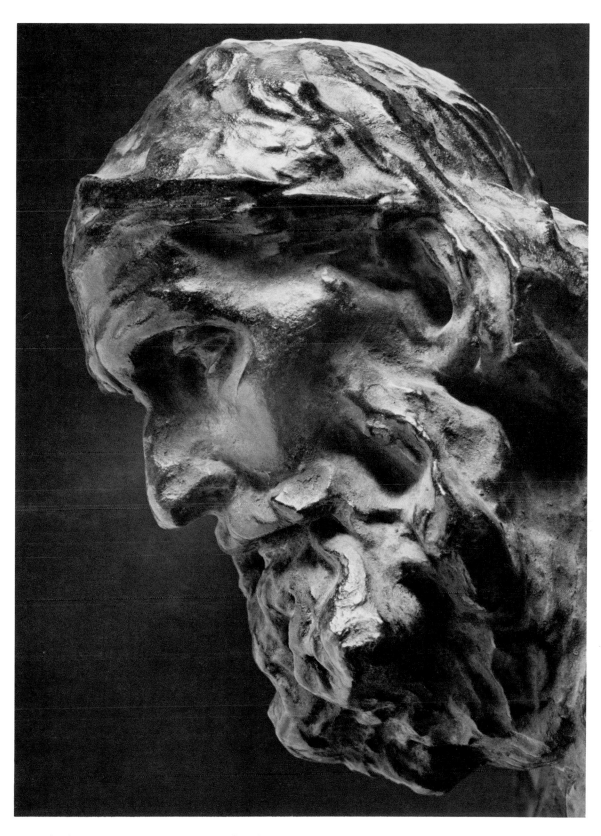

Eustache de Saint-Pierre. Cat. no. 43, detail.

Left: *Andrieu d'Andres*. Cat. no. 39, detail.

45
The Benedictions

Untinted plaster; on a hexagonal plaster base tinted dark brown
7 x 7 1/8 x 5″ (17.8 x 18.1 x 12.7 cm)
Inscribed: esquisse / . . . [illegible] / Benedictions [sic] (left wing, figure with head)
1933.12.16

These two birdlike figures form a study for *The Benedictions* group[1] intended to crown the projected *Tower of Labor*, Rodin's tribute to man's toil. The two nearly identical winged torsos hover in mid-air, their gyrating wings either propelling them upward or helping them to land as they bend forward toward the earth. The involuted arched bodies and curved wings echo the spiral form of Rodin's tower. The voids, penetrating the group and allowing light to freely circulate in and around the figures, add to the lightness and buoyancy of the beneficent spirits. If the composition is intricate, the figures themselves are modelled simply; Rodin intensified this effect by applying a thin coat of liquid plaster to focus attention on the striking interplay of abstract forms, rather than on the particulars of the figures. Rodin's emphasis on the subtle interplay of parts and on fluent forms gives new life to a time-worn symbol of spiritual life.

The specific meaning of this group can be understood only in light of its function on the *Tower of Labor*. Begun in the 1890s, this project never progressed beyond the model, today located in the Musée Rodin at Meudon.[2] A *Benedictions* group tops the arcaded tower, which encloses a column covered with spiralling bas-reliefs. Rodin planned that the visitor should view these reliefs while mounting the helical stairway; the viewer would thus be totally enveloped by the sculptural-architectural ensemble, an example of total artistic environment advocated in late nineteenth-century aesthetics. Rodin's elaborate program for this colossal monument centered on the glorification of the worker, a major concern of several artists around the turn of the century; similar projects were under way by prominent sculptors like Dalou and Meunier.

The visitor to Rodin's proposed monument would enter the crypt, passing between the heroic guardian figures symbolizing Night and Day. In the crypt—this word was used by Rodin himself and stresses the religious ingredients of the work—the viewer would see representations of miners and divers, those who worked beneath earth and water. Mounting the spiral staircase, the visitor would study the labors that took place above ground, depicted on the ascending bas-relief. These labors were evidently to be arranged in hierarchical order, beginning with the trades—carpentry, blacksmithing and masonry—and culminating with

Inscription: *The Benedictions*. Cat. no. 45.

the more intellectual activities of artists, poets and philosophers.[3] At the very top, the viewer would meet the alighting *Benedictions*, which Rodin called "two winged genii who descend from heaven, like a beneficent rain, to bless the work of men."[4] Rodin expanded on the function of these two spirits:

> On the coping will be my Blessings, the reward merited by a life of labour accomplished. The worker will climb one by one the steps of the great stairway, pausing, thinking, before each bas-relief; and when he is at the summit, on the platform, the wings of the angels in blessing will cast a restful shade on his weary head.[5]

On another occasion, he noted:

> And my tower rising toward the heavens is meant to symbolize the apotheosis of labor, crowned by the inspiring spirits of work.[6]

The two winged figures, then, aid in the apotheosis not of a saint or a hero but of the worker; at the same time they are inspiring agents, or muses, of the laborer. Since Rodin planned to represent man rising from the basest manual occupations to increasingly intellectual endeavors, *The Benedictions* can also be seen as the representation of the triumph of man's spirit over matter, a theme frequently met in Rodin's sculpture.

228

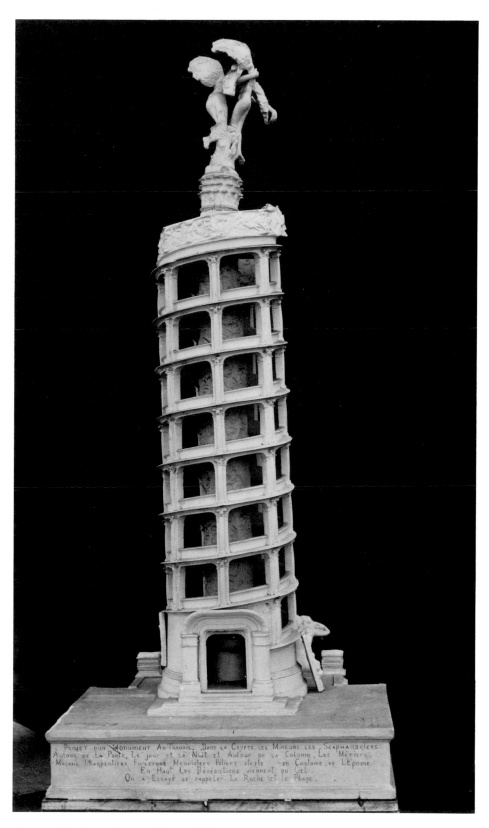

Tower of Labor, plaster. Photo Bulloz.

The problem of dating the *Tower of Labor* and *The Benedictions* brings to light information that indicates either that the winged figures were created before the *Tower* or that the monument was actually begun much earlier than is generally realized. The *Tower* is usually dated in the late 1890s; however, evidence suggests that *The Benedictions* was completed by 1894.[7] The question of a possible use of *The Benedictions* prior to Rodin's undertaking of the *Tower of Labor* is also raised by the close relationship of the group to studies for the Victor Hugo monument, where numerous winged figures of a similar type appear. It is entirely possible that *The Benedictions* was conceived in connection with this earlier project and later transferred to the monument to labor.

Several versions of *The Benedictions* group exist. The Spreckels' cast, apparently a unique plaster since no other replicas have yet been discovered, was given to the Legion of Honor in 1933. It is the only known study for the finished group. These figures are less defined than in the group atop the maquette of the *Tower*; parts of the limbs have been broken off, whereas in the work on the tower these are complete. Bronze casts of the isolated group exist in four sizes: ca. 28 cm, ca. 68 cm, ca. 84 cm and ca. 90 cm. The ca.-68-cm version appears to have been cast directly from the group on the *Tower*, where the legs are nearly free of the conical base. In the other three versions, the figures are partially embedded in the swirling forms of the base, which is no longer conical in form but spreads outward at the bottom. Some variation occurs in the exact shape of these bases.

In addition to the bronze casts, at least two marble versions were executed during Rodin's lifetime. One of these marbles is today in the Ny Carlsberg Glyptotek; the location of the other is unknown. A version showing the two winged figures emerging from a waterlike base is illustrated in a monograph of 1908.[8] What appears to be a plaster cast after a marble is reproduced in a periodical of 1914.[9] In this version, the base surges up around the figures like the froth of a wave.

NOTES

1. Though usually known as *The Benedictions*, this group has also been called *L'Envolée*, *Les Gloires* and *Les Victoires* (Grappe, 1944, no. 272).

2. Another version of the *Tower of Labor* was illustrated by Maillard in his 1899 monograph (p. 67). What became of this less-elaborate project is unknown. J. A. Schmoll gen. Eisenwerth, "Denkmäler der Arbeit—Entwürfe und Planungen," *Denkmäler im 19. Jahrhundert. Studien zur Kunst des neunzehnten Jahrhunderts*, Munich, 1970, pp. 253-81.

3. A brief description of the program is inscribed on the model of the tower itself: "Project of a Monument to Labor. In the Crypt—Miners, Divers. Around the Gate, Day and Night and around the Column: the Trades—Masons, Carpenters, Blacksmiths, Joiners, Potters etc. etc. in Costume of the time. Above the Benedictions come from Heaven. The intention was to recall the Hive and the Lighthouse." ("Projet d'un Monument au Travail. Dans la Crypte—Mineurs, les Scaphandriers. Autour de la Porte, le jour et la Nuit et Autour de la Colonne: Les Métiers—Maçons, Charpentiers, Forgerons, Menuisiers, Potiers etc. etc. en Costume de l'Epoque. En Haut Les Bénédictions viennent du Ciel. On a Essayé de rappeler La Ruche et Le Phare.") More detailed descriptions are given in a document, written by Rodin, in the Princeton University Library; repro-duced by Howard C. Rice, Jr., in "Glimpses of Rodin," *Princeton University Library Chronicle*, XXVII (1965), following p. 40. Cf. Ricciotto Canudo, "La Torre del Lavoro e della Volontà," *Vita d'Arte*, 1908, and Cladel, 1917, p. 40.

4. Rice, *op. cit.*

5. Marcelle Tirel, *The Last Years of Rodin*, New York, 1925, p. 113.

6. Frisch/Shipley, p. 308.

7. Dates of 1898 or 1899 are suggested by Maillard, p. 156; Cladel, 1908, p. 159; Coquiot, *Vrai Rodin*, p. 244; Léon Riotor, *Rodin*, Paris, 1927, p. 130; and Frisch/Shipley, p. 432. More recent writers have tended to date the monument somewhat earlier, probably on the basis of the earlier date of *The Benedictions* (Elsen, *Rodin*, p. 210; Denys Sutton, *Triumphant Satyr*, New York, 1966, p. 76). Both *The Benedictions* and the model for the monument were exhibited at the 1900 Rodin exhibition (nos. 125 and 124). Grappe assigns the date of 1894 to this group on the basis of a receipt for putting in place the wings of this group, signed by a practitioner in that year (1944, no. 272).

8. Cladel, 1908, p. 68.

9. *L'Art et les Artistes*, p. 21. Despite the visible traces of casting seams, this is labeled: "Les Bénédictions (Marbre)."

Balzac

Introduction

Two heads in the Spreckels collection (cat. nos. 46-47) belong to the long series of studies that preceded the final statue of Balzac—a highly controversial work in Rodin's time, regarded even today as his most daring and successful sculpture. After receiving the commission for a monument to Balzac in 1891 from the Société des Gens de Lettres, Rodin proceeded with meticulous care to achieve an expression of Balzac's personality.[1] For seven years Rodin submerged himself in contemplation of the writer, reading his works,[2] visiting his native Touraine, studying portraits of Balzac by his contemporaries, finding models who resembled him and producing about fifty studies of both head and figure before arriving at a startling sculptural innovation.

Rodin's prodigious research implies something more than a scientific study of a man's appearance; it suggests a desire to understand intimately a personality that had so much in common with his own. Balzac's ambitious attempt to probe all levels of French society in his novels of *The Human Comedy* is matched, in scope and mood, by Rodin's life-long preoccupation with *The Gates of Hell*. Balzac's emphasis on the corruption, misery and absurdity of early nineteenth-century society is echoed in the tormented inhabitants of Rodin's *Gates*. The celebrated driving force that pushed Balzac to undertake such a broad project and his cynical view of mankind were aspects of the author's personality that Rodin wanted to capture in his statue.

This aim to go beyond a mere likeness, to create a poetic image of the writer, was expressed by Rodin in a long comment to Paul Gsell in 1907:

> . . . I maintain that there was only one manner of evoking my personage: I had to show a Balzac panting in his work room, his hair in disorder, his eyes lost in a dream, a genius who, in his little chamber, reconstructs piece by piece an entire society in order to make it live tumultuously before his contemporaries and before the generations to come; a Balzac truly heroic who does not take a moment for rest, who makes day of night, who struggles in vain to fill the gap hollowed out by his debt, who above all sets to building an immortal monument, who boils with passion, who, frantic, violates his body and scorns the warnings of the heart ailment of which he would soon die. It seems to me that such a Balzac, even for a public place would be far greater, far more worthy of admiration than any writer who swaggers in a chair or who throws out his chest proudly in order to offer himself to the enthusiasm of the crowd.[3]

In the statue of Balzac, it is evident that Rodin has rejected the conventional nineteenth-century formula for statues to illustrious men which required didactic gestures and period costume; instead he stressed the inner life of the man. Balzac's famous robe, wrapped around him like a toga, hides his ungainly body and focuses our attention on the head.[4] The head, rather than the gestures, conveys the genius of Balzac. Encompassed in his cocoonlike gown, he proudly tosses his head and sneers; his aloofness suggests a spiritual detachment and a superiority, frequent components of Balzac's novels.[5] Artistic struggle is denoted by the wild, unkempt shock of hair, while the cavernous eyes convey an inhuman depth of vision. The face of the ailing man is fat and distorted, as if ravaged by long years of burning ambition. Still, Balzac is bursting with energy; the tilted attitude and smooth planes of the garment suggest a shooting fountain, or a rocket about to leave the earth. This image of soaring, appropriate to the writer who admired the mystical fantasies of Swedenborg, suggests the force of genius and artistic striving.

Rodin's *Balzac* lends itself to a variety of interpretations, many of which were loosed in a barrage of reviews when the statue was exhibited at the Salon of 1898. Nearly 100 articles appeared from May to July in newspapers and periodicals.[6] For the moment, the *Balzac* scandal rivaled the Dreyfus Affair, a racist political issue that split France into two camps. At the same time the issue pitted the Right, primarily concerned with national honor, against the Left, concerned with the individual. The political climate is reflected in reaction to the *Balzac*. Those who took a position for or against Dreyfus also took a stand for or against *Balzac*, although this great bulk of criticism also reflects more reasoned analyses. To some, the *Balzac* was a masterpiece; to others, it was a monstrosity. Cartoonists poked fun at Rodin and his statue, but graver political and artistic criticism was implied when French President Félix Faure praised *The Kiss* but snubbed the *Balzac*.[7] The Société des Gens de Lettres was outraged and refused to accept Rodin's statue, commissioning the sculptor, Alexandre Falguière, to create a new one.

Many people rallied to Rodin's support, seeing in him a new revolutionary symbol. Several proposals were made to purchase the statue. Friends circulated a petition, which was signed by such prominent men as Georges Clémenceau, Claude Debussy, Claude Monet and Anatole France,[8] questioning the artistic judgment of the Société and urging Rodin to complete his work.[9] A subscription was opened in Paris to purchase the statue, and the required sum was quickly raised. Though grateful for this support, Rodin, who shunned political involvement, became alarmed when he realized that the majority of the subscribers were also supporters of Dreyfus. Ultimately he decided not to sell the *Balzac* to anyone, and retired it to his home at Meudon, where it remained until his death.[10] This controversy, so upsetting to Rodin, in the end strengthened his international reputation and contributed to many commissions and purchases of his sculptures.[11]

Much of the criticism that followed the exposure of Rodin's *Balzac* in 1898 was little more than a battle of words, bitter invective aimed at Rodin and his supporters on the one hand and at the Society and Rodin's opponents on the other. To many, Rodin seemed a madman; to others, he was a visionary. Opponents called the statue a seal, a pig or a toad, a sack of potatoes, a lump of flour, a nightmare. They were outraged, mystified. Some felt Rodin had taken a wrong turn with the *Balzac*, which they thought was not quite up to his other works. The exhibition of *The Kiss* in the same Salon offered an all-too-convenient example to prove their point, and many directed their attention to this sculpture rather than to the *Balzac*. Rodin's defenders were frequently as irrational and hot-headed as his opponents, but more serious criticism also emerged from the general uproar.

Right: *Balzac*, plaster. (Judith Cladel, *Auguste Rodin*. Brussels: G. Van Oest & Cie, 1908.)

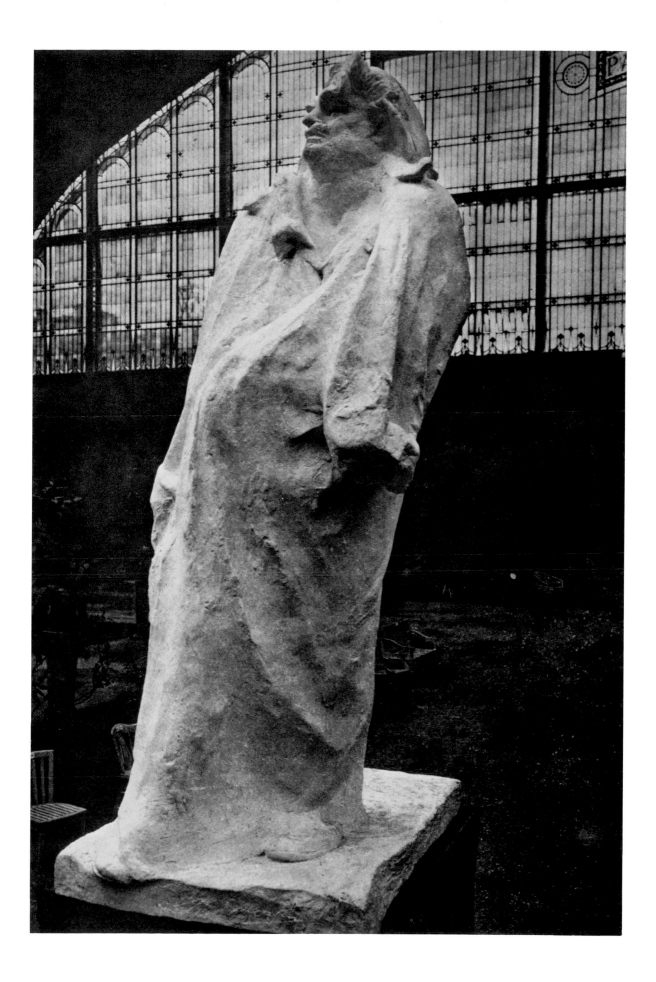

Much of this centered on Rodin's stylistic decisions. *Balzac*-haters condemned the instability of the statue, but its admirers pointed to the sense of liveliness and movement Rodin achieved. Many were disturbed by the unfinished quality of a statue that had not even been reworked after the mechanical enlargement of the original model. Others defended Rodin from such charges, praising his daring and primitive simplicity, his vigorous modelling and synthesis. Some felt compelled—through a critical practice standard at the time—to justify the simplifications and sketchiness of the *Balzac* by comparing it to the art of Egypt and of Michelangelo. Rodin himself replied to the complaint that his *Balzac* was nothing more than a sketch:

> My essential modellings are here, whatever may be said and they would be flabby if I were to give it a more finished appearance. As to the polishing and repolishing the toes of the foot or the loops of hair, that is of no interest in my eyes, that jeopardizes the central idea, the overall design, the spirit of what I wanted, and I have nothing more to say on this to the public. Here is the dividing line between the public and me, between the faith that it owes me and the concessions that I do not owe it.[12]

The major conflict arose over whether a portrait of a great man should be a faithful representation of his physical appearance or whether it should attempt to express his personality. Both sides generally agreed that Rodin's *Balzac* was no mere photographic image. To some, this departure from the external appearance of the author was anathema, an unacceptable departure from what, in the course of the nineteenth century, had become tradition. To others, Rodin's interpretation was a mark of excellence; they saw the *Balzac* as an expression or symbol of the soul, of the writer's genius, replacing the mere physical envelope of the man. In response to the new expressive and "unnatural" quality of the *Balzac*, some called Rodin's conception too intellectual, too literary; they said that he had been led astray by his writer friends.

In short the *Balzac* was clearly seen as breaking with tradition, a source of dismay to some and delight to others. Rodin was associated with the vanguard of those artists in the 1890s who strove for a new public art reduced to the basic formal components. This emphasis on the revolutionary character of the *Balzac*, both formal and conceptual, is not unrelated to the political and social climate of the time. The two groups that formed around the *Balzac* issue basically conformed to conservative and anarchist lines. The anarchism and social-reform movements that emerged in the 1890s in France seem to have created a general paranoia among much of the public, which viewed any sort of nonconformity as a challenge to the whole of society. This feeling repeatedly focused on the arts; Impressionism and free verse, for instance, were seen as challenges to tradition and were thus considered unpatriotic. One political and artistic radical, Gustave Kahn, expressed this general fear of the unconventional in the 1890s:

> Where is the innovator who, much as he is aware of his origins . . . does not dream of a total reconstruction of everything, inasmuch as any serious critic realizes that in shattering a fragment of the artistic façade one touches the social façade; it is this that explains why artistic demands once made encounter such aggressive resistance. The guardians of the constituted order are in agreement along this entire line[13]

Rodin was guilty not only of breaking with conventional notions of the portrait and with the accepted standards of the masterpiece but also of association with many known social and political radicals such as Octave Mirbeau, Camille Mauclair and Gustave Geffroy. No wonder some saw in the *Balzac* the spirit of anarchy.[14]

The division of the critical public into conservative and radical camps indicates that the true significance of the *Balzac* was suspected in Rodin's time. The statue was so revolutionary that Rodin himself seemed somewhat taken aback by it and wavered in his evaluation, taking comfort in his friends' encouragement.[15] On one occasion Rodin called his *Balzac* a "defeat," but on another he said that he was too close to his work to really judge. He complained that one could find faults in his *Balzac*, that it perhaps fell short of his dream, but still he believed in the truth of his principle and that the statue was a clear break with commercial sculpture.[16] In 1908 he commented on the importance of the *Balzac* for his art, calling it "the result of all my life, the pivot even of my aesthetic" and adding that "from the day when I had conceived it, I was another man. My evolution was radical: I had renewed between the great lost traditions and my own time a tie that each day tightens more."[17]

If Rodin was a little uncertain about the significance of his *Balzac* for the future of art, the twentieth century would confirm it. Rodin's new methods of revealing the psychological qualities of Balzac and of breaking with the prevalent requirement for highly finished surfaces had far-reaching impact for the expressionistic and abstract trends in modern sculpture. Rodin's conception was at last vindicated in 1939—more than twenty years after his death—when the first bronze cast of the *Balzac* was erected in the streets of Paris.

NOTES

1. The historical account of the commission, Rodin's difficulties while developing the statue and genesis of the *Balzac* have been discussed in detail by Lawton, pp. 174-90; M. Morhardt, "La bataille du Balzac," *Mercure de France*, CCVVII (December 15, 1934), no. 879, pp. 463-89; Cladel, 1950, pp. 181-228; C. Goldscheider, "La Genèse d'une oeuvre, le Balzac de Rodin," *La Revue des Arts*, 2:1 (March, 1952), pp. 37-44; Elsen, *Rodin*, pp. 89-103; J. de Caso, "Rodin and the Cult of Balzac," *Burlington Magazine*, 106:735 (June, 1964), pp. 279-84; J. de Caso, "Balzac and Rodin in Rhode Island," *Bulletin of Rhode Island School of Design. Museum Notes*, 52:4 (May, 1966), pp. 1-21; and Elsen "Rodin's 'Naked Balzac,'" *Burlington Magazine*, 109:776 (November, 1967), pp. 606-17. One aspect of the commission has been neglected—the base which architect Frantz Jourdain designed and which Rodin was to decorate with a bas-relief. In 1897, Rodin was preoccupied with this relief of "a woman holding a mask, *The Human Comedy*" (". . . une femme tenant un masque, la Comédie humaine"); "Petite Chronique," *L'Art moderne*, 17:30 (July, 1897), p. 243.

2. According to Léonce Bénédite, Rodin had developed "an avid and passionate interest in *The Human Comedy*" while in Brussels (1871-1877); "Auguste Rodin," *Gazette des Beaux-Arts*, ser. 4, 14(January-March, 1918), p. 26; Cf. Lawton, p. 176. Rodin had associated with Balzac admirers Alphonse Daudet and Gustave Geffroy since the 1880s.

3. ". . . Je prétends, moi, qu'il n'y avait qu'une manière d'évoquer mon personnage: je devais montrer un Balzac haletant dans son cabinet de travail, les cheveux en désordre, les yeux perdus dans le rêve,

un génie qui, dans sa petite chambre, reconstruit pièce à pièce toute une société pour la faire vivre tumultueuse devant ses contemporains et devant les générations à venir; un Balzac vraiment héroïque qui ne prend pas un moment de repos, qui fait de la nuit le jour, qui s'efforce en vain de combler le trou creusé par ses dettes, qui surtout s'acharne à l'édification d'un monument immortel, qui bouillonne de passion, qui, frénétique, violente son corps et méprise les avertissements de la maladie de coeur dont il doit bientôt mourir. Il me semble qu'un tel Balzac, même sur une place publique, serait autrement grand, autrement digne d'admiration qu'un écrivain quelconque qui se carre sur un siège ou qui se cambre fièrement pour se proposer à l'enthousiasme de la foule" ("Chez Rodin," *L'Art et les Artistes*, 4 [February, 1907], pp. 410-11).

4. This practice of draping a contemporary garment so that it came to resemble antique garb became a major aspect of sculpture in the late eighteenth and early nineteenth century. Rodin said of Houdon's *Voltaire*: "He transformed the armchair into a curule chair, the dressing gown which hugged the long, thin body into an antique toga. . . ." ("Il a transformé le fauteuil en chaise curule, la robe de chambre qui enserrait le corps maigre et long en toge antique"); Dujardin-Beaumetz, p. 16. Like his famous predecessor, Rodin arranged Balzac's robe in this manner to achieve a timeless effect: "But the dress of the Roman was universal and for all time, in this sense, that it did not mar the beauty of the human body. This is also true of much of the clothing of the Middle Ages. That is why I did not strip Balzac; because, as you know, his habit of working in a sort of dressing-gown (*houp-*

pelande) gave me the opportunity of putting him into a loose flowing robe that supplied me with good lines and profiles without dating the statue" (A. M. Ludovici, *Personal Reminiscences of Auguste Rodin*, Philadelphia/London, 1926, p. 112).

5. For instance, these are the main themes of his *Louis Lambert*, an autobiographical novel that Balzac considered his masterpiece.

6. For a sampling of this criticism, see Cladel, 1950, pp. 204-209; de Caso, "Rodin and the Cult of Balzac," p. 284; de Caso, "Balzac and Rodin in Rhode Island," p. 21.

7. Morhardt, p. 464; Cladel, 1950, pp. 205-206.

8. Cladel, 1950, pp. 214-15.

9. Apparently, Rodin did not feel that his *Balzac* was complete when he submitted it to the Salon in 1898. He told a journalist: "I hope that I have succeeded . . . and yet, if I must be frank, I must own that I should have liked to keep still for some months, away from every eye, the statue to which I have given the final pressure of my thumb. I should prefer to contemplate it every day for a while, and wait until a sudden inspiration, such as occasionally flashes through the brain, came to flood my imagination and enable me to perfect and idealise my work. For a work, even when achieved, is never perfect; it is always susceptible of a modification that can increase its beauty" (quoted in Lawton, pp. 183-84).

10. Lawton, p. 188; Cladel, 1950, p. 218.

11. Prominent articles on the *Balzac* affair appeared not only in France, but also in the United States, England and Central Europe. The image of *Balzac* was used as an emblem of Rodin's art on a relief frieze for the pavilion exhibiting his sculpture at Prague in 1902 (ill. *International Studio*, 18 (December, 1902), p. 143) and on the reverse of Henri Nocq's Rodin medallion (ill. *Art et Décoration*, XIII [January-June, 1903], p. 106).

12. ". . .Mes modelés essentiels y sont, quoi qu'on en dise, et ils seraient mous si je finissais davantage en apparence. Quant à polir et à repolir des doigts de pied ou des boucles de cheveux, cela n'a aucun intérêt à mes yeux, cela compromet l'idée centrale, la grande ligne, l'âme de ce que j'ai voulu, et je n'ai rien de plus à dire là-dessus au public. Ici s'arrête la démarcation entre lui et moi, entre la foi qu'il doit me garder et les concessions que je ne dois pas lui faire" (*L'Art Moderne*, v. 22, 1902, p. 391; cf. Cladel, 1903, p. 51).

13. Preface to *Premiers poèmes*, Paris, 1897, p. 24, quoted in Eugenia W. Herbert, *The Artist and Social Reform, France and Belgium, 1885-1898*, New Haven, 1961, p. 54.

14. The anarchical implications of the *Balzac* were voiced by Jean Rameau in 1898: "There is another reason for which this sculptor is extolled, and this is more serious. It is anarchy that has shown the tip of its ear, as it shows it in most of the present scuffles All the discontents, all the revolutionaries, all those who dread the great final fiasco naturally are grouped around him. And there is a very telling fact in this

connection; it is that most of the anarchists of art who escort M. Rodin were found last around M. Zola" ("Il y a une autre raison pour laquelle on a hissé ce sculpteur sur le pavois, et celle-ci est plus grave. C'est l'anarchie qui a montré le bout de l'oreille, comme elle le montre dans la plupart des bagarres actuelles Tous les mécontents, tous les révolutionnaires, tous ceux qui redoutent le grand ratage final se sont groupés naturellement autour de lui. Et il y a un fait bien caractéristique à ce propos, c'est que la plupart des anarchistes de l'art qui font escorte à M. Rodin se sont retrouvés naguère autour de M. Zola"); "La victoire de M. Rodin," *Le Gaulois* (May 3, 1898). Likewise, arch-conservative American, F. Wellington Ruckstuhl, who consistently attacked Rodin's sculpture on moral grounds ("Why the deformation of the form in public monuments is a social menace," *Art Week*, 1 [February, 1917], pp. 294, 302).

15. In a letter of February 18, 1907, Rodin thanked Anatole France for expressing himself on the *Balzac*: ". . . You have shown it [*Balzac*] to me in a new way and your criticism has increased it in my mind, that is to say that you have created something, which can serve me in its defense if in more fortunate times it reappears before the public" (". . . vous me l'avez montré, à moi d'une façon nouvelle, et votre critique l'a grandi à mon esprit, c'est à dire que vous y avez créé quelque chose, qui peut me servir de défense si dans un temps plus fortuné il reparaissait devant le public"); original letter in Princeton University Library.

16. "This Balzac has been for me a defeat and I do not dare run others in Belgium" ("Ce Balzac a été pour moi une défaite et je n'ose courir à d'autres en Belgique"); undated letter to Meunier, from a typescript of a letter in the Library of the Philadelphia Museum of Art. "Ai-je pourtant réussi à faire ce que je voulais? J'avoue que je suis trop près de mon oeuvre pour la bien juger. Il faudrait que je fusse un an sans la voir. Alors je me dégagerais de ma personnalité. Je la jugerais comme un étranger" (Rodin quoted by Charles Chincholle, "La Vente de la Statue de Balzac," *Le Figaro* [May, 1898], pp. 2-3). "On peut trouver des erreurs dans mon *Balzac*; on ne réalise pas toujours son rêve; mais je crois à la vérité de mon principe et *Balzac* rejeté ou non n'en est pas moins une ligne de démarcation entre la sculpture commerciale et la sculpture d'art que nous n'avons plus en Europe" (Rodin quoted in anonymous article, "La statue de Balzac," *Journal des Débats politiques et littéraires* [May 12, 1898]).

17. ". . . C'est la résultante de toute ma vie, le pivot même de mon esthétique. Du jour où je l'eus conçue, je fus un autre homme. Mon évolution fut radicale: j'avais renoué entre les grandes traditions perdues et mon propre temps un lien que chaque jour resserre davantage" (*Le Matin*, July 13, 1908; quoted in *Les Arts Français*, 14 [February, 1918], p. 41).

46

Head of Balzac

Bronze, black to green patina; on a tall variegated marble base
6 1/2 x 7 7/8 x 7 5/8" (16.5 x 20 x 19.4 cm)
Signed: A. Rodin (lower left side)
1941.34.5

47

Head of Balzac

Plaster, tinted light brown, with impression of cloth which covered the clay model
7 1/8 x 6 7/8 x 6 13/16" (18.1 x 17.5 x 17.3 cm)
Signed: R (lower left side)
1933.12.17

Among the numerous studies for the *Balzac* monument, we find many, like the two heads in the Spreckels collection, that are independent works of art in their own right. Working from a wealth of visual material, Rodin simultaneously developed studies of heads and figures. The importance of the head in the final monument, where it is the focal point, explains the greater number of head studies.[1] Rodin told Camille Mauclair that he believed the head should be emphasized in the portrayal of a man of intellect; his explanation further elucidates the significant role given to the head in the statue:

> Rodin explains that in his opinion the statue of a man celebrated for his heart and mind should not be a representation of his body, but a sort of construction whose lines should express the soul of the man It is illogical, he says, to give the feet and the dress the same value as the head, which is alone important, unless you want to make a photograph and not a work of homage.[2]

The many studies for the monument indicate a transformation in Rodin's conception of Balzac from a naturalistic to a symbolic image. This development was not a steady progression; rather, the studies seem to have been executed during two periods, when Rodin's enthusiasm for the project was at its peak. After receiving the commission in 1891, Rodin plunged enthusiastically into his study of the artist, producing many studies in which he attempted to capture an accurate likeness of the novelist, relying on earlier representations by Balzac's contemporaries and on models who resembled the writer.[3] In the second campaign Rodin reintensified his researches, but his representations of Balzac became less objective and more expressive. Rodin exaggerates the features in this second series of heads, aligning himself with the nineteenth-century tradition of caricature heads, such as those made by Dantan *jeune* and Daumier.[4] Moreover, Rodin's *portrait-charge* reflects the frequent appearance of caricatured types in Balzac's novels. The distorted features transform the portrait into

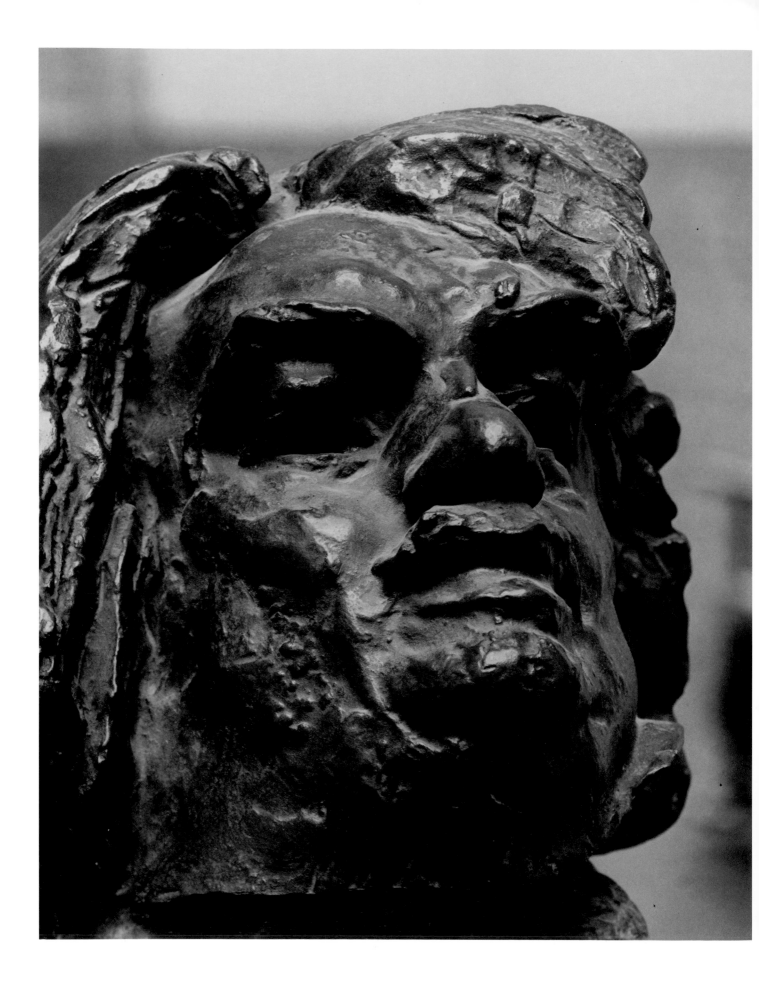

a symbol of Balzac's personality as Rodin saw it. The deeply gouged eyes beneath jutting eyebrows suggest a superhuman depth of vision; they allude to Balzac's prophetic powers and superior insights. The huge, sneering lips reflect Balzac's cynicism and sensuous nature. The bloated face melting into a thick neck is the inevitable result of a life lived to excess and of disregard for the body of a mind on fire.[5] This tumultuous life, the constant struggle with artistic creation, is also reflected in the wild shock of hair.

With varying degrees of intensity, these features occur in the second series of heads. The Spreckels' heads, which belong to the group, were executed shortly before Rodin began the definitive *Balzac* and consequently are two of the most poignant versions. The hairstyle and features are very similar to the final head, although the surfaces are more complex and rich, while the sneer becomes less defined in the definitive version.

Head of Balzac. Cat. no. 46.

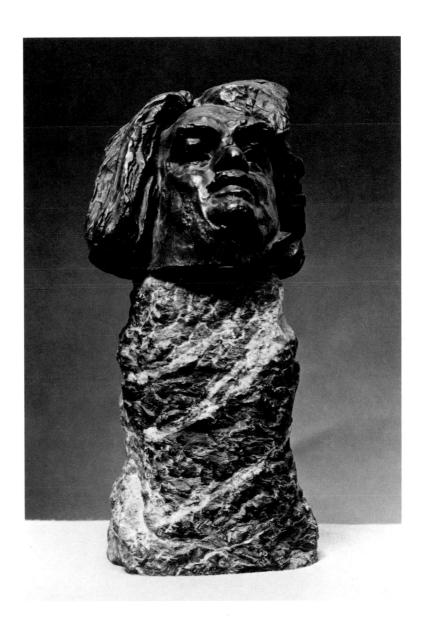

Left: *Head of Balzac*. Cat. no. 46, detail.

The two Spreckels' heads are not identical casts but two versions of a single conception. The differences are negligible, but slight variations can be discerned, particularly in the arrangement of the hair on the left side of each head. The plaster cast is particularly fine for its faithful duplication of the clay model. The impression of the damp cloth that once protected the clay is visible on the left cheek, and a deep indentation made by Rodin's thumb appears at the base of the left side of the neck towards the back. This head looks directly ahead, but the bronze cast is mounted so that the head is thrown back as in the definitive statue. The tall variegated marble base that carries the bronze is striking, although the use of a different material is itself not exceptional (see cat. no. 56). The shape of the support, which is extraordinarily elongated, repeats the hermetic and elemental nature of the body in the statue and seems to be symbolic of Balzac as an elemental force of nature. Its erotic implications, also a part of the image of the writer, are evident.

The two heads represented in the Spreckels collection are among the most popular studies for the *Balzac* and have each been cast many times in various materials. The first casts of the type like the Spreckels' bronze seem to have been cast soon after the debut of Rodin's *Balzac*; this head was exhibited, and it was reproduced in periodicals around the turn of the century.[6]

Mrs. Spreckels bought the bronze study in 1915 from Loïe Fuller.[7] It was exhibited in the Legion of Honor in 1924. The plaster head was presented to the museum in 1933; its date of purchase is unknown.

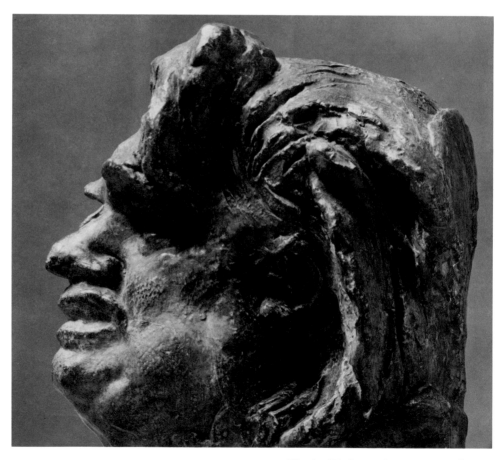

Head of Balzac. Cat. no. 47, detail.

240

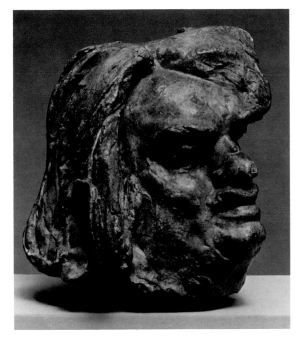 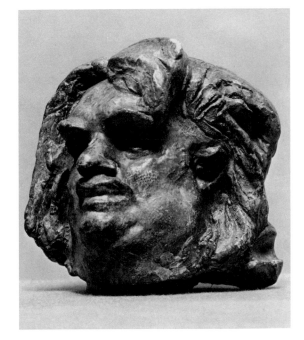

Head of Balzac. Cat. no. 47.

NOTES

1. For an analysis and photographs of most of the studies, see A. T. Spear, *Rodin Sculpture in the Cleveland Museum of Art*, Cleveland, 1967, pp. 9-30, 91-92; C. Goldscheider, *Balzac et Rodin*, Paris, 1950; Albert Elsen, Stephen C. McGough and Steven H. Wander, *Rodin and Balzac*, Beverly Hills, 1973. An article of 1896 mentions that Rodin first made studies of Balzac nude and seated and only later decided on a standing figure ("Au Jour le Jour," *Le Temps*, August 19, 1896, p. 3).

2. *International Monthly*, III(1901), pp. 171-72.

3. For information and illustrations of the various portraits of Balzac used by Rodin, see C. Goldscheider, *Balzac et Rodin*; J. Lethève, "Les portraits de Balzac," *L'Année Balzacienne* (1963). In a letter of September 6, 1891, Rodin wrote to a friend: "I am making as many models as possible for the construction of the head, with types in the country; and, with the abundant information I have secured, and am still procuring, I have good hope of the Balzac . . ." (English translation quoted by Lawton, p. 205).

4. This similarity to Daumier was pointed out in a disparaging way by one of Rodin's critics in 1898, who wrote: "It is not the memory of Phidias, but that of Daumier that it evokes" ("Ce n'est pas le souvenir de Phidias, c'est celui de Daumier qu'elle évoque"); Thiébaut-Sisson, *Le Temps*, quoted in *La Revue Illustrée*, May 15, 1898.

5. The extremely large neck of the definitive Balzac was one of the few aspects of the sculpture that did not satisfy Rodin. He told Charles Chincholle in 1898: "The only thing that I notice today is that the neck is too large. I had believed that it should be enlarged because, in my opinion, modern sculpture, from the psychological point of view, ought to exaggerate forms. By exaggerating this neck I had wanted to represent force. I confess that the execution has surpassed my thought. However, have you looked at my statue while standing at the right of Balzac, twenty paces from the base?" ("La seule chose dont je me rende compte aujourd'hui est que le cou est trop fort. J'avais cru devoir le grossir parce que, selon moi, la sculpture moderne doit exagérer, au point de vue moral, les formes. Par ce cou exagéré, j'avais voulu représenter la force. Je reconnais que l' exécution a dépassé ma pensée. Pourtant, avez-vous regardé ma statue en vous mettant à la droite de Balzac, à vingt pas du socle?") "La Vente de la Statue de Balzac," *Le Figaro*, May 12, 1898.

6. A bronze cast was included in a 1901 exhibition of French art at the Ateneumin Taidemuseo (Helsinki), which acquired it at that time. The bronze replica in the Cleveland Museum of Art was also purchased from Rodin in 1901; Spear, *op. cit.*, p. 91. Mauclair reproduces this study in his monograph of 1905 (opposite p. 110), and Lawton illustrates it in his 1906 biography (opposite p. 175).

7. A copy of the contract of August 27, 1915, between Mrs. Spreckels and Loïe Fuller was owned by Miss Jean Scott Frickelton, Palo Alto.

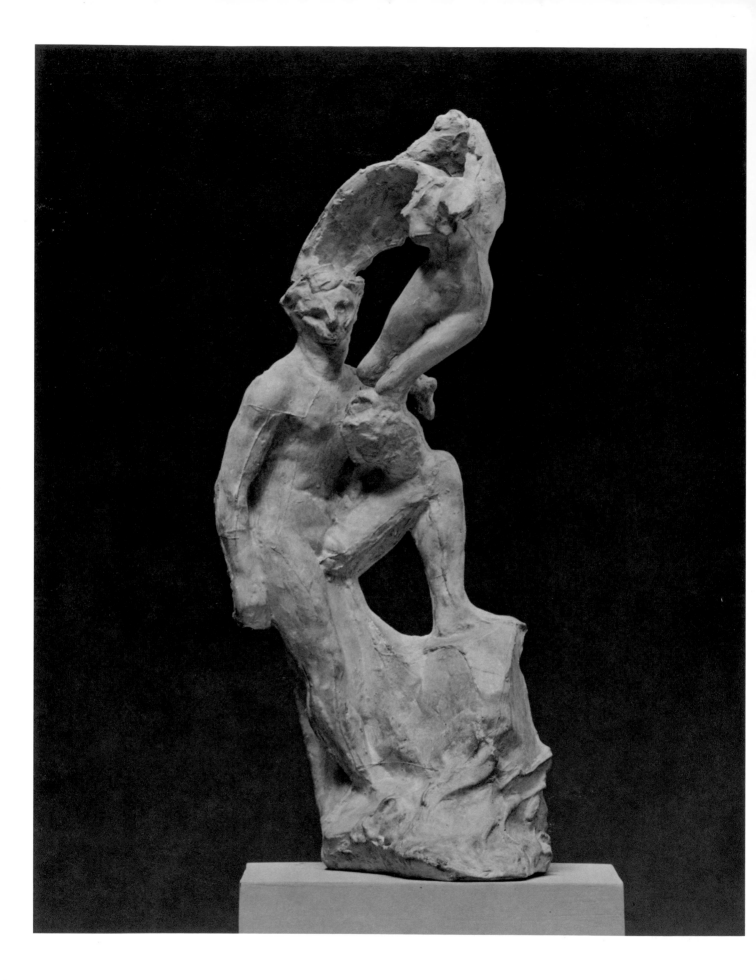

48

Study for a Monument
(to Eugène Carrière?)

Plaster, tinted flesh color; traces of piece mold
16 1/4 x 7 x 6 5/8″ (41.3 x 17.8 x 16.8 cm)
Signed: Rodin (base, back, lower left)
1933.12.20

49

Study for a Monument
(to Eugène Carrière?)

Bronze, dark brown patina; traces of piece mold
17 3/8 x 6 15/16 x 7 1/16″ (44.1 x 17.6 x 18 cm)
Signed: A. Rodin/ No. 2 (lower right side)
Stamped: .Alexis RUDIER. /.Fondeur. PARIS. (rear)
1950.59

These identical casts[1] of a very cursory sketch of a standing nude man and a winged torso have historical as well as artistic significance. The close relationship of this group to a similar but more finished work bearing the inscription "Carrière" suggests that this may be a study for a never-completed monument to Eugène Carrière (1849–1906).[2] Rodin's friendship with the painter, who was acclaimed by the Symbolists for his misty paintings of intimate family scenes, began in the 1880s and lasted until Carrière's death.[3] Appropriately, Rodin was commissioned to execute a monument to his friend in 1912.[4] Why Rodin did not complete this project has never been explained. Very likely, his work on it was affected by a ruling by the Municipal Council of Paris, which was concerned with the growing number of monuments crowding Paris streets; just a few months after Rodin received the commission, the Council decided to limit the erection of commemorative monuments to those honoring men who had been dead for at least ten years.[5]

Rodin's vertically oriented group is indebted to earlier artistic traditions. The confident pose of the man, with one leg resting on a tall projection—a pose which occurs in several of Rodin's sculptures[6]—has many precedents, dating back to ancient Greek art, which frequently convey the idea of superiority or victory. This pose continued to be used throughout the centuries, sometimes in scenes of the Resurrection. In other contexts we find it in the work of nineteenth-century artists from Ingres to Moreau.[7] Rodin's figure surpasses its predecessors in the exaggerated lift of the left leg. The group itself depends on traditional symbolism of funerary and memorial monuments where an idealized image of the deceased is frequently accompanied by a winged figure. The more finished version of this group shows a completed

winged female figure holding a wreath, an attribute linking this figure with the victories or fames who crown the deceased in funerary sculptures.[8] In Rodin's group, she may be helping the artist to ascend from his grave, one leg already elevated. The associations with earlier works of art suggest the program of Rodin's group: the triumph of the artist's genius over death.

Only a few bronze and plaster casts of the two versions of this work are known to exist. The plaster in the Legion of Honor appears to be unique in this medium. A slightly reworked figure like the man in the Legion of Honor casts is combined with two casts of the figure known as *Day* from the *Tower of Labor* (see cat. no. 45) to form a group known as *Study of Three Figures*.[9] Another slightly reworked version of the man is combined with another figure to form the group known as *Proserpine*, which was reproduced in a publication of 1908, indicating that the conception of the figure type and pose of the man preceded by several years the Carrière monument study, if this is indeed the correct identification.[10] Also pointing to an early dating for the initial conception is the work entitled *The Poet and Love*, where a bearded man in the same pose is combined with a winged female figure; this work is usually dated around 1896.[11]

The date of purchase of the plaster study is unknown. Mrs. Spreckels bought the bronze from Eugène Rudier in 1949 and gave it to the Legion of Honor the following year.[12]

Right: *Study for a Monument*. Cat. no. 49.

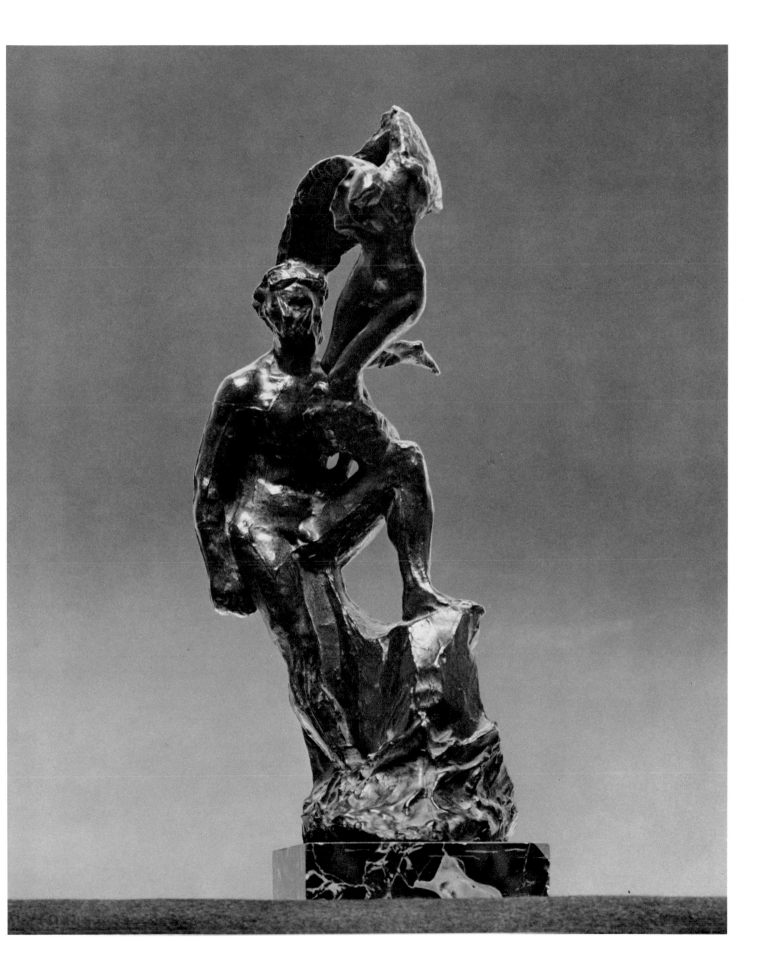

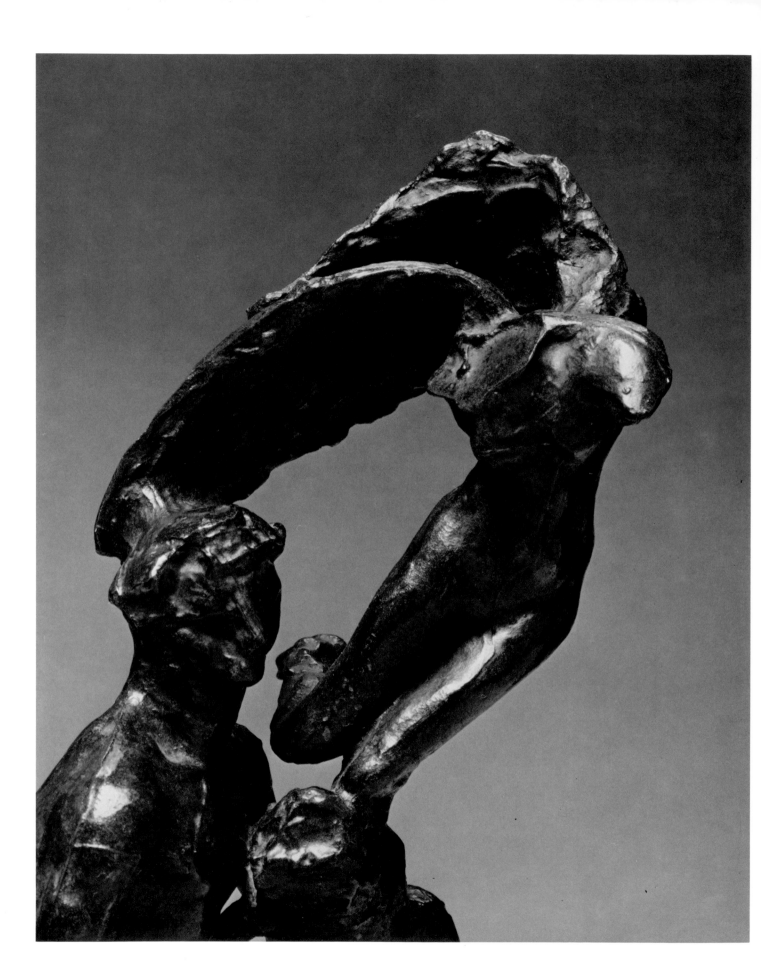

1. Both casts were formerly referred to in this collection as *Man Holding an Angel on His Knee*. The bronze in the National-galerie, Berlin (West), is called *Man and His Genius*.

2. The association of this figure with the Carrière project was first made by Cécile Goldscheider (*Rodin Inconnu*, Paris, 1962, no. 213). This connection has since been endorsed by Descharnes/Chabrun (p. 219) and by John Tancock (*Rodin Museum Handbook*, Philadelphia, 1969, no. 69). Since this attribution apparently rests only on the inscription appearing on the Musée Rodin and Philadelphia plasters, caution must be exercised in making too firm an attribution of the Spreckels' casts. The pose of the man and the group with a man and a winged female occur frequently in Rodin's work. The group is most probably intended as a monument to an artist or a poet—the same pattern is explored for the Hugo monument—but possibly it was made to celebrate someone other than Carrière. Many of Rodin's projects for monuments to famous men (for example, projected monuments to Byron, Léon Cladel, Puvis de Chavannes and Whistler) are known only through studies or through brief mentions by early biographers. If others have remained unreported, we do not know, but this possibility should be kept in mind when examining the piece in the Spreckels collection.

3. The impact of Carrière's art on Rodin sculpture has yet to be determined. More is known about the close friendship of the two artists. Lawton (p. 63) lists Carrière among those who were drawn to Rodin at the time of the disputes over *The Age of Bronze* (1877) and the *St. John* (1880). Their friendship was expressed in part by exchanges of works of art and adulatory remarks. Rodin owned several of Carrière's paintings, and Carrière possessed several of Rodin's sculptures, including a marble version of *The Eternal Idol* (see cat. no. 5). For a list of the paintings owned by Rodin, see Léonce Bénédite, *Catalogue sommaire des oeuvres d'Auguste Rodin . . . Exposées à l'Hôtel Biron*, Paris, 1926, nos. 387-92. Some of the sculptures owned by Carrière are listed in the sale catalogue for Galerie Manzi and Joyant, February 2 and 3, 1920, nos. 183-85. Rodin voiced his great admiration for the painter at Carrière's funeral in 1906 (oration reprinted in Charles Morice, *Eugène Carrière*, Paris, 1906, pp. 217-18). Earlier Carrière had praised Rodin's work in the 1900 catalogue (10-11). For further comments on their friendship see Frisch/Shipley, pp. 297-305.

4. Rodin was to be assisted by Jules Desbois ("Petite Chronique," *L'Art Moderne*, XXXII:21 [May 26, 1912], 165). The committee to erect the monument was formed in May with Léon Bérard, Dujardin-Beaumetz and Rodin as presidents of honor, Charles Morice as secretary and Henri Bourrelier as treasurer ("Art et curiosité," *Le Temps*, May 25, 1912, p. 4). Although this fact has not been established, likely this committee grew out of the Société des Amis de Carrière, formed in 1906 with Rodin as its president (Paul Delsemme, *Un Théoricien du Symbolisme: Charles Morice*, Paris, 1958, p. 96).

5. The Council also prohibited the erection of any monument on the Champs-Elysées, the location requested by the Carrière committee ("Art et curiosité," *Le Temps*, August 23, 1912, p. 5). Finally, in 1936, a monument by the painter's son, Jean-René Carrière, was erected (Goldscheider, *Rodin Inconnu*, no. 213).

6. These include the *Nude Study for Balzac G, Le Poète et l'Amour* (Grappe, 1944, no. 281), *L'Epervier et la Colombe* (Grappe, 1944, no. 311), the muse for the projected Whistler monument and the *Study of Three Figures* (Rodin Museum, Philadelphia).

7. For example, Ingres' *Oedipus Solving the Riddle of the Sphinx* and Moreau's painted and sculpted versions of Prometheus.

8. Examples of this version are in the Musée Rodin, Paris, and the Rodin Museum, Philadelphia.

9. A plaster cast of this group is in the Rodin Museum, Philadelphia.

10. Illustrated by Cladel, 1908, opposite p. 118.

11. Grappe, 1944, no. 281.

12. In an album of photographs in the CPLH library, the plaster group is entitled *L'Enlèvement*; this is oddly translated in the list of gifts of December 19, 1933, as *Group: Leave-taking* (CPLH archives). The bronze is listed among the works acquired from Rudier in October, 1949, as *Abduction (Enlèvement)*; list was in the collection of Miss Jean Scott Frickelton, Palo Alto.

Left: *Study for a Monument*. Cat. no. 49, detail.

PORTRAITS

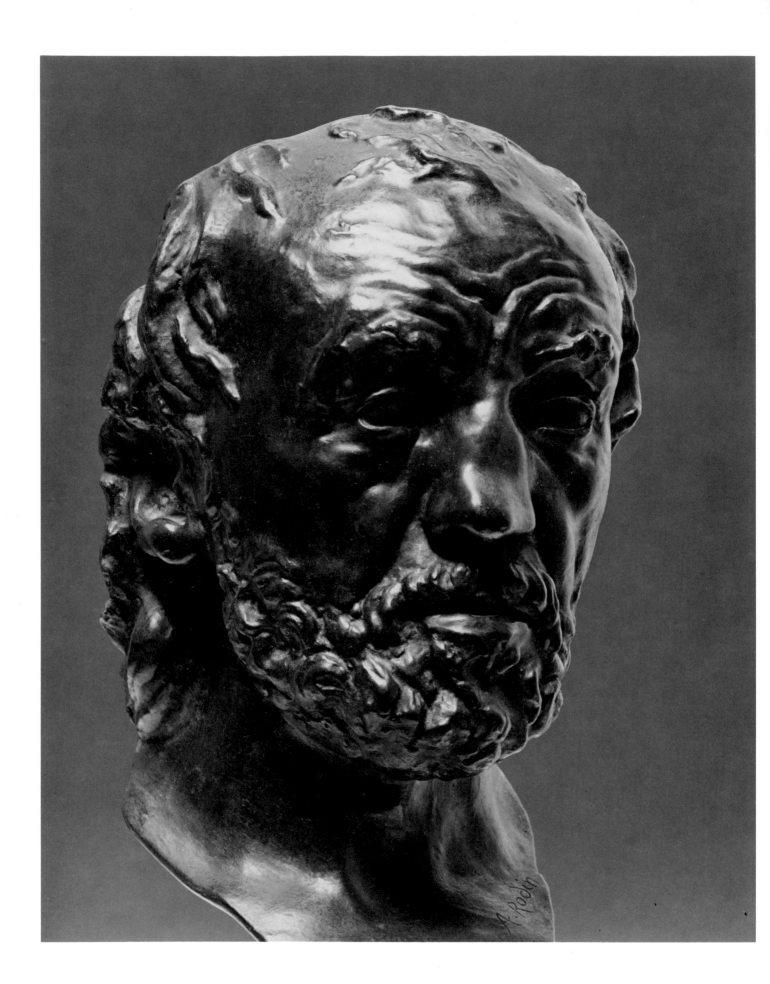

50

Man with the Broken Nose
(*L'Homme au Nez Cassé*)

Bronze, black patina with traces of green; on a cream-colored marble base
12 1/2 x 7 x 6″ (31.7 x 17.8 x 15.3 cm)
Signed: A. Rodin (front, lower right)
Stamped: A. Rodin (inside, lower left), and: ALEXIS RUDIER. / FONDEUR. PARIS.
 (inside, lower right)
1941.34.10

Man with the Broken Nose[1] is a crucial piece in Rodin's work, not only as his earliest masterpiece but also as a touchstone for his evaluation of other sculptures.[2] Though Rodin later declared that "it was made as a piece of sculpture, solely, and without reference to the character of the model, as such,"[3] he has achieved a careful physiognomical description and substantial psychological insight. The ravages of time are clearly depicted on the wrinkled and battered face. The serious, unflinching head suggests the character's stoical acceptance of his fate; the questioning eyes and jutting lower lip give him a slightly baffled appearance.

The style of the head particularly pleased Rodin; he called it "the first good piece of modelling I ever did."[4] Compared to his later busts, it seems tightly handled, with each detail carefully rendered. Yet the broken and fluctuating surfaces have a freshness and appeal lacking in most contemporary sculptures. From these nervous, volatile surfaces will evolve those less meticulous and more fluid executions which make their appearance in the 1880s and which have since become the most frequently remarked characteristic of Rodin's sculpture.

This early indication of Rodin's delight in liquid modelling of the features, suggesting the erosion of time, marks a break with the dryer manner of his contemporaries, even if the naturalism of *Man with the Broken Nose* continues a time-honored tradition in sculpture. The conventional aspect of Rodin's work is also evident in his allusion to antique prototypes. The thoughtful features, the wrinkled face, the arrangement of hair and beard, the traces of a fillet recapture the mood of antique portraits. Rodin's contemporaries recognized these qualities; biographers have reported how the young sculptor Desbois successfully presented the work as an antique at the Ecole des Beaux-Arts.[5] Though Rodin claimed that he created it "without reference to the character of the model," one biographer implies that the sculptor was attracted to certain qualities reminiscent of antique sculptures:

> Struck by the curious face of an old shepherd, flat-nosed, with every appearance of a slave that had been crushed under heel, Rodin made a bust of the man and strove to portray the energy and imposing simplicity that had astonished him in the antique busts and the statue of "The Knife-Grinder" that he had seen in the galleries of the Louvre.[6]

Left: *Man with the Broken Nose*. Cat. no. 50.

These associations are just part of the almost legendary history of the *Man with the Broken Nose*. Many have retold the anecdote about how Rodin selected a local handyman, Bibi, to model for the work.[7] The date usually assigned to the sculpture is 1864. Rodin began the portrait from his model a year or two earlier.[8] Some say that after Rodin had worked more than a year, carefully studying each contour of Bibi's head, the clay froze in his unheated studio, and the back cracked and fell, leaving only the face intact.[9] Confronted with a fragment, Rodin might have realized, even at this early date, the expressive power of the accidental, the fragmentary and the unfinished—a new dimension in the work of art on which he would later capitalize. Rodin's submission of a plaster mask to the Salon jury (which refused it) would support this view. However, the unique character of his innovation remains to be ascertained in view of nineteenth-century studio practices and the tradition of the mask as a style of portraiture.[10]

This refusal was another setback by officialdom—Rodin had already three times been denied admission as a student of sculpture to the Ecole des Beaux-Arts—and further delayed his public recognition. He did not submit again to the Paris Salon until 1875, when his art had achieved some notoriety; at that time a marble bust based on the mask of *Man with the Broken Nose*, conceived in a more neo-classical mood, was accepted. Why the original mask was refused is open to conjecture, though most of Rodin's biographers attribute it to his daring imitation of nature. This explanation is in keeping with the tendency on the part of official artistic circles to refuse overtly "realistic" styles.[11] The work of the then-unknown artist might have been rejected by a caprice of the jury; still, its "ugliness"—especially the battered nose—could be seen as a challenge to academic canons of beauty. Indeed, the work stimulated Rodin's reappraisal of the nature of beauty and ugliness:

> At first I could hardly bear to do it, he seemed so dreadful to me. But while I was working, I discovered that his head had a wonderful shape, that in his own way he was beautiful . . . that man taught me many things.[12]

Man with the Broken Nose continued to be an important work for Rodin for many years since he seems to have frequently gone back to it, making minor variations. As a result today a great many casts with such variations can be found in public and private collections. These casts vary not only in size (ranging from ca.-10-cm to ca.-56-cm high) and media, but also in the basic format. Two distinct groupings are identifiable by the termination point of the lower part of the sculpture; in some it stops just below the beard, while in others—like the version in the Legion of Honor—it continues to the sternum. The head may be mounted erect or slightly tilted forward, and the back of the head may be solid or hollow like a mask. Exactly which version corresponds to the one modelled for the 1864 Salon is uncertain.[13] Probably the first casts were those Rodin allowed admiring students to make.[14] Collectors seem to have made an early demand for this work, since by 1889 ten casts were to be found in English collections alone.[15] Besides the various casts of the head, Rodin reused *Man with the Broken Nose* for a jardinière commissioned allegedly around 1900 by Samuel Isham (and found today in the Boston Museum of Fine Arts).

The Legion of Honor bronze mask is probably one of a group of sculptures that Mrs. Spreckels kept in her home prior to loaning them to the museum in 1933.[16]

Right: *Man with the Broken Nose*. Cat. no. 50.

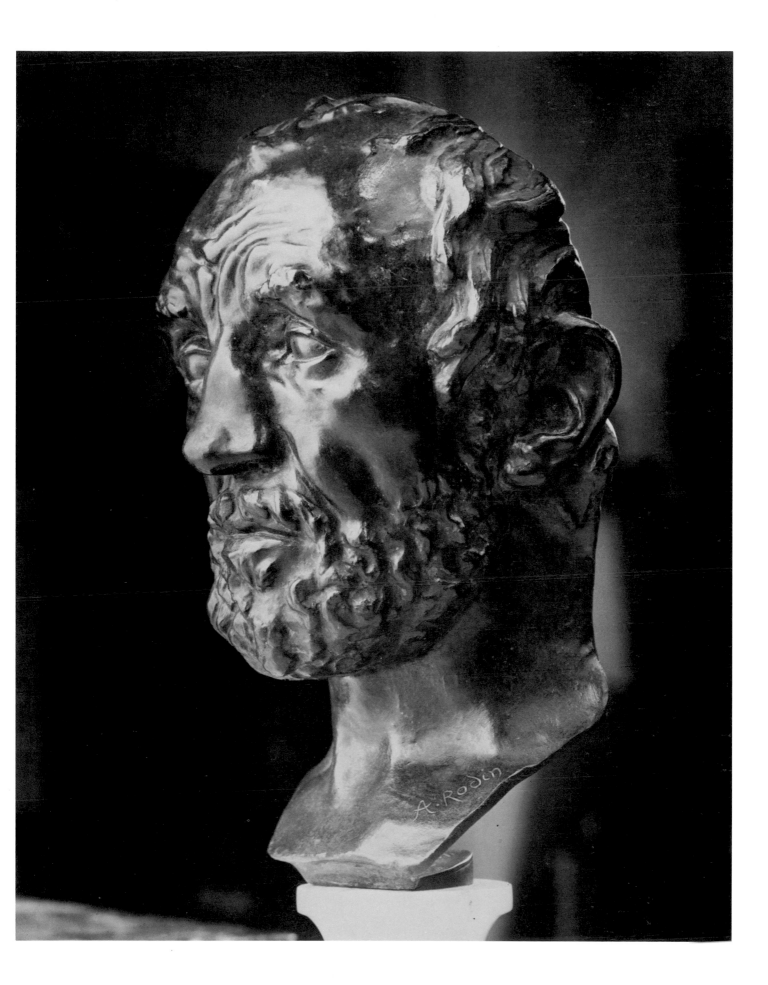

1. In the 1875 Salon it was called *Portrait de M.B.* (no. 3368). It was exhibited in London in 1882 as *Etude de Tête*. From 1895 it was called either *Homme au nez cassé* or *Masque de Michel-Ange* (Grappe, 1944, no. 8).

2. Rodin later told Bartlett: "That mask determined all my future work. It is the first good piece of modelling I ever did. From that time I sought to look all around my work, to draw it well in every respect. I tried it on my first figure, 'The Bacchanate' [sic], but did not succeed; I again tried it on 'The Age of Brass', also without success, though it is a good figure. In fact, I have never succeeded in making a figure as good as 'The Broken Nose'" (p. 28).

3. *Ibid.*

4. *Ibid.* See note 2 for complete quote.

5. Cladel, 1950, p. 91; Bartlett, p. 99; Frisch/Shipley, p. 96. It is noteworthy that when exhibited as *Etude de Tête* at the Dudley Gallery in London in 1883, the *Man with the Broken Nose* was called "a kind of Socrates"; "Current Art," *Magazine of Art*, 6 (1883), p. 431.

6. Cladel, 1917, pp. 53-54.

7. Bartlett, p. 28; Lawton, p. 25; Frisch/Shipley, p. 66; Cladel, 1950, p. 90.

8. Bartlett, who is more specific on this work than any other biographer, says that the head was completed in eighteen months and that Rodin thought of exhibiting it at "The National Exhibition of Fine Arts," to which he belonged, in 1863 (pp. 28-29). This comment implies that the work was completed by 1863. Elsewhere Bartlett tells us that Rodin made the *Man with the Broken Nose* when he was about twenty-two, which reinforces a dating of about 1862-1863 (p. 65).

9. Dujardin-Beaumetz, p. 116; Cladel, 1950, pp. 90-91.

10. An example of the use of the mask as a form of portraiture prior to Rodin's *Man with the Broken Nose* is Carpeaux's mask of Anna Foucart (1860).

11. This mid-nineteenth-century attitude is graphically described by Zola in his novel *L'Oeuvre*, where the painter Bongrand speaks bitterly of the exclusion of the realists from the official Salon: "Non . . . vous n'avez pas idée des indignations, parmi les membres du jury! . . . Et encore on se méfie de moi, on se tait, quand je suis là! . . . Toutes les rages sont contre les affreux réalistes. C'est devant eux qu'on fermait systématiquement les portes du temple; c'est à cause d'eux que l'empereur a voulu permettre au public de réviser le procès; ce sont eux enfin qui triomphent . . ." (*Oeuvres Complètes*, v. 5, Paris, 1966-1970, p. 529).

12. Agnes Meyer, "Some Recollections of Rodin," *Camera Work*, no. 34-35 (1911), p. 19. Charles Morice saw the *Man with the Broken Nose* as the "strict application" of Rodin's theory of beauty and ugliness: "Tout dans la nature est beau, d'une absolue beauté! Il n'y a pas de fleur laide, ni de nuage laid" ("Rodin," *Mercure de France*, 124 [December 16, 1917]:468, pp. 582-83).

13. Elsen believes the original version showed the head inclined (*Rodin*, p. 110). However, Rudolf Perl believes that a terracotta version with the head held erect and with a small area of the head behind the fillet still intact is the first draft ("Eine Terrakotta-Variante des 'Homme au nez cassé' von Auguste Rodin," *Weltkunst*, 36 [1966]:22, p. 1148). Unfortunately, neither writer presents conclusive evidence.

14. Bartlett, p. 100.

15. *Ibid.*, p. 261.

16. For more information on the casting sequences, see Patricia Sanders, "Auguste Rodin," *Metamorphoses in Nineteenth-Century Sculpture*, Fogg Art Museum, Cambridge, Massachusetts: Harvard University Press, 1975, pp. 153-65.

Right: *Man with the Broken Nose*. Cat. no. 50, detail.

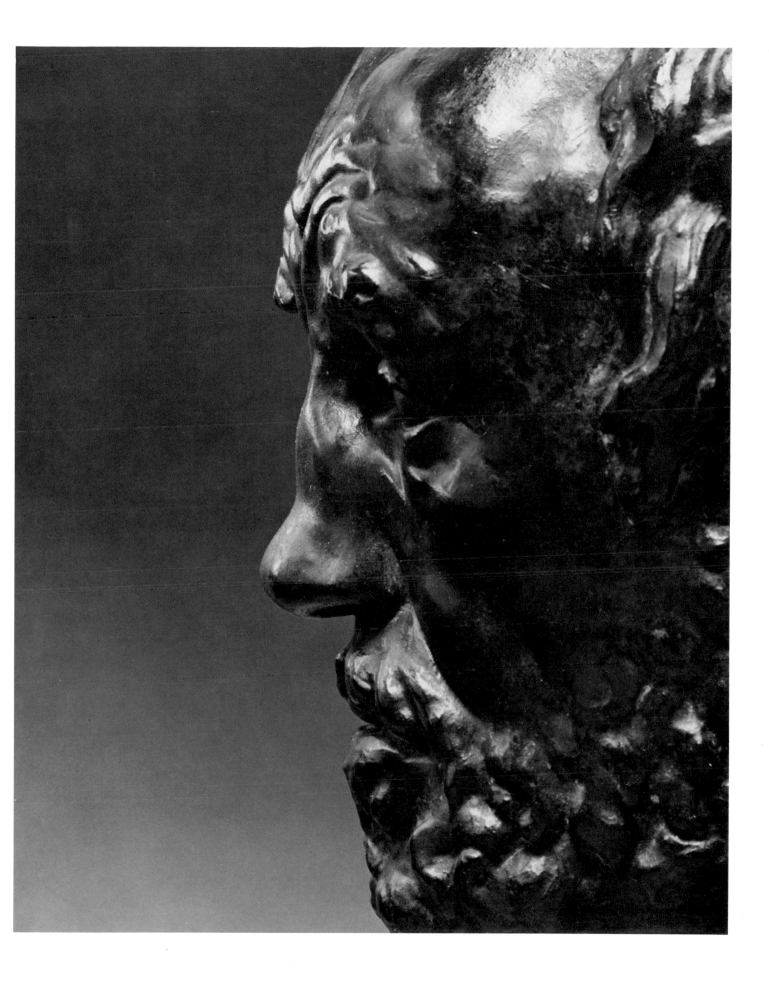

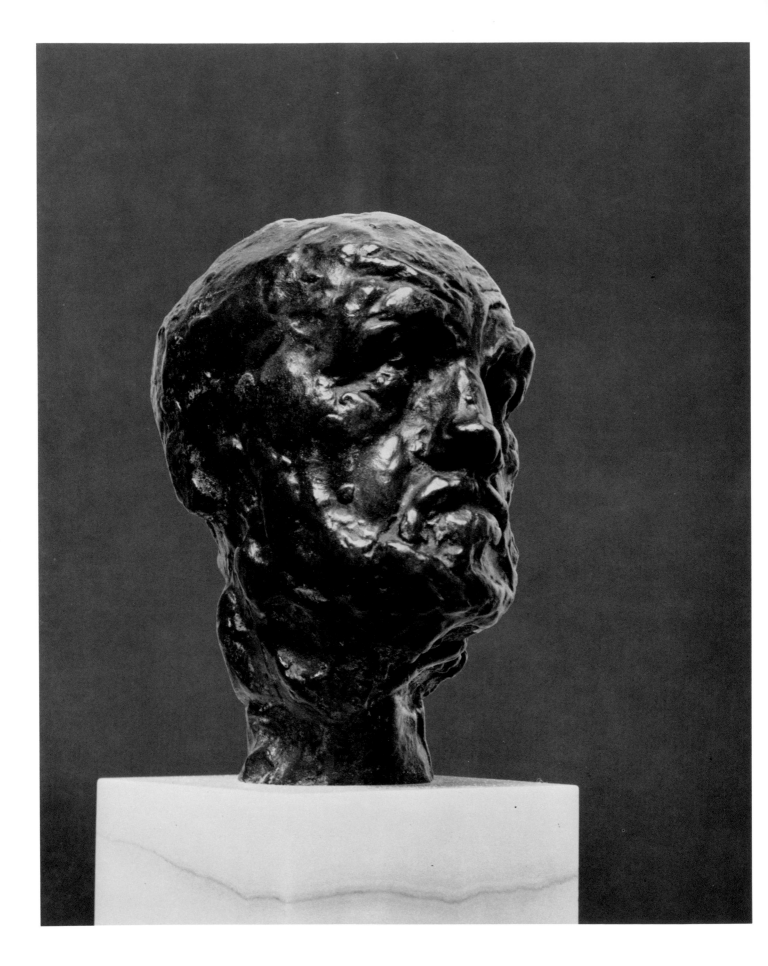

51

Little Man with the Broken Nose
(*Le Petit Homme au Nez Cassé*)

Bronze, black to dark brown patina with areas of gilt, green and brown;
on a white marble base
5 x 3 x 3 7/8″ (12.7 x 7.7 x 9.8 cm)
Signed: A. Rodin (lower right side)
Stamped: A. Rodin (inside, lower right in relief), and:
 ALEXIS RUDIER / FONDEUR PARIS (rear, lower right)

1942.43

Some twenty years after creating his famous *Man with the Broken Nose* (see cat. no. 50), Rodin redefined this portrait for his *Gates of Hell*, where it appears twice.[1] The later version is transformed into an even more pathetic image. Rodin retains the resemblance as well as the battered nose, but the features are so freely handled that the former clarity of detail is gone. With blobs of clay roughly fused and with little modelling, he builds up the head, which seems to fade before our eyes. Rodin has used the textural richness of clay to heighten the emotional appeal of the little head. The rising arches above the deep-set and distorted eyes, countered by the drooping cheeks and the resigned tilt of the head, convey suffering. With only a little kneading of the clay, Rodin magnified the spiritual qualities of the portrait into an unexpected evocation of melancholy.

The very fine bronze cast in the Spreckels collection, with its subtly modulated patina reminiscent of glazes on Japanese vases, was in the Legion of Honor by 1937. The exact date of purchase is not known. Several other replicas of this piece exist in plaster and bronze, including twelve posthumous casts.[2] These replicas seem to differ little except in the length of the base and the quality of casting. At some point, Rodin experimented with a cast of the *Little Man with the Broken Nose* attached to a portion of *Earth*, creating a writhing symbol of striving and, once again, demonstrating his flexible method of composition.[3]

NOTES

1. Though he dates the *Little Man with the Broken Nose* 1882, Grappe suggests the possibility that it is a study (presumably for the bust of ca. 1863-1864; no. 78). Elsen dates it ca. 1882 (*Rodin*, p. 111). Partially emerged casts of this head can be seen in the tympanum to the right of *The Thinker* and at the extreme right of the row of heads just beneath *The Three Shades* (Elsen, *Gates*, pls. 57 and 80).

2. The bronze cast in the B. Gerald Cantor collection is cast no. 12 in the posthumous edition.

3. A cast of this figure is in the Musée Rodin, Meudon; plaster, 12 x 24 x 7″ (30.5 x 61 x 18 cm).

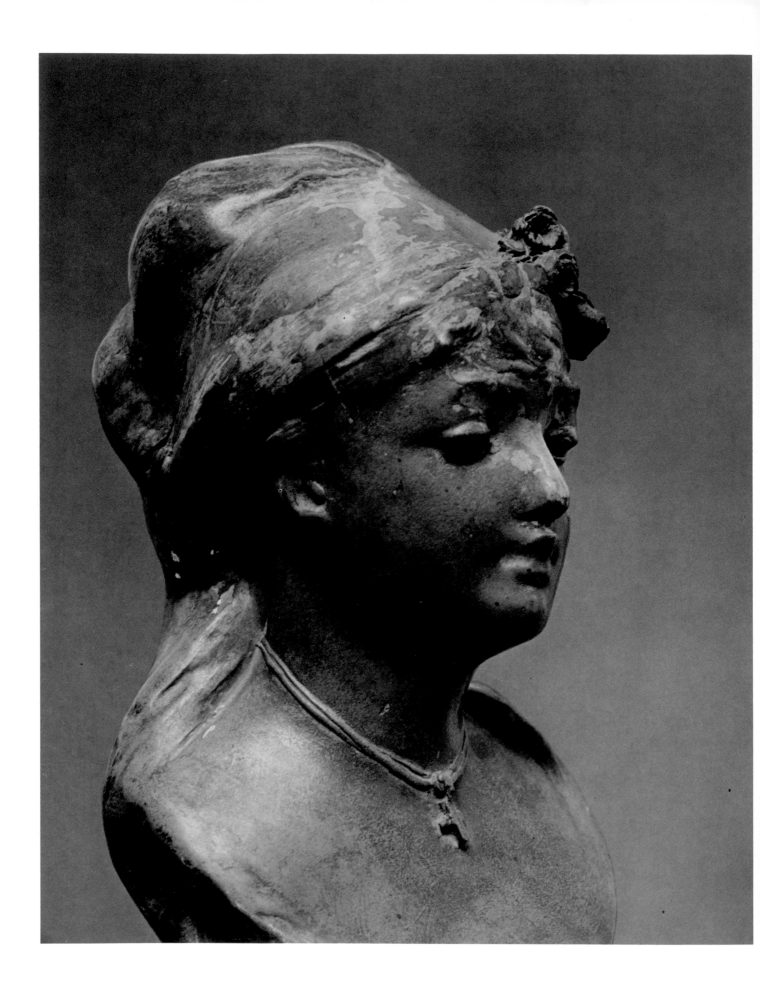

52
Madame Cruchet

Plaster, tinted to imitate terracotta; on a wood base
10 5/8 x 4 3/8 x 4 7/8″ (27 x 11.1 x 12.4 cm)
Signed: A R (scratched into plaster, lower rear), and: A. RODIN (on rear)
1933.12.22

This terracotta-colored bust is one of several conventional busts of women by the young Rodin.[1] One biographer reports that the sculptor modelled it in gratitude for the friendship shown by the sitter's husband, a Montmartre craftsman.[2] M. Cruchet was one of several artisans for whom Rodin worked in the late 1850s and early 1860s. Although the bust was reportedly a portrait, Rodin seems to have been more interested in representing a feminine type of the day than in capturing the exact likeness of the model.

The style of the bust brings to mind eighteenth-century modes, much admired by Rodin and many of his contemporaries; it reflects the eclectic manner of another of Rodin's employers, the eminently successful A. E. Carrier-Belleuse, who first hired Rodin around 1864.[3] The wistfully tilted head and delicate features have a certain charm, but they lack the crisp, vigorous modelling of Rodin's more personal works such as the *Man with the Broken Nose* (see cat. no. 50). The poor quality of modelling is especially evident in the barely defined lips and the smooth, dry surfaces of the bust. The fresher modelling of the flower indicates that this detail was added as an individual touch to the bust cast in a mold. These minor variations added to a standard bust and the cheap base suggest that *Madame Cruchet* may have been produced in quantity, although only three other casts have been located.[4]

Grappe dates this piece between 1865 and 1870, but specific documentation is lacking.[5]

At the time this bust was given to the Legion of Honor, it was incorrectly described as being terracotta. Its history prior to its donation is unknown.

Left: *Madame Cruchet*. Cat. no. 52, detail.

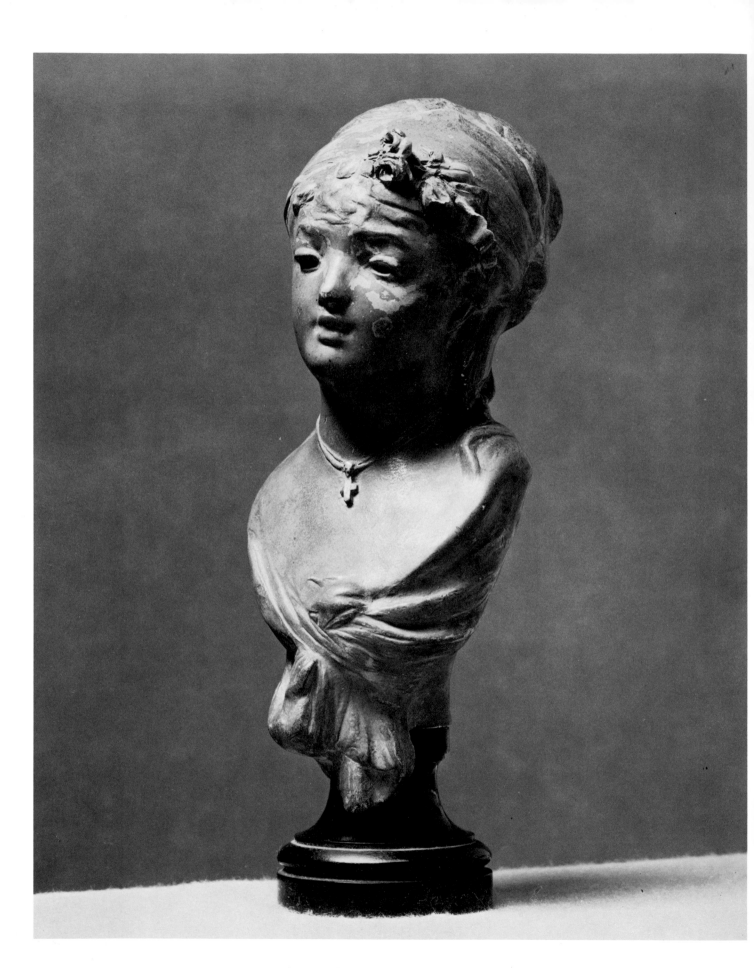

1. The attribution as Madame Cruchet is made by Grappe, 1944, no. 13. He gives no supporting documentation.

2. Cladel, 1950, p. 82. The association of this bust with the one mentioned by Cladel raises some questions. The size and quality of the so-called *Madame Cruchet* bust are more consistent with the *objet d'art* than with the typical nineteenth-century portrait. Furthermore, the youthful appearance of the bust suggests a young girl rather than the wife of a craftsman.

3. On the Rodin/Carrier-Belleuse relationship in the 1870s, see H. W. Janson, "Rodin and Carrier-Belleuse: The *Vase des Titans*," *Art Bulletin*, L:3 (September, 1968), pp. 278-80. Some aspects of this relationship are evoked in J. de Caso, "Ein vergessenes Frühwerk Rodins. Die Skulpturen an der Loggia des Théâtre des Gobelins," *Beiträge zum Problem des Stilpluralismus. Studien zur Kunst des neunzehnten Jahrhunderts*, vol. 38, Prestel-Verlag, Munich, 1977. Rodin's description, as paraphrased by Bartlett (p. 44), of the kind of work demanded by Carrier-Belleuse conforms closely to a sculpture like the *Madame Cruchet*: ". . . the main object was to please the uncultivated, often vulgar, fancy of the commercial world. To accomplish this, the living model was dispensed with, haste took the place of thought and observation, a bad style of modeling was practiced, and a manner of finishing equally reprehensible." To Rodin this method was unpleasant and injurious.

4. Speaking of Rodin's work of the late 1870s in Paris, Judith Cladel tells us that Rodin made numerous little subjects in the manner of Carrier-Belleuse, of which Rose Beuret made molds. Floral decoration was added to these by the sculptor Legrain (Cladel, 1950, p. 128). Considering the stylistic differentiation between bust and floral ornament of the *Madame Cruchet* bust, one wonders if it belongs to this class of work, although it is closer in style to Rodin's works of the 1860s. Perhaps the bust was modelled in the 1860s and cast commercially only in the 1870s.

5. 1944, no. 13. See note 4. According to Grappe the *Portrait de Madame A. C.* at the 1879 Salon (no. 5323) was a replica of the *Madame Cruchet* bust.

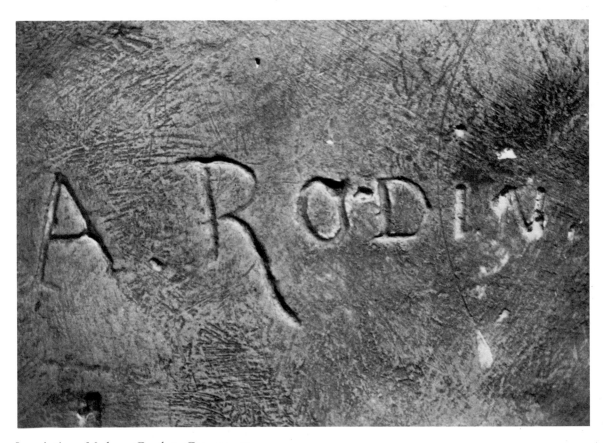

Inscription: *Madame Cruchet*. Cat. no. 52.

Left: *Madame Cruchet*. Cat. no. 52.

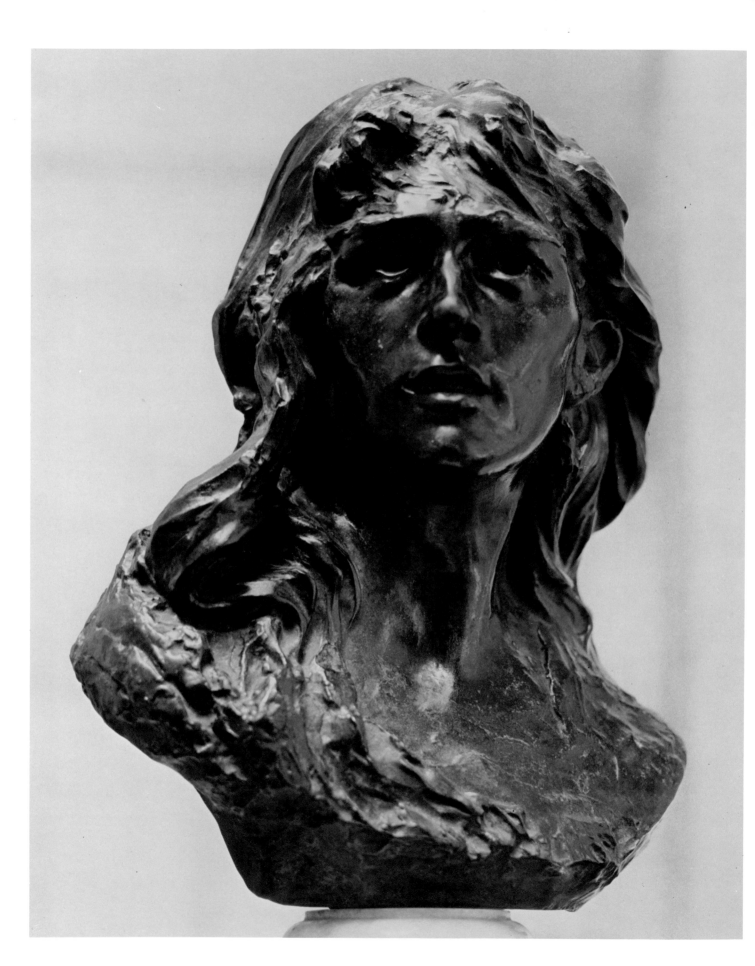

53

Mignon

Bronze, dark brown to black patina and touches of green, dull red and blue; on a cream-colored marble base; traces of piece mold
16 1/2 x 12 5/8 x 10 7/8" (40.9 x 32.1 x 27.6 cm)
Signed: A. Rodin (at termination of left shoulder), and: Auguste Rodin (left shoulder, back)
Stamped: ALEXIS RUDIER. / FONDEUR. PARIS. (right shoulder, back), and: A. Rodin (in relief, inside front)
1941.34.9

54

Mignon

Bronze, black patina, traces of green and red; traces of piece mold
16 x 13" (40.7 x 33.1 cm)
Signed: A. Rodin (right side of bust at edge)
Stamped: A. Rodin (inside, front at right), and: ALEXIS. RUDIER. / FONDEUR. PARIS (back edge at left)
Gift of Mr. Herbert Fleishhacker to the M. H. de Young Memorial Museum, San Francisco, 1965
65.23

Surprisingly, this vivacious portrait of Rodin's life-long companion, Rose Beuret,[1] probably dates from the same decade as the *Madame Cruchet* bust.[2] Rodin has given a new freedom of modelling and liveliness to *Mignon*, which we miss in the slightly earlier bust. Masses of hair, which retain the texture of the clay, contrast with the smoother treatment of the face. Very likely this new spontaneous handling arises from Carpeaux's interest in preserving the freshness of the sketch in his modelled portraits. Rodin has freed *Mignon* from the rigid symmetry and contrived termination of the Cruchet bust, thus conveying a more spontaneous and more complex image. The erect and abruptly turning head and the tilted shoulders add to *Mignon*'s energetic appearance.

The combined expression of surprise, suffering and melancholy in *Mignon* give this bust a new immediacy and imply a deeper interest in psychological states. The drawn, hurt look of the eyes, suggesting a woman on the verge of tears, reveals Rodin's penetrating observation of the fleeting play of emotions on his sitter's face. Her pathetic appearance identifies her with Romantic heroines who reveal their tragic fate through their mussed hair, parted lips, turning heads and wistful expressions. The new lifelike quality of *Mignon*, as well as the freely handled passages and the stress on characteristic expressions rather than superficial appearance, already point to a fresh approach to portraiture which will reach its epitome in Rodin's busts of the 1880s. In these early years of his career, Rodin continued to develop, side by side with

Left: *Mignon*. Cat. no. 53.

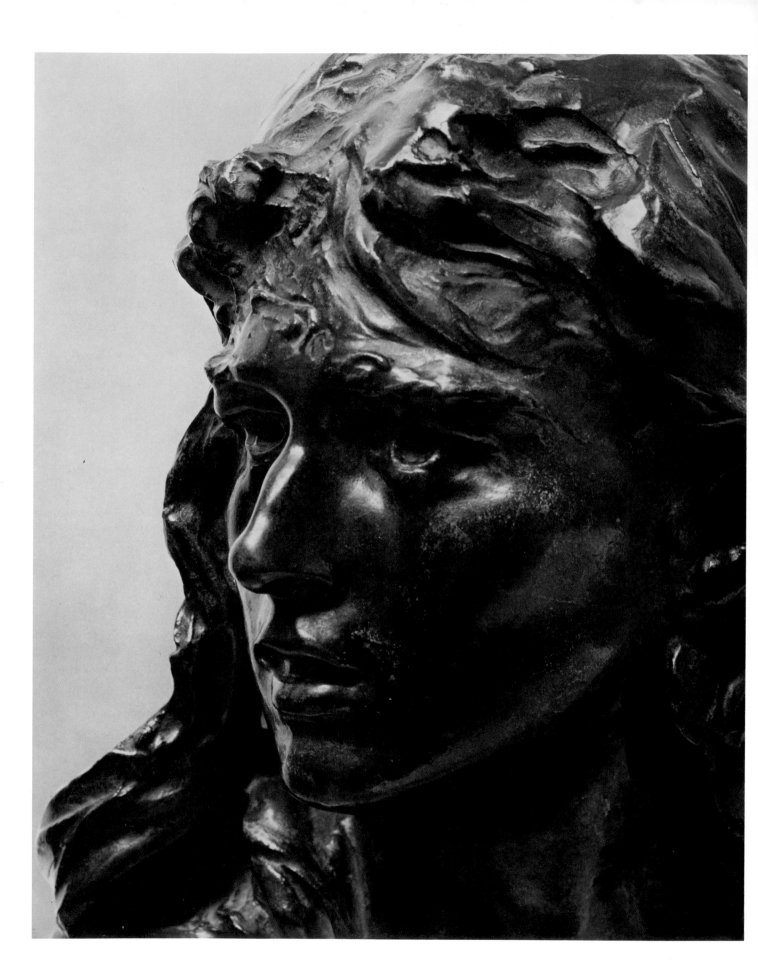

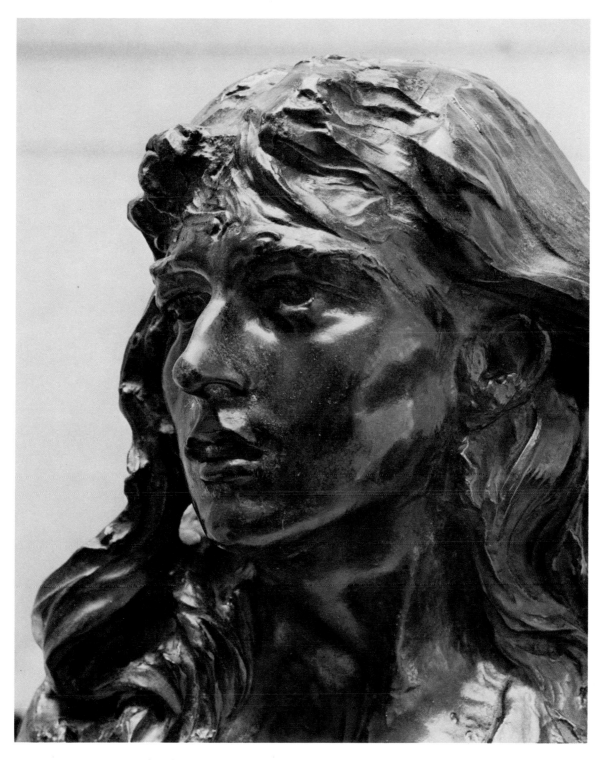

Mignon. Cat. no. 54, detail.

Left: *Mignon*. Cat. no. 53, detail.

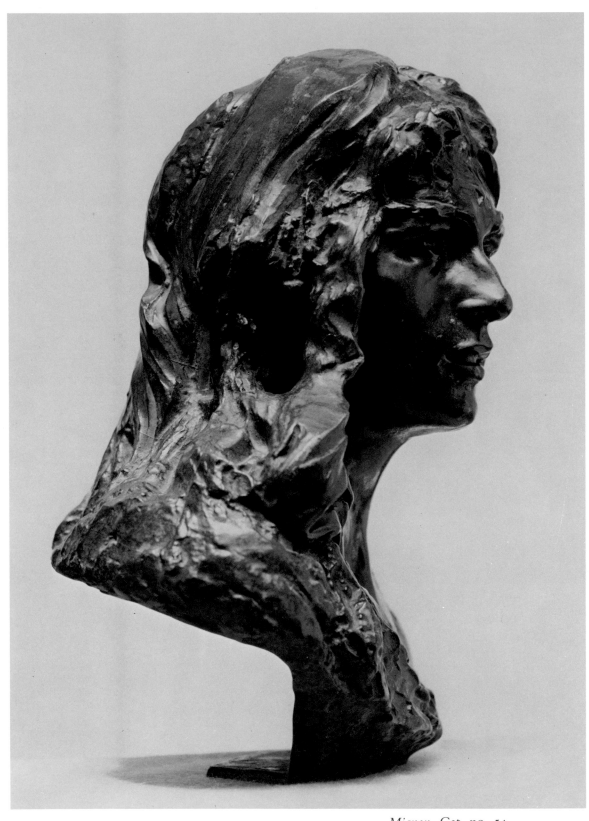

Mignon. Cat. no. 54.

Right: *Mignon*. Cat. no. 54, detail.

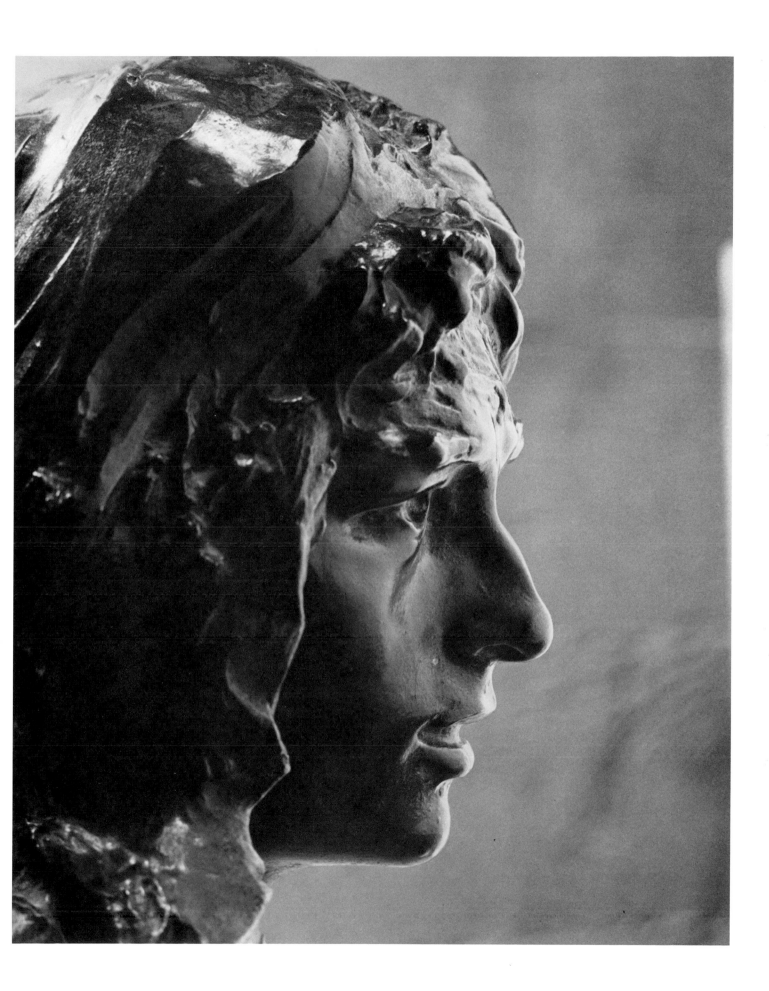

innovative works like *Mignon* and the *Man with the Broken Nose*, conventional works in the line of *Madame Cruchet*. This dualistic production continued well into the 1870s, showing that his habit was to work simultaneously in a commercial and a personal style.[3]

The significance of Rodin's *Mignon* goes beyond mere representation of the model, since it portrays both Rodin's companion and an imaginary character, a practice still in favor during the nineteenth century. Mignon, a central character in Goethe's novel, *Wilhelm Meister*, is an adolescent girl who dresses as a boy and is subjected to many fantastic adventures.[4] Abducted and transformed into a performer by a troup of travelling Italian rope-dancers, Mignon's freedom is purchased by Wilhelm, with whom she falls in love. Wilhelm regards her as a mere child and does not suspect her jealousy of his girlfriends, a jealousy which will end in her death. Rodin's *Mignon* does not illustrate any episode in Goethe's story, but the bust recaptures fully the mood of the heroine. Rodin, like Goethe, stresses her tempestuous behavior by giving her loose, disarrayed hair and tears. Mignon's frequent scenes of jealousy in the novel[5] make it tempting to relate Rodin's interest in her character to his personal experiences with Rose Beuret, who was known for her jealous tirades.[6] Certainly one is struck by the physical kinship of the two personages, whom Rodin and Goethe saw as slender adolescents of androgynous appearance.[7]

Casts of the *Mignon* exist in two slightly different versions. In casts like the one in the Legion of Honor, the back of the base is left hollow. Later Rodin filled in this hollow area to create a solid back. The small number of casts of both versions certainly does not reflect upon the fine quality of the work. The beautifully patinated bronze in the Legion of Honor is an outstanding cast. It first entered the museum in 1924.

NOTES

1. The work is traditionally associated with Rose Beuret (Cladel, 1950, p. 21; Grappe, 1944, nos. 14 and 15). However, it differs significantly from other representations of Rose in *The Call to Arms* (see cat. no. 36), *Bellone* and *L'Alsacienne* (reworked in several versions). Still, the facial structure of *Mignon* with the wide jaw, prominent cheek bones and close-set eyes can be compared with later photographs of Rose (see Bernard Champigneulle, *Rodin*, New York, 1967, p. 200, and Descharnes/Chabrun, p. 264).

2. *Mignon* is usually dated ca. 1870 (Grappe, 1944, no. 14).

3. Works in the more conventional style include *Flora* (Grappe, 1944, no. 10); *Jeune Fille avec fleurs dans les cheveux* (Grappe, 1944, no. 11); *Dosia* (Grappe, 1944, no. 29); and *Suzon* (Grappe, 1944, no. 30).

4. Since this work was apparently not exhibited during Rodin's lifetime, we cannot be absolutely certain that Rodin gave it the title *Mignon*, or, if he did, at what date, though we know of a drawing called "Mignon" exhibited in 1907 at the Bernheim-Jeune gallery (catalogue no. 13). Whether the drawing is in any way related to the bust has not been ascertained, but the catalogue does show Rodin's use of the title. Furthermore, this name is used consistently by Rodin biographers. Bénédite explicitly states that Rodin christened it " . . . 'Ma Mignon,' because of the loosened tresses which fall on her shoulders and her ecstatic gaze . . ." (*Rodin*, London, 1924, p. 27). Its identification with Goethe's character certainly clears up certain peculiarities of the name, which is the masculine rather than the feminine form of the term of endearment. Though it is uncertain whether Rodin actually read Goethe in the 1860s, very likely he was familiar with Mignon through popular representations. The fashionable painter, Ary Scheffer, had depicted several episodes of Mignon's life, and Goethe's influence is obvious in Théophile Gautier's poem, "Chanson de Mignon." In 1866 Thomas's opera, *Mignon*, a loose translation of Goethe's novel, was performed for the first time in Paris. Mignon's influence continued well into the 1880s when sculptures of the heroine by Aizelin (Salon of 1881) and Dampt (Salon of 1884) were exhibited. The story of Mignon is related to a major theme in nineteenth-century art and literature, that of the wandering performer.

5. Violent scenes of jealousy are also prominent in the opera.

6. Most accounts of Rose's jealous rages refer to her later years, but it appears that she had equal cause for such outbursts in the first years of their liaison (Cladel, 1950, pp. 19 and 20; M. Tirel, *The Last Years of Rodin*, New York, 1925, pp. 22, 54, 57, 59, and 60-61. Frisch/Shipley, pp. 60, 338-40, 342-43; Malvina Hoffman, *Heads and Tales*, New York, 1936, p. 44. excerpt from Lady Sackville's diary in Benedict Nicolson, "Rodin and Lady Sackville," *Burlington Magazine*, CXII:802 [January, 1970], p. 43).

7. On his model for the lost *Bacchante*, Rose Beuret, Rodin remarked on its "masculine charm which augments the beauty of a woman's body" (Dujardin-Beaumetz, p. 116).

55

Victor Hugo

Bronze, cast with base, dark brown to black patina
15 x 6 5/8 x 6 3/4″ (38.1 x 16.8 x 17.1 cm) excluding base
Signed: 1891 (rear) and: A mon Ami / Arsene [sic] Alexandre, and: A. Rodin (base, right side)
1942.38

56

Victor Hugo

Bronze, greenish-brown patina; set in a porous marble base
15 7/8 x 10 7/16 x 9 3/8″ (40.3 x 26.5 x 23.8 cm)
Signed: A. Rodin (right rear shoulder)
1942.37

If these two replicas of the bust of Victor Hugo (1802-1885) executed in 1883 do not represent Rodin's most lively and exacting portraits, they show a likeness remarkable in light of the difficult conditions imposed on the sculptor by the aging writer and politician. Hugo refused to sit regularly for Rodin and, except for a single occasion when Rodin tricked the poet into posing (for less than an hour) by challenging the proportions of the bust by David d'Angers, he had to rely on quick sketches and his memory to create this portrait of the beloved Romantic.[1]

In the 1880s, the author of *Notre-Dame de Paris* and *Les Misérables* was still something of a folk-hero to the general public. When Victor Hugo died two years after Rodin executed his bust, throngs kept vigil over his body as it lay in state beneath the Arch of Triumph in Paris and then accompanied it to Hugo's tomb at the Pantheon.[2] Rodin, too, venerated the poet and from an early age avidly read his work. This fact may explain the slight idealization of the bust, an unusual feature in Rodin's portraits, which are usually relentlessly faithful to the sitter. Comparison with contemporary photographs of Hugo indicates that Rodin portrayed his sitter accurately but made him appear more youthful and forceful than Hugo actually was at the time. Rodin stresses the characteristically stern expression of Hugo's face, minimizing less important details such as hair, beard and clothing. He emphasizes the features for which the poet had long been admired: his high forehead—a feature then thought to signify superior intellect—and his deep, penetrating eyes, associated with spiritual insights. By stressing Hugo's intellectual powers, Rodin creates an image of the man as the public knew him rather than penetrating into the deepest recesses of Hugo's character, but we must also remember

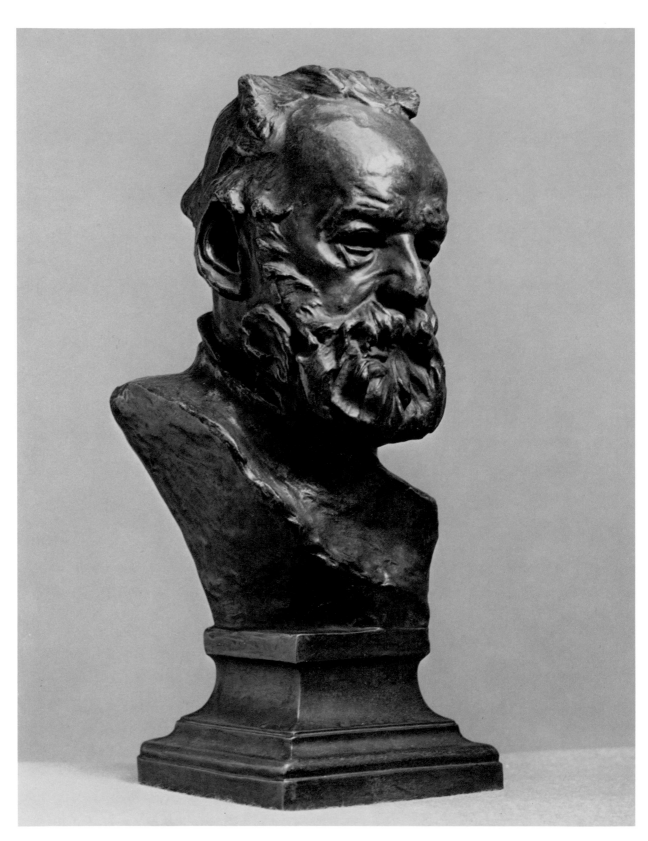

Victor Hugo. Cat. No. 55.

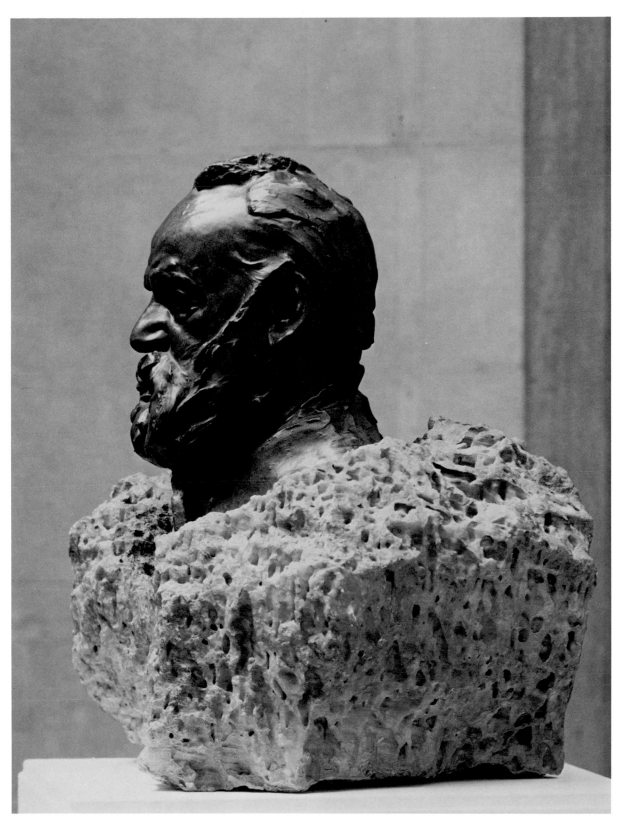

Victor Hugo. Cat. no. 56.

that Rodin was never on the same intimate terms with the poet as he was, for instance, with Jules Dalou and Camille Claudel, whose portraits by him are so moving and so personal.

The history of Rodin's bust of Victor Hugo is documented with unusual thoroughness. In 1883, Rodin was introduced to the poet, probably by the journalist Edmond Bazire, and obtained permission to model Hugo's bust.[3] Rodin was allowed to visit the Hugo house in the avenue d'Eylau and to study the poet but without disturbing him.[4] Rodin described the situation in a letter of 1883:

> . . . He has not—what is called—posed; but I have lived with him, lunching or driving or frequenting his soirées for the last four months, with the bust at his house, which allowed me to work there always . . .[5]

Several months after Rodin wrote this letter, the bust was cast in bronze and exhibited at the Salon of 1884.[6]

Reaction to the portrait varied. We are unaware of Hugo's opinion, but his entourage was clearly displeased.[7] Rodin's friends, however, admired it,[8] and Rochefort, at first critical, ended by acquiring a marble replica.[9] Rodin himself was uncertain of the success of the portrait, although he once said that he considered it superior to his *Age of Bronze* and his bust of Dalou.[10]

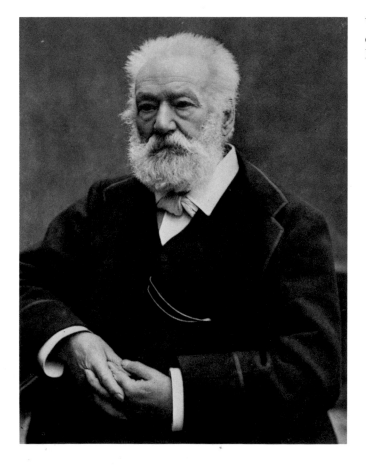

Victor Hugo. Collections de la Maison de Victor Hugo, Paris.
Photo Bulloz.

Right: *Victor Hugo*. Cat. no. 56, detail.

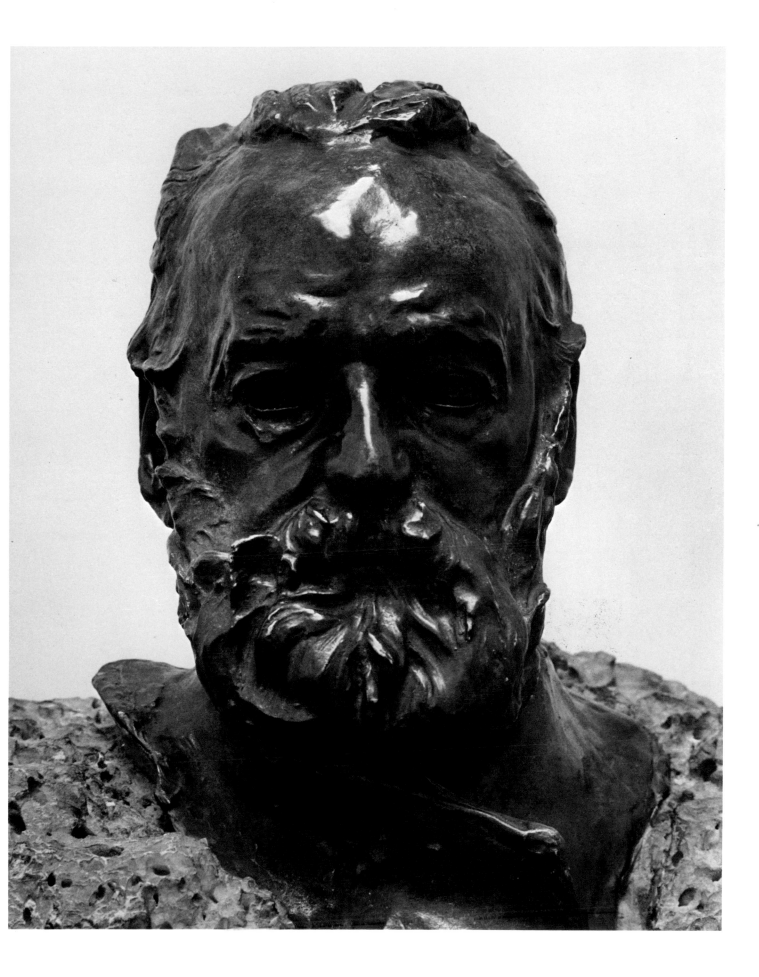

Despite misgivings over the bust, it became one of Rodin's most popular sculptures, as the many replicas in bronze, plaster and marble testify. The appreciation of the bust began in the 1880s; several replicas were made during this decade.[11] Rodin created several versions, varying the termination of the busts and experimenting with different types of bases. The ca.-48-cm version exhibited in the Salon was cast using the lost-wax process by Gonon in an edition of two. One of these (now in the Musée Rodin) was given to Victor Hugo, and the other was kept by Rodin.[12] This version shows the bust set into a sketchy blocklike base with sloping sides. Another version (ca. 45 cm) with no base may be a variation of this bust.[13] The Spreckels' bronze set in marble probably is based on this variation. Rodin also created a version with a taller, carved base in the 1880s.[14] From the original bust, at least three reduced versions were cast in bronze, one of ca. 18 cm and two of ca. 38 cm.[15] The small bronze in the Legion of Honor is an example of one of the ca.-38-cm busts; the date of 1891 inscribed on its back suggests the date of casting. Another ca.-38-cm version with a laurel branch attached was illustrated in 1899 and shows a less regular termination than is found in the small Spreckels' bronze.[16] In addition to the bronze busts, several marble versions with some variations in the base and the carving were executed.[17] The first of these was acquired by the city of Paris in 1888 (and is now is the Musée du Petit Palais). A bronze mask of Victor Hugo found in the National Museum of Wales at Cardiff is a variation of the bust.[18] One of the Legion of Honor busts, probably the large bronze set in marble, was undoubtedly the bronze *Head* purchased by Mrs. Spreckels from Loïe Fuller in 1915. Both sculptures were loaned to the Legion of Honor in 1924.[19]

The small bronze bears a dedication to the art critic, Arsène Alexandre; possibly it was presented to him in appreciation for a favorable article, a common practice in nineteenth-century France.[20] When he inserted the larger bronze into the rough marble base, Rodin broke down the usual distinction between sculpture and pedestal. This bold juxtaposition of bronze and marble reflects the nineteenth-century interest in combining varied materials in a single work, one method of introducing color into sculpture. While this juxtaposition was common practice for many sculptors, Rodin rarely used it.[21]

Inscription: *Victor Hugo*. Cat. no. 55.

NOTES

1. According to Rodin, Hugo told him: "I cannot prevent your working . . . but I warn you that I will not pose. I will not change one of my habits on your account. Make what arrangements you like" (quoted in *On Art and Artists*, p. 147; cf. Mauclair, 1905, p. 18). The story of Hugo's single sitting was related by Emile Bergerat in an article of the 1880s (reprinted in "Auguste Rodin," *L'Art moderne*, August 2, 1891, pp. 248-49). A different version was given years later by Rodin (Dujardin-Beaumetz, pp. 108-109). Rodin made numerous sketches of Hugo from various points of view to assist him in the sculpture; several are reproduced by Maillard (pp. 9, 12, 18, 87, 97, 100 and 102). The drawings were purchased by a M. Sagot for a Besançon iron merchant who later auctioned them at Lyons (Bartlett, p. 114). The drawings temporarily dropped from sight but were rediscovered and purchased by Georges Hugo before the turn of the century (1900 Rodin exhibition catalogue, no. 86; Lawton, p. 84). Several of these drawings are today found in the Musée Rodin in Paris. From these drawings, Rodin made a series of drypoints (Bartlett, p. 114; Loys Delteil, *Le Peintre Graveur illustré*, Paris, 6:1910). Rodin's drawing reproduced in *L'Art* is not a study but a drawing after the finished bust; 77 (1884), p. 37. However, Rodin's memory was more important than the sketches in executing the bust. He told Dujardin-Beaumetz that his lessons in drawing from memory from Lecoq de Boisbaudran at the Petite Ecole helped him with the bust of Victor Hugo (p. 109).

2. The procession from the Arch of Triumph to the Pantheon consisted of two million people (André Maurois, *Olympio, The Life of Victor Hugo*, New York, 1956, p. 443).

3. Bartlett, p. 114; Lawton, p. 83; Marcelle Adam, "Victor Hugo et Auguste Rodin," *Le Figaro* supp., December 28, 1907; Cladel, 1950, p. 36. The date 1883 appears on the cast made for Victor Hugo which is now in the Musée Rodin.

4. Lawton, p. 84; Cladel, 1950, pp. 36-37. Rochefort, who was present while Rodin was working on the bust, said that only a window separated Rodin from the dining room where Hugo and his guests sat; "La Collection de M. Henri Rochefort," *Les Arts*, 4:43 (July, 1905), p. 16.

5. Letter to W. E. Henley, quoted by Lawton, p. 206.

6. It had also been exhibited in February, 1884, at the Salon des XX in Brussels ("La Sculpture au Salon de Paris," *L'Art moderne*, 4:23 [June 22, 1884], p. 204).

7. Bartlett, p. 114; Dujardin-Beaumetz, p. 108; Coquiot, *Rodin à l'Hôtel de Biron*, pp. 106-107; Cladel, 1917, pp. 305-306; Léon Daudet, *Souvenirs des milieux littéraires, politiques, artistiques et médicaux*, v. 1, Paris, 1920, pp. 5-6; Cladel, 1950, p. 37.

8. Dalou, who was to make Victor Hugo's death mask, praised it (Cladel, 1950, p. 37). W. E. Henley championed the bust in England ("Two Busts of Victor Hugo," *Magazine of Art*, 7 [1884], pp. 127-32).

9. Dujardin-Beaumetz, p. 108; Rochefort, "La Collection. . .," p. 16. This bust is now in the Fogg Art Museum, Cambridge, Massachusetts.

10. According to Frisch/Shipley, Rodin was not proud of the bust (p. 175). On his comparison of the Hugo bust to *The Age of Bronze* and the *Dalou*, see Cladel, 1903, p. 39.

11. Writing in 1889, Bartlett reported that several bronze replicas had already been sold (p. 113). One cast was owned by the poet and art critic Emile Bergerat; Will Low saw it in 1886 (*A Chronicle of Friendships 1873-1900*, New York, 1908, p. 316). Edmond Bazire offered his plaster cast of the bust to the Société des Gens de Lettres in 1886; (Bazire to Emmanuel Gonzalès, n.d. [January 1886] in *Chronique de la Société des Gens de Lettres*, March, 1886, p. 203). Casts were also acquired in the 1880s by the Musée de Cambrai and the Art Gallery and Museum in Glasgow. A marble replica was acquired by the city of Paris in 1888.

12. Bartlett, pp. 113-114.

13. An example of this type is found in the Durban Art Gallery, Natal, South Africa.

14. A plaster cast of this type was purchased by the Glasgow International Exhibition Committee in 1888 and is now in the Art Gallery and Museum in Glasgow.

15. Grappe dates the ca.-18-cm head around 1886 (1944, no. 161).

16. Maillard, p. 108.

17. One was carved by the sculptor Jean Baffier (Lawton, pp. 63-64).

18. Perhaps this is the study for the mask of Hugo carved on a keystone that Rodin showed to Gsell (*On Art and Artists*, pp. 148-49). Several busts are reproduced by Spear; pls. 5-9.

19. The bust of Hugo set in marble appears in a photograph of Mrs. Spreckels' home taken before the opening of the CPLH, but we have no record of the small bust until 1924 (photo in ex-collection of Miss Jean Scott Frickelton, Palo Alto).

20. This custom is described by Low, *op. cit.*, pp. 315-16 (n. 11, above).

21. Interest in color and contrasting materials in sculpture had been revived in the mid-nineteenth century, with Simart, Pradier and Clésinger leading the way. This concern became even greater at the end of the century, particularly with artists associated with the Art Nouveau movement. We find relatively few attempts to introduce color into sculpture in Rodin's art.

57

Victor Hugo

White marble
41 1/2 x 41 7/8 x 27 1/2" (105.4 x 106.4 x 69.8 cm)
Inscribed: 3886 (base, back left; probably a quarry number)
1962.28
Gift of an anonymous donor

This over-life-size marble bust, an outgrowth of the studies for the Victor Hugo monument, presents an imposing image of the poet. The unfinished marble that sweeps around the bust focuses our attention on the powerful chest and pensive face. With this type of sculpture—the figure emerging from uncut marble—Rodin dared to redefine the finished work of art. To many, such works were little more than sketches, but others pointed to the eminent examples of Michelangelo. The effect of the figure just evolving from its amorphous matrix suggests an air of mystery enhanced by the veiled features of the face.

Such qualities seem to link this particular bust with a series of marble portraits executed around 1910,[1] but in fact it is based on the first series of studies, dating from the late 1880s, for a monument to Victor Hugo to be erected in the Pantheon.[2] In those studies, Rodin celebrated Hugo's poetic genius; we still sense this emphasis in the pensive tilt of the marble head, based on Rodin's earlier portrait of the writer (see cat. nos. 55-56). The bared and powerful chest suggests a man of superhuman power. Rodin admired above all the force of Hugo's genius:

> Hugo had the air of a Hercules; belonged to a great race. Something of a tiger, or of an old lion. He had an immense animal nature. His eyes were especially beautiful, and the most striking thing about him. As a man he was large and agreeable, no personal pride . . . It was not until two or three years after his death that I really saw the man, the amplitude of his character, and felt the force of his private work and impersonal nature.[3]

The nude representation of a great man (as Rodin showed Hugo in many of his studies for the monument) was hardly new; it went back to the ideas of the neo-classicists who wanted to immortalize their heroes by removing references to a particular historical period. But it was still something of a shock to represent a man so recently dead with his clothes off, and Rodin had to defend himself when objections were raised:

> . . . I hope the eyes of many generations . . . will one day contemplate this monument. Why, then, should I clothe him to make him look ridiculous in the foolish masculine fashions of his time? There is nothing more banal than these statues of recent notabilities, to be seen in every big city of Europe, masquerading as tailors' models of their ugly period. Man's naked form on the other hand, belongs to no particular moment in history; it is eternal, and can be looked upon with joy by the people of all ages.[4]

Left: *Victor Hugo*. Cat. no. 57.

The bust in the Legion of Honor, which seems to be the only marble version, is probably the work referred to in a periodical article of 1922, which states:

> Rodin's last work, the bust of Victor Hugo, which he was finishing at the time of his death, has been presented to the San Francisco Museum of Art . . . Raphael Weill . . . gave Rodin the commission for the work, intending to present it himself, but he died in his native country, France, before his intention could be realized. The presentation was made by his nephew, Michel D. Weill It has lately become known that the Louvre desired to obtain the work for its permanent collection[5]

A limited number of bronze casts exist, also based on studies for the monument. Their surfaces are much sketchier than the 1883 bust of Hugo (cat. nos. 55 and 56). For example, the forehead is partially covered by unmodelled bits of clay. In the marble this same area becomes a whiplash curve of crudely worked stone. In the bronzes we do not find the background that was included in the marble, where the position of the arms is obscured. The drill holes on the chest and face of the marble left by a pointing machine indicate that this bust is a reproduction by mechanical means of the modelled version.

NOTES

1. See, for example, Grappe, 1944, nos. 412, 413, 414 and 418. According to Grappe, an example of the second bust of Victor Hugo was exhibited at the 1897 Salon (1944, no. 287). Albert Ludovici saw Rodin working on an over-life-size bust of Victor Hugo when he visited his studio in 1898 (*An Artist's Life in London and Paris, 1870-1925*, New York, 1926, p. 122). A cast was also included in the 1900 Rodin exhibition.

2. Although Rodin received the commission from the French State for this monument only in 1889, evidence suggests that he was already preparing it in 1886. A project for a tomb to Victor Hugo is mentioned in that year in an article by Gustave Geffroy, following his discussion of three projects for a memorial to the poet by the sculptors Darbefeuille, Pallez and Dalou exhibited at the 1886 Salon: "It is entirely just to add that M. Rodin, who has exhibited nothing this year, is preparing also, a project for the tomb of the poet who sleeps at the Pantheon" ("Il est de toute justice d'ajouter que M. Rodin, qui n'a rien exposé cette année, prépare, lui aussi, un projet pour le tombeau du poète qui dort au Panthéon"); in "Les oeuvres décoratives au Salon de 1886," *Revue des Arts décoratifs*, 6 (1885-1886), p. 361. Furthermore, the first

sketches for the Hugo monument by Rodin are frequently dated 1886 (Maillard, p. 154; Mauclair, p. 125; Frisch/Shipley, p. 419). Frisch adds that the first plaster cast of the monument was exhibited at the Georges Petit Gallery in 1886 (p. 175). A drawing of a tomb monument, inscribed "Victor Hugo" at the bottom, may be an early conception for this monument (Elsen, *Gates*, pl. 34). For an expanded account of the commission and development of the two conceptions of the Victor Hugo monument, see Cladel, 1950, pp. 173-78, and Cécile Goldscheider, "Rodin et le monument de Victor Hugo," *Revue des Arts*, VI (October, 1956), pp. 179-84. Examples of the various studies for the monument are found in the Musée Rodin. Although the busts like the one found in the CPLH are usually associated with the studies for the second Victor Hugo monument, the positions of the arms and the head make it evident that it is either a study for or a fragment of a full figure study for the first monument.

3. Bartlett, p. 114.

4. Anthony M. Ludovici, *Personal Reminiscences of Auguste Rodin*, Philadelphia/London, 1926, p. 11.

5. "San Francisco Given Hugo Bust by Rodin," *American Art News*, April 15, 1922.

58

Henri Rochefort

Bronze, light green patina; traces of piece mold; on a cream-colored marble base
27 5/8 x 16 1/8 x 14 3/16″ (70.2 x 41 x 36 cm)
Signed: A. Rodin (inside right shoulder), and: A. Rodin (rear, left shoulder)
Stamped: ALEXIS. RUDIER / FONDEUR. PARIS (back edge of bust at right), and: A. Rodin
 (inside, front right)
1941.34.4

In this sketchy portrait, Rodin has created a remarkable likeness of the famous polemicist, Marquis Henri de Rochefort-Luçay (1831-1913) who preferred the more plebian name, Henri Rochefort. This aggressive bust forces us to accept it as an actual personality, not a mere image frozen in bronze. For its liveliness and for its exquisite modelling, the Rochefort bust must be placed with Rodin's finest portraits.

Henri Rochefort, an impoverished radical of noble birth, was best known to his contemporaries as a muckraking journalist and as an agitator, though he also dabbled in politics and art collecting.[1] He was one of those highstrung and flamboyant personalities who tread the thin line between the ridiculous and the sublime. More than once his political views and actions led to recriminations against him by the government in power. The founder of the controversial publication, *La Lanterne*, he was forced to leave France to avoid imprisonment during the Second Empire. He was less fortunate in the 1870s when he was transported to the penal colony in New Caledonia for his participation in the Paris Commune of 1871. He escaped in 1874, and, when political amnesty was granted, he returned triumphant to Paris in 1880. He then founded the newspaper, *L'Intransigeant*, but was exiled again following the Boulangist trials in 1889.[2]

In Rodin's bust we recognize the zealous and incisive side of Rochefort's personality. The sculptor has gone beyond mere superficial appearance.[3] The alert and narrowed eyes of the bust suggest either intense concentration or cold perusal of an adversary—then again, perhaps the model is irritated at Rodin's slow working methods. Though Rodin is faithful to Rochefort's actual appearance, he emphasizes the facial muscles and renders the wild shock of hair—the journalist's trademark—with huge lumps of clay. This style results in a portrait which is as fiery and as emphatic as the man himself. Rochefort was conscious of these probing qualities in Rodin's portrait, which he saw as an expression of the "public man" in contrast to Dalou's bust of him, which he saw as the "private and intimate man." Rochefort added: "It is like the synthesis of an entire life which was somewhat agitated. One feels that the model has traveled by roads where there were a good many stones."[4]

Though the friendship between Rodin and Rochefort was to last for many years, from the first it was testy. The sittings for the bust, which began in 1884 between exiles, soon came to an end, since Rochefort was dissatisfied with the work and became impatient with Rodin's slow method of working. With typical sarcasm he described these sittings:

> I went to the studio in the morning, sat down ready for Rodin to begin. Then he would look at me for an hour or two, turn to his work and look at that for the same length of time, put a bullet of clay carefully on it, and by that time we were ready for breakfast. On returning to the studio he would go through the same preliminary operation and then take off the bullet. The bust never will be done.[5]

Humorous, yes, but obviously an exaggeration, despite what we know of Rodin's meticulous technique. The striking likeness achieved in only a few sittings testifies to Rodin's ability to capture quickly his sitter's personality. Though he admired Rochefort, Rodin became unhappy with his sitter's impatience and lack of appreciation.[6] He later explained that Rochefort "had such a joyous spirit that it was an enchantment to listen to him, but he could not keep still for a single instant."[7] Though work stopped before the bust was completed, Rodin had several plaster casts made.[8] In 1886, the Rochefort bust was shown to the public at the Galerie Georges Petit and received high praise.[9] Despite this successful reception, Rochefort is said to have relegated his cast to the attic.[10] Only later as Rodin's reputation grew did the writer begin to regret his former impatience, and he expressed the desire to resume the sittings. But this time Rodin was unwilling.[11] When others praised the bust, Rochefort claimed that Rodin had retouched it. Rodin said he had not.[12] Apparently satisfied with the bust in its sketchy state, in 1899 Rodin considered it superior to *The Age of Bronze*.[13] Later he

Henri Rochefort.
(Camille Ducray, *Henri Rochefort*.
Paris: Libraire Ambert, 1913.
Photo G. Gysels.)

Right: *Henri Rochefort*. Cat. no. 58, detail.

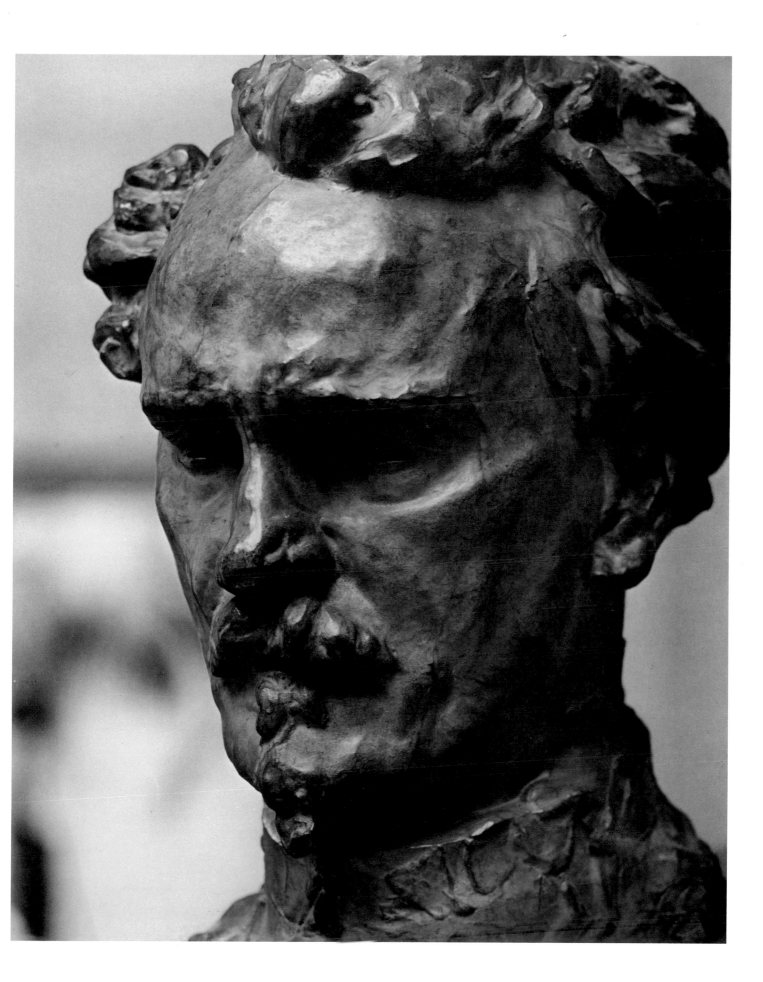

saw the bust as an evocation of a Roman emperor, saying: "I have never found the Latin classic type as pure as in Rochefort."[14]

Rodin made two versions of the Rochefort bust. One is life-size with the neck and chest left bare; this version is usually considered to be the first.[15] Probably from this version, Rodin had an enlargement made to which sketchy indications of clothing were added. The enlarged version is usually dated in the 1890s,[16] but since Rodin gave a bronze cast to Rochefort himself,[17] perhaps the enlargement was done soon after the completion of the smaller bust. Mrs. Spreckels acquired a cast of the enlarged version through Loïe Fuller in 1915.[18]

NOTES

1. On Rochefort's collecting activities, see his article, "La Collection de M. Henri Rochefort," *Les Arts*, 4:43 (July 1905), pp. 1-22. Of his connoisseurship, Rodin later said, perhaps somewhat defensively: "Come on, fundamentally, he understood absolutely nothing about Art; but one could speak to him about anything else." ("Au fond, allez, il n'entendait absolument rien à l'Art; mais on pouvait parler de tout d'autres choses avec lui"; quoted in Coquiot, *Rodin à l'Hôtel de Biron*, p. 111). We get a clear picture of Rochefort's journalistic practices from a recent biography by Roger L. Williams: "He had something to say about every regime, about every scandal, and most leading politicians through those turbulent years—rarely anything flattering" (Henri Rochefort, *Prince of the Gutter Press*, New York, 1966, p. x).

2. For further biographical information, see R. Williams, *op. cit.*; "Portraits of Celebrities," *Strand*, III (Feb. 1892), p. 171; and Rochefort's autobiography, *The Adventures of My Life*, London and New York, 2 vols., 1896.

3. Ill. Camille Ducray, *Henri Rochefort*, Paris [1914?], p. 65.

4. "C'est comme la synthèse de toute une vie qui fut quelque peu agitée. On sent là que le modèle a passé par des chemins où il y avait pas mal de pierres" ("La Collection de M. Henri Rochefort," p. 20).

5. Quoted in Bartlett, p. 198. Rodin was introduced to Rochefort by Edmond Bazire, editor-in-chief of *L'Intransigeant*, who had also helped Rodin obtain the commission for the bust of Victor Hugo (*On Art and Artists*, p. 149).

6. Bartlett, p. 198; Coquiot, *Rodin à l'Hôtel de Biron*, p. 111.

7. *On Art and Artists*, pp. 149-50.

8. In a letter of December 29, 1884, to Edmond Bazire, Rodin mentions seven casts of the bust: "Les bustes de Rochefort sont coulés, il y en a 7, je crois, ils vous appartiennent c'est ce que je vous offre cette année. Vous pourrez faire emballer dans le quartier ceux qui vont en Afrique"; quoted in "Echos," *Mercure de France*, 132:498 (March 16, 1919), p. 377. The present locations of the casts sent to Africa are unknown. Though Rodin does not mention the medium of these first casts, Bartlett said that it was plaster, adding that several were then owned by editors of Rochefort's newspaper, *L'Intransigeant* (p. 198).

Bartlett illustrates one of these early casts (March 9, 1889).

9. Bartlett, p. 199; Grappe, 1944, no. 108.

10. Rodin told Coquiot: "Pour le buste que je fis de lui, de même il le laissa bien des années dans son grenier" (quoted in *Rodin à l'Hôtel de Biron*, pp. 110-111). The first cast (the dressed version) which Rodin gave to Rochefort is now in the Musée d'Art et d'Histoire at Geneva.

11. Bartlett, p. 198.

12. *On Art and Artists*, p. 150.

13. Cladel, 1903, p. 39.

14. *On Art and Artists*, p. 150.

15. A photograph of this version is reproduced by Bartlett; March 9, 1889. A plaster cast of this bust was in the collection of Mme Edouard Manet until it was acquired by Henri Matisse in 1898 (present location unknown). A drawing after the plaster by Matisse is now in the Musée Matisse, Nice-Cimiez.

16. The dating of the enlarged bust is confused. Grappe dates it 1897 (1944, no. 288). However, he is wrong in his allegation that it was exhibited in the Salon of 1897, presumably the basis for his dating. Actually it was shown only at the Salon of 1899. Indeed, Albert Ludovici, father of Rodin's secretary and biographer, Anthony Ludovici, saw Rodin working on an over-life-size bust of Rochefort when he visited the sculptor in 1898 (*An Artist's Life in London and Paris, 1870-1925*, New York, 1926, p. 122). Rodin may have prepared a life-size version of the clothed bust before enlarging it, since Lami informs us that the bust was mechanically enlarged (p. 167) and since a marble, which also shows a clothed portrait, was completed in 1892 (Lawton, p. 90). That date is given the marble by most of Rodin's biographers, despite proof that the original unclothed bust, which corresponds to the type then known as *coupé à l'antique*, was completed in 1884 (see note 8).

17. This cast is now in the Musée d'Art et d'Histoire, Geneva.

18. Mrs. Spreckels took possession of the bust at the end of its exhibition at the 1915 Panama Pacific Exposition in San Francisco (no. 97). Another bust of Rochefort appeared in this exhibition, but it belonged to a Mme Marshall (no. 99). The Spreckels' bust was on loan to the CPLH from 1924.

Right: *Henri Rochefort*. Cat. no. 58.

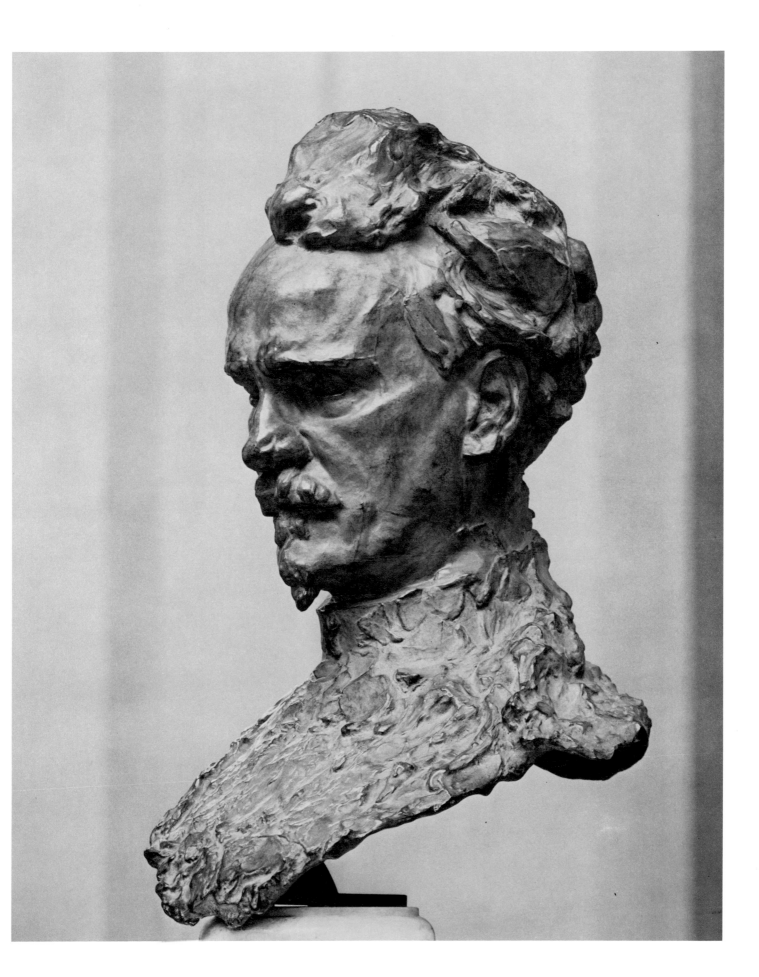

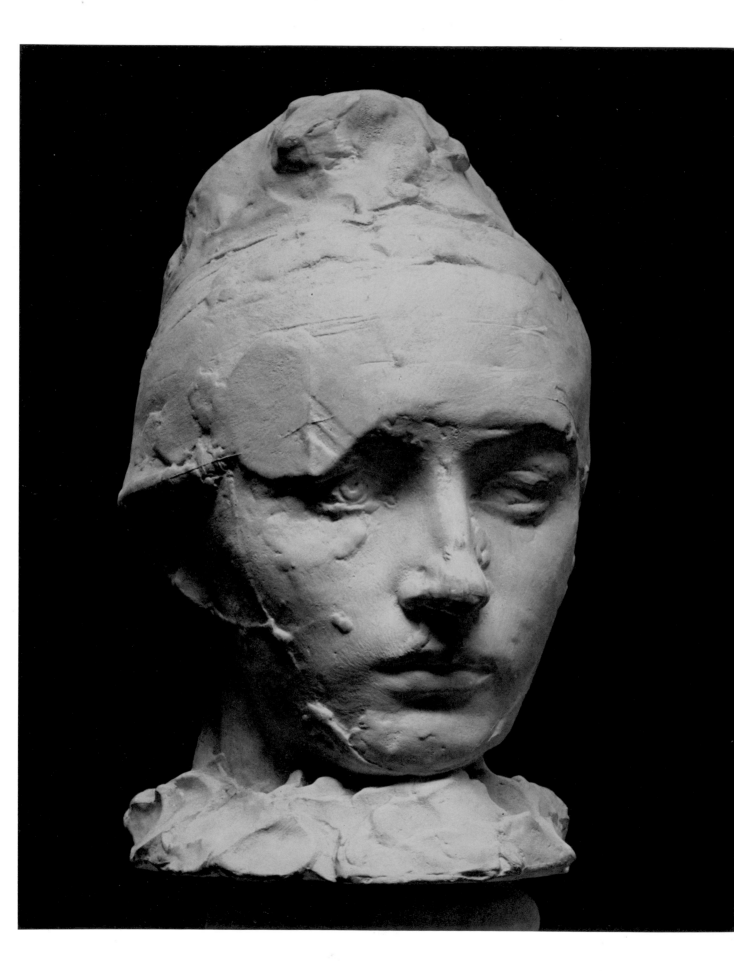

59

Camille Claudel
(*Camille Claudel au Bonnet*)

Untinted plaster cast with a plaster base; traces of piece mold
10 x 6 x 7 1/4″ (25.4 x 15.3 x 18.4 cm)
No inscription
1933.12.7

This small sketchy head perched atop a formless base is one of several portraits Rodin made of Camille Claudel (1856-1943),[1] a talented sculptress and Rodin's lover, protégée and companion of the 1880s and 1890s. The head shows the same melancholy and delicate features which we find in photographs of the sitter.[2] The turbanlike headdress focuses our attention on the face with its vacant expression. Rodin uses a similar device in his *Thought*, where Camille's head, crowned with a Breton cap, emerges from a block of marble. In the plaster sketch, which is closely related to *Thought*,[3] Rodin allowed the accidents of execution to remain. A large, crudely applied circle of clay over the right eye has not been worked into the surrounding areas, and smaller blobs of unmodelled clay dot the surface. Since he allowed them to remain, Rodin must have liked these reminders of the creative act; they contrast sharply with the refined surfaces of the marble *Thought*, where the emphasis is on the smooth texture of polished marble.[4]

The tumultuous affair between Rodin and the blue-eyed, auburn-haired beauty began sometime in the early 1880s.[5] Her independence led her to adopt a career as a sculptress against her family's wishes. Rodin soon recognized her talent; she became his partner in work and in love. When not working on her own sculptures, outstanding in their own right, Camille posed for Rodin and apparently modelled portions of his figures.[6] Their mutual devotion is expressed in their many artistic portrayals of one another: Camille modelled a magnificent bust—a cast is in the Legion of Honor—and several drypoint portraits of Rodin, while Rodin produced a series of portraits and, according to one biographer, a large number of drawings in "unstudied" poses.[7]

Camille and Rodin also took trips together, visiting cathedrals and friends such as the Renoirs.[8] The affair was naturally food for gossips; rumors circulated that the pair had two to four children, but Rodin denied this.[9] Rodin's peaceful coexistence with Camille and his lifelong companion, Rose Beuret (see cat. no. 53), was threatened; terrible arguments raged, each woman demanding that he choose between them.[10] Sometime in the 1890s, the liaison between Camille and Rodin ended. She left him to live alone and in poverty; Rodin secretly assisted her whenever she would allow it.[11] If the separation was painful for Rodin, it was

Left: *Camille Claudel*. Cat. no. 59.

tragic for Camille. She became progressively disturbed and in 1913 was committed to a psychiatric asylum where she spent the remaining thirty years of her life.[12]

The *Camille Claudel*, because of its close relationship to *Thought*, usually dated 1886, probably was executed in the 1880s.[13] This ca.-24-cm head exists in terracotta and bronze, but the Spreckels' cast is a unique plaster so far as we know. In 1911 Rodin had Jean Cros reproduce this work—as well as heads of Rose and Hanako—in *pâte de verre*, a glass process rediscovered by Cros's father, Henri,[14] which was quite popular at the turn of the century. In this version the sketchy appearance is diminished and is replaced by an overall grainy texture.

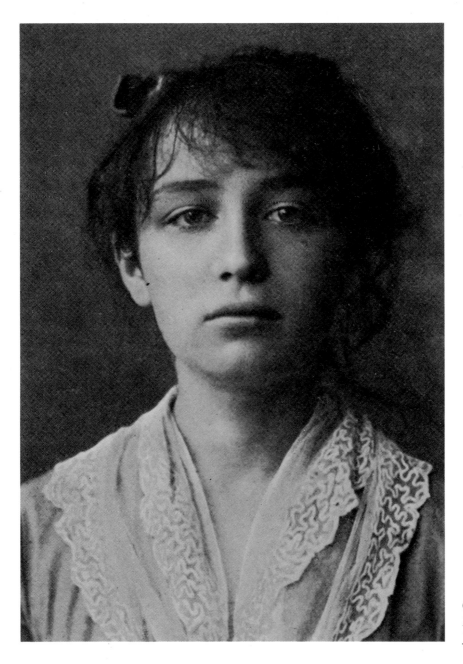

Camille Claudel.
L'Art Décoratif,
July-December, 1913.

NOTES

1. These are *Mlle. Camille Claudel* (1884, Grappe, 1944, no. 107); *L'Aurore* (1885, Grappe, 1944, no. 125); *Thought* (1886, Grappe, 1944, no. 165); *Saint Georges* (before 1889, Grappe, 1944, no. 214); *La Convalescente* (1892, Grappe, 1944, no. 259); *L'Adieu* (1892, Grappe, 1944, no. 260); and *La France* (see cat. no. 60). Replicas of all of these busts are in the Musée Rodin. Rodin created still another portrait, since a study for *Thought* was reproduced in Judith Cladel, "Rodin's Notebook," *Century*, 88 (1914), p. 516. This study is probably identical with the *Buste de Femme*, a mask reproduced in the 1900 Rodin exhibition catalogue. One more portrait head is said to exist in the row of heads in *The Gates of Hell* (William Harlan Hale, *The World of Rodin*, New York, 1969, p. 88).

2. See photograph reproduced in *L'Art Décoratif*, XXX (July, 1913), p. 5; reprinted Descharnes/Chabrun, p. 128.

3. In his discussion of *Thought*, Grappe refers to a terracotta sketch with the head held erect and with a slightly different expression. He calls this work *Petite Bretonne* (1944, no. 165). Frisch/Shipley describe a variant of *Thought*, which they likewise call *Little Breton Woman*. They say this head was later cast in glass by Jean Cros (p. 421). Since we know that a version of the Spreckels' head was cast in *pâte de verre*, presumably Grappe and Frisch/Shipley refer to this piece.

4. According to Lami, this piece was carved in 1889 by the sculptor Peter after a mask modelled by Rodin (p. 167). Very likely the mask used was the head reproduced in the 1900 Rodin catalogue (see note 1).

5. We have no exact documentation for their first meeting, and Rodin biographers differ on its dating, though most agree that it took place in the 1880s. The date of their separation is equally uncertain.

6. Cladel, 1950, p. 230. In Cladel's lengthy account of the Claudel-Rodin affair, Camille's name is never mentioned, though her identity is evident from other accounts.

7. The drypoints of Rodin and the drawings of Camille are mentioned by Frisch/Shipley (pp. 159 and 197). Two of Camille's drypoints are illustrated by Maillard (pp. 20 and 21).

8. Frisch/Shipley, p. 154.

9. Léon Daudet, *La Vie Orageuse de Clemenceau*, Paris, 1936, p. 149; Cladel, 1950, p. 232.

10. Cladel, 1950, p. 231-32. An alternative explanation of their breach may have been Debussy's admiration for Camille (Edward Lockspeiser, *Debussy: His Life and Mind*, 1962, I, p. 183; cited in Denys Sutton, *Triumphant Satyr*, New York, 1966, p. 79).

11. Cladel, 1950, pp. 232-33.

12. Letter from Paul Claudel to André Gide, March 22, 1913, in *The Correspondence 1899-1926 between Paul Claudel and André Gide*, New York, 1952, p. 196; Jean Amrouche, *Mémoires Improvisés de Paul Claudel*, Paris, 1954, p. 332.

13. Grappe dates *Thought* 1886 (1944, no. 165). He adds that it was exhibited as *Tête* at the Salon de la Nationale of 1895. René Chéruy dates it 1889 (Cladel, 1908, p. 158).

14. Grappe, 1944, no. 420; Frisch/Shipley, p. 439.

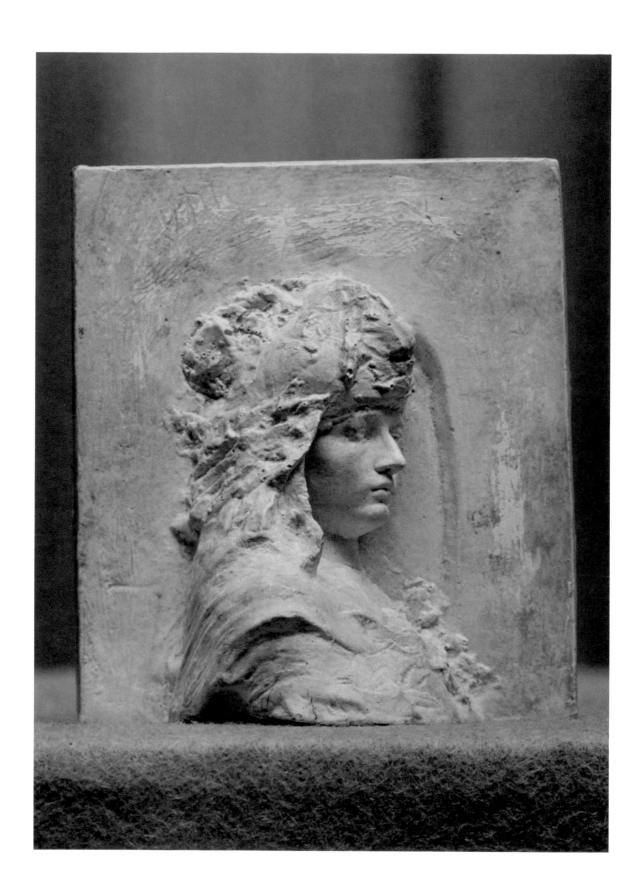

60

La France

Plaster, tinted flesh color
3 3/8 x 2 3/4″ (8.6 x 7 cm)
Signed: A Rodin (in ink, bottom)
1933.12.24

In this tiny sketch, remarkably precise for its size, the viewer can recognize the finely chiselled features of Camille Claudel (see cat. no. 59). Her serene, expressionless countenance is set within the massive helmet like a jewel. The heavy trappings, enhanced by the rich textures of clay, and the rectangular background, with its faint suggestion of an arch, enhance Camille's delicate profile.

The Spreckels' plaster is probably a study for the larger bronze, a composite of an isolated bust and a plaque. Though executed a few years after the turn of the century, this bronze bust was based on earlier portraits of Camille.[1] René Chéruy, Rodin's secretary from 1902 to 1908, witnessed the assembling of *La France*:

> I must confess that Rodin did not exert himself in doing this composition. He took a face of Camille Claudel, added the shoulders and the sketchy helmet in the round. Then placed it as a high relief in front of a plaster plaque with the indication of a vault—profile turned to the right he called it *La France*. Immediately after, perhaps the next day, he took a second cast and repeating the same process he turned the profile to the left and called it *St. Georges*.[2]

The large version of *La France* differs from the Spreckels' study in its slightly more finished appearance, the somewhat larger background and the revised arch. Around 1912, a committee charged with sending a gift from France to America as part of the Champlain Tercentenary celebration selected *La France*, and to this gift an inscription was added. The work was installed in the Champlain Memorial Lighthouse in New York in 1912.[3]

Its destination and most common name, *La France*, suggest a specific interpretation for this piece; however, it has been associated with a variety of meanings, expressed by its diverse titles.[4] As *La France* it obviously relates to representations of the French Republic, a subject Rodin had treated twice before in his *Call to Arms* and his *Bellone*. The ambiguous headdress can be seen as a Phyrigian cap, a traditional attribute of the Republic. Yet, compared with Rodin's two earlier treatments of that allegorical personage, *La France* is more personalized and more enigmatic. The hieratic, reserved character of Rodin's later work probably explains certain unexpected titles for this work. As the *Empress of the Late Empire* and the *Byzantine*

Princess, it reflects the late nineteenth-century association with early Christendom, then considered decadent and exotic. A striking outcome of this taste was ascendency of the cold, cruel woman, popularized in Flaubert's novel *Salammbô* and in the art of Gustave Moreau. Moreau evokes an idollike remoteness in his richly bejewelled Salomes, whose androgynous features are usually sharply defined in profile. We find similar qualities of reserve and sexual ambiguity in Rodin's bust; significantly, another title for *La France* is the *Young Warrior*, and a variant is known as *St. George*. The exquisite craftsmanship of the tiny plaster in the Legion of Honor makes the regular profile stand forth with great clarity against the flat background. These characteristics remind us of contemporaneous developments in jewelry and medals, then a significant aspect of sculpture, which Rodin esteemed and indeed practiced.[5]

The Spreckels' cast of *La France* appears to be a unique version since no other cast of this size has been located.[6]

NOTES

1. Grappe dates both the bust and *La France* 1904 (1944, nos. 337 and 338). René Chéruy disagrees with this dating: "The inauguration of the bronze was 1912, but the plaster of *La France* and *St. Georges* goes back to end of 1907 or beginning of 1908—I saw it being made, standing near Rodin when he was working on it" (letter from Chéruy, 18/8/57, Tate Gallery archives).

2. Letter of 1/1/57, Tate Gallery archives. Very likely, in creating *La France* Rodin reused a cast of the portrait of Camille Claudel found in the CPLH (see cat. no. 59); the features and handling of the two heads are nearly identical.

3. For an extensive account of how Rodin's bust came to be selected and its subsequent journey to the United States, see Gabriel Hanotaux, *La France vivante en Amérique du Nord*, Paris, 1913, pp. 165-77, 211-19.

4. It was also called *Buste de Jeune Guerrière, l'Impératrice du Bas-Empire* and *Princesse Byzantine*.

5. Rodin's early biographers have reported his lasting association with the decorative arts, including jewellers. The art of the medallist was revived towards the end of the nineteenth century. See Roger Marx, *Les Médailleurs français, depuis 1789*, Paris, 1897. Rodin's role in this development has yet to be studied; it has generally been overlooked that Rodin himself created several medallions, representing Stendhal, Bastien-Lepage, César Franck and Octave Mirbeau (Grappe, 1944, nos. 234, 258, 276 and 374).

6. The plaster appears in a photograph at Mrs. Spreckels' home prior to the opening of the CPLH and was probably purchased long before the year it was donated.

Right: *La France*. Location unknown. Photo Bulloz.

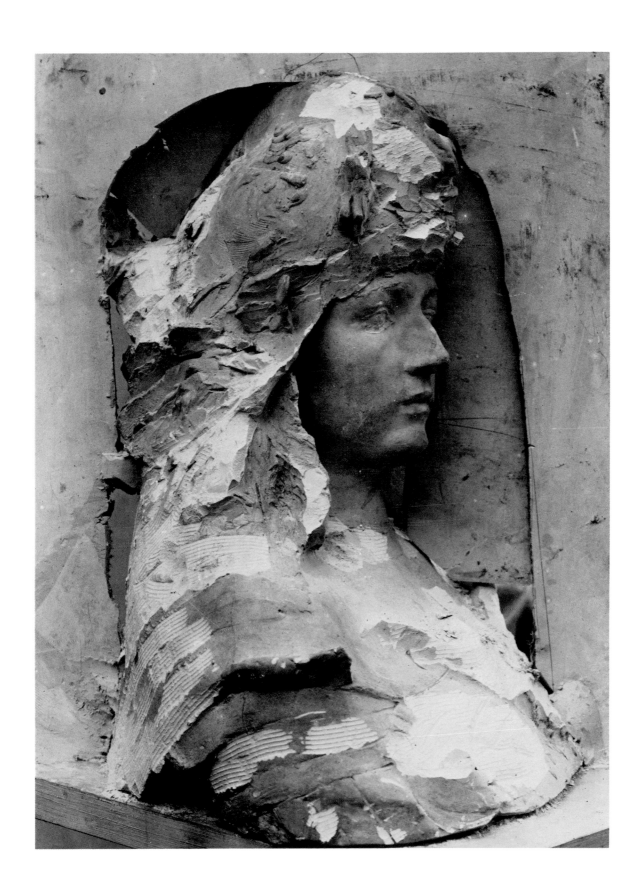

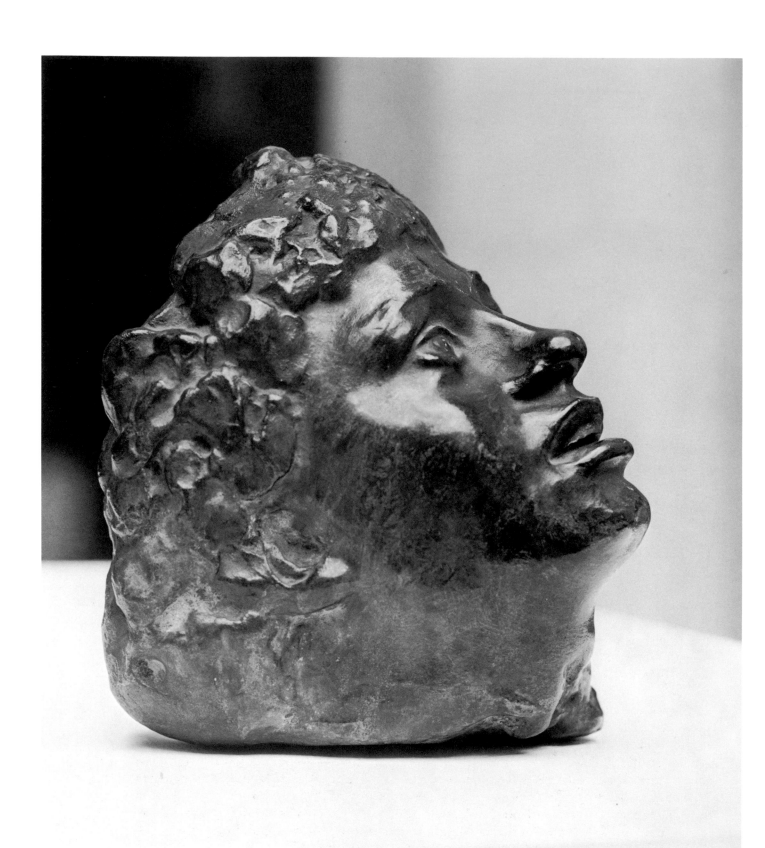

61
Séverine

Bronze, green to dark brown patina
5 5/8 x 4 15/16 x 4 15/16″ (14.3 x 12.5 x 12.5 cm)
Signed: Rodin (back, lower right)
1941.34.6

This portrait[1] is of the literary woman and social reformer, Caroline Rémy (1855-1925), who used the pseudonym "Séverine."[2] Dating from 1893, it has some of the haunting wistfulness characterizing the busts of Camille Claudel (see cat. no. 59) and Mme Russell of the 1880s. Rodin retains a general likeness; he is not overly conscientious toward physiognomic details. Some incongruity occurs between the right and left sides of the face, and the coiffure does not pretend to imitate hair, indicating a portrait that is not belabored. When we examine this head in connection with a beautiful series of drawings, we realize that Rodin, not content with a mere likeness, stressed his sitter's emotional nature.[3] Her thrown-back head, open mouth, raised eyes and tense muscles show Séverine as her friends saw her, a modern-day martyr. Indeed, Henri Rochefort somewhat cynically called her "Notre-Dame de la larme à l'oeil" (Our Lady of the tear-filled eyes).[4]

With minimal attention to detail, Rodin captures the generous and passionate nature of this liberated woman. Her life was colorful and frequently tragic and governed by her desire to help the downtrodden classes. An unhappy marriage at the age of fifteen ended in divorce. Her second husband, the permissive Dr. Guebhard, introduced her to the socialist, Jules Vallès, then exiled in Brussels. When Vallès returned to Paris, Séverine became his disciple and collaborator, working for the polemical newspaper, *Le Cri du Peuple*. Guebhard left her free to pursue her literary and crusading career, and, when she deserted him to live with the political activist, Georges de la Bruyère (or Broyère), he patiently awaited her return years later. Séverine's biographers leave a picture, much like Rodin's portrait—a vivacious, attractive and excitable feminist.[5]

Séverine's relationship with Rodin is a mystery, as are the circumstances under which her bust was executed. Though the bust is usually dated 1893, the two may have met earlier at one of the regular gatherings at Léon Cladel's. Grappe reports that she occasionally modelled for Rodin.[6] It has not been determined whether the portrait was a commission or a token of appreciation; for she advocated Rodin's cause.[7] Despite her devotion to Rodin, she reportedly was not satisfied with her bust, an opinion we cannot verify.[8]

One of a small number of existing casts, the Spreckels' *Séverine* is beautifully patinated in subtle and luminous shades of green. Mrs. Spreckels acquired it in August, 1915, from Loïe Fuller. It was loaned to the Legion of Honor from 1924 onward.[9]

Left: *Séverine*. Cat. no. 61.

NOTES

1. Formerly called *The Negress* and, then, *Head of the Martyr* in this collection. The first title may come from Loïe Fuller, since she uses it in her description of Rodin sculptures (CPLH archives).

2. Other *noms de plume* include "Renée," "Jacqueline," "Arthur Vingtras." She wrote for several newspapers and published several books, including *Pages rouges* (1893), *Notes d'une frondeuse* (1894), *Pages mystiques* (1895), *Vers la lumière, Impressions vécues* (1900) and *Line, 1855-1867* (1921).

3. Athena Tacha Spear has identified four drawings as portraits of Séverine (p. 93). To these we can add the frontal portrait, signed "A.R." (lower rt.) in the Szepmuveszeti Muzeum, Budapest.

4. André Billy, *L'époque 1900*, Paris, 1951, p. 231.

5. One of the best and earliest biographical ac-counts of Séverine is Frantz Jourdain's "Séverine," *La Revue Illustrée*, v. 5:2 (June to December, 1890), pp. 61-66.

6. Camille Lemonnier, *Une Vie d'Ecrivain, Mes souvenirs*, Brussels, 1945, p. 223; Grappe, 1944, no. 263.

7. Séverine included Rodin in her series of interviews of famous men; see Goncourt, *Journal*, entry for November 27, 1894. In 1917 she delivered a moving and spontaneous address at Rodin's funeral (Cladel, 1950, p. 423).

8. Coquiot, *Vrai Rodin*, pp. 96-97.

9. A copy of the contract of August 27, 1941, between Loïe Fuller and Mrs. Spreckels was owned by Miss Jean Scott Frickelton, Palo Alto.

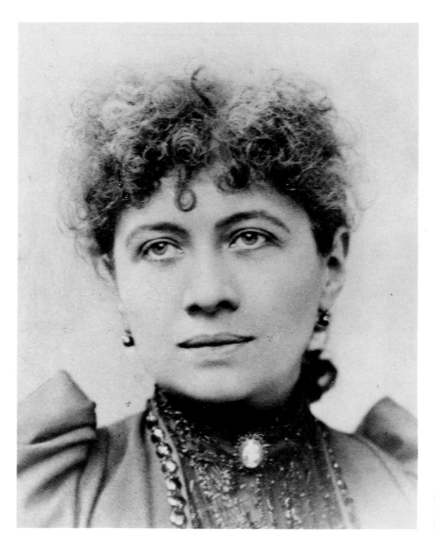

Séverine,
Librairie Larousse, Paris.
Photo Bangue.

62
The Athlete

Plaster, tinted light brown; traces of piece mold
18 1/8 x 13 1/4 x 7 7/16″ (46.4 x 33.7 x 18.9 cm)
No inscription
1933.12.9

This subtly rendered figure indicates Rodin's reluctance to idealize his sitters. The model, Samuel S. White III (d. 1952), was then a young physical culturalist, and Rodin is faithful to his highly developed arms and shoulders that contrast so strikingly with his slender legs and hips.[1] When the American offered to pose for Rodin in 1901, he spontaneously assumed a relaxed, seated posture.[2] The casual position of the left leg and twisted foot differ from the studied attitudes of conventional artists. Temporarily relaxed, the figure's energetic turn to the left suggests potential action. All parts of the body twist and bend creating a subtle interplay of lines which further activates the figure. From head to toe we can follow the complex movement of the contours, which change continuously as we move around the sculpture. Unlike many of Rodin's works, *The Athlete* suggests no meaning beyond itself. True, the contemplative expression and pose bring to mind *The Thinker*, but *The Athlete* lacks the deeper implications of that sculpture. Instead, it has the immediacy of a nude figure portrait after a living model.

Between 1901 and 1904, Rodin created two versions of *The Athlete*.[3] The version with the head facing forward and with less-refined modelling may have been the first, since a bronze cast, which Samuel White called "a first casting," was presented to him by Rodin.[4] A second more-finished version with the head turned to the side was purchased by Mrs. Spreckels. Nothing is known of the previous history of the Legion of Honor plaster. Relatively few casts of either version exist.

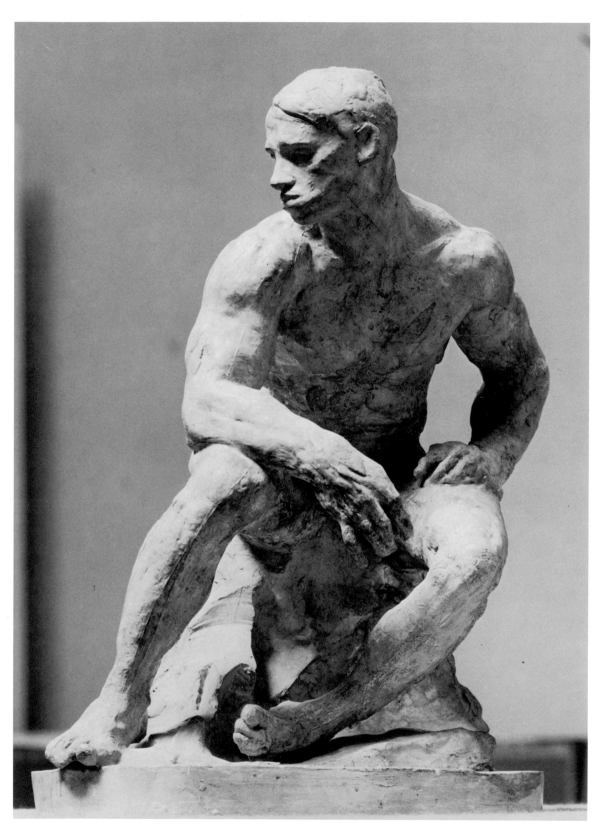

The Athlete. Cat. no. 62.

Right: *The Athlete*. Cat. no. 62, detail.

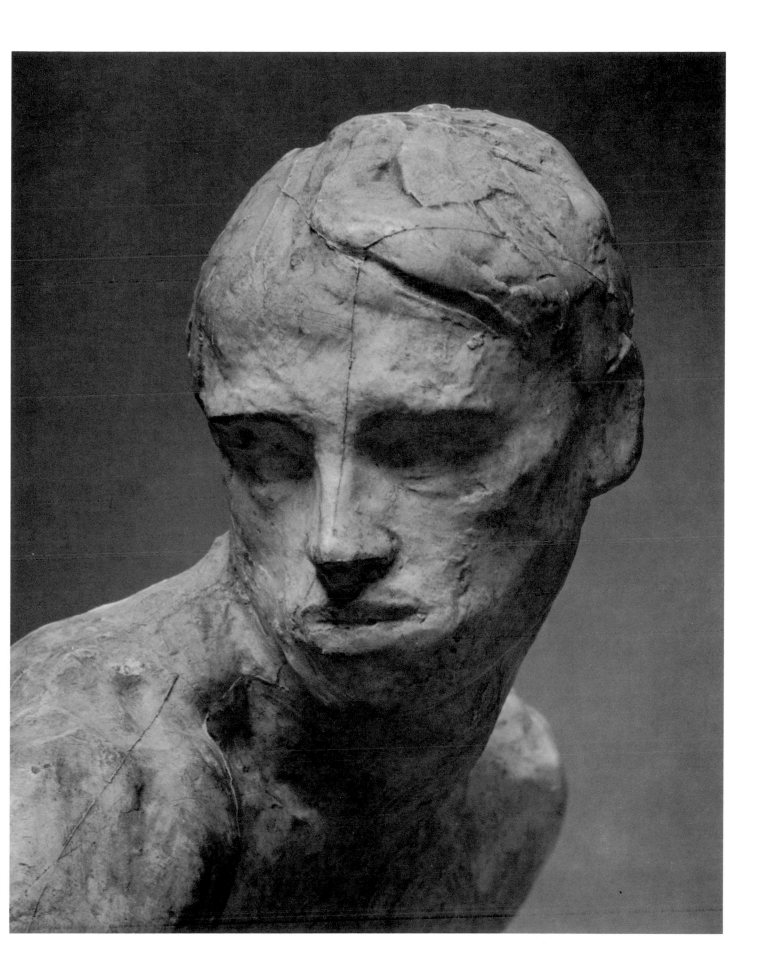

NOTES

1. Samuel White had been a protégé of the strong man, Eugene Sandow. For such athletes to pose for sculptors was common practice in the nineteenth century. Rodin had used such a model for his *Adam* (Cladel, 1950, p. 143). In his *Mon Frère Yves*, Pierre Loti described his character Barrada as "... l'ami de tous les hercules de foire posant chez des sculpteurs" (Paris, 1920, p. 123).

2. Samuel White, who is today known for his extensive art collection now housed in the Philadelphia Museum of Art, spoke in his later years of posing for Rodin: "... When I was in Paris some friend suggested Rodin would be interested in my muscular development. Rodin did want me to take a pose, and since I knew sitting was more comfortable than standing, I sat in a relaxed way—and Rodin did *The Athlete*—that was in 1901 ..." (Aline B. Louchheim, "Philadelphia Story: Modern Angles," *New York Times*, Sunday, February 5, 1950, sec. II, p. 10).

3. On his visit to the CPLH on June 29, 1947, Samuel White said that he posed in 1901 and 1904 for *The Athlete* (CPLH archives). One of the versions was exhibited in 1904 at the International Exhibition in Düsseldorf as the *Athlète américain* (Grappe, 1944, no. 328). A third version in a New York private collection, showing a figure basically like the CPLH version but with the figure seated at an angle, is described in the catalogue of the White collection in Philadelphia [*Philadelphia Museum of Art Bulletin*, LXIII:296, 297 (January-March, 1968, and April-June, 1968), p. 97. We have not seen this version, and therefore we cannot confirm this allegation.

4. Louchheim, *op. cit.* This cast is now in the Philadelphia Museum of Art (White collection). Possibly Rodin at one time planned to develop this sculpture further. Lawton (p. 269) remarked in his 1906 biography that *The Athlete* was "as yet in its first reduced size of the clay model."

63

La Nature

(Miss Eve Fairfax)

White marble
22 5/8 x 27 1/8 x 20 1/8" (57.5 x 68.9 x 51.1 cm)
Signed: A Loïe / Rodin (rear), and: Rodin (left side)
1941.34.17

This bust of the English beauty, Eve Fairfax, is one of many portraits of socialites and prominent figures that became a major aspect of Rodin's art in the early years of the twentieth century. Such portraits mark his "arrival" as an international celebrity much sought after by the rich and the famous. In the bust of Eve Fairfax, we note the veiled appearance of the features and the gentle restraint that characterize the portraits of these years.[1] The sitter sways slightly, and her face has the inscrutable quality of one lost in a dream.

The pensive, withdrawn mood of the model indicates Rodin's attempt to spiritualize this portrait. The head is framed by stylized vegetation, an aesthetic device commonly found in art at the turn of the century and one which raises the portrait bust to the realm of poetry. The sea of flat reedlike elements arranged in a pattern from which the sitter emerges and the simplified stalks of wheat that fall like a veil from the turn-of-the-century coiffure signify her closeness to natural forces and at the same time suggest that she herself personifies vegetal nature. The composite character of this bust links it with the long tradition of allegorical portraits but without their usual emblems. Rodin pays lip service to the Symbolist attitude toward portraiture; he adds symbolic elements to the immobile and frontal portrait, but he chooses not to endow the bust with the rich and meaningful qualities of the best Symbolist portraits, such as Gauguin's painted and sculpted images of Meyer de Haan (1890) and Jean Delville's painting of Mrs. Stuart Merrill (1892). We frequently find these decorative or symbolic elements in Rodin's marbles, both figures and portraits.[2] His busts of Mrs. Mariana Russell as Minerva, executed in the 1890s, are loaded with details that refer to classical antiquity but are not archeologically exact. Such sculptures are in keeping with the diluted symbolism fashionable around the turn of the century.

Eve Fairfax was one of several women who took Rodin's fancy and inspired numerous sculptures. Rose Beuret, Camille Claudel and Mrs. Russell had been followed by Hanako (see cat. no. 64). In 1902, Eve Fairfax caught his eye.[3] The sittings for her portrait began in that year when Ernest Beckett, later Lord Grimthorpe, commissioned Rodin to do her bust. At that time Miss Fairfax (b. 1872), a member of a prominent York family, was thirty and much admired for her beauty. When she refused to marry Ernest Beckett, Rodin was asked to stop

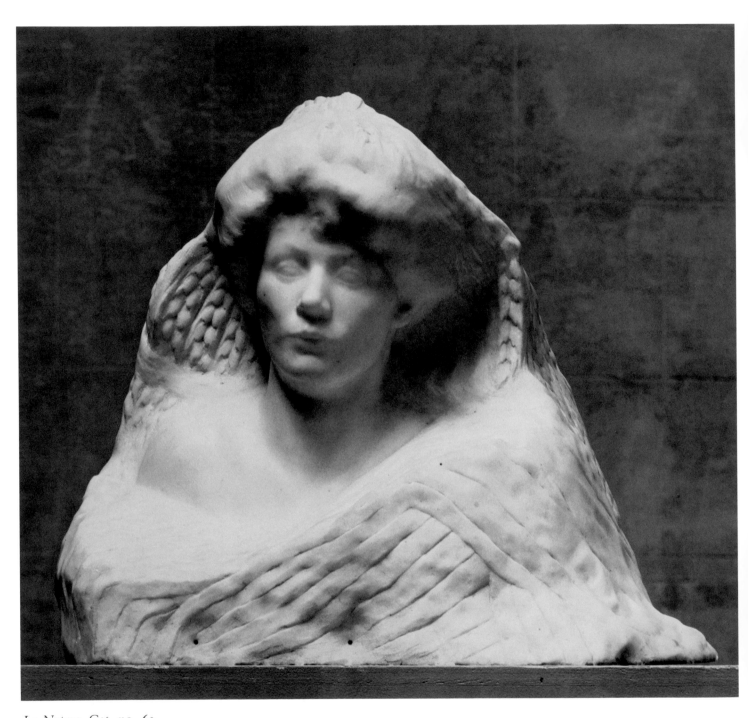

La Nature. Cat. no. 63.

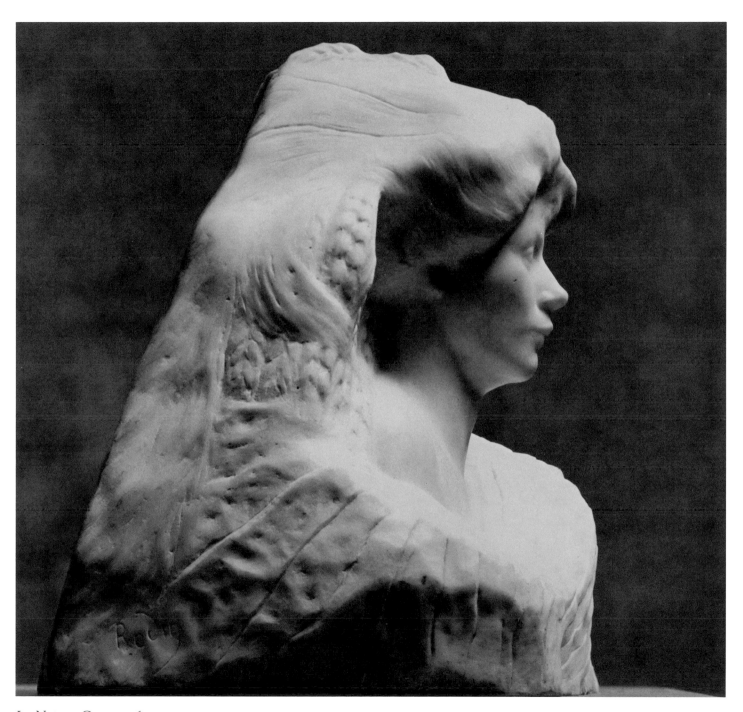

La Nature. Cat. no. 63.

work on the bust. But he nonetheless continued working on it. Miss Fairfax went to live in Paris in 1903, and later that year Rodin had completed a bust that pleased him.[4] Recently Miss Fairfax explained the secret of her appeal to the sculptor, who already had established a reputation as a sensualist:

> He was a remarkable man—very charming, kind and a dedicated artist. We spent the modelling sessions speaking to each other, I in broken French Rodin liked me very much, and I say it quite humbly. He found me refreshing, because at the time he was very popular and many French women were running after him. I think I appealed to him because, unlike most other women at the time, I was not prepared to jump into bed with him at every occasion. This, I think appealed to Rodin. The fact that I treated him rather indifferently made me different from all others.[5]

For his part, Rodin saw visions of antiquity in his sitter; he divined in her the unexpected combination of "a Diana and a Satyr."[6] These evocations are stressed in the antique garb of one of the marble versions and in certain titles for busts; the bust exhibited in Rome in 1913 was called the *Amazon*, and one version was sometimes referred to as *Sappho*.[7]

In all, Rodin created five versions of the bust. The terracotta in the Musée Rodin was probably the first version modelled directly from the sitter; at least one bronze cast of this version exists, in the Tate Gallery, London. This bust has an immediacy and vitality that is diminished in most of the subsequent marble versions, where the proud wistfulness of the original is replaced by a vague, dreaming quality and where vigorous, sensitive modelling is transformed into vaporous surfaces. The first marble was probably begun in 1904, but Rodin was dissatisfied with this and had a second carved by Bourdelle.[8] When the other two marbles were carved is uncertain, but in 1907 Rodin presented Miss Fairfax with the elegant marble (now in the Johannesburg Art Gallery) which shows her dressed as Diana.[9] A bronze cast after the Johannesburg marble is in the Galleria Comunale d'Arte Moderna in Rome.[10]

The Legion of Honor marble was in Mrs. Spreckels' collection by 1917, but the dates of execution and of purchase are unknown.[11]

NOTES

1. See, for example, the busts of the Duchesse de Choiseul and of W. de Kay (Grappe, 1944, nos. 377 and 380).

2. Since these decorative details are typically lacking in the casts after the original clay model, Rodin's role in their execution must be questioned. A thorough study of Rodin's marbles is necessary to determine whether such details were defined by Rodin himself or whether they were left more or less to the discretion of his marble carvers. Until such a study is made, these and many other questions will remain unanswered.

3. The commission and the relationship between Eve Fairfax and Rodin are documented in a series of letters from Rodin to the sitter from 1902 to 1909, now in the Johannesburg Art Gallery.

4. "Also I am very happy to tell you now that your bust will be worthy of you, it succeeded two months after your departure" (letter from Rodin to Eve Fairfax, December 14, 1903, quoted in Alley, p. 218).

5. Quoted in "Still Refreshing English Rose, a Woman, Now 98, Who Was Immortalized by Rodin," *The Star Johannesburg*, April 4, 1970, 11. We are deeply grateful to Miss P. M. Erasmus, Curator of the Johannesburg Art Gallery, for sending us a photocopy of this interview and for supplying other valuable information about the Eve Fairfax bust.

6. J.-E. Blanche, *Portraits of a Lifetime*, New York, 1937, p. 114; cited by Denys Sutton, *Triumphant Satyr*, New York, 1966, p. 131.

7. Grappe, 1944, no. 346.

8. Rodin wrote to Miss Fairfax on July 1, 1904: ". . . the marble is progressing slowly" (quoted in Alley, p. 219). René Chéruy, Rodin's secretary at the time, spoke of two marble versions: "It was later, probably in 1904, that I became acquainted with the marble bust of Miss Fairfax. In fact, Rodin had *two* marbles made for his own satisfaction. I don't know who had cut the first one, but Rodin was not completely satisfied, and commissioned Bourdelle to make the second one—which satisfied him completely. I don't remember if this second bust was different in 'pose' from the first one—probably not—but my clear recollection is that with one shoulder emerging from the mass of the base, the figure gave an impression of *effort*, as struggling against an opposition. Rodin, who that day was in a good mood, told me, 'You see she is struggling' and so on, giving me to understand that the young woman was, or wanted to be an actress against the will of her family" (letter of 1/1/57, Tate Gallery archives).

9. Rodin gave it to her as a "memento of your time spent in Paris" (Alley, p. 218). Miss Fairfax kept the bust for three years and then, because of financial difficulties, was forced to sell it. "I wrote to Rodin," she said in the 1970 interview, "explaining the position, and he told me to ask about 800 pounds . . . for it, if I remember rightly. I then sold the bust to the Johannesburg Art Gallery." A photograph of this bust is reproduced in *L'Art et les Artistes*, 4(February, 1907), p. 408.

10. *Mostra di Auguste Rodin*, Accademia di Francia, Rome, 1967, no. 129.

11. The Spreckels' marble is mentioned in a Rodin obituary in the *San Francisco Examiner* of November 18, 1917. It entered the CPLH in 1924 and appeared in the first catalogue (no. 175), where it was incorrectly described as a bronze. This error was corrected in the 1926 catalogue (no. 330).

Inscriptions. *La Nature*. Cat. no. 63.

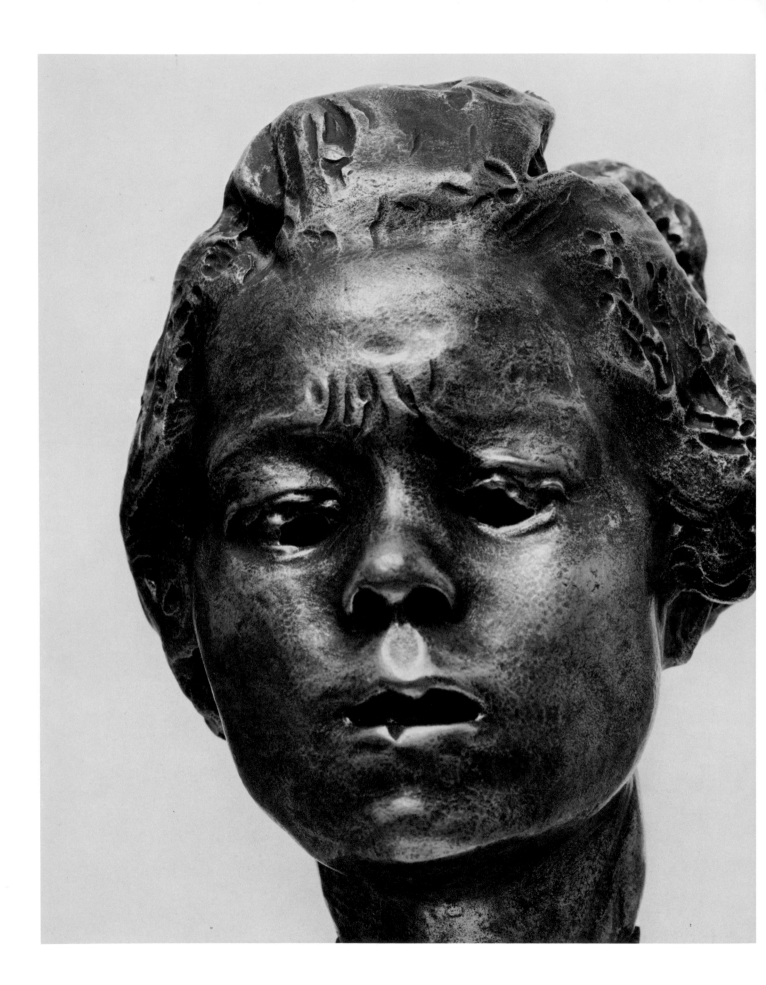

64
Hanako

Gilded bronze on a wood base
6 1/2 x 5 x 5 5/8″ (16.5 x 12.7 x 14.3 cm)
Signed: A-l'Admirable et/ Geniale [sic] artiste / Loie-fuller/ A Rodin (on hair, back)
1941.34.7

This expressive head is one of a series of portraits and drawings of the Japanese actress, Ohta Hisa (1868-1945), better known as Hanako, the name given to her by Loïe Fuller.[1] In the wake of the famous Sadda-Yacco,[2] who had enjoyed a great success at the International Exposition of 1900, Hanako's troupe achieved a notoriety under the patronage of Loïe Fuller. The American dancer introduced her Japanese protégée to Rodin, who was making studies of the face and figure of this petite woman early in 1907.[3]

Rodin made at least eight portraits of Hanako, emphasizing not her beauty but the different moods revealed by her mobile face.[4] Her dramatic training enabled her to retain such expressions for hours, allowing Rodin to study facial contortions in a way never before possible.[5] In some of the studies, Hanako's face is beautifully serene and pensive, but in others, such as the Spreckels' bronze, her grimaces convey anger, perplexity or horror. In the bronze head, her knit brows, the wild, deep-set eyes and the parted lips suggest pain and bewilderment. The crude modelling of the eyes and the depressed area over the left eye intensify her haggard expression. Despite the intense emotions revealed on this face, the fluid surfaces and sensitive modelling give it strength and elegance, elevating it far above mere caricature.

Rodin arrived at these almost scientific studies of expression by the same painstaking technique used for his other portraits. Judith Cladel watched Rodin model one of the heads of Hanako and later described it:

> I watched Rodin model the head of Hanako, the Japanese actress. He rapidly modelled the whole in the rough, as he does all his busts. His keen eye and his experienced thumb enable him to establish the exact dimensions at the first sitting. Then the detailed work of modelling begins. The sculptor is not satisfied to mold the mass in its apparent outlines only. With absolute accuracy he slices off some clay, cuts off the head of the bust, and lays it upside down on a cushion. He then makes his model lie on a couch.[6]

If the methods were the same, his emphasis on the inner emotions of his sitter differed from his commissioned portraits of women, whose privacy the sculptor always respected:

> In portraits of our own sex, we must pierce without pity the innermost crannies of the soul, must strip them of disguise, lay bare the intemperate, even vicious passions that surge in their daily struggle to have and to hold But a portrait of a woman is another thing. Their nature is not ours, we are far from grasping it; we must therefore be respectful and discreet. We must be circumspect, in unveiling their tender and delicate mystery. Even with them, always the truth—but not always all the truth; sometimes we may, just a little drop the veil.[7]

Left: *Hanako*. Cat. no. 64, detail.

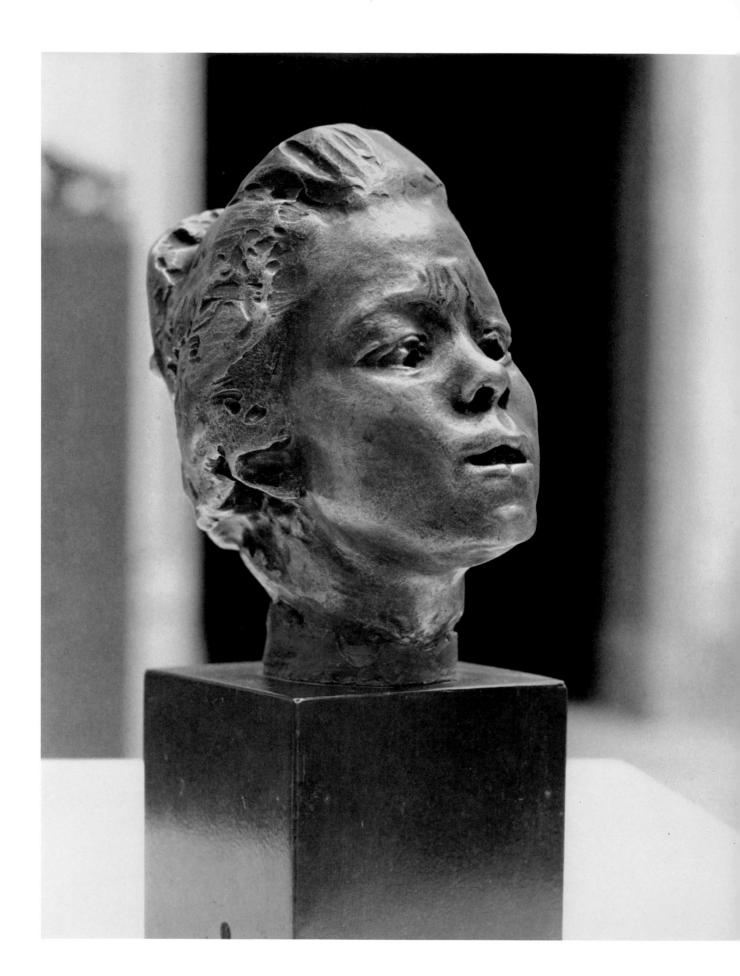

In the Hanako portraits, Rodin certainly did "drop the veil" in order to expose the soul as he had done in many instances on his *Gates of Hell*, particularly in his studies of weeping heads (see cat. nos. 30, 31, 32).

Besides being an example of Rodin's long concern with facial expression, the Hanako heads are part of his search for a variety of physiognomic types. These portraits are one aspect of his interest in Eastern culture.[8] This interest is not really surprising considering the widespread mania for the Orient among Rodin's contemporaries. Japanese art had a profound impact on French artists in the second half of the nineteenth century. Despite this craze for things Oriental, Rodin does not represent Hanako as a racial type; her face is not the stereotyped image that appeared on the Japanese stage but the head of a human being expressing real emotions. Rodin focuses so intensely on the human soul of his sitter that individual peculiarities are lost, although physiognomic accuracy is preserved. Realizing the universality of his conceptions of Hanako, Rodin dubbed one of the studies *Beethoven*.[9] This potentiality of the portrait to express a variety of ideas and moods clearly expresses Rodin's belief that "a human head is a universe and the portrait sculptor is an explorer."[10]

The head in the Legion of Honor is one of the most popular of the eight portraits of Hanako and has been cast many times in terracotta, plaster and bronze.[11] This particular rendition exists as both a complete head and as a mask. The posthumous edition of the head is complete; cast number 12 was offered for sale at Sotheby's on November 30, 1967.

Besides the sculpted portraits of Hanako, we know of at least five drawings by Rodin which further testify to his interest in the Japanese actress.[12]

The Spreckels' bronze entered the Legion of Honor in 1924. The gilded finish, which we find in this cast, occurs occasionally in Rodin's bronzes; it was an increasingly popular patina for sculpture during the second half of the nineteenth century.

NOTES

1. For biographical information on Hanako, see Donald Keene's delightful and informative "Hanako," *New Japan*, XIV, 1962, 125-27 (reprinted in his *Landscapes and Portraits*, Tokyo/Palo Alto, 1971, pp. 250-58). We would like to thank Mr. Keene for his generous personal assistance. In her autobiography, Loïe Fuller wrote of her christening of Hanako: "And as she had a name that could not be translated, and which was longer than the moral law, I christened her on the spot Hanako" (pp. 208-209). Mrs. Yamada of the Eastern Asian Library at the University of California at Berkeley, who has been most helpful in translating Japanese source material, tells us that Hanako means literally "flower child" and that it was a popular name at the turn of the century in Japan.

2. Rodin may have portrayed Sadda-Yacco. He was enthusiastic about her performance in 1900 (Cladel, 1903, pp. 109-10). A bronze mask called *Sadda Yacco* is listed in the *Catalogue du Musée du Luxembourg*, Paris, n.d. (no. 941). Whether this listing is simply an inaccurate attribution of one of the Hanako heads is uncertain. According to Rokusuke Ei, Sadda-Yacco refused to model for Rodin (*Waraiete* [*Variety*], Tokyo, 1965, p. 76).

3. The date of their first meeting is usually given as 1908; however, conclusive evidence suggests that Rodin was making studies of her in the preceding year, and Keene dates their first meeting 1906 (*op. cit.*, p. 256). At the exhibition of Rodin drawings at the Bernheim Jeune Gallery in October, 1907, a drawing titled "Hanako" (no. 27) appeared. Two other sketches in the same exhibition may also be studies of the Japanese dancer: "Psyché Japonaise" (no. 188) and "Petite Japonaise" (no. 205). A few months earlier the art critic, Jules Claretie, wrote in an article on Loïe Fuller and Hanako: "Le statuaire Robin [sic] nous montrera peut-être ses traits fins et ses yeux vifs au prochain Salon, car il est occupé présentement de faire le buste et, je crois même, la statue de la comédienne" ("La Vie à Paris," *Le Temps*, February 1, 1907, p. 2). Claretie's reference to a statue of Hanako is curious. We know of no sculpture that would specifically answer this description, but additional evidence suggests that such a sculpture, or sculptures, did at one time exist. Frisch/Shipley refer to "figures" and "figurines" after the Japanese actress (pp. 381 and

436). Rodin did make a drawing of a full dancing figure which is inscribed with Hanako's name, and in his comment on his studies of Hanako he stresses her body rather than her face: "I have made studies of the Japanese actress Hanako. Her muscles stand out as prominently as those of a fox-terrier; her sinews are so developed that the joints to which they are attached have a thickness equal to the members themselves. She is so strong that she can rest as long as she pleases on one leg, the other raised at right angles in front of her. She looks as if rooted in the ground, like a tree. Her anatomy is quite different from that of a European, but, nevertheless, very beautiful in its singular power" (*On Art and Artists*, p. 128). Keene has brought attention to the short story "Hanako" (1910) by Mori Ogai about an encounter between Hanako and Rodin in the artist's studio. In this account Rodin asks the Japanese woman to pose in the nude and she consents (*Landscapes and Portraits*, p. 257). Whether this anecdote alludes to an actual event is uncertain; no work showing Hanako in the nude has yet come to light. According to Cladel, Rodin was still making portraits of Hanako in 1911 (1950, p. 276). Rodin saw the Japanese actress for the last time in 1914 (*ibid.*, pp. 15-17).

4. For the various sculpted portraits of Hanako, see the lists of versions and replicas given by Athena Tacha Spear, *Rodin Sculpture in the Cleveland Museum of Art*, Cleveland, 1967, pp. 32 and 93-94. In addition to the versions listed by Spear, Malvina Hoffmann, who worked with Rodin from 1910 to 1914, mentions a wax mask, but we have not located such a piece (*Yesterday Is Tomorrow*, New York, 1965, p. 118).

5. "Hanako did not pose like other people. Her features were contracted in an expression of cold, terrible rage. She had the look of a tiger, an expression thoroughly foreign to our Occidental countenances. With the force of will which the Japanese display in the face of death, Hanako was enabled to hold this look for hours" (Cladel, 1917, p. 162).

6. *Ibid.*, p. 161.

7. Frisch/Shipley, pp. 359-60.

8. The Hanako studies had been preceded by numerous drawings of the troup of Cambodian dancers that visited Paris in 1906. Rodin's enthusiasm was so great that when they traveled to the Colonial Exposition held in Marseille in the summer of 1906, he followed them (memoir by Rodin in "Petite Chronique," *L'Art Moderne*, XXXII:36 [June 30, 1912], p. 205. Rodin's enthusiasm for Oriental art, however, began many years earlier. In 1887, he examined Goncourt's collection of erotic Japanese art (Goncourt, *Journal*, XIV, entry for January 5, 1887, p. 184). Four years later Rodin expressed his admiration to Goncourt for Javanese and Japanese dancing; he had made rapid sketches of these forms as he would later of the Cambodian dancers (*Journal*, XVIII, entry for July 23, 1891). Rodin responded enthusiastically to the exhibition of Japanese art held in 1893, which he attended with Camille Pissarro and Claude Monet (letter of February 3, 1893, *Camille Pissarro, lettres à son fils Lucien*, edited by John Rewald, Paris, 1950, p. 298). Somewhat later, at the suggestion of a friend, he compared his own drawings with Japanese art: "C'est de l'art japonais avec des moyens d'Occidental" (Cladel, 1903, p. 26). Mauclair wrote in 1905 of Rodin's admiration for Japanese bronzes (p. 87), and his art collection testifies to his taste for Oriental art. In 1905, Rodin became friends with the Orientalist Victor Goloubew, and they had long discussions on their common interest (Frisch/Shipley, pp. 170-71). In 1913, Rodin contributed notes on an Indian sculpture of Shiva to the book edited by Goloubew, *Ars Asiatica* III (*Sculptures Civaïtes*), Brussels and Paris, 1921.

9. ". . . Another one of them [the masks] enclosing a sublime thought beneath a forehead kneaded by genius and that Rodin, surprised himself, by this unforeseen evocation, baptised *Beethoven*" (". . . l'un d'eux, enfermant une pensée sublime sous un front pétri de génie et que Rodin, surpris lui-même, de cette évocation imprévue, baptisa *Beethoven*"); Cladel, 1950, pp. 15-16.

10. Rodin, quoted in J. E. Blanche, *Portraits of a Lifetime*, New York, 1936, 119.

11. The CPLH head corresponds to Spear's type C.

12. Bust-length drawings are in the Musée Rodin, Paris (nos. 2867 and 4472); the Metropolitan Museum of Art, New York; and Sotheby sale, December 3, 1970, no. 16 (present location unknown). A drawing of a full-length figure was formerly in the collection of Arthur Symons; its present location is unknown (ill. Arthur Symons, *From Toulouse-Lautrec to Rodin*, London, 1929, opposite p. 220).

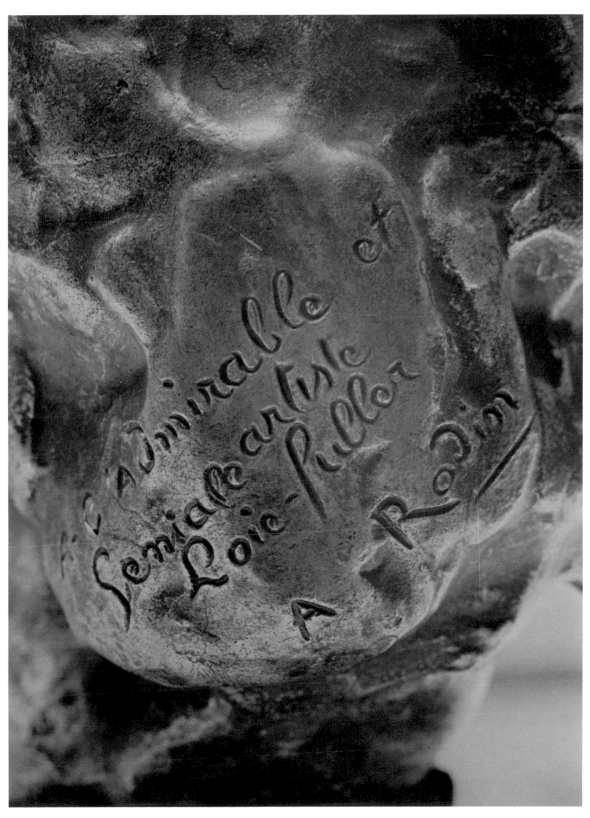

Inscription: *Hanako*. Cat. no. 64.

65

Bust of Edward H. Harriman

Marble
H: 20 3/4″ (52.7 cm) Base: 16 x 35″ (40.7 x 88.9 cm)
Signed: Rodin (right side of base toward front)
Gift of W. A. and E. Roland Harriman, 1940
40.6

Railroad executive Edward H. Harriman (1848-1909) apparently sat for his portrait by Rodin in 1909. The sculpture, not part of the Spreckels collection, came to the Legion of Honor as a result of its merger with the M. H. de Young Memorial Museum. An essay on Harriman and this bust is not included in the catalogue.

FRAGMENTS

Introduction

The several examples of the fragment in the California Palace of the Legion of Honor allow us to examine this important and innovative aspect of Rodin's art that has received increasing attention in recent years.[1] Despite many historical precedents, Rodin was the first to use the fragment as a complete sculpture in itself.[2] His realization of this new function of the fragment came earlier than is often assumed. Though previous examples had occurred where sculptures were fragmented by accident—for example, the *Man with the Broken Nose*—or deliberately, in emulation of famous remnants of antique sculpture—as with Rodin's copy of the Belvedere torso used on the Palais des Académies in Brussels (ca. 1875), Rodin fully realized the potential of the fragment while working on *The Gates of Hell*.[3] In the late 1880s and the 1890s, Rodin was already exhibiting fragments, some of substantial proportions.[4] By the early years of the twentieth century, he had filled cases in his studios with a large number of fragments that he would take out and admire for their own sakes or use to construct assemblages or new figural studies.[5]

The intellectual and artistic climate of the nineteenth century paved the way for the emergence of the fragment as an important element of Rodin's art in the 1880s. Throughout the century, fragments of antique sculpture had been much admired, and some people were beginning to appreciate such works as being beautiful in their own right.[6] This attitude was in keeping with neo-classical art theory and was fostered by the practice in art schools of drawing and modelling after casts of antique fragments to learn the anatomy of various parts of the body, an exercise to which Rodin was exposed in the 1850s at the Petite Ecole.[7]

On the basis of the popular acceptance of the antique fragment, the progressive critic, Jules Castagnary, whom Rodin met in the late 1870s, suggested a drastic method of improving Perraud's statue *Le Désespoir* exhibited at the Salon of 1869. The reviewer called the head useless, saying that it added nothing to the general effect. He asked if when the viewer suppressed the head in his imagination the idea was lessened:

> Does it not gain in force and intensity? . . . Do not the torso, the arms, the legs constitute a magnificent debris entirely worthy of being compared with the beautiful fragments of antiquity? May M. Perraud reflect on this, later, when he feels less involved with his work; and I do not doubt that, then, the justice of my reflection returning to him, he might be inclined to decapitate his statue, thus omitting the only fault that mars it.[8]

If Perraud was not willing to brutally sever an unsatisfactory portion of his statue as the critic recommended, several years later Rodin was to do exactly this, just as he later covered with a scarf an ill-executed portion of an antique sculpture in his personal collection.

At any rate the fragment was generally accepted long before the 1880s as an historical curiosity as well as an artistic aid. Since the Renaissance, sculptors had kept casts of parts of the living model and of antique fragments. However, the fragment deliberately constructed by the modern artist after the living model was still not valued as a work of art in itself before Rodin. Acceptance of the fragment was facilitated by the growing philosophical tendency to view life as unfixed and unstable and in a continual process of *becoming*. In the wake of Hegel, Schopenhauer and, more recently, Bergson, Charles Morice defended Rodin's fragments in the following manner in 1899:

> Do not think that he [Rodin] spares himself from finishing, or that he does not feel the need to finish. Even put in such laudatory terms, such a judgment would not do justice to him. For if the morsel does not look really finished to you, this is because you have looked at it superficially; in actuality what you took for a sketch, look at again, this is in actuality a very elaborated work, and it is because this is elaborated that it appears to be open to further development: like life itself. Here is revealed the only true meaning (if there is one in art) of the word "finish." It is: to identify itself with life, which never begins and never ends, which is perpetually becoming. If one were to understand it differently, the same word [finish] could only have a negative meaning, that is death; and it is exactly in this way that the mediocre sculptors, or the sculptors of the Institute, unconsciously understand this word: they finish— that is to say they isolate their works from life—that is to say that they give their works the characteristics of death.[9]

Rodin understood, as did many artists of the period, that no such thing as a "finished" work of art existed, that the artist's work never ended. His *Balzac* revealed his understanding; we see it again in his fragmented sculptures.

Rodin often dismantled whole figures to create new works consisting of the components—heads, arms, hands, torsos, legs and feet. Although Rodin valued each part of the body in isolation, he singled out the hand, long prized for its expressive power.[10] Rodin had worked intensely for many years to evoke the poetry of the hand; he once remarked that he had "modelled 12,000 hands and smashed up 10,000."[11] Rodin told of his long efforts to accurately portray the human hand:

> I had to work much in order to attain this maximum of truth of expression in the modelling of the hand. The study of the human hand is full of difficulties. Today, it is for me a very familiar subject and I amuse myself with it effortlessly. It is the same with everything I undertake. I believe that I have reached a definite mastery where I only find profound satisfaction and infinite delight, but at the price of what work, of what observation of nature, of what studies[12]

In the end Rodin extracted from the hand the revealing powers that the human head had formerly enjoyed.

The expressive power of the fragment, which is characteristic not only of Rodin's hands but of his torsos and even of his feet, is but one significance of the fragment. Sometimes Rodin dismembered sculptures that were not entirely to his liking; in this way he could salvage these fragmentary works.[13] On other occasions, sculptures were left in a fragmental state because they better expressed Rodin's ideas. For instance, in the torso called *Meditation*, arms and legs

were eliminated because " . . . reflection, when persisted in, suggests so many plausible arguments for opposite decision that it ends in inertia."[14] The fragment could also create a sense of mystery; like Symbolist poetry, it evokes without stating. Certain fragments, such as *The Mighty Hand* (see cat. nos. 68 and 69), have a macabre quality that suggests a link with the nineteenth-century literary motif of the magical implications of detached parts of the human body.[15] Above all, the fragment was a means of reducing a sculpture to its most elemental parts, which were in themselves beautiful and complete. The viewer's attention could thus be focused on the most essential qualities of the sculpture, be it the modelling, the movement or a philosophical statement.[16] Taken in its broadest significance, the fragment is part of Rodin's reevaluation of what constitutes a complete work of art, an assessment that was to have profound importance for twentieth-century sculpture.

NOTES

1. The importance of the fragment as a work of art has been stressed increasingly in recent years, and Rodin's significant role in the ascendency of the fragment has been duly emphasized. This role is reflected in several exhibitions and publications: Joseph Gantner, *Rodin und Michelangelo*, Vienna, 1953, pp. 32-56; J. A. Schmoll gen. Eisenwerth, *Der Torso als Symbol und Form: Zur Geschichte des Torso-Motivs im Werk Rodins*, Baden-Baden, 1954; and "Zur Genesis des Torso-Motivs und zur Deutung des fragmentarischen Stil bei Rodin," in *Das Unvollendete als Kunstlerische Form*, Berne/Munich, 1959, pp. 117-39; Albert Elsen, *The Partial Figure*, Baltimore, 1970; Leo Steinberg, "Introduction," *Rodin, Sculptures and Drawings*, New York, Slatkin Galleries, 1963, pp. 10-27.

2. One overlooked artistic predecessor is Carpeaux, who systematically produced small sketches of figures lacking peripheral anatomical parts—hands, arms, feet and heads. Rodin may have seen them, either in retrospective exhibitions or in Carpeaux's studio which, after his death (1875), his wife converted into a "museum" which was visited by select circles ("Galerie Carpeaux," *L'Art moderne*, 16 [1896], p. 150).

3. Cf. G. Kahn, "Notes sur Rodin," *Mercure de France*, 172:623 (June 1, 1924), p. 318. The incomplete arms of *The Three Shades* provide one example of fragmental sculpture on *The Gates* themselves (see cat. no. 20).

4. In the 1889 Monet-Rodin exhibition, he showed two torsos and two masks. Fragments by Rodin were exhibited at the Salon for the first time in 1890 and were discussed by Gustave Geffroy, "Rodin," *La Vie Artistique*, 1 (1892), p. 225. In her 1903 biography, Cladel wrote that the fragmental figures of *Earth*, the *Voix Intérieure* (Salon of 1897) and *Iris* had been exhibited (p. 88). Many fragments were displayed at the 1900 Rodin exhibition. After the turn of the century, Rodin exhibited large torsos at the Salons of 1905 and 1910. The pair of hands known as *The Secret* was shown in London in 1910 (Grappe, 1944, no. 415).

5. L. Bénédite, *Rodin*, New York, 1927, 50. Early reports of glass cases filled with fragments are found in Jean Schopfer and Claude Anet, "Auguste Rodin," *Craftsman*, 5:6 (March, 1904), p. 536; and Anna Seaton-Schmidt, "Auguste Rodin: Man and Sculptor. An Appreciation," *American Magazine of Art*, 9:4 (February, 1918), p. 137 (describes visit of 1905).

6. As if challenging the future Rodin, the sculptor David d'Angers wrote in the later 1840s: " . . . a foot, a torso or an arm [of an antique statue] are pages of this book. Would it be possible for you to make a similar judgment when examining a fragment of one of our modern statues?" (" . . . un pied, un torse ou un bras sont des pages de ce livre. Vous serait-il possible de porter un pareil jugement sur l'examen d'un fragment d'une de nos statues modernes?") *Les Carnets de David d'Angers* (1828-1855), edited by A. Bruel, II, Paris, 1958, p. 272.

7. Dujardin-Beaumetz, p. 111; Cladel, 1950, p. 77.

8. "Est-ce qu'elle ne gagne pas en force et en intensité? . . . Est-ce que ce torse, ces bras, ces jambes ne constituent pas un magnifique débris tout à fait digne d'être rapproché des beaux fragments de l'antiquité? Que M. Perraud y réfléchisse, plus tard, quand il se sentira tout à fait désintéressé de son oeuvre; et je ne doute pas qu'alors, la justesse de ma réflexion lui revenant en mémoire, il n'ait par moments la vélléité de décapiter sa statue, faisant ainsi sauter avec la tête la seule faute qui la dépare" (*Salons*, Paris, 1892, vol. 1, p. 386).

9. "Ne pensez donc pas qu'il se dispense de finir, ou encore qu'il n'a pas besoin de finir. Même sous cette forme admirative un tel jugement serait une façon d'ingratitude; car, si le morceau ne vous parait pas achevé réellement, c'est que vous l'avez regardé superficiellement; ce que vous preniez pour une ébauche, regardez mieux, c'est précisément une oeuvre très poussée, et c'est parce qu'elle est telle qu'elle parait susceptible de développement: comme la vie elle-même. Ici se livre la seule acception vraie

(s'il y en a une, en art) du mot 'finir.' C'est: rejoindre la vie, qui ne commence et ne s'achève jamais, qui est en développement perpétuel. Autrement compris, le même mot ne pourrait avoir qu'un sens négatif, le sens de la mort; et c'est bien ainsi, en effet, que l'entendent inconsciemment les sculpteurs médiocres, ou de l'Institut: ils finissent,—c'est-à-dire qu'ils isolent leurs oeuvres de la vie,—c'est-à-dire qu'ils donnent à leurs oeuvres les caractères de la mort'' (*Rodin,* Paris, 1900, pp. 16-17; paper read at the Maison d'art, Brussels, May 12, 1899). The unfinished work of art is also discussed in nineteenth-century literature, for example, in Zola's *L'Oeuvre.* Zola ascribes Claude Lantier's unfinished masterpiece to artistic impotence—the rationale, incidentally, that many used to condemn Rodin's own incomplete works.

10. Many artists made separate studies of hands to scrutinize their complex movements and gestures. In the nineteenth century, the hand was also a poignant image in poetry for writers like Gautier and Verlaine. For extensive comments on the expressiveness of the hand, see Henri Focillon, ''In Praise of Hands,'' *The Life of Forms in Art,* New York, 1948. The studies of hands were so important to Rodin that he asked Gustave Kahn to write a special page on them for the 1900 Rodin issue of *La Plume* (pp. 28-29).

11. Anne Leslie, *Rodin, Immortal Peasant,* New York, 1937, p. 219. How many of Rodin's fragments that were merely studies of form and movement had been discarded by the sculptor is uncertain, but this practice was apparently common. A visitor to Rodin's studio was given permission to keep and cast in bronze a torso that the sculptor had thrown aside (P. Hamerton, ''The Present State of the Fine Arts in France,'' *Portfolio,* 1891, p. 200). The painter Frank Brangwyn told how the sculptor Edouard Lanteri visited Rodin's studio and saw ''a whole collection of small clay figures (fragments of torsos, arms, heads, and little groups that were going to the dust heap),'' in William de Belleroche, *Brangwyn Talks,* London 1944).

12. ''J'ai du beaucoup travailler pour atteindre à ce maximum de vérité d'expression dans le modelé de la main. L'étude de la main humaine est pleine de difficultés. Aujourd'hui, j'y trouve un sujet des plus familiers et je m'y complais sans effort. Il en est d'ailleurs de même pour tout ce que j'entreprends. Je crois être arrivé, mais au prix de quels travaux, de quelle observation de la nature, de quelles études, à une certaine maîtrise où je ne trouve que satisfaction profonde et jouissance infinie''); quoted in Armand Dayot, ''Le Musée Rodin,'' *L'Illustration,* 143 (March 7, 1914), p. 174.

13. Rodin explained to Vollard the need to remove portions of certain sculptures that had been enlarged: ''I am giving away one of my secrets. All those trunks that you see there, so perfect in their forms now that they no longer have heads, arms or legs, belonged to an enlargement. Now, in an enlargement, certain parts keep their proportions, whereas others are no longer to scale. But each fragment remains a very fine thing. Only, there it is! You have to know how to cut them up. That's the whole art'' (A. Vollard, *Recollections of a Picture Dealer,* Boston, 1936, p. 210). Cf. Lami, p. 163.

14. Rodin in *On Art and Artists,* p. 164.

15. Literary examples of such magical members that have the ability to move about at will are described in Balzac's ''The Elixir of Life,'' Gérard de Nerval's ''The Enchanted Hand,'' Gautier's ''The Mummy's Foot'' and Maupassant's ''The Hand.''

16. On Rodin's lack of concern for unessential elements, Bartlett wrote: ''Another characteristic of the sculptor is that of often stopping work on a figure the moment he has found, by general movement, the fundamental object he was seeking, and leaving the head, hands, and feet unfinished'' (p. 250). Rodin later complained that the public did not understand the importance of the formal aspects of his fragments: ''The public, and the critics enslaved by the public, have they not reproached me enough for having exhibited *simple parts of the human body*? I have suffered the lewd drawings of caricaturists. Did these people understand nothing of sculpture? Of the study? Did they not imagine at all that an artist ought to apply himself to give as much expression to a hand, to a torso, as to a physiognomy? And that it was logical and, even more, for an artist to exhibit an arm rather than a 'bust' arbitrarily deprived by tradition of arms, legs and abdomen? Expression and proportion, that is the goal. The means is modelling: it is by modelling that the flesh lives, vibrates, fights, suffers'' (''Le public, et les critiques asservis au public m'ont-ils assez reproché d'avoir exposé *de simples parties du corps humain*? J'ai essuyé jusqu'aux dessins impudiques des faiseurs de caricatures. Ces gens-là ne comprenaient donc rien à la sculpture? à l'étude? N'imaginaient-ils point qu'un artiste doit s'appliquer à donner autant d'expression à une main, à un torse qu'à une physionomie? Et qu'il était logique et beaucoup plus d'un artiste d'exposer un bras plutôt qu'un 'buste' arbitrairement privé par la tradition, des bras, des jambes et de l'abdomen? L'expression et la proportion, c'est le but est là. Le moyen, c'est le modelé: c'est par le modelé que la chair vit, vibre, combat, souffre'') Quoted in Michel Georges-Michel, *Peintres et sculpteurs que j'ai connus: 1900-1942,* New York, 1942, p. 264. In his notebooks, Rodin wrote: ''Beauty is like a God! A morsel of beauty is the entire beauty'' and ''The life is in the modelling, the soul of the sculptor is in the morsel; all sculpture is there'' (''Le beau est comme un Dieu! Un morceau de beau est le beau entier'' and ''La vie est dans le modelé, l'âme de la sculpture est dans le morceau; toute la sculpture est là''); quoted in Coquiot, *Rodin à Hôtel de Biron,* pp. 66 and 82.

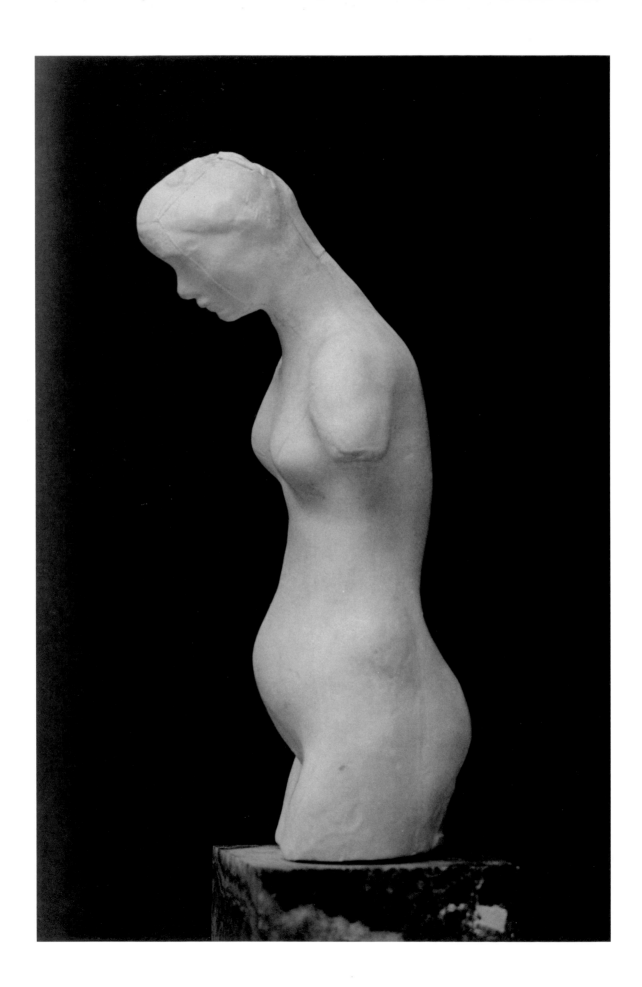

66
Female Torso

Plaster, spots of mauve tint at back, beneath right arm, and between legs; traces of piece mold; on a marble base
8 x 2 3/4 x 4″ (20.4 x 7 x 10.2 cm)
No inscription
1933.12.14

This strange torso is one of the many little figures that Rodin liked to assemble from available parts in his spare time. In this piece, he joins a head from one figure to the legless and armless body of another.[1] The head, which exists as a separate fragment, is grafted onto the snakelike body by means of an elongated neck. Although too small for the torso, the head droops forward like a ripe fruit on a branch. The torso seems about to topple forward, since nothing counterbalances the sunken head and swollen abdomen.

With such sculptures, problems of dating are inevitable, since the parts may have been created at one time and assembled at another. Comparison with other sculptures provides some clues, but no definitive date can be given. The facial type, with its vague features, as well as the swollen curves of the body, are comparable to the figure of *Pomona*, usually dated around 1886.[2] However, the torso in the Legion of Honor is unusually elongated and lacks the broader hips we expect in such figures by Rodin. The flattened and simplified face with its immobile features is a type found many times in Rodin's little studies of movement, particularly in the series of dancers usually dated around 1910.[3] This face seems to be one of those used as a kind of shorthand, a type created from the imagination rather than from a model. In the Legion of Honor plaster, the features are unusually vague, as if Rodin had bathed it in liquid plaster after modelling it.

The date of purchase of the Spreckels' plaster torso is unknown.

NOTES

1. A separate casting of the head appeared at Sotheby's, December 9, 1969, no. 24 (withdrawn).
2. Grappe, 1931, no. 182; Cladel, 1908, opposite p. 122.
3. Grappe, 1944, no. 426; Jianou/Goldscheider, p. 113. A similar head is used for the plaster study called *Femme assise sur un vase de marbre* (C. Goldscheider, *Rodin inconnu*, Paris, 1962, no. 167). A figure very similar to the CPLH torso but no longer armless is coupled with another figure inside what looks like an antique vase to form the *Plaster Study* illustrated by Otto Grautoff (*Auguste Rodin*, Bielefeld/Leipzig, 1905, p. 75). We can also compare the elongated, elastic figure with a tiny head to the woman in the group called *Faun with Bow* of 1898 (Grappe, 1944, no. 296; ill. Descharnes/Chabrun, p. 140).

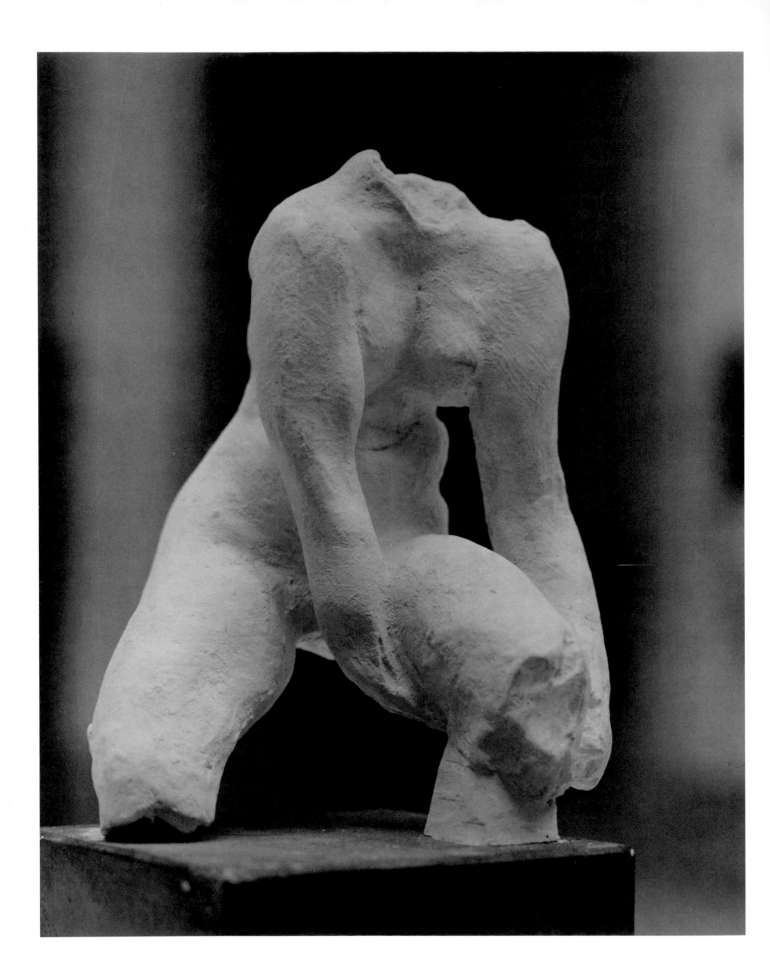

67

Headless Female Torso Seated

Untinted plaster on a brown-tinted plaster base
5 1/4 x 3 15/16 x 3 15/16″ (13.3 x 10 x 10 cm)
No inscription
1933.12.10

The casual pose of the model for this torso expresses intimate movements which were central to the art of Dalou and Degas. Even Rodin's stocky figure reflects a physical type commonly seen in much of the art of the period.

In an early biography, this work is designated as a study for the *Iris, Messenger of the Gods*, which was originally created in connection with the Victor Hugo monument.[1] Since this monument was commissioned in 1889 and received its final form in 1890, we can locate this plaster chronologically.

The cast of the *Headless Torso* is among the plasters given by Mrs. Spreckels in 1933. Besides this small version, a larger, ca.-34-cm one exists.

NOTE

1. "Studie für die Iris am Victor Hugo-Denkmal," O. Grautoff, *Auguste Rodin*, Leipzig/Bielefeld, 1908, 81. Also illustrated in *Pall Mall Magazine*, 27 (July 1, 1902), p. 336. The 1900 Rodin exhibition catalogue describes the *Iris, messagère des dieux* as "*une étude pour le monument à Victor Hugo, qui comportait d'abord trois Voix*" (no. 89).

Left: *Headless Female Torso Seated*. Cat. no. 67.

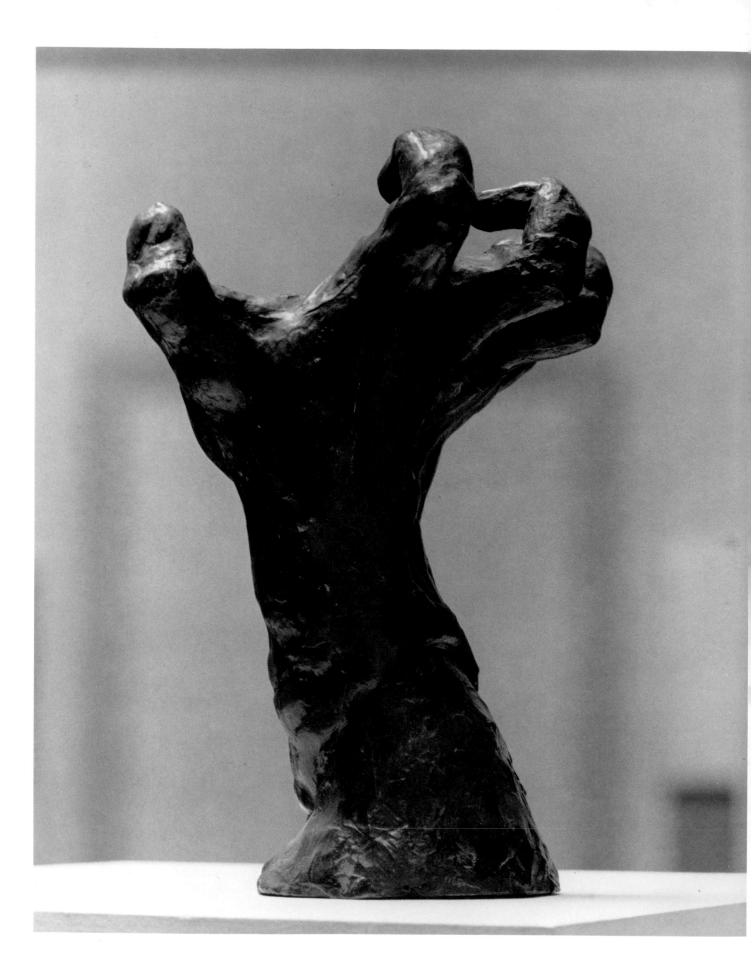

68

The Mighty Hand (right hand)

(*Main Crispée*)

Bronze, black patina with traces of natural bronze and green; traces of piece mold;
cast with base
18 x 12 3/8 x 7 9/16″ (45.8 x 31.4 x 19.2 cm)
Signed: A. Rodin (lower right side)
Stamped: A. Rodin (inside, left), and: ALEXIS. RUDIER / FONDEUR. PARIS (rear, lower right)
1942.39

69

The Mighty Hand (right hand)

(*Main Crispée*)

Plaster, tinted beige; traces of piece mold
18 3/8 x 12 3/8 x 7 9/16″ (46.7 x 31.4 x 19.2 cm)
No inscription
1933.12.2

A perfect wedding of dramatic gesture and emphatic modelling makes *The Mighty Hand* one of Rodin's most daring conceptions. Tense with pain and suffering, the hand grasps desperately, convulsively, like that of Grünewald's crucified Christ. In Rodin's hand, however, the source of the suffering is unexplained. Muscles and tendons seem about to burst the limits of the restraining skin, and we perceive only the raw emotion. Rodin has surpassed anatomical norms in this hand, with its magnified depressions and swellings; by holding one's hand in this position, the excruciating, contorted posture is fully appreciated. This ghastly distortion of the hand recalls the popularity of tales of horror earlier in the century.[1]

Such a mood is in keeping with the atmosphere of *The Gates of Hell*. *The Mighty Hand* was probably executed at the same time as the first studies for the door.[2] The exaggerated musculature and the strained posture of the hand are particularly close to works like *The Thinker* and *The Three Shades* (see cat. nos. 19 and 20).

The Mighty Hand is one of Rodin's most popular fragments; a considerable number of casts exists. Besides large and small versions of the right hand, Rodin created a left-hand variation even more contorted than the right. Its middle finger is elongated and lies flat on the palm, and the profile reveals a serpentine movement created by a complex bending of joints impossible to achieve in human anatomy. The left hand also differs in its surface treatment. In the wrist area, knotty muscles and tendons are replaced by a roughly textured column. The

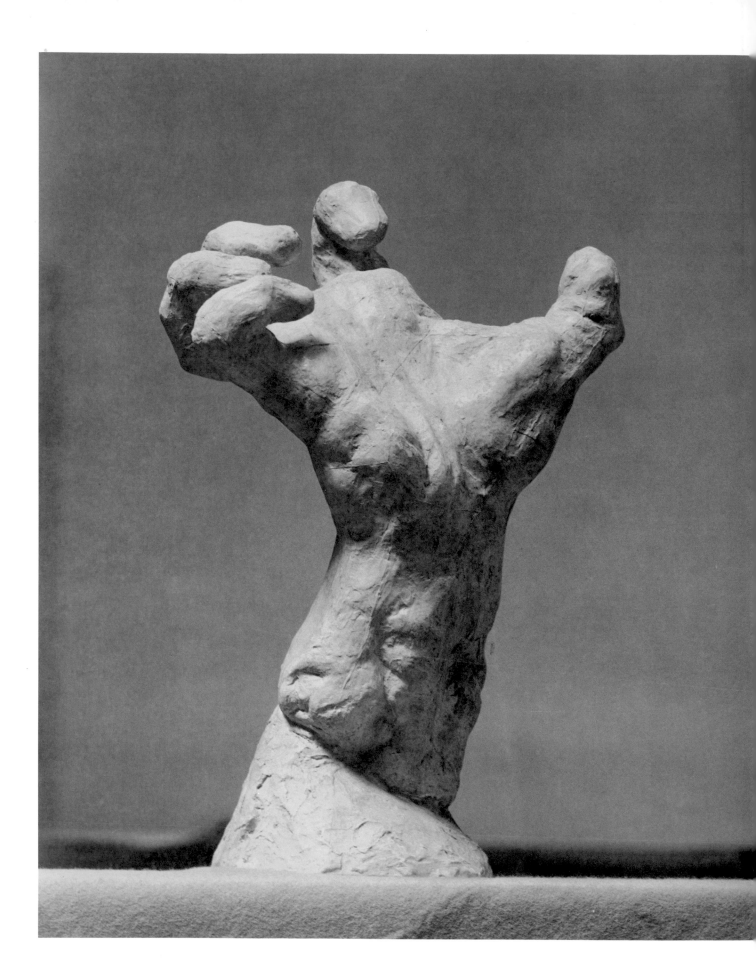

less realistic treatment of the left hand suggests that it was made later than the right one.[3] The left hand is combined with the torso of *The Despairing Adolescent* to create yet another work.[4]

The bronze cast of *The Mighty Hand* in the Legion of Honor was probably the bronze *Hand* purchased by Mrs. Spreckels from Loïe Fuller in 1915, which entered the museum in 1924. The previous history of the plaster cast is unknown.

NOTES

1. French poets like Gautier, Baudelaire and Hugo had referred to convulsive hands to express lust, hatred and horror. In his "Sultan Mourad," for instance, Hugo wrote: "Et l'on voyait sortir de l'abîme insondable/Une sinistre main qui s'ouvrait, formidable"; "La Légende des siècles" (*Oeuvres complètes de Victor Hugo*, v. 21, part 1 [n.p.], 1968, p. 288. Hugo's drawings of such contorted hands seem to anticipate Rodin's *Mighty Hand*.

2. *The Mighty Hand* is usually dated around 1885, presumably on its alleged association with *The Burghers of Calais*, although evidence of this association has not been presented. Stylistic evidence suggests a somewhat earlier dating. In the special Rodin issue of *La Plume*, several photographs of *The Mighty Hand* are entitled *Main d'expression* (pp. 28-32). They show the hand emerging from draperies, as if Rodin's contemporaries were not yet ready to see the hand as a total entity. This hand may have been exhibited at the 1900 Rodin exhibition as the *Etude de Main* (no. 47), which is described as a "small hand opened and contracted."

3. The left hand was completed by 1906, when Rodin was photographed with a version where apparently a strange armature is still attached (ill. *L'Art et les Artistes*, 4 [February, 1907], p. 411.

4. Ill. Descharnes/Chabrun, p. 229.

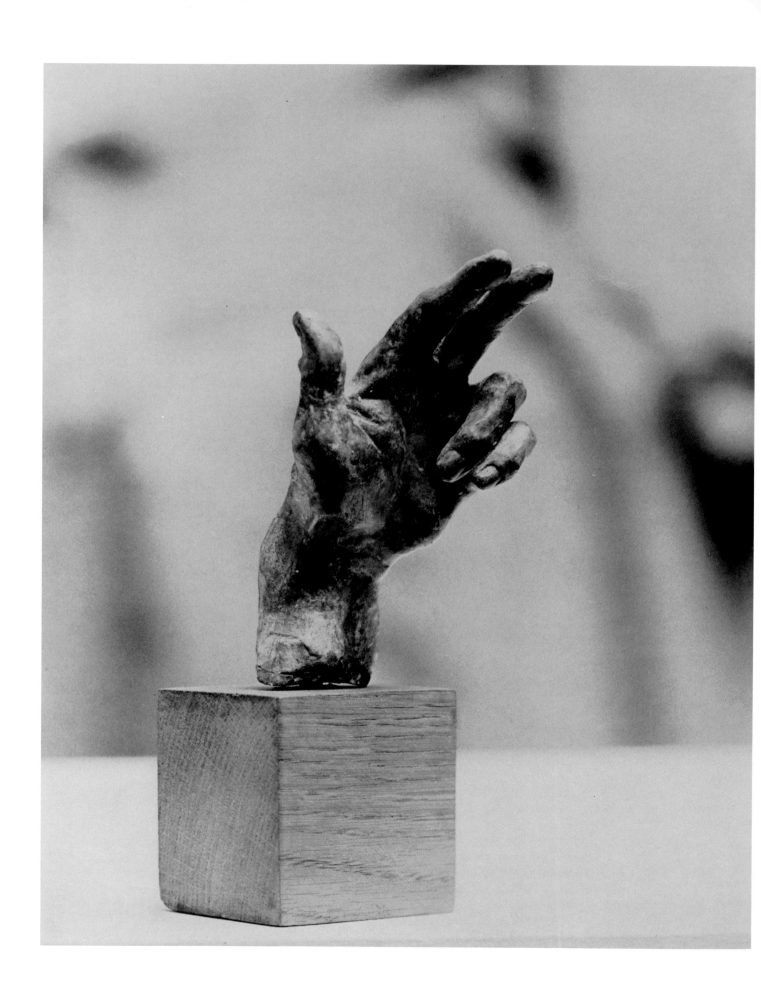

70

Left Hand

Plaster, tinted yellowish brown; on a wood base
5 7/8 x 3 1/4 x 1 7/8" (14.9 x 8.3 x 4.8 cm)
No inscription
1933.12.25

This hand making the Latin sign of benediction illustrates the importance of gesture in Rodin's studies of hands. Though the gesture of blessing is associated with religious ceremonies, we discover in Rodin's hand not the calm motion of the priest but an agitated movement like the hand in *The Gates of Hell* and *The Burghers of Calais*. This hand is not the rigid blessing hand of medieval statues or reliquaries but a hand that pulsates with life. The contours fluctuate, activated by swelling joints, distended veins and tendons and bloated muscles. Furthermore, the blessing gesture, made with the left hand rather than the right, adds a satanic note.[1]

This plaster hand probably entered the Legion of Honor in 1924; its previous history is unknown. It may be a unique cast, since no other example has been located.

NOTE

1. The left-hand benediction was part of the reversed masses of the satanists, as we see in Huysmans' *Là-Bas* (1891) where the Canon Diocre blessed the congregation at a black mass with his left hand (*Oeuvres complètes de J.-K. Huysmans*, v. 12, part 2 Paris [1928], pp. 165-66). Rodin made several studies of the benediction gesture, sometimes by the right hand, sometimes the left. See, for example, the plaster *Study for a Hand* in the Metropolitan Museum of Art.

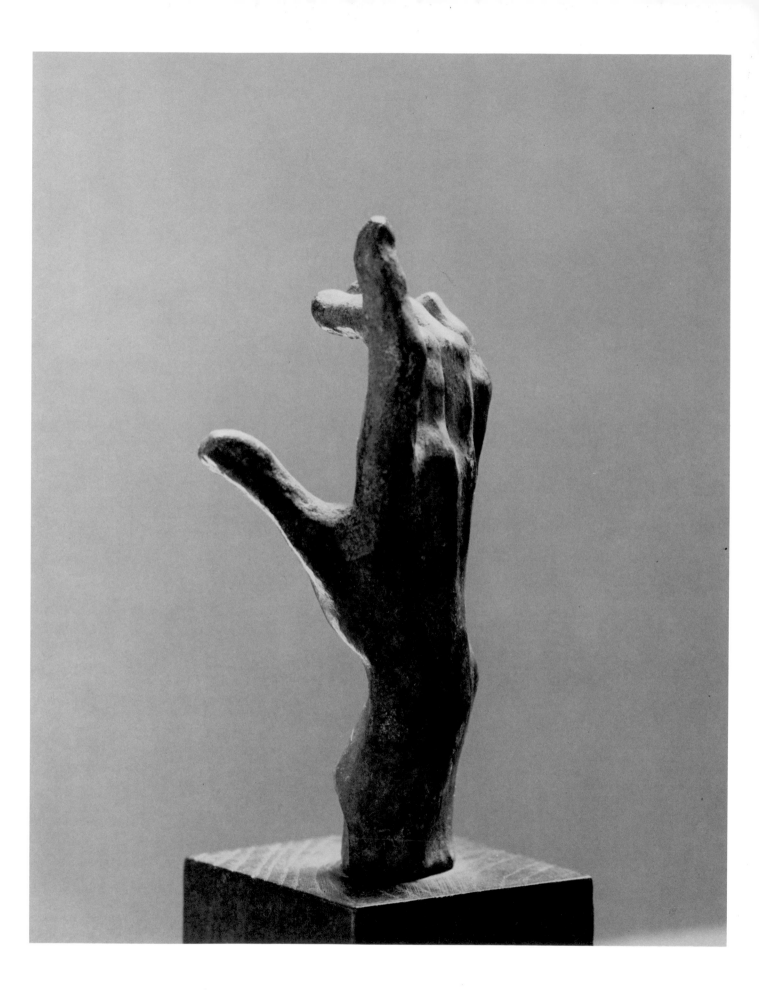

71
Right Hand

Bronze, orange, green, and dark brown patina; on a wood base
3 7/8 x 1 15/16 x 1 1/4″ (9.88 x 4.9 x 3.2 cm)
Signed: A. Rodin (lower right)
1962.25

This attenuated and delicate hand evokes the graceful movements of a dancer or a pianist.[1] Contrasting with the previous robust hand (see cat. no. 70), this hand expresses a lyrical mood, as it gradually unfolds like a flower.

The gesture is given symbolic significance in the sculpture composed of two casts of this hand, enlarged and enclosing a mysterious box. This work, called *The Secret*, is usually dated 1910, but the hand itself is similar to certain hands used for *The Burghers of Calais*.[2]

The date of entrance into the Legion of Honor and its previous history are unknown. This bronze cast may be unique.

NOTES

1. Rodin was fascinated by the hands of the pianist, moving adroitly over the keyboard. He made several studies of such hands in action (see Descharnes/ Chabrun, p. 233). Other examples are in the National Gallery in Washington; the plaster cast there which corresponds to the CPLH hand is called *Hand of a Pianist*.

2. Grappe, 1944, no. 415.

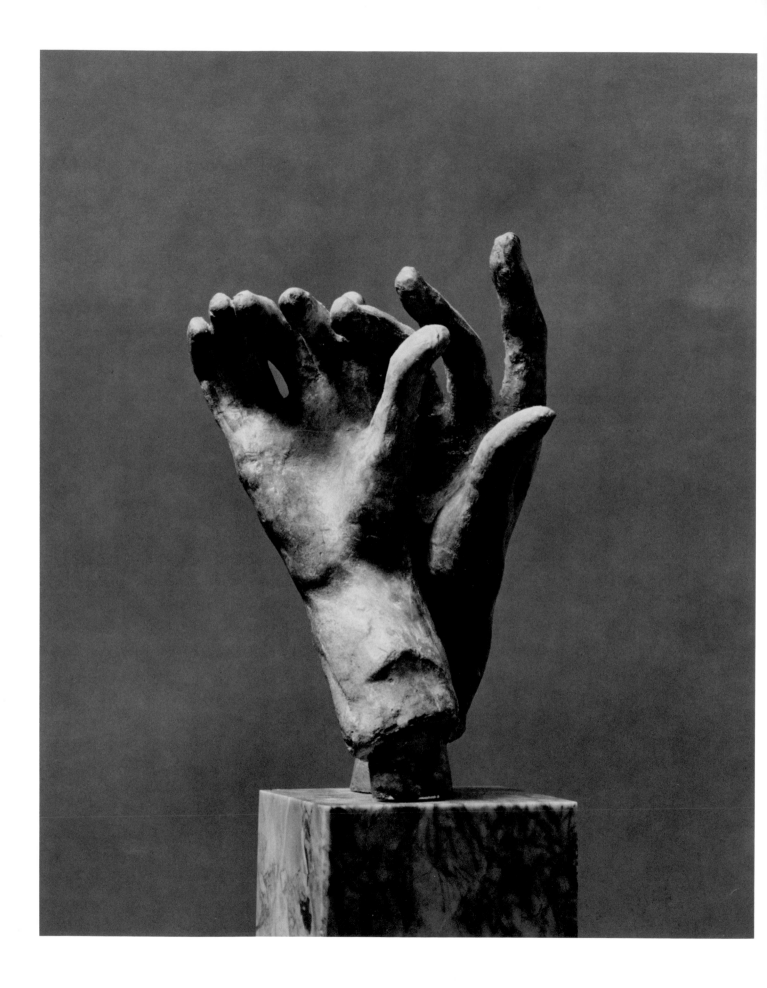

72
Two Right Hands

Plaster, tinted brown; on a variegated marble base
4 1/8 x 3 x 2 1/4" (10.5 x 7.7 x 5.7 cm)
No inscription
1933.12.12

These two exquisitely modelled hands held upright seem to fly in tandem, a pair of delicate butterflies. This fragment is an outstanding example of the way Rodin combined hands to achieve a variety of effects. The hands themselves are variations of the small bronze hand (see cat. no. 71).

Left: *Two Right Hands*. Cat. no. 72.

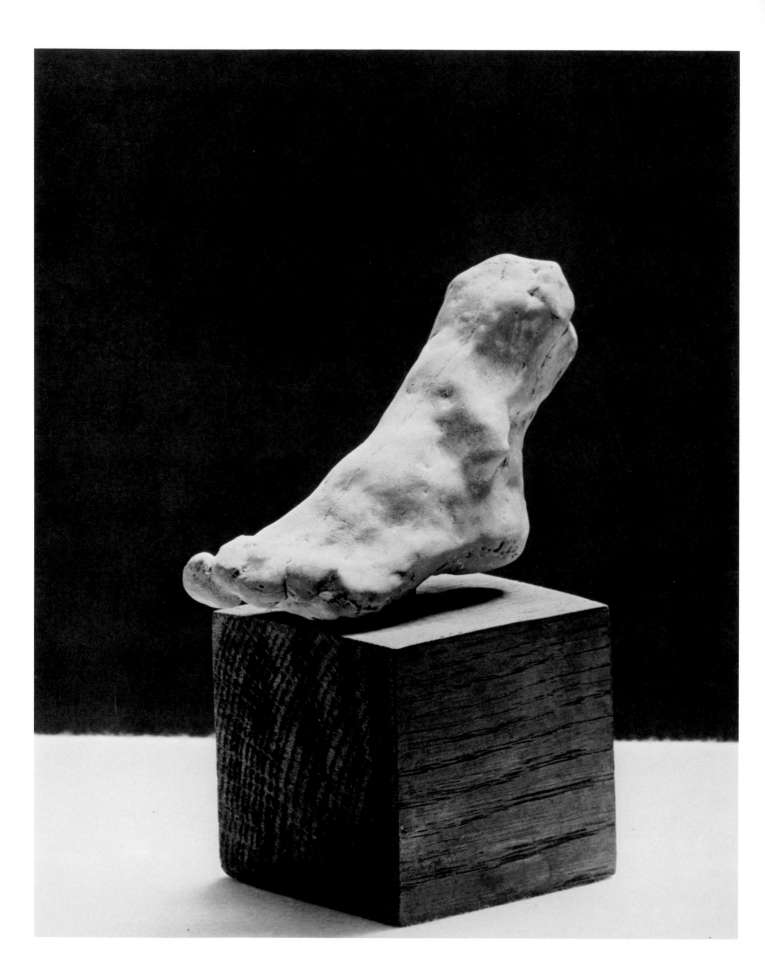

73
Study of a Left Foot

Plaster, tinted with light sienna wash; traces of piece mold; on a wood base
3 1/16 x 1 1/2 x 4 1/4″ (7.8 x 3.8 x 10.8 cm)
No inscription
1933.12.23

In this sensitively modelled left foot, the deep depressions convey not only muscle, bone and tendon but also the loving caress of the sculptor's fingers. The exaggerated lumps and hollows suggest tension and nervous unrest in a part of the body not usually endowed with any expressive function. Instead of cutting the foot from the leg at right angles, Rodin has continued the undulating surfaces at the point of truncation as if the foot were some self-sustaining form of life.

Left: *Study of a Left Foot*. Cat. no. 73.

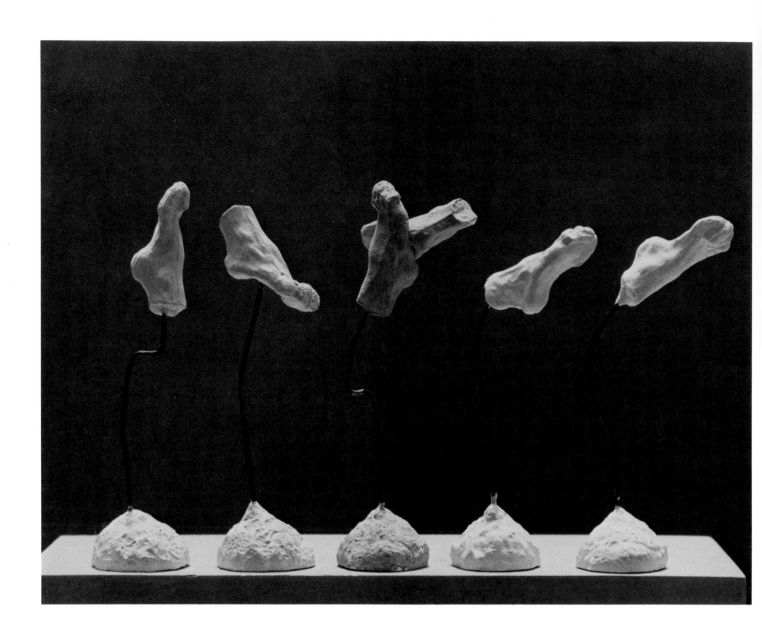

74

Compositions of Right Feet

Plaster and clay; traces of piece mold
Each foot measures: h., heel to ankle top 1″; w. at widest point, 5/8″; d. from heel to toe,
1 3/4″ (2.6 x 1.6 x 4.4 cm)
1949.19A–T

Rodin's preoccupation with varied arrangements and mountings of casts of the same right foot in this series of compositions borders on the obsessive. Such an extensive experimentation with a single fragment is unusual in Rodin's work.[1] By placing the foot in many different positions, Rodin reveals to us the infinite variety and complexity of a single part of the human anatomy. We marvel at the care with which Rodin has modelled this single detail, a complexity attested to by the seven-piece mold required to cast the foot.

Deep hollows and projections and the strained positions of the feet lend them a lifelike vigor. Their various arrangements make us realize that no position is "correct" and no single view may be held. As if endowed with an energy of their own, these feet fly, stand, recline or dive. Grouped like still lifes in sculpture,[2] they multiply the expressive possibilities of the fragment. They embrace sole to sole, they drift apart and meet again toe to toe or ankle to ankle. Used as building blocks in this compositional game, such fragments anticipate found objects used in twentieth-century sculpture.

These studies entered the Legion of Honor in 1924.

NOTES

1. We know of no other example of such an extensive series of studies using a single motif, although similar examples may be part of the collection in the Musée Rodin, Paris.

2. In such assemblages of fragments, Rodin surely owes something to Géricault's still lifes composed of severed parts of the human body.

Left: *Compositions of Right Feet.* Cat. no. 74.

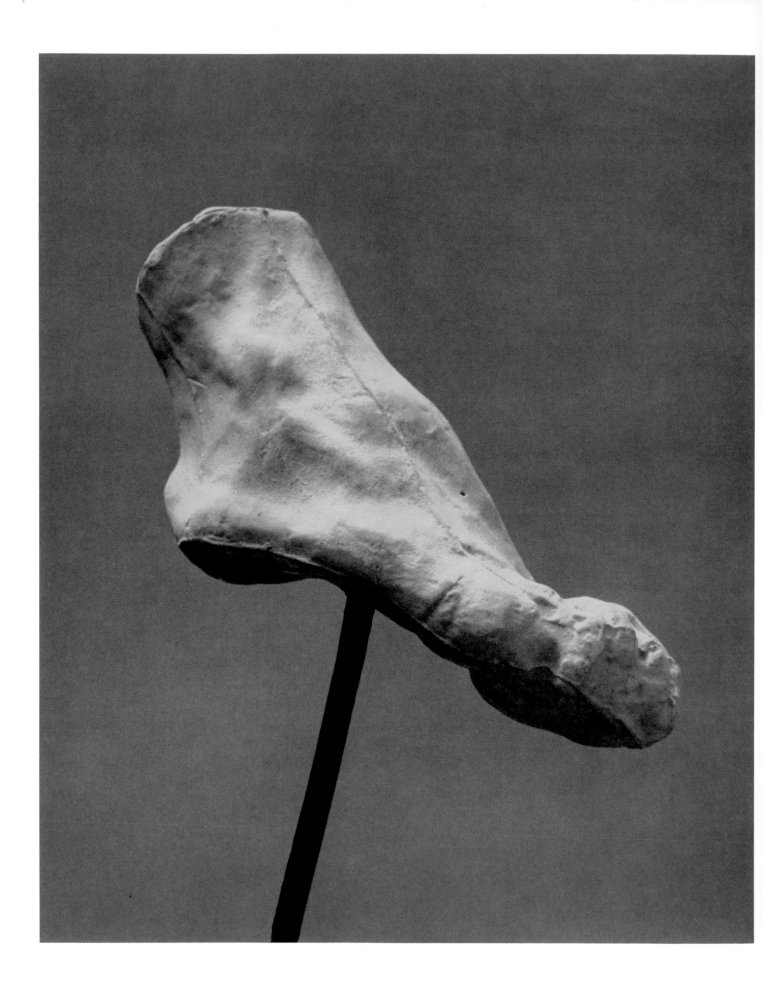

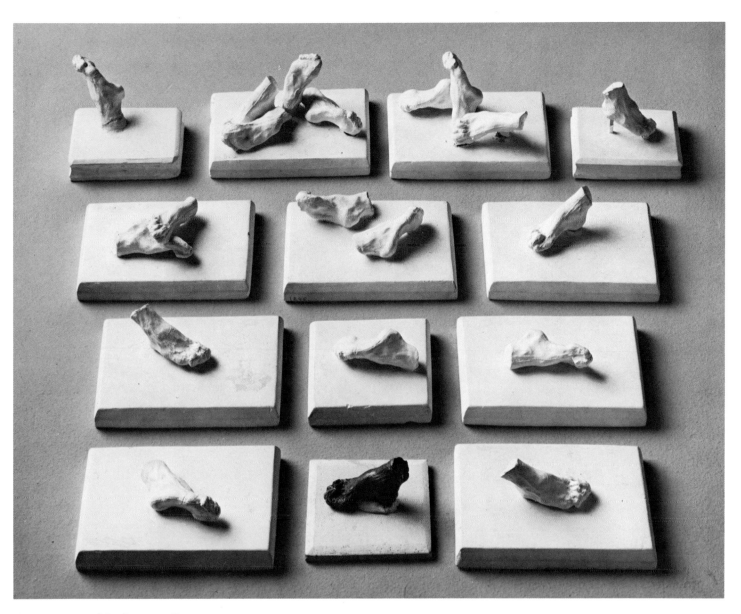

Compositions of Right Feet. Cat. no. 74.

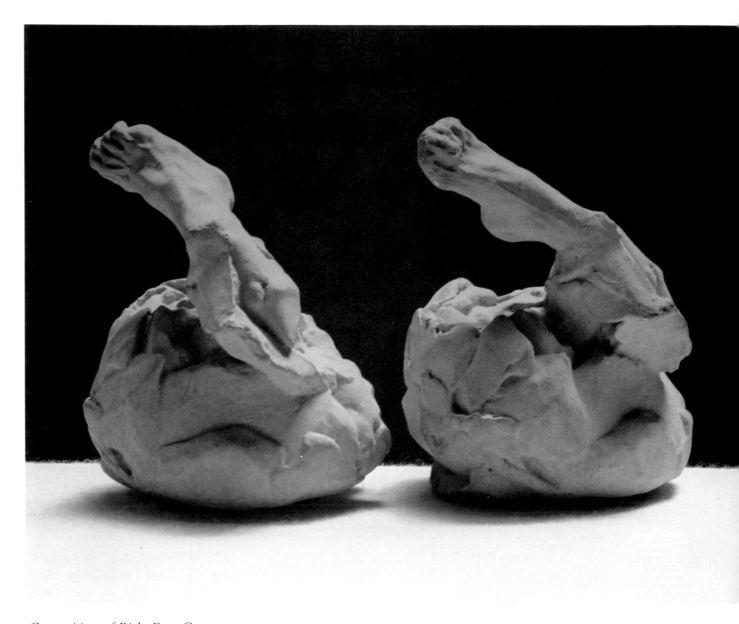

Compositions of Right Feet. Cat. no. 74.

APPENDIX

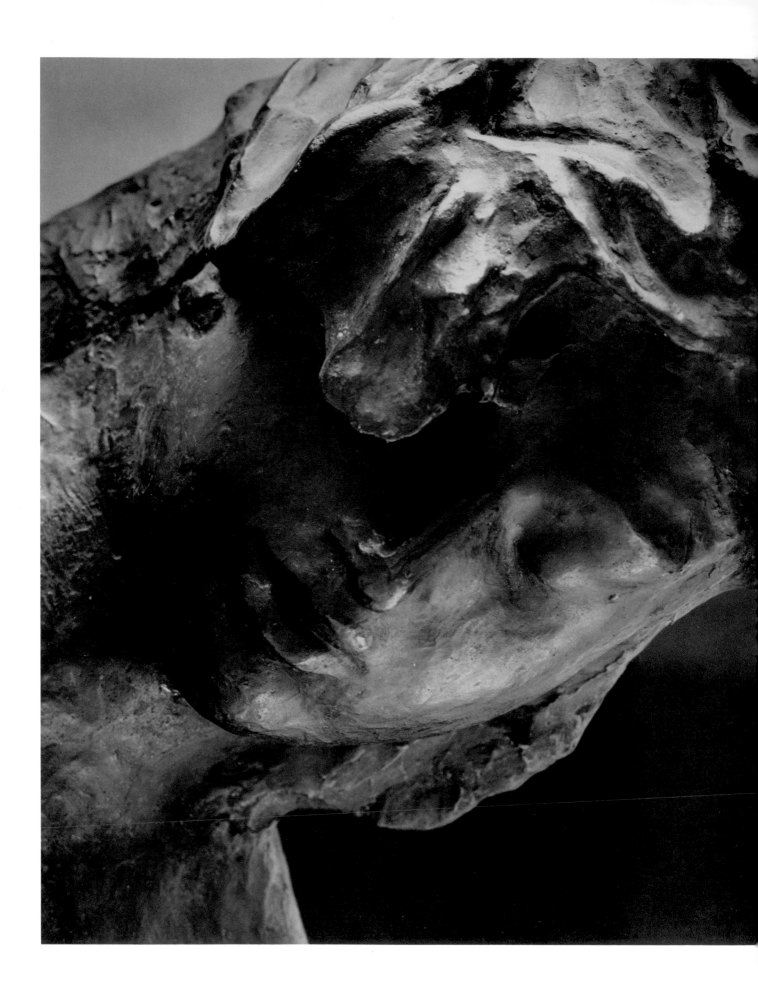

75

Female Torso
(*Torse de Femme à mi-corps*)

Bronze, black patina with traces of green
29 1/4 x 12 1/4 x 23 5/8" (74.3 x 31.1 x 60 cm)
Signed: RODIN (on section of left leg)
Stamped: MONTAGUTELLI / FRES / PARIS / CIRE PERDUE (within oval, on section of left leg)
1942.36

This cast of a precariously balanced adolescent torso has been placed in a separate category because it was produced by the Montagutelli brothers who for a number of years produced some bronzes without Rodin's consent or supervision.[1] Rodin, like many sculptors, did not consider unauthorized casts to be authentic.[2] The Montagutelli cast of this torso is usually dated 1910.[3] It differs from authentic casts only in the termination of the bit of hair that hangs from the left side of the statue's head. This lock is cut off somewhat higher, perhaps due to a fault in the Montagutelli cast.

Unfortunately, we do not know how Mrs. Spreckels acquired this bronze cast. It was in the Legion of Honor by 1924.

NOTES

1. The Montagutelli brothers (sometimes misspelled "Montacutelli" or "Montagutelle") had been Rodin's plaster casters at least since the 1890s when they were entrusted to make the first plaster cast of the Balzac (Frisch/Shipley, p. 220). Some suspect the illegal casts by one of the Montagutellis had been discovered earlier by Rodin, who prosecuted and then withdrew his case in 1913. In 1919, Montagutelli and his son were accused of having counterfeited by *surmoulage* a great number of casts between 1913 and 1918 ("Rodin Counterfeits," *London Times*, May 10, 1919, p. 11). A court trial did not stop Montagutelli, and in 1923 he was found guilty of illicitly making casts of the *Little Girl in a Chemise* by a sculptor named Bristol, to which he forged Rodin's signature ("Bristol Says His Statuettes Were Palmed off as Rodin's," *New York Times*, March 21, 1923, p. 1). A number of Montagutelli casts are still found in modern collections.

2. When asked by the art dealer, A. Vollard, how to distinguish a false from a true Rodin, the sculptor replied: "Only I can do so. It's quite simple! A true Rodin is one that has been cast with my consent; the false is done without my knowledge" (*Recollections of a Picture Dealer*, Boston, 1936, p. 209).

3. Grappe, 1944, no. 419.

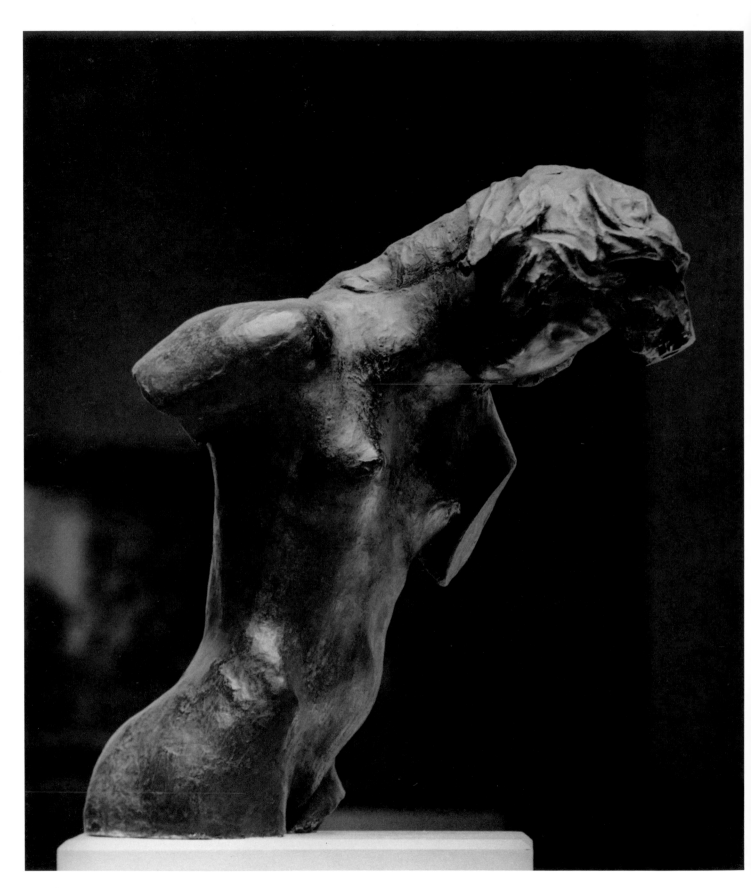

Female Torso. Cat. no. 75.

Founder's Mark: *Female Torso*. Cat. no. 75, enlarged.

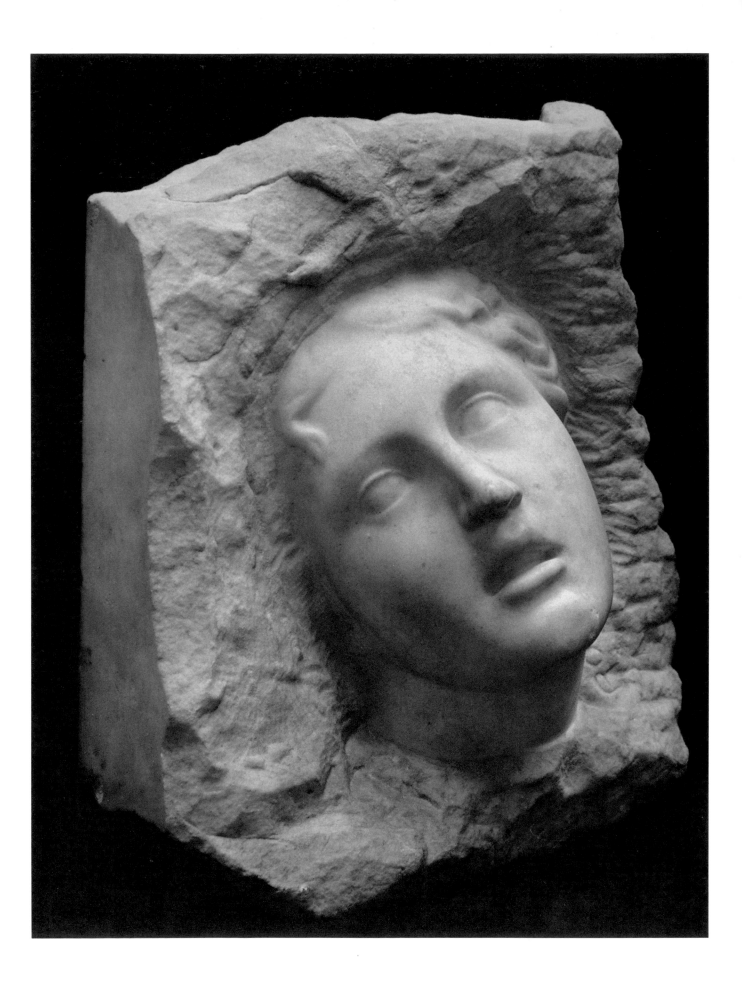

76

Greek Head

White marble
14 x 11 3/4 x 6 7/8″ (35.6 x 29.8 x 17.4 cm)
Signed: RODIN (lower right beside neck)
1941.34.18

Although this work is signed, no known document establishes the attribution to Rodin. Indeed, the work bears little similarity to the few works known from his earliest years as a sculptor. The style of the signature itself cannot be used to authenticate the sculpture, since signatures were not always carved by the artist. The head has been described as a work by Rodin at the age of twenty-two and has been cited as showing his interest in Greek art.[1] Rodin's early training, as for all art students, certainly included the study of antique sculpture and some of his earliest works, such as the *Man with the Broken Nose* (see cat. no. 50), reflect it.[2] The *Greek Head* superficially recalls Hellenic sculpture in which pathos is evoked through the tilted head, raised eyes and open mouth.

However, this head is much closer to a style of sculpture popular in France around 1850. Pradier had reinterpreted Greek sculpture in a manner that stressed a greater sensuality. This marble is also strikingly similar to Préault's sculptures of women. Several examples by Préault show similar facial expressions, simplified forms and emphatic curvilinear elements. Even the style of specific physiognomic details—such as mouth, eyes and bulging neck—can be closely compared.[3] As a young artist, Rodin was impressed by a notable type of sculpture which celebrated spiritual and emotional states without attempting a faithful representation of the model, emphasizing instead the expressive effects of the formal patterns.[4] Such a style of sculpture, which existed in the middle of the nineteenth century side-by-side with the more naturalistic sculpture of Carpeaux, is not one generally associated with Rodin; nevertheless, it provided a continuing source of compositional patterns in his art.

The *Greek Head* has the appearance of a copy after this type of sculpture, best exemplified by Pradier and Préault, a copy such as any perceptive young sculptor could have made at the time.

This marble head entered the Legion of Honor in 1924. The date of purchase is unknown.

Left: *Greek Head*. Cat no. 76.

Inscription: *Greek Head*. Cat. no. 76.

NOTES

1. In the CPLH 1924-1925 catalogue, it is described as "Head, carved by the Master at the age of twenty-two, when he was under the influence of Greek art" (no. 178). This appears to be a quote from a description by Loïe Fuller (typescript, CPLH archives).

2. Much of Rodin's early training is still a mystery. However, his study of antique art was described by his biographers (Bartlett, p. 28; Cladel, 1950, p. 77; Dujardin-Beaumetz, p. 111). Examples of early drawings after antique art are reproduced by Descharnes/Chabrun (p. 16).

3. Examples of such sculptures by Préault are *Sainte Marthe*, *Ophélie* (Salon of 1850), *Sainte Catherine* (1862) and the tomb of Mme Didier (1865).

4. Rodin later told Bartlett of his great admiration for such sculptors: "Like every young artist, he indulged in the prevailing belief that such men as Ingres, Perault [sic], and Pradier were gods in art, to be loyally worshipped by every student" (p. 28). Examples of his interest in this type of sculpture are also found in an early sketchbook (J. de Caso, "Rodin's Mastbaum Album," *Master Drawings*, X:2 (Summer, 1972), pls. 34a and 36).

Selected Bibliography

The Rodin bibliography is enormous and cannot be dealt with at length within the scope of this work. For the reader's convenience, we have listed separately under Early Bibliography the most fundamental publications before 1950, some of which include additional bibliography. Works after 1950 with bibliographies have been noted below. We have limited this bibliography primarily to major articles and books written since 1950, which marks the time of a strong revival of interest in Rodin.

Abbreviated citations: In the Notes to the foregoing catalogue entries, a number of works in this bibliography which are referred to frequently are given in shortened form. These forms are included in alphabetical order by author above the works to which they refer; see, for example, entries for Cladel, below. (References to works not in this bibliography, or to infrequently cited works in it, are given in full in the Notes.)

Recent works: Works in the bibliography marked with an asterisk (*) were published after completion of the manuscript and were unavailable for citation.

EARLY BIBLIOGRAPHY

"Auguste Rodin et son oeuvre," *La Plume*, 1900 (special Rodin issue).

BARTLETT
Bartlett, T. H., "Auguste Rodin, Sculptor," *American Architect and Building News*, vol. 25:
no. 682 (Jan. 19, 1889), pp. 27-29
no. 683 (Jan. 26, 1889), pp. 44-45
no. 685 (Feb. 9, 1889), pp. 65-66
no. 688 (March 2, 1889), pp. 99-101
no. 689 (March 9, 1889), pp. 112-14
no. 696 (April 26, 1889), pp. 198-200
no. 698 (May 11, 1889), pp. 223-35
no. 700 (May 25, 1889), pp. 249-51
no. 701 (June 1, 1889), pp. 260-63
no. 703 (June 15, 1889), pp. 283-85

(Reprinted in Albert Elsen, *Auguste Rodin, Readings on His Life and Work*, Englewood Cliffs, N.J.: Prentice-Hall, Inc., 1965.)

CLADEL, 1903
Cladel, Judith, *Auguste Rodin Pris sur la Vie*, Paris: Editions de la Plume, 1903.

CLADEL, 1908
Cladel, Judith, *Auguste Rodin, l'oeuvre et l'homme*, Brussels: Van Oest, 1908.

CLADEL, 1917
Cladel, Judith, *Rodin, the Man and His Art with Leaves from His Notebook*, New York: Century Co., 1917.

CLADEL, 1950
Cladel, Judith, *Rodin, sa vie glorieuse, sa vie inconnue*, Paris: Grasset, 1936 (definitive edition, 1950).

COQUIOT, *Vrai Rodin*
Coquiot, Gustave, *Le vrai Rodin*, Paris: Eds. Jules Tallandier, 1913.

COQUIOT, *Rodin à l'Hôtel de Biron*
Coquiot, Gustave, *Rodin à l'Hôtel de Biron et à Meudon*, Paris: Librarie Ollendorff, 1917.

DUJARDIN-BEAUMETZ
Dujardin-Beaumetz, François, *Entretiens avec Rodin*, Paris: Paul Dupont, 1913 (private edition). Translated and reprinted in Albert Elsen, *Auguste Rodin, Readings on His Life and Work*, Englewood Cliffs, N.J.: Prentice-Hall, Inc., 1965.

FRISCH/SHIPLEY
Frisch, Victor, and Joseph T. Shipley, *Auguste Rodin*, New York: Frederick A. Stokes Co., 1939.

GRAPPE, 1931
Grappe, Georges, *Catalogue du Musée Rodin I*. Hôtel Biron, Paris, 1931 (3rd. ed.).

GRAPPE, 1944
Grappe, Georges, *Catalogue du Musée Rodin I. Hôtel Biron. Essai de classement chronologique des oeuvres d'Auguste Rodin*, Paris, 1944 (bibliography).

LAMI
Lami, Stanislas, *Dictionnaire des Sculpteurs de l'école française au dix-neuvième siècle*, Paris: Editions Champion, 1921, v. 4, pp. 161-75.

LAWTON
Lawton, Frederick, *The Life and Work of Auguste Rodin*, London: Grant Richards, 1904; T. Fischer Unwin, 1906; Grant Richards, 1907; New York: Charles Scribner's Sons, 1907.

MAILLARD
Maillard, Léon, *Auguste Rodin, statuaire*, Paris: H. Floury, 1899.

MAUCLAIR
Mauclair, Camille, *Auguste Rodin: The Man—His Ideas—His Works*, London: Duckworth and Co., 1905.

Rilke, Rainer Maria, *Auguste Rodin*, Leipzig Inselverlag, 1920. The first essay (dated 1903) in this book was reprinted in Albert Elsen, *Auguste Rodin, Readings on His Life and Work*, Englewood Cliffs, N.J.: Prentice-Hall, Inc., 1965.

Rodin, Auguste, *On Art and Artists* [interview with Paul Gsell, first published in 1911]; New York: Philosophical Library, 1957.

"Rodin, l'homme et l'oeuvre," *L'Art et les Artistes*, 1914 [special Rodin issue (bibliography)].

BIBLIOGRAPHY SINCE 1950

Alhadeff, Albert, "Michelangelo and the Early Rodin," *Art Bulletin*, 45 (1963), pp. 363-67.

ALLEY
Alley, Ronald, *The Foreign Paintings, Drawings and Sculptures* (Tate Gallery Catalogues), London: Tate Gallery, 1959, pp. 205-27.

Carley, Lionel, "Jelka Rosen Delius: Artist, Admirer and Friend of Rodin. The Correspondence 1900-1914," *Nottingham French Studies* IX:1 (May, 1970), pp. 16-30; and IX:2 (October, 1970), pp. 81-102.

Caso, Jacques de, "Rodin at the Gates of Hell," *Burlington Magazine*, 106 (February, 1964), pp. 79-82.

Caso, Jacques de, "Balzac and Rodin in Rhode Island," *Rhode Island School of Design Bulletin*, 52 (May, 1966), pp. 1-28.

Caso, Jacques de, "Rodin et l'Amérique," *Le Monde* (Paris), February 2, 1968.

Caso, Jacques de, "Rodin's Mastbaum Album," *Master Drawings*, 10:2 (Summer, 1972), pp. 155-61.

Caso, Jacques de, and Patricia B. Sanders, *Rodin's Thinker*, San Francisco: Fine Arts Museums of San Francisco, 1973.

Charpentier, Thérèse, "Notes sur le Claude Gellée de Rodin, à Nancy," *Bulletin de la Société de l'histoire de l'art français*, 1970, pp. 149-58.

DESCHARNES/CHABRUN
Descharnes, Robert, and Jean François Chabrun, *Auguste Rodin*, New York: Viking Press, 1967 (extensive bibliography).

ELSEN, *Gates*
Elsen, Albert E., *Rodin's Gates of Hell*, Minneapolis: University of Minnesota Press, 1960 (bibliography).

Elsen, Albert E., *Rodin*, New York: The Museum of Modern Art, 1963 (bibliography). For review, see Mirolli, *Art Bulletin*, 46 (December, 1964), pp. 577-79.

Elsen, Albert E., "Rodin's 'La Ronde,'" *Burlington Magazine*, 107 (June, 1965), pp. 290-99.

Elsen, Albert E., "Rodin's Portrait of Baudelaire," *Catalogue and Collection of Essays Honoring Henry Hope*, no. 25, Bloomington, Indiana: Indiana University, 1966.

Elsen, Albert E., and Henry Moore, "Rodin's *Walking Man* as Seen by Henry Moore," *Studio*, 174 (July, 1967), pp. 26-31.

Elsen, Albert E., "Rodin's 'Naked Balzac,'" *Burlington Magazine*, 109 (November, 1967), pp. 606-17.

Elsen, Albert E., and J. Kirk T. Varnedoe, *The Drawings of Rodin*, with additional contributions by Victoria Thorson and Elisabeth Chase Geissbuhler, New York and Washington, D.C.: Praeger Publishers, 1972 (bibliography).

Geissbuhler, Elisabeth Chase, *Rodin: Later Drawings*, Boston: Beacon Press, 1963.

Goldscheider, Cécile, "Rodin et le monument de Victor Hugo," *Revue des Arts*, VI (October, 1956), pp. 179-84.

Goldscheider, Cécile, "La Nouvelle salle des Bourgeois de Calais," *La Revue du Louvre*, 21:3 (1971), pp. 165-74.

GONCOURT, *Journal*

Goncourt, Edmond de, and Jules de Goncourt, *Journal, mémoires de la vie littéraire*, Monaco: Impr. nationale, 1956, 22 vols.

Janson, H. W., "Rodin and Carrier-Belleuse: The Vase des Titans," *Art Bulletin*, 50 (September, 1968), pp. 278-80.

Janson, H. W., "Une source négligée des Bourgeois de Calais," *Revue de l'art*, 5 (1969), pp. 69-70.

JIANOU/GOLDSCHEIDER

Jianou, Ionel, and Cécile Goldscheider, *Rodin*, Paris: Artaud, Editions d'Art, 1967 (extensive bibliography). Translated by Kathleen Muston and Geoffrey Skelding. For review, see Elsen, *Burlington Magazine*, 109 (November, 1967), pp. 649-50.

*McNamara, Mary Jo, and Albert Elsen, *Rodin's Burghers of Calais: Rodin's Sculptural Studies for the Monument to the Burghers of Calais*, published by the Cantor, Fitzgerald Group, 1977.

Mirolli, Ruth Butler, *The Early Work of Rodin and Its Background*, Ann Arbor, Michigan: University Microfilms, 1966.

Nicolson, Benedict, "Rodin and Lady Sackville," *Burlington Magazine*, 112 (January, 1970), pp. 37-43.

Rice, Howard C., Jr., "Glimpses of Rodin," *Princeton University Library Chronicle*, 27 (1965), pp. 33-44.

Rostrup, Haavard, *Ny Carlsberg Glyptotek. Modern Skulptur danske og udenlandsk*, Copenhagen: Moderne afdeling, 1964, pp. 133-41.

Sanders, Patricia, "Auguste Rodin: The Man with the Broken Nose, The Little Man with the Broken Nose, The Kiss," *Metamorphoses in Nineteenth-Century Sculpture* (Jeanne L. Wasserman, editor), Cambridge: Fogg Art Museum, Harvard University Press, 1975, pp. 144-79.

Schmoll, gen. Eisenwerth, J. A., "Zur Genesis des Torso-Motivs und zur Deutung des fragmentarischen Stils bei Rodin," *Das Unvollendete als Kunstlerische Form*, Berne-Munich: A. Francke, 1959, pp. 117-39.

Schmoll, gen. Eisenwerth, J. A., "Auguste Rodin. Das heutige Bild seines Werkes und seiner Wirkung," *Universitas*, 23:4 (1968), pp. 393-409.

Selz, Peter, "Rodin and America," in A. Elsen, *Rodin*, New York: Museum of Modern Art, 1963, pp. 191-203.

Spear, Athena Tacha, "The Prodigal Son, Some New Aspects of Rodin's Sculpture," *Allen Memorial Art Museum Bulletin* (Oberlin College), 1 (1964), pp. 23-29.

Spear, Athena Tacha, *Rodin Sculptures in the Cleveland Museum of Art*, Cleveland: Cleveland Museum of Art, 1967 *Supplement* Cleveland Museum of Art, 1974.

Spear, Athena Tacha, "A Note on Rodin's Prodigal Son and on the Relationship of Rodin's Marbles and Bronzes," *Allen Memorial Art Museum Bulletin* (Oberlin College), 27:1 (Fall, 1969), pp. 25-36.

Sutton, Denys, *Triumphant Satyr: The World of Auguste Rodin*, London: Country Life Ltd., 1966 (bibliography). For review see Elsen, *Burlington Magazine*, 109 (February, 1967), pp. 105-06.

*Tancock, John L., *The Sculpture of Auguste Rodin*, Boston: David R. Godine, 1976 (bibliography).

Varnedoe, J. Kirk, "Early Drawings by Auguste Rodin," *Burlington Magazine*, 853 (April, 1974), pp. 197-202.

EXHIBITION CATALOGUES

Musée Rodin, *Balzac et Rodin*, Paris: Musée Rodin, 1950.

Goldscheider, Cécile, *Musée Rodin, Rodin, ses collaborateurs et ses amis*, Paris: Musée Rodin, 1957.

Goldscheider, Cécile, *Rodin Inconnu*, Paris: Musée Rodin, 1962.

Slatkin, Charles E., Galleries, *Rodin, Sculptures and Drawings* (exhibition catalogue), New York, 1963 (Introduction by Leo Steinberg, catalogue notes by Cécile Goldscheider).

Goldscheider, Cécile, *Mostra di Auguste Rodin. Villa Medici, Roma*, Rome: Inst. graf. tiberino, 1967.

Goldscheider, Cécile, *Rodin collectionneur*, Paris: Musée Rodin, 1967-1968.

Elsen, Albert E., *The Partial Figure in Modern Sculpture from Rodin to 1969*, Baltimore: Baltimore Museum of Art, 1969, pp. 16-28.

Arts Council of Great Britain, *Rodin*, London, 1970 (bibliography). Foreword by Gabriel White: "Rodin, a conversation with Henry Moore," and catalogue, by Alan Bowness.

Elsen, Albert, Stephen C. McGough, and Steven H. Wander, *Rodin and Balzac: Rodin's Sculptural Studies for the Monument to Balzac*, Beverly Hills, California: Cantor, Fitzgerald and Co., Inc., 1973.

Thorson, Victoria, *Rodin Graphics: A Catalogue Raisonné of Drypoints and Book Illustrations*, San Francisco: The Fine Arts Museums of San Francisco, 1975.

*Musée Rodin, *Rodin et les écrivains de son temps; sculptures, dessins, lettres et livres du fonds Rodin*, Paris: Musée Rodin, 1976.

Index of Proper Names and Exhibitions

Index of Works by Rodin

Note: Titles of works in the Spreckels' collection appear in capital letters, followed by the catalogue number in italic. Numbers in parentheses indicate an inclusive page reference for a catalogue entry.

359

STAFF

Ian McKibbin White, *Director of Museums*

CURATORIAL DIVISION

Africa, Oceania, and the Americas
Thomas K. Seligman, *Curator in Charge*
Kathleen Berrin, *Assistant Curator*

Decorative Arts
D. Graeme Keith, *Curator in Charge*
Anna Bennett, *Curator*
Gene Munsch, *Conservator*
Bruce Hutchison, *Conservator*

Paintings and Sculpture
Thomas P. Lee, *Curator in Charge*
William Elsner, *Curator*
Teri Oikawa-Picante, *Conservator*

Prints and Drawings
(Achenbach Foundation for Graphic Arts)
Robert F. Johnson, *Curator in Charge*
Fenton Kastner, *Curator*
Maxine Rosston, *Curatorial Assistant*
Robert Futernick, *Conservator* (Western Regional
 Paper Conservation Laboratory)

Publications
Thomas P. Lee, *Editor*
Edward T. Engle, Jr., *Publications Manager*

Registration
Frederic P. Snowden, *Registrar*
S. DeRenne Coerr, *Registrar*
Paula March, *Assistant Registrar*
Harry Fugl, *Registration Assistant*
James Medley, *Photographer*
William Boyd, *Museum Packer*

EDUCATIONAL DIVISION

Thomas K. Seligman, *Deputy Director for Education
 and Exhibitions*

Art School
Elsa Cameron, *Curator in Charge*
Richard Fong, *Associate Curator*
James Stevenson, *Assistant Curator*
Shelley Dowell, *Program Coordinator*

Eileen Lew, *Senior Curatorial Assistant*
Mary Stofflet, *Administrative Assistant*
John Chiu, *Assistant Curator*
Michael Chin, *Exhibitions Coordinator*
Hitoshi Sasaki, *Designer/Preparator*

Exhibitions
Susan Levitin, *Curator in Charge*
Michael Cox, *Exhibition Designer*
Ron Rick, *Graphic Designer*
Steve Weiss, *Exhibition Manager*
Raymond E. Raczkowski, *Principal Preparator*

Interpretation
Renée Beller Dreyfus, *Assistant Curator*

Library
Jane Gray Nelson, *Librarian*

Program
Bruce Merley, *Assistant Curator*
Charles Mills, *Assistant Curator*
James Baldocchi, *Theater Manager*

ADMINISTRATIVE DIVISION

Ronald Egherman, *Deputy Director for
 Administration and Development*

Accounting
Delores Malone, *Controller and Executive
 Secretary of the Board of Trustees*
Jose Velasco, *Accountant*
John V. Hourihan, *Foundation Accountant*
Josephine Regan, *Senior Account Clerk*

Administration and Personnel
Joanne Backman, *Operations Administrator*
Charles Long, *Public Information Officer*
Patricia Pierce, *Payroll Clerk*
Ola Kupka, *Volunteer Coordinator*
Katharine Livingston, *Project Development Coordinator*
Earl Anderson, *Assistant to the Director*
Regina Irwin, *Assistant to the Director*

Engineering
John Cullen, *Chief Stationary Engineer*

Superintendence
Salvatore Priolo, *Museum Services Coordinator*
Elvin Howard, *Chief Guard*